THE CIVIL WAR

WAR

DAY BY DAY

PHILIP KATCHER

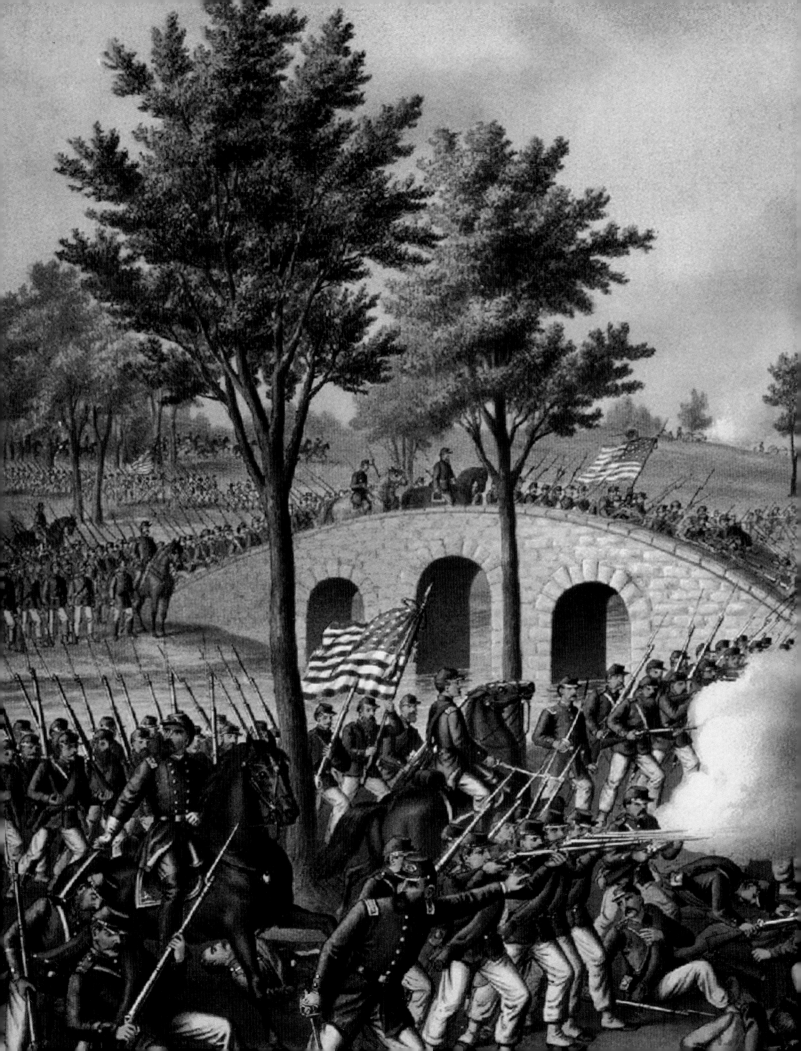

THE CIVIL WAR

WAR

DAY BY DAY

PHILIP KATCHER

CHARTWELL
BOOKS, INC.

This edition published in 2010 by
CHARTWELL BOOKS, INC.
A division of BOOK SALES, INC.
276 Fifth Avenue Suite 206
New York, New York 10001
USA

Reprinted in 2011

ISBN-13: 978-0-7858-2664-4
ISBN-10: 0-7858-2664-5

Produced by
Windmill Books
First Floor
9-17 St. Albans Place
London N1 ONX

Senior Editor: Peter Darman
Designer: Jerry Udall
Cartographer: David Atkinson
Production: Beckie Sanderson
Picture Research: Andrew Webb
Index: Indexing Specialists (UK) Ltd

Printed in China

Pages 2-3: The Battle of Antietam, September 17, 1862

CONTENTS

INTRODUCTION

For years before the outbreak of the American Civil War the populations of the geographic regions of the country had grown ever more different. Indeed, they had started differently. Northern settlers came to create good lives for themselves and a good society for all, often basing this society on religious principles such as those of the Puritans of Massachusetts and the Quakers of Pennsylvania. For the most part, Southern settlers came to make as much money as quickly and as easily as possible, and leave, unconcerned with anybody but themselves. Northern crops were foodstuffs such as wheat and rye, while Southern crops were tobacco and cotton. And though the latter were easier to grow and more profitable to sell, they were nonetheless labor-intensive.

The institution of slavery

It is not surprising then, that in the 17th century, when human slavery was introduced throughout what would become the United States, it was in the South that it found the most fertile ground. The system would die by the end of the next century in New England and the mid-Atlantic states as far south as Pennsylvania and New Jersey because it ran against their basic ethical beliefs, as well as the fact that it made less economic sense on the small farms of those areas. In the South, where farmers aspired to own large plantations dedicated to one or two cash crops, slavery was quickly adopted widely. At first laborers were both white and black. Whites, however, served for only a set period of years before being relieved of their duties. Blacks, though, first introduced as slaves in Virginia in 1619, were quickly seen as heathens little suited for, or capable of, operating as free men. Racial discrimination soon became institutionalized, both in peoples' minds and in the legal systems of the Southern states. By the mid-1850s, therefore, Southern thinking was totally rigid on the question. Growing pressure by moralists against the use of slavery only further hardened their positions.

At the same time, notions of racial superiority produced a feeling of being a member of an aristocracy, not just an aristocracy over blacks, but over foreigners and anybody who differed from one's own class. This would naturally include the many Germans, Irish, Scandinavians, and others who flocked to Northern cities in the first half of the 19th century.

Southern politicians

In the early years of the republic, Southern politicians dominated the national government. Their states were the most populous, especially Virginia, and economically all the states were similar in that they were agrarian, rather than industrial. By 1820, however, Southern leaders began to lose their power. Northern states grew in terms of population and economic progress much more quickly than Southern ones. At the same time, the nation began to see a growing moral indignation about holding human beings as slaves, a movement that started in Pennsylvania and Massachusetts. This gave Southern leaders cause for concern that they now had to defend a major part of their culture with an ever-decreasing amount of economic and political power. As a result, the notion of "states' rights," something not found in the Constitution, gained credence in the popular Southern mind.

John Brown's raid

Finally, these leaders found themselves under physical attack. The assailant would be John Brown, a radical abolitionist. On October 16, 1859, Brown and 21 followers armed with weapons secretly provided by New England abolitionist leaders attacked the U.S. Arsenal at Harpers Ferry, Virginia. Ten of Brown's men were killed in the subsequent fighting. Brown himself was turned over to Virginia authorities to stand trial for treason against the state. He was hanged on December 2, 1859. Northern officials did not endorse the Brown raid and officially the country returned to the status quo. But in fact, many Northerners saw Brown as a martyr and Southerners began to fear that their rights to hold slaves would be taken from them by force if the opposition in the North grew too strong. Virginians and other Southern states' citizens began to form volunteer militia units in earnest.

By November 1860, spurred on by the increase in tensions after the John Brown raid as well as the presidential election results, there were three volunteer regiments and six more battalions in Virginia alone. This number grew to five regiments and six battalions by the following April. Still there was no war. What finally triggered the conflict was the election of Abraham Lincoln, the second candidate of the Northern-based Republican Party founded in 1854.

The reason most quoted after the war by Southern leaders for trying to break up the republic was to "defend states' rights." The actual election of 1860 was not even over when a number of Southern leaders began to call for action if Lincoln were to win. Alabama and Florida said they would leave the Union, while Mississippi and Louisiana called for a Southern convention to plan on a united course of action. Once the results of the election were known, however, South Carolina decided not to wait, but called a state convention for December 17, the day on which they voted the state out of the Union. From there, there was no going back. South Carolina's secession was soon followed by conventions in Florida, Mississippi, Alabama, Georgia, Louisiana, and Texas, all of which, by large majorities, voted to dissolve their ties with the United States.

The next step was for these like-minded states to band together. They picked the town of Montgomery, Alabama, as the site of their convention, which was opened on February 4, 1861. Once there they voted to form a new nation, the Confederate States of America. They picked for their president a moderate, Jefferson Davis from Mississippi.

Lincoln was not yet the president when Davis was sworn in. On March 4, 1860 Abraham Lincoln was sworn in as the 16th president of the United States. Lincoln and his administration were willing to fight a war to prevent the Southern states from seceding, and Fort Sumter would be the place where his resolve would be tested. On March 29, President Lincoln decided to send provisions to Fort Sumter, and he made this decision known to the South Carolina officials on April 6. On April 11, P.G.T. Beauregard, one of Alabama's most senior generals, demanded the fort's surrender. The Union commander refused, and an hour before midnight that evening the Confederates opened fire on Fort Sumter. The first shots of the American Civil War had been fired.

▼ The American Civil War would be a bloody conflict, with the increased killing power of small arms and artillery inflicting high casualties. This is the Battle of Cold Harbor, where 15,500 men were killed and wounded.

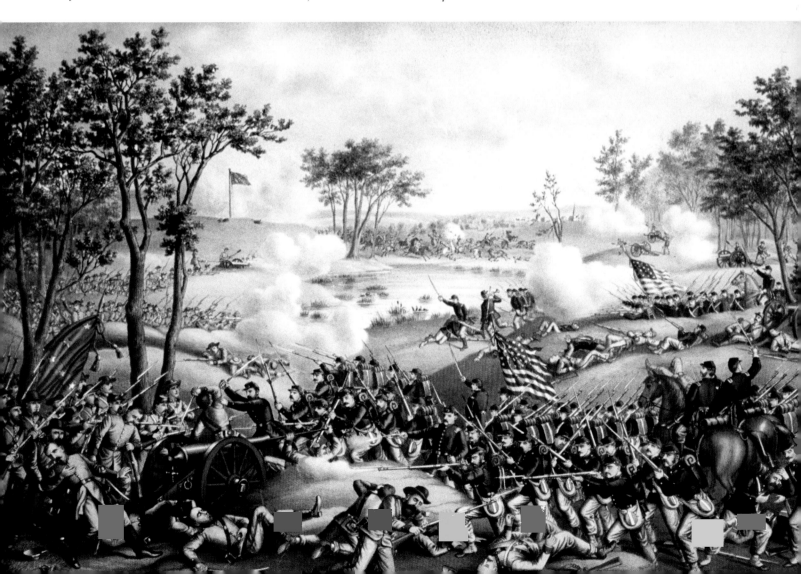

THE ROAD TO WAR

In the first half of the nineteenth century tensions increased between the Southern and Northern states. Southern leaders acted to "defend states' rights" (the right of a state's population to overrule the decisions of the national majority, and to protect certain privileges and customs, particularly slavery). In their vision, the state was the dominant political body, and the national government was simply an organization made up of these states. The election of Abraham Lincoln in November 1860, who was vehemently opposed to secession, brought matters to a head. South Carolina was the first state to vote to leave the Union. This act would be followed by other Southern states in 1861, leading to the outbreak of the Civil War between North and South.

1820

WASHINGTON, D.C., *POLITICS*
Disagreements over slavery had existed since before the American Revolution. The Constitution was unclear about permitting slavery in newly created states. That became a major issue in 1819, when the territory of Missouri applied for statehood.

Congress had to pass a law to grant Missouri statehood. As the legislation was being debated in the House of Representatives in February 1819, Representative James Talmadge of New York proposed

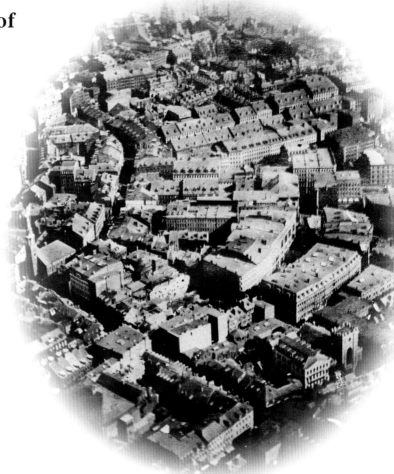

▶ A photograph of Boston, the capital of Massachusetts, taken from a balloon in 1861. Boston was a large, thriving city and the center of the antislavery movement in the North.

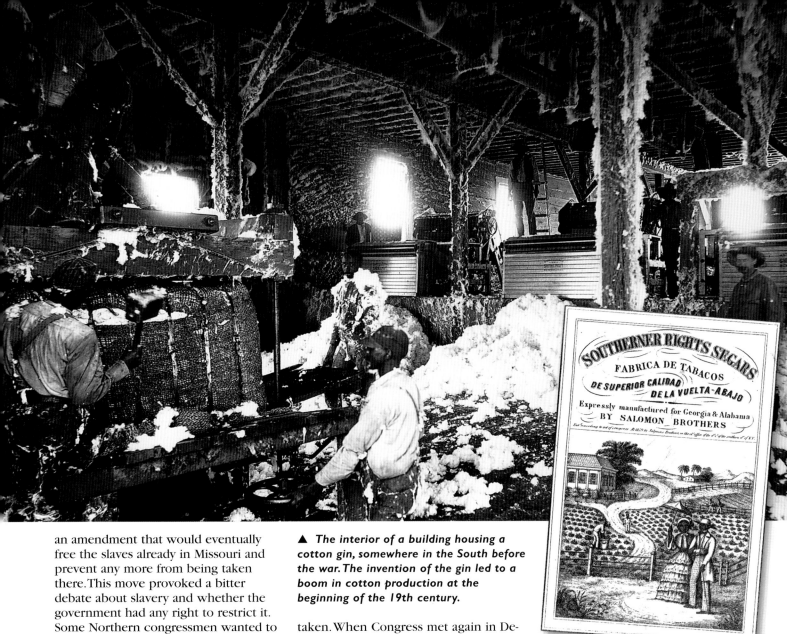

an amendment that would eventually free the slaves already in Missouri and prevent any more from being taken there. This move provoked a bitter debate about slavery and whether the government had any right to restrict it. Some Northern congressmen wanted to stop the westward spread of slavery as a first step to abolishing it altogether. For Southerners it was a matter of equal rights—if Northerners could take their property into the west and settle there, Southerners should be allowed to bring their slave property. The question of Missouri was also important because at the time the number of free states and slave states was equal, and so the Senate was evenly balanced between free-state and slave-state senators. Any laws passed had to be supported by politicians from both sides. The addition of Missouri on either side would upset the balance.

Although the House of Representatives passed the Missouri bill, Southerners in the Senate blocked it. Congress adjourned with no action having been

▲ *The interior of a building housing a cotton gin, somewhere in the South before the war. The invention of the gin led to a boom in cotton production at the beginning of the 19th century.*

taken. When Congress met again in December 1819, the debate raged furiously (the Missouri crisis could have led to civil war in 1820). However, Speaker of the House Henry Clay champions a compromise that he hopes will satisfy

▲ *A label for cigars made by a New York company from Southern tobacco. The label shows an idealized view of slave life on a tobacco plantation.*

▶ *A cartoon of 1854 depicts Liberty "the fair maid of Kansas" being mistreated by the "border ruffians." It criticizes the administration for the violence in Kansas that followed the Kansas-Nebraska Act.*

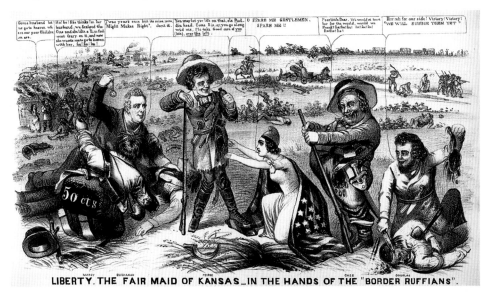

LIBERTY. THE FAIR MAID OF KANSAS_IN THE HANDS OF THE "BORDER RUFFIANS".

KEY PERSONALITY

JOHN BROWN

As a passionate enemy of slavery, John Brown (1800–1859) worked closely with the free black community. He acted as a "conductor" on the Underground Railroad, a secret series of safe houses for Southern slaves to use as they escaped to the North. In 1849 Brown spent two years living in a community of free blacks in New York state.

In the mid-1850s John Brown's beliefs led him to violence. He saw slavery as a sin against God, and his work to rid the United States of racism and oppression took on a religious fervor. He resolved to use armed force and to encourage a slave uprising.

In 1855, Brown moved to Kansas with five of his sons to help prevent the territory from becoming a slave state. In 1856 proslavery settlers attacked the free-state community of Lawrence. On May 23, in retaliation, Brown and six followers murdered five proslavery men using swords at Pottawatomie Creek.

After the murders, Brown became a hate-figure for proslavers and was burned out of his homestead but managed to escape. With financial help from Northern abolitionists he began raids on plantations in the neighboring slave state of Missouri.

On October 16, 1859, Brown launched an attack on the government armory at Harpers Ferry in western Virginia. He intended the raid, made with 21 supporters including five blacks, to spark a slave revolt throughout Virginia and across the South. It failed. Brown and his men were surrounded in the fire house, and on October 18 they were attacked by a company of U.S. Marines commanded by Colonel Robert E. Lee. Ten of Brown's men were killed and seven others captured, including Brown himself.

The authorities in Virginia acted swiftly. Brown was tried and convicted of murder and treason. On December 2, 1859, he was hanged at Charles Town, Virginia.

both Northerners and Southerners. Clay first proposed that a new state, Maine, be carved out of northern Massachusetts. Maine would become a free state, and Missouri would be allowed to enter as a slave state, keeping an even balance of power in the Senate. To avoid any future problems of this kind, Jesse B.

▼ A romanticized, Southern view of slaves picking cotton. The slaves in this picture are well clothed and fed, and the whips of the overseers are nowhere to be seen.

▶ The slave pen in Alexandria, Virginia, showing the doors of the cells where slaves were kept before being sold. Conditions in slave pens themselves were inhumane.

Thomas, an Illinois senator, proposes that a line be drawn on the map across the country along the latitude of 36° 30' (the latitude of the southern border of Missouri). All states created north of the line will be free, and all states south of the line will be slave. In the future new states will enter the Union in pairs, one free and one slave, just as Missouri and Maine has. Clay used his charm and political ability and succeeds in getting the compromise passed (Missouri was admitted to the Union in March 1821).

The Missouri Compromise originally only applied to the territory bought from France in the 1803 Louisiana Purchase (from the present-day state of Louisiana in a northwesterly direction all the way to Oregon). Texas, California, and the rest of the Southwest still belonged to Spain. Over the following 30 years most Americans came to view the Missouri Compromise as a sacred agreement between the North and South that would prevent a civil war over slavery.

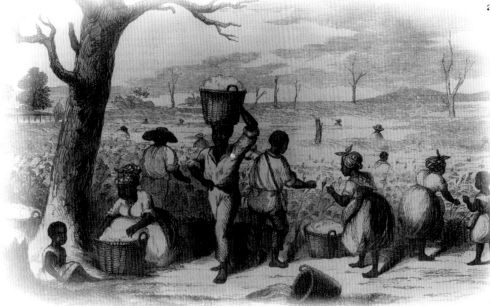

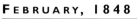

FEBRUARY, 1848

UNITED STATES, *DIPLOMACY*
The Treaty of Guadaloupe Hidalgo. As a result of its victory in the Mexican War (1846–1848), the United States gains a large area of land at the

Slave crops in the South, 1860 ▶

The distribution of the principal slave crops in the South, circa 1860. Another staple crop was hemp, grown in some counties of Missouri and Kentucky. Census estimates of 1850 put the number of slaves on cotton plantations as 1,815,000, while 125,000 slaves were producing rice, 350,000 tobacco, and 150,000 were cultivating sugarcane. The map shows the South's economic dependency on slave crops, and thus slaves.

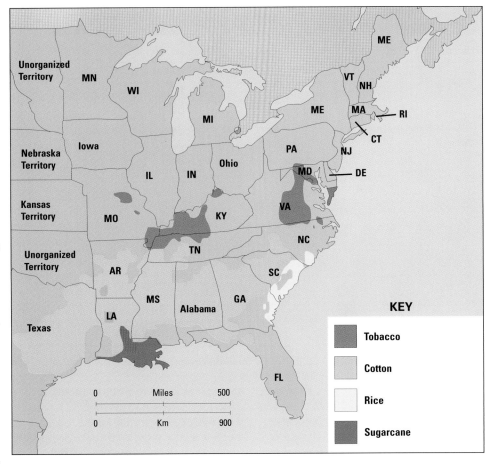

KEY

Tobacco

Cotton

Rice

Sugarcane

expense of Mexico (modern-day California, New Mexico, Arizona, Nevada, Utah, Colorado, and parts of Wyoming). However, the subsequent political wranglings over whether these new territories should allow slavery or not intensified the divisions that led to the Civil War.

MAY, 1854

KANSAS AND NEBRASKA, *POLITICS*

The Kansas-Nebraska Act is passed by Congress by a vote of 115 to 104. The reaction is immediate and fierce. Anti-slavery Northern congressmen are outraged because the bill potentially opens up Northern territories to slavery. Furthermore, the bill repeals the Missouri Compromise, which for 30 years has preserved the balance of power between the North and South by providing that new states north of the 36° 30' line be admitted as free states and states south of the line become slave states. The impact of the act can be clearly seen in the fall congressional elections of 1854: the number of Northern Democrats in the House of Representatives falls from 92 to 23. Opponents of the act elect 150 congressmen.

▼ *Abraham Lincoln's house in Springfield, Illinois. He bought it in 1844 and it was his home for 17 years until he moved to Washington, D.C., to take up his duties as U.S. president.*

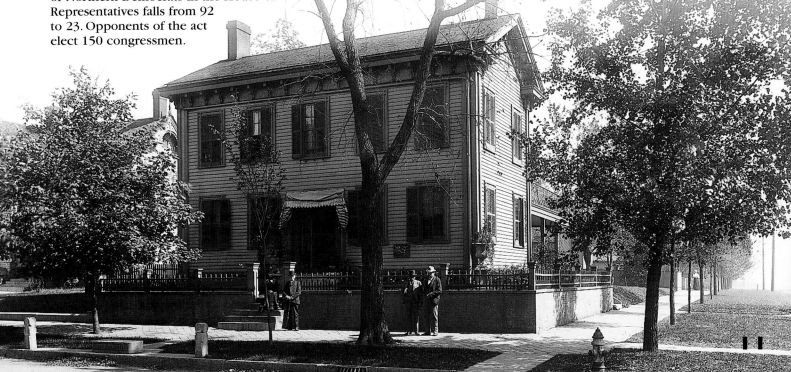

11

DECISIVE MOMENT

THE MASON-DIXON LINE

In 1760 Pennsylvania (which included present-day Delaware) and Maryland were both English colonies and were in dispute over their common border. A court in London decreed that the border would run north–south between Maryland and Delaware, and then west from Delaware along latitude 39° 43' North. Two Englishmen, a surveyor named Charles Mason and an astronomer, Jeremiah Dixon, were given the job of marking its position.

Their survey mission lasted from 1763 to 1767. As Mason mapped the route, Dixon found their precise latitude by means of the stars. In this way the pair charted the north–south line between Delaware and Maryland, and then a line running 244 miles (393km) west from the Delaware border. The new boundary was marked every mile with blocks of limestone 5 feet (1.5m) long. In 1779 the line was extended farther to mark the border between Pennsylvania and what is today West Virginia.

In the independent United States of the early 19th century, the Mason-Dixon Line took on special significance in the debate over whether slavery should be permitted in the territories of the Louisiana Purchase. In 1820, the Missouri Compromise established a boundary between the Southern slave states and the free North, running west from the Mason-Dixon Line, south along the Ohio River, and then west along latitude 36° 30'. This new boundary was to become the broad frontline of the Civil War.

Last year, Senator Stephen A. Douglas of Illinois introduced a bill in Congress to organize a new territory, Nebraska. Douglas, a rising star in the Democratic Party, hoped that its creation would be the first step toward the construction of a transcontinental railroad that would connect his hometown of Chicago with California. Southern congressmen blocked the bill because they hoped for a southern route for the railroad. Needing Southern support,

Douglas revised the bill to create two new territories, Kansas and Nebraska. The bill provided that settlers who moved to the new territories would be allowed to decide for themselves whether Kansas and Nebraska would permit slavery. Douglas called this "popular sovereignty." Many assumed that Nebraska would vote against slavery, while Kansas, which bordered slaveholding Missouri, would permit it.

By 1856 most of the political forces opposed to the act had reorganized themselves into the new Republican Party. The act continued to provide a rallying point for antislavery forces, and thus it led to the triumph of Republican Abraham Lincoln in the presidential elections of 1860, which in turn brought on secession and war.

In Kansas itself the act resulted in years of violence, a period known as "Bleeding Kansas," as pro- and antislavery settlers struggled for control. Kansas was finally admitted to the Union as a free state in 1861.

OCTOBER 16, 1859

VIRGINIA, *LAND WAR*

John Brown, an abolitionist crusader, leads a raid on the Federal arsenal at Harpers Ferry in Virginia. His aim is to lead a slave uprising that will sweep the South once he is able to provide local slaves with arms. Marines under U.S. Army Colonel Robert E. Lee besiege the fire-engine roundhouse in which Brown and his followers have barricaded themselves. Lee's men storm the building on the 18th and arrest Brown with six followers. Ten of Brown's men are killed in the fighting.

Brown was convicted of murder and hanged on December 2, 1859. Despite his violent fanaticism, the noble bearing Brown presented at his trial gained him sympathy in the North. To Southerners the elevation of a murderer to the status of a martyr in the North was proof that their fellow-countrymen despised them. Many believed it was time to go their separate ways.

JANUARY 1860

VIRGINIA, *ARMED FORCES*

Volunteer militia officers meet in Richmond under the direction of State Major General William B. Taliaferro, who

▼ The thick-walled brick building at the armory gate where Brown barricaded himself after the raid on Harpers Ferry. Brown's raid was a fiasco which was speedily suppressed.

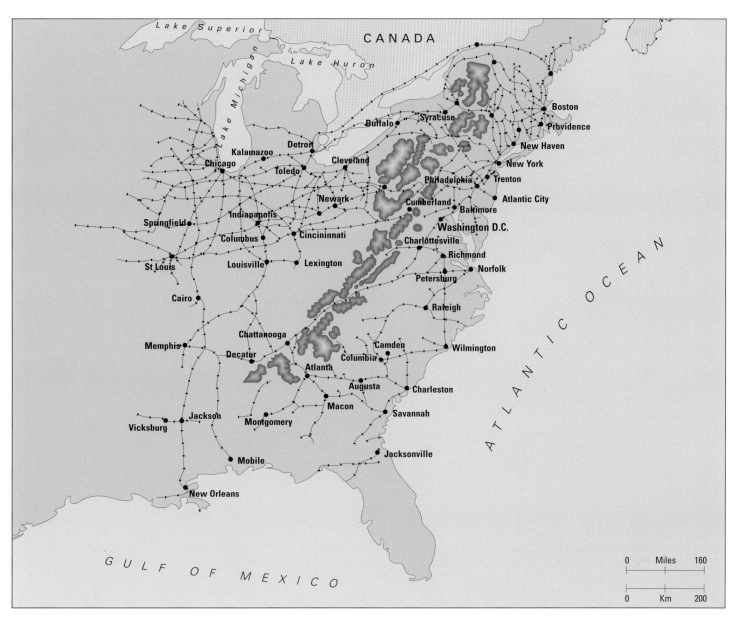

▲ **Railroads in operation, 1860**
By 1860 the United States had some
30,600 miles (48,960km) of railroad,
though only 8,500 miles (13,600km) of this
was in the South. There was only one di-
rect rail link from Richmond south to the
Mississippi, which ran through
Chattanooga to Memphis. The Civil War
would be the world's first "railroad war,"
with strategically important Southern rail
junctions such as Petersburg and
Chattanooga becoming the focus of
Union offensives to take them.

◄ *Warehouses in Little Rock, Arkansas.
Much of the state's wealth depended on
the products of slave labor. The 1860
census showed that 110,000 slaves lived in
Arkansas (there were 324,143 whites). One
in five whites either owned slaves or
belonged to a slaveowning family.*

13

DECISIVE MOMENT

THE 1860 ELECTION

Abraham Lincoln was the second-ever presidential nominee of the Republican Party, which had only been formed in 1854. By 1860 the Republicans had developed a coherent platform with policies that were very appealing to people in the Northeast and the West. Above all, the party was opposed to any further territorial expansion of slavery. Lincoln was a natural choice for candidate. He had few enemies and was nationally known for a series of debates with leading Democrat and fellow Illinoisan Stephen Douglas in 1858. The Republicans named Hannibal Hamlin of Maine as Lincoln's running mate.

While the Republicans were united, the Democratic Party was badly strained. Southern Democrats were determined to have a slave code that protected slave owners in the territories. Without it they believed that most territories would enter the Union as free states. Northern members of the party, led by Stephen Douglas, opposed a slave code. On April 23, 1860, the Democratic National Convention convened in Charleston, South Carolina, where these divisions became glaring, and 15 Southern delegates walked out.

After the convention the Democratic Party divided into two sharply opposed factions. Northern Democrats nominated Douglas as their presidential candidate. Douglas was considered a traitor by Southern Democrats and also by the serving Democrat President James Buchanan. Meeting separately, the Southerners nominated John C. Breckinridge of Kentucky, the then vice president, as their candidate for the 1860 election.

The Northerners named Herschel V. Johnson of Georgia as Douglas' running mate in an attempt to make their faction seem national in scope. Southerners took the same approach and nominated Joe Lane of Oregon for vice president. However, with a national political party divided in this way, neither faction had much real chance of winning the election.

With the Republican campaign going strong, many Southerners grumbled that if Lincoln and his so-called "Black Republicans" won, their states would leave the Union. With no united opposition party to hamper Abraham Lincoln's path to the presidency, conservative-minded politicians hastily formed a new party. The Constitutional Union Party, as it was named, intended to appeal to moderates looking for a compromise on the slavery issue. It was mostly made up of older statesmen and was quickly nicknamed the "soothing syrup"

party in the press. The party nominated John Bell of Tennessee for president. His running mate was Edward Everett of Massachusetts, a famed orator.

The election was held on November 6, 1860. As it turned out, Lincoln only captured 39.8 percent of the popular vote, but he was victorious because he won 180 electoral votes. Stephen Douglas ran second in the popular vote, with 29.5 percent, but last in the electoral college with only 12 votes. Breckinridge was third in the popular vote, with 18.1 percent, but second in the electoral college with 72 votes. John Bell took 12.6 percent of the popular vote and 39 electoral votes.

Lincoln was chosen president by a minority of the people. However, inasmuch as both he and Douglas were opposed to slavery's expansion, the results show that 69.3 percent of the electorate opted for candidates with that view. Breckinridge and Bell, both in favor of slavery's expansion, got only 30.7 percent of the popular vote.

On the day following the election South Carolina raised its state flag—the palmetto flag—at Charleston in defiance of Lincoln's election. On December 17, 1860, the state's secession convention met and voted 159 to 0 to proclaim South Carolina out of the Union. Six other Southern states promptly followed.

On February 4, 1861, a convention of delegates from the seceded states met at Montgomery, Alabama, to form a new nation, the Confederate States of America. On February 8 the convention adopted a constitution and the following day elected Jefferson Davis provisional president.

In the aftermath of the 1860 election and the ensuing crisis Stephen Douglas, who was now terminally ill, toured the South urging reconciliation. Lincoln remained quiet, although he asserted that the Union could not be divided. The new Confederate president was inaugurated two weeks before Lincoln, whose inauguration took place on March 4, 1861. One month later, on April 12, 1861, the Confederates fired the first shots of the American Civil War.

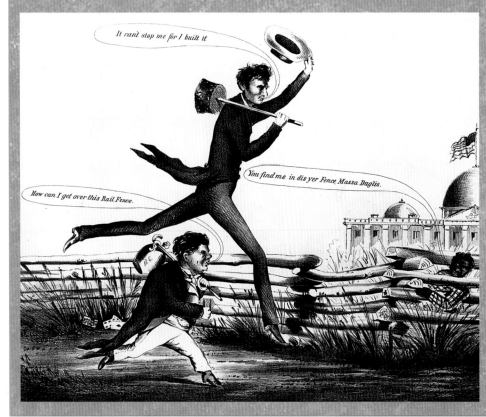

◀ *Northern Democrat Stephen Douglas races Republican Abraham Lincoln for the presidency. The figure on the right reminds the candidates that slavery is the key issue in the upcoming 1860 presidential election.*

► *A public meeting in Johnson Square, Savannah, Georgia, on November 8, 1860, calling for a state secession convention. Georgia seceded on January 19, 1861.*

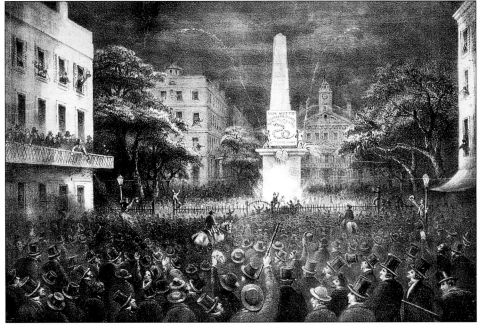

serves as the convention president. The convention passes a number of resolutions dealing with the training and growth of the volunteer militia corps, and these form the basis of legislation later passed by the state government.

NOVEMBER 6, 1860

WASHINGTON, D.C., *POLITICS*
Abraham Lincoln is elected President of the United States, having taken 180 electoral votes and over 1.8 million individual votes. Hannibal Hamlin is Lincoln's vice president.

Lincoln will become the 16th president of the United States, and in his inaugural address states flatly that "the Union of these States is perpetual." Moreover, attempts to leave it are "insurrectionary or revolutionary. I therefore consider that, in view of the Constitution and the laws, the Union is unbroken; and, to the extent

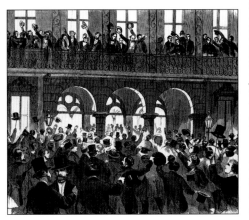

of my ability, I shall take care, as the Constitution itself expressly enjoins upon me, that the laws of the Union be faithfully executed in all the States."

While it is clear that Lincoln and his followers are willing to fight a war to prevent the Southern states from leaving, it is less clear that the general public will follow them. Large areas of the North, such as northern New Jersey which has many economic ties to the South, are pro-Southern. Unless there is some spark to unite Northerners behind the common

◄ *An engraving in the* Illustrated Newspaper *depicting a crowded secession meeting in Charleston, South Carolina, in December 1860. South Carolina was the first state to secede.*

cause, Jefferson Davis and his Confederate supporters have a real chance to secede peacefully as he desires.

DECEMBER 20, 1860

SOUTH CAROLINA, *POLITICS*
In the light of Lincoln's election as president, South Carolina's state legislators sign the Ordinance of Secession in Charleston. The state is the first to leave the Union. On Christmas Eve Governor Wilkinson Pickens will issue a proclamation declaring the state to be separate, independent, and sovereign. On the eve of the Civil War, South Carolina is the third richest state in the country. Pickens will authorize troops to fire on the *Star of the West*, a Union ship, in the first military engagement of the Civil War.

▼ *The Tredegar Works in Richmond was the only major ironworks in the South in 1860. On the outbreak of war the owner of Tredegar sent a telegram to the Confederate government promising to "make anything you want—work day and night if necessary."*

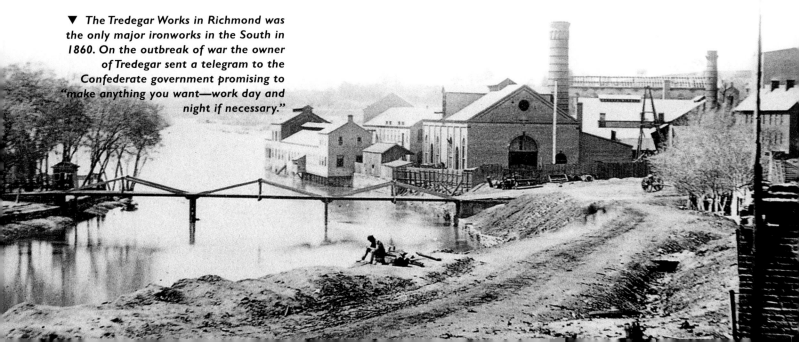

1861

The industrial and financial resources of the North, which produced 97 percent of the nation's firearms, suggested an early Federal victory. However, the small standing army (17,000) was mostly deployed in the West, and the South mobilized 100,000 men before Lincoln's 75,000 volunteers could be mustered. And the South defeated the Union army in the war's first major battle, at Bull Run in July.

▼ During the war Fort Morgan guarded the entrance to Mobile Bay. The Confederacy ran blockade-runners to and from this port and protected the bay with an underwater minefield.

JANUARY 2

SOUTH CAROLINA, *LAND WAR*
Fort Johnson in Charleston harbor is seized and occupied by South Carolina troops. The fort had been in a near derelict condition and was poorly defended by Federal forces.

JANUARY 4

ALABAMA, *LAND WAR*
Southern forces continue to occupy US forts and bases in the South, as Alabama militia seize the Federal arsenal at Mount Vernon.

JANUARY 5

ALABAMA, *LAND WAR*
Alabama troops seize Forts Morgan and Gaines. The capture of the forts gives the Confederate forces a commanding position over Mobile Bay.

JANUARY 6

FLORIDA, *LAND WAR*
The Federal arsenal at Apalachicola is seized by Florida state forces. It becomes the first Federal facility in Florida to be taken by the Confederacy.

JANUARY 7

TENNESSEE, *POLITICS*
Tennessee's Governor Isham G. Harris delivers a speech to the Tennessee General Assembly discussing the possibility of a "homogeneous Confederacy of Southern States."

JANUARY 9

MISSISSIPPI, *POLITICS*
The Mississippi legislature in the state capital, Jackson, passes the ordinance of secession and becomes the second state to join the Confederacy. The "Republic of Mississippi" is born, and

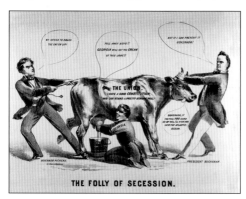

▲ A Northern cartoon attacks the seceding states of South Carolina and Georgia. The Union is depicted as a cow. U.S. President James Buchanan tries to stop the seceding states pulling it apart.

KEY PERSONALITY

ABRAHAM LINCOLN

Abraham Lincoln (1809–1865) was born in a one-room log cabin in Hardin County, Kentucky, on February 12, 1809, the son of Nancy Hanks and Thomas Lincoln. His father was a poor frontier farmer and could provide his son with little formal education. Lincoln later said he went to school "by littles"—in all for less than a year. Lincoln's mother died when he was nine, and the family moved twice before Lincoln was 22, first to Indiana and then to Illinois.

As a young man in Illinois Lincoln held a number of jobs, and also served briefly in the Illinois militia in 1832. Despite his lack of schooling, Lincoln educated himself to a high level with borrowed books and participated in a local debating society.

In 1834 Lincoln was elected to the Illinois legislature as a member of the Whig Party. He went on to serve four terms, and during these years he studied law and settled in the new state capital, Springfield. By the 1840s he was a successful lawyer. In 1842 he married Mary Todd, a young woman from a wealthy Kentucky banking family. Four years later he was elected to the House of Representatives. As a congressman he opposed the United States' war with Mexico (1846–1848). This was an unpopular stance, and he was not reelected. Lincoln returned to his law practice but remained active in politics.

The Kansas–Nebraska Act of 1854 outraged him. He joined the new Republican Party, which was opposed to the westward expansion of slavery, and in 1858 the party nominated him for the Senate. During his campaign Lincoln made a statement that emphasized the crisis the nation was facing: "A house divided against itself cannot stand. I believe this government cannot endure permanently half slave and half free."

When the Republican national convention met in May 1860, Lincoln was one of several candidates for the presidential nomination. His main opponent, Senator William H. Seward of New York, was thought too radical in his antislavery views, so Lincoln was nominated. In the November election he received 39.8 percent of the popular vote and won the election with 180 of the 303 electoral votes.

In the slaveholding states not one electoral vote was cast for Lincoln. By the time he took office in March 1861, seven slaveholding states had seceded from the Union. Lincoln did not want to respond aggressively, but when the Confederacy demanded that Union troops surrender forts in Confederate states, he refused to give them up. Here he acted

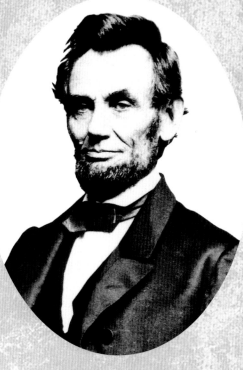

against the advice of his cabinet. In April Confederate forces attacked Fort Sumter, South Carolina. Congress was not in session, but Lincoln acted swiftly, issuing a call for 75,000 volunteers to join the Union army and suspending *habeas corpus* (the right not to be imprisoned without trial). Until July 4, when Congress met, Lincoln effectively conducted the war alone. Accusations of dictatorship, which continued throughout his presidency, were first made in these early months.

Commander-in-chief

Lincoln was equally decisive as commander-in-chief of the Union forces. At the start of the war General Winfield Scott submitted a war strategy known as the "Anaconda Plan," which advised defeating the Confederacy by means of a blockade. Lincoln accepted some parts of Scott's plan, but he also insisted on invading the South at multiple points. This action set a pattern for Lincoln as commander-in-chief of the army: he listened to his generals but made his own decisions.

Some historians believe that Lincoln's lack of a military background may have been an advantage. He was not blinkered by formal training. Instead, he was able to apply his intelligence and devise strategies that often contradicted the military textbooks. During the course of the war Lincoln became one of the most able commanders-in-chief that the nation has ever had.

Lincoln's ideas about how the war should be fought brought him into conflict with many of his generals. He removed George B. McClellan from command following his failure to pursue the retreating Confederates after the Battle of Antietam (Sharpsburg) in September 1862. It was a bold move, since McClellan was popular with his men and the Northern public alike. Lincoln subsequently fired several more generals who failed to carry out his ideas. In each case Lincoln displayed strong executive leadership.

Lincoln also had responsibilities as the leader of his political party. The Republican Party was barely five years old when he took office. It was composed of former Whigs and Democrats, and its members had a wide range of opinions on key issues such as slavery. Lincoln worked hard to keep the Republican coalition together throughout the war. He knew that he needed the support of Congress and the public to win the war and to be reelected for a second term in 1864. To achieve this broad support, he included former Whigs and former Democrats in his cabinet and appointed men of all political backgrounds to military commands.

One of Lincoln's greatest and most important assets was the way he interpreted his power, making extensive use of executive orders. The greatest of these was the Emancipation Proclamation, which came into effect on January 1, 1863. Lincoln accepted that slavery could only be abolished by state-level action or by an amendment to the Constitution—neither of which were politically possible at that time. When he decided to strike a blow against slavery, he therefore did it by issuing a presidential proclamation. He justified the measure on the grounds of "military necessity," which is why it was limited to states in rebellion rather than applying to the whole country. For this reason the proclamation did not free slaves in Union territory.

Lincoln's leadership held the Union cause together through the difficult first three years of the war. He won the November 1864 election against Democrat George B. McClellan. On April 9, 1865, Lincoln received the news of Lee's surrender at Appomattox. A month earlier he had outlined his broad philosophy for the postwar reconstruction of the seceded states in his second inaugural address, stating that the Union should be reconstructed "with malice toward none, and charity for all." However, on April 14 Lincoln was shot by John Wilkes Booth during a theater performance in Washington. He died the next day.

JANUARY 10

Union and Confederate States ▶
This map shows which side each state took in the Civil War. Of the four slave states that remained in the Union, Missouri, Kentucky, and Maryland had deeply divided loyalties. Troops from these states fought on both sides.

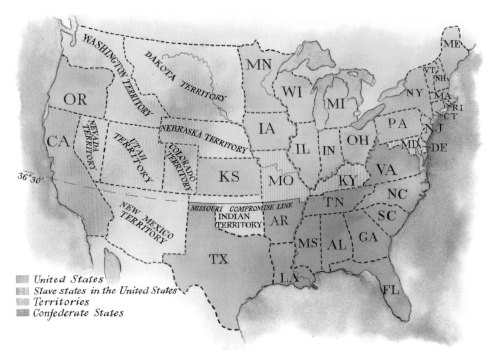

United States
Slave states in the United States
Territories
Confederate States

there is rejoicing throughout the state. The women of Jackson present the convention with the "Bonnie Blue Flag," which features a single white star on a blue background and has come to symbolize Southern independence.

JANUARY 10

FLORIDA, *POLITICS*
Delegates at a special conference in Tallahassee vote by 62 votes to 7 to secede from the Union. Governor Madison Starke Perry and governor-elect John Milton are strong advocates of this move, although ex-governor Richard Call opposes it.

There were several garrisons of Federal troops in the state. Among them is the 1st U.S. Artillery at Barrancas Barracks, near Pensacola. Its commanding officer, Adam Slemmer, moves his small force from the barracks into the more easily defended Fort Pickens on nearby Santa Rosa Island.

Confederate troops then seized the barracks, Fort McRee, and Pensacola Naval Yard, and demanded the surrender of Fort Pickens. Slemmer refused to give up the fort. A temporary truce was agreed over the fort.

▼ *The Union Fort Massachusetts, built to protect the approaches to Washington. Its name was later changed to Fort Stevens, after Brigadier General Isaac Ingalls Stevens, who was killed at the Battle of Chantilly on September 1, 1862.*

JANUARY 11

ALABAMA, *POLITICS*
Alabama becomes the fourth state to secede from the Union, after Mississippi and Florida followed South Carolina on January 9 and 10 respectively. Alabama will be followed by Georgia, Louisiana, and finally Texas on February 1.

JANUARY 19

GEORGIA, *POLITICS*
A special convention meets at the state capital, Milledgeville, and votes to leave the Union. The wartime governor of Georgia, Joseph Emerson Brown, is an extreme advocate of states' rights.

JANUARY 22

MINNESOTA, *POLITICS*
A resolution is passed offering men and money to the Union.

JANUARY 24

GEORGIA, *LAND WAR*
Georgia state troops take control of the Federal arsenal in Augusta. The Federal facility surrenders without a fight.

JANUARY 26

LOUISIANA, *POLITICS*
Louisiana becomes the sixth state to secede. The vote is 113 in favor of secession against only 17 against.

JANUARY 28

LOUISIANA, *LAND WAR*
Following Louisiana's secession, Fort Macomb is occupied by troops of the 1st Regiment, Louisiana Infantry.

JANUARY 29

WASHINGTON, D.C., *POLITICS*
The U.S. Congress admits Kansas to the Union as the 34th state.

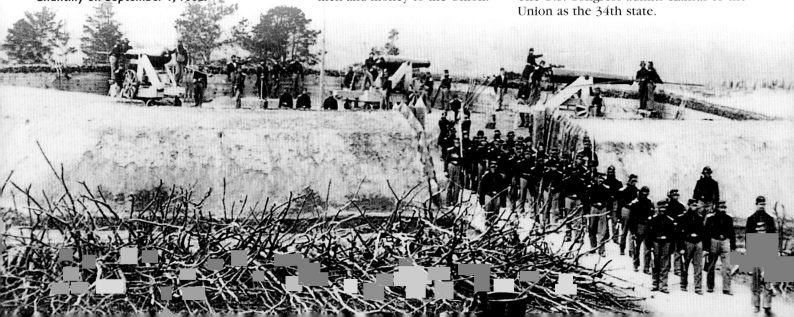

NEW ORLEANS, *LAND WAR*

Louisiana state troops seize the US Mint and Customs House in New Orleans.

FEBRUARY 1

TEXAS, *POLITICS*

With 166 votes to 8, the Convention of the State of Texas votes for secession from the Union.

FEBRUARY 4

ALABAMA, *POLITICS*

Delegates from the seven states meet in Montgomery, the Alabama state capital, and draft a constitution for the Confederate States of America. Jefferson Davis of Mississippi is chosen as provisional president and will be inaugurated on February 18. The capital will remain at Montgomery until May 1861, when it will be moved to the city of Richmond, Virginia.

FEBRUARY 7

MISSISSIPPI/ALABAMA, *INDIAN WARS*

The Choctaw Indian Nation makes an alliance with the Southern states. It is one of many Indian tribes to make an alliance with the South during 1861.

FEBRUARY 26

ALABAMA, *POLITICS*

Having established a Confederate War Department five days earlier, the Confederate Congress passes "An Act for the Establishment and Organization of a General Staff for the Army of the Confederate States."

▲ *Alexander H. Stephens, Confederate vice president (1812–1883). During the war he was of the opinion that the invasion of the South was an unjust war for conquest and subjugation.*

ARMED FORCES

THE UNION NAVY

At the outbreak of war the Union navy had 90 ships. Of them only 41 were serviceable, and many were in different parts of the world. Navy personnel included about 1,500 officers—an estimated 300 of whom resigned to join the Confederacy—and 7,500 enlisted men. Lincoln's proclamation of a blockade of Southern ports in 1861 meant that the navy had to be rapidly enlarged, since such a proclamation was not valid under international law unless foreign vessels were physically stopped from entering or leaving a blockaded port.

Union navy officials immediately began adding to the fleet by commissioning new vessels. In addition, they bought civilian vessels of all sorts to fit out for wartime use. By the end of 1861 the Union navy had nearly 200 vessels in service and 22,000 naval personnel. This number continued to grow until by the end of the war the navy had some 670 ships and 51,500 men.

In May 1861 the navy organized two blockading squadrons, one for the Atlantic coast and one for the Gulf of Mexico. The two were later divided into four: the North and South Atlantic Blockading Squadrons and the East and West Gulf Blockading Squadrons. These squadrons, each command-ed by a commodore (a temporary flag officer position until the rank of rear admiral was created in July 1862), handled all blockading duties. Although in 1861 there was a block-ade in name only, by the end of the war some 500 ships had played a part in enforcing it.

The opening of the Mississippi River to transportation was a major objective for the Union navy, and the Mississippi Squadron was also created in May 1861. An ironclad-building program on the upper reaches of the Missis-sippi very rapidly produced the gunboats for this squadron—the first ones were launched in October 1861. Squadrons along the Atlantic coast also maintained ironclads for warfare on the many rivers that opened into the sea. Ironclads were used in a number of joint army/navy operations during the war. The Potomac Flotilla was organized to keep the Potomac River clear and to defend the nation's capital. Squadrons off South America, Europe, and Africa had the duty of destroying Confederate commerce raiders, which preyed on Union merchant ships.

Naval officers were divided into two types. The first, known as executive officers, were actually in charge of vessels. From August 1863 they wore a star over their gold sleeve rank stripes. The second type of

officers were specialists. They included surgeons, who were stationed onboard ships and in naval hospitals set up in ports; naval constructors, who designed and built vessels; paymasters, who handled ships' funds and supplies, as well as pay; engineers, who maintained onboard machinery; chaplains; and math and chemistry professors, who taught midshipmen and cadets chemistry, geometry, and calculus. The specialized officers, who did not wear the executive star, held "relative rank" with executive officers. For example, a fleet surgeon was ranked equal to a captain, although he only commanded individuals in his field, rather than a ship.

The traditional method of training naval officers through years of sea service was unable to produce all the officers needed for such a rapidly enlarging navy, so senior mid-shipmen were commissioned immediately in 1861 before their schooling was finished. This measure alone did not manage to make up the shortage of officers, so on July 24, 1861, the secretary of the navy was authorized to appoint acting, volunteer officers below the rank or relative rank of lieutenant. At its greatest extent the Union navy had some 7,500 volunteer officers, and 84,500 men enlisted in the navy during the war.

Black sailors had worked on naval vessels for years and were accepted into the unsegregated Union navy from the beginning of the war. They made up between 8 and 25 percent of all Union navy personnel. There were several celebrated incidents of naval daring by black sailors. The most famous was the action of Robert Smalls, a slave who worked on the Confederate transport steamer, the CSS *Planter*. On May 13, 1862, Smalls sailed the *Planter* out of Charleston Harbor with the help of 12 other slaves while the ship's white officers were asleep onshore. Once past the Confederate guns, he handed over the ship to the Union navy. As a result of this heroic action, Smalls was feted in the North. He later served with distinction in the Union navy.

New volunteers were first sent aboard receiving ships. They were old ships that had been converted into floating barracks and training facilities. Here they received their uniforms, which they had to pay for, and were given basic training in seamanship and gunnery. Sailors were sent from the receiv-ing ships to their duty stations as soon as they were needed, regardless of how much training they had had. In fact, training was fairly rare; most new sailors learned their jobs once they reached their duty station.

MARCH 4

WASHINGTON, D.C., *POLITICS*

Abraham Lincoln is inaugurated as the sixteenth President of the United States. In his address he states: "I have no purpose, directly or indirectly, to interfere with the institution of slavery in the States where it exists."

MARCH 9

TEXAS, *POLITICS*

George Williamson, Commissioner from Louisiana to the Texas Secession Convention, urges the Texan people to secede from the Union.

MARCH 11

ALABAMA, *POLITICS*

The Confederate Congress adopts the Constitution of the Confederate States

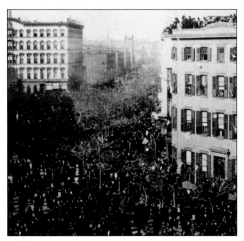

▲ *The great patriotic rally held in Union Square, New York, on April 20, 1861, one week after the shelling of Fort Sumter.*

▶ *An engraving showing the Confederates bombarding Fort Sumter from the shores of Charleston Harbor on April 13, 1861. The garrison was low on ammunition and could not respond with heavy fire. Fort Sumter fell that afternoon.*

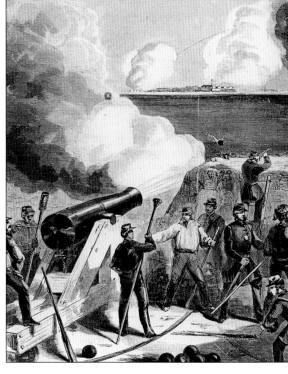

of America. Article 1's opening statements asserts: "All legislative powers herein delegated shall be vested in a Congress of the Confederate States."

APRIL 12

SOUTH CAROLINA, *LAND WAR*

At 03:20 hours Confederate Colonel James Chesnut and Captain Stephen D. Lee row out to Fort Sumter in Charleston Harbor to make a final demand for surrender. Major Robert Anderson refuses, believing that the arrival of backup troops and supplies are imminent. The Confederates warn him that shelling will start within the hour, and at 04:30 hours the first shell is fired.

Anderson gives the honor of the Union's first shot to his second-in-command, Captain Abner Doubleday, who fires it at around 07:00 hours. The Union troops are short of ammunition and so fire only occasional rounds from a few of their guns—without much effect (the fort has only 66 cannons, several of which are unmounted because the fort is only half-finished; it has been neither resupplied nor reinforced since December 26, 1860).

Meanwhile, the Confederates subject the fort to a heavy barrage from their battery at Point Cummings on Morris

Island to the south. By the time they cease firing at dawn, several fires have broken out inside the fort. The Union supply ship, *The Star of the West*, arrives at Charleston in the afternoon, but is kept outside the harbor by Confederate artillery.

Confederate batteries resumed heavy shelling at dawn on April 13. The barracks inside the fort caught fire, and Anderson's men lay on the ground to escape the smoke. At 12:48 hours a Confederate shell dislodged Fort

▼ *New recruits at Camp Curtin in Harrisburg, Pennsylvania. Opened in April 1861 to deal with Union volunteers in the state, more than 300,000 men passed through the camp.*

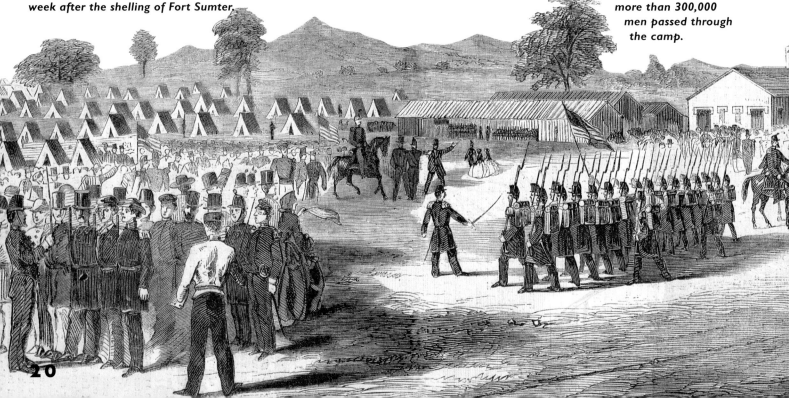

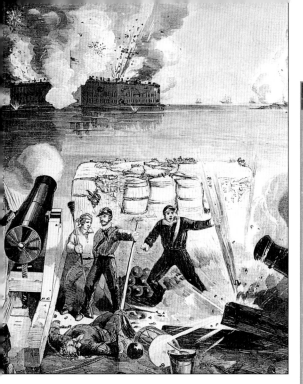

Sumter's flagstaff. When Confederate Colonel Louis T. Wigfall saw the flag go down, he rowed out to the fort to demand its surrender. This time Anderson conceded defeat. Fort Sumter will remain in Confederate hands for most of the war.

APRIL 13

MINNESOTA, *POLITICS*
Governor Alexander Ramsey, hearing of the attack on Fort Sumter, immediately offers Secretary of War Simon Cameron 1,000 Minnesota men for the Union cause.

APRIL 15

THE UNION, *ARMED FORCES*
Having had his request approved by Congress,

ARMED FORCES

CAVALRY
Like the infantry, the basic cavalry component on both sides was a regiment commanded by a colonel. A Confederate cavalry regiment was made up of some 10 companies of between 60 to 80 men. In the Union army a cavalry regiment had about 1,000 men divided into six squadrons, each containing two troops of up to 100 men. The organization was simplified in 1863, and the squadron was replaced by battalions of four troops each.

Every regiment had a blacksmith and a farrier (who shoed the horses). A Union cavalry regiment also took along a surgeon, his assistant, and two hospital stewards—luxuries most Confederate outfits could not afford. The numbers in each unit varied widely on campaign, since most cavalry units, particularly on the Confederate side, were always understrength.

One of the great differences between the Union and Confederate cavalry was that Southern troopers had to supply their own horses. The system worked well enough in the first years of war, because the South was largely rural, and most volunteers could supply their own mounts. As the war went on and losses of horses through battle, sickness, and sheer exhaustion took their toll, the numbers of Confederate cavalry dwindled as cavalrymen who had no horse to ride had to leave their companies to find new mounts. Attempts by the army to make these men fight on foot as infantry usually failed—most cavalrymen would sooner desert than become infantrymen.

The Union government also started the war asking volunteer regiments to supply their own horses as a way of saving money. Cavalry were the most expensive soldiers to equip—a single regiment might cost up to $600,000. By July 1863 a new supply system had been imposed in the Union army. The War Department established the Cavalry Bureau to buy mounts for the cavalry. Within a year 150,000 horses had been purchased and supplied through two depots, one in Washington, D.C., and one in St. Louis, Missouri.

Lincoln publicly calls for the raising of 75,000 soldiers from the Northern states. The response from the states themselves is mixed.

APRIL 17

VIRGINIA, *POLITICS*
The Virginia secession convention votes 88 to 55 to secede. Virginia is crucial to the South's fortunes. It is

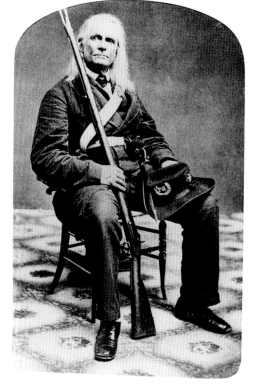

▲ Confederate Private Edmund Ruffin (1794–1865) was a wealthy plantation owner who was given the honor of firing the first shot against Fort Sumter on April 12, 1861. A rabid Yankee hater, he shot himself on June 17, 1865.

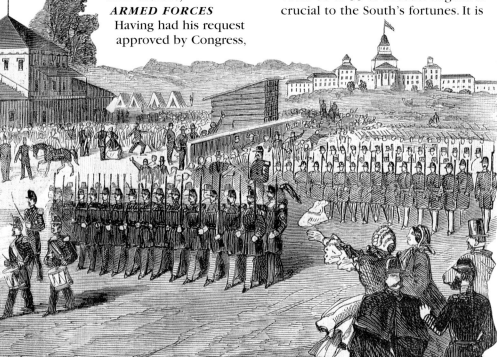

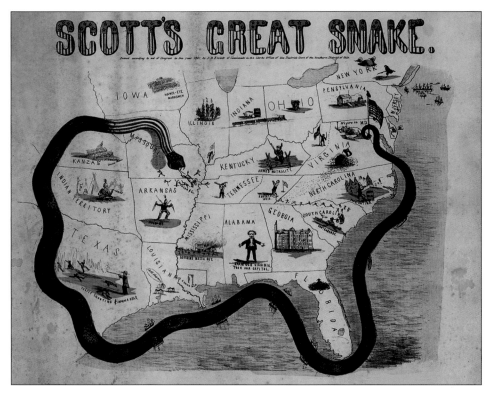

the most populous Southern state, it is located in a critical position across the Potomac River from Washington, D.C., and it has the greatest industrial capacity of any Southern state.

APRIL 19

THE UNION, *STRATEGY*
President Abraham Lincoln proclaims a naval blockade of the Southern states of Texas, Louisiana, Florida, Georgia, and South Carolina. On April 27 he extended the proclamation to include North Carolina and Virginia.
BALTIMORE, *CIVIL DISTURBANCE*
When the 6th Massachusetts Infantry Regiment changes trains in the city, it is attacked by a pro-Confederate mob. Bricks are thrown and shots exchanged

◄ *A cartoon of General Winfield Scott's "Anaconda Plan" to defeat the South. By blockading Southern ports and gaining control of the major rivers, Scott hoped to win the war without bloodshed by strangling the South economically.*

STRATEGY AND TACTICS

THE ANACONDA PLAN

When war broke out on April 12, 1861, the Union had no overall strategy for defeating the Confederacy. The commander-in-chief of the U.S. Army, Winfield Scott, devised a plan that became known as the Anaconda Plan.

Scott outlined his strategy in a letter to General George B. McClellan on May 3, 1861. He did not propose an invasion of the South but a campaign to surround and isolate the Confederate states to deprive them of supplies and force a peace deal.

Part of Scott's plan was already in action by the time he set it down on paper. On April 19, President Lincoln had ordered a naval blockade of the major Confederate ports. By the end of April the blockade was being established from Norfolk, Virginia, to Galveston, Texas. Scott proposed to tighten this cordon and shut down the Confederacy's Atlantic trade.

Scott also proposed that the Union close off the western part of the Confederacy by gaining control of the Mississippi River, which was held by the Confederates from Tennessee down to the Gulf of Mexico. This would be achieved by capturing the forts in the Mississippi Delta, occupying New Orleans, and sending gunboats and an army of 60,000 men down the river from Illinois. Mastery of the river would cut off the Confederate states of Texas, Arkansas, and most of Louisiana from the rest of the South and, in Scott's words, "envelop the insurgent States and bring them to terms with less bloodshed than by any other plan." It was a cautious, long-term strategy that relied for success on squeezing the South economically.

Scott decided on his plan for two reasons. First, he had a limited number of men. The U.S. Army he commanded was a tiny force of 16,000 professional soldiers, or "regulars." On April 15 Lincoln had called on the Union states to recruit 75,000 volunteer militia, but they were only to serve for three months. Scott doubted whether these "90-day men" could be relied on to fight a long campaign. The

government promised an extra 25,000 regulars and 60,000 volunteers who would enlist for three years, but that was still not enough to defeat the Confederacy.

The other reason for Scott's strategy was that he hoped to win the South back without destroying it. The general understood the depth of hatred a civil war would create. He could see that an invasion of the Confederacy would bring about, "devastated provinces — not to be brought into harmony with their conquerors, but to be held for generations by heavy garrisons."

When the Northern press learned of Scott's idea, they ridiculed its caution and dubbed it "the Anaconda Plan" for a river snake that coils around its prey and squeezes it to death. The Anaconda Plan also found little favor with Union politicians and army officers eager for a quick victory—they thought it not aggressive enough. Scott had foreseen this in his letter to McClellan: "The greatest obstacle in the way of this plan [is] the impatience of our patriotic and loyal Union friends. They will urge instant and vigorous action, regardless, I fear, of the consequences."

Scott was right. The North was gripped with war fever. In May the Confederacy had set up its capital in Richmond, barely 100 miles (160km) from Washington, and a Southern army was forming south of the Potomac at Manassas. The North was eager to strike at the Confederacy—"On to Richmond!" was the popular cry. By June 1861 the Anaconda Plan had been quietly dropped. In November Winfield Scott retired from the army, to be replaced as commander-in-chief by his protégé McClellan.

Scott's plan to regain the Mississippi River was not rejected entirely. The campaign began in February 1862 with the first attack by generals John Pope and Ulysses S. Grant and the recapture of New Orleans in April 1862 by naval officer David G. Farragut. It proved a longer and bloodier business than Scott ever imagined, but played a vital part in the Union's final victory.

between the two sides. Officials, including Baltimore's mayor, George Brown, vow that no more Union troops will be allowed in the city.

On May 13, however, Union troops occupied the city and rounded up and imprisoned Confederate supporters, including Brown. Many of these prisoners were held in Baltimore's Fort McHenry, along with prisoners of war bound for larger institutions elsewhere. Fort McHenry became known as the "Baltimore Bastille." At one point during the war it housed 6,957 prisoners.

APRIL 21

NORTH CAROLINA, *LAND WAR*
State militia forces in North Carolina seize the mint in the city of Charlotte.

TEXAS, *ARMED FORCES*
General Earl Van Dorn, a veteran of the Mexican and Indian Wars, assumes command of Confederate forces in Texas.

APRIL 22

ARKANSAS, *POLITICS*
U.S. secretary of war, Simon Cameron, sends a telegram to Henry M. Rector, the state governor, requesting a regiment of 780 men. Rector refuses.

Arkansas has a population of 435,450, approximately one-quarter of them slaves. Much of the state's wealth has been built on slave labor, and there-

▼ *The 96th Pennsylvania Infantry drilling at Camp Northumberland in 1861. Constant drilling was essential for troops to operate successfully on the battlefield.*

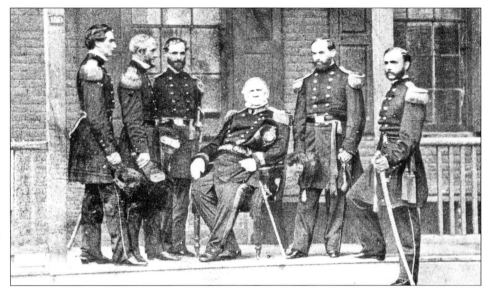

fore the government of Arkansas favors the right to own slaves.

APRIL 23

ARKANSAS, *LAND WAR*
Fort Smith, a Federal supply post, is captured by Arkansas state troops. It will not return to Union hands until 1863.

VIRGINIA, *ARMED FORCES*
Major General Robert E. Lee becomes the commander of land and naval forces in the state of Virginia.

APRIL 25

TENNESSEE, *POLITICS*
Isham Harris delivers his Second Message to the Tennessee Assembly, recommending that the state break

▲ *Winfield Scott (seated), the architect of the Anaconda Plan, and his staff in 1861. Scott's plan for defeating the Confederates was ridiculed in the North.*

from the Union and ally itself with the Confederacy.

APRIL 27

WASHINGTON, D.C., *POLITICS*
President Lincoln withdraws the right of *habeas corpus*. This cornerstone of civil and constitutional law will not be reinstated until 1866.

MAY 6

MAY 6
ARKANSAS, *POLITICS*
The state government votes to join the Confederacy, and organize the state's volunteer army. Arkansas is on the west bank of the strategically important Mississippi River.

MAY 9
BRITAIN, *POLITICS*
Britain, wishing to avoid embroiling itself in a conflict, declares its neutrality as the Civil War unfolds.

MAY 18–19
VIRGINIA, *LAND/SEA WAR*
The Battle of Sewell's Point. Two Union gunboats, commanded by Lieutenant D.L. Braine, fire on Rebel positions in a small action at Sewell's Point in Norfolk Bay in an effort to reinforce the blockade of Hampton Roads. There is little damage and only 10 casualties.

MAY 20
NORTH CAROLINA, *POLITICS*
North Carolina becomes the last state to secede. When the secession is announced in the state capital, Raleigh, there is a 100-gun salute, and

▼ *A cartoon in* Harper's Weekly *of June 1, 1861, highlighting the importance of logistics, with the caption "Reinforcements for our volunteers on the march southward." A butcher carries a commissariat flag, followed by rows of marching chefs, cattle, pigs, and sauce bottles.*

everybody congratulates everybody else. For a while it was unclear whether or not North Carolina would secede. However, its citizens reacted with hostility to the plan to use force to bring the seceded states back into the Union. As a result, when President Abraham Lincoln issued a general call for troops to fight the Confederacy after its bombardment and capture of Fort Sumter in April 1861, the majority of North Carolina's former Unionists and conservatives suddenly turned into secessionists and radicals.

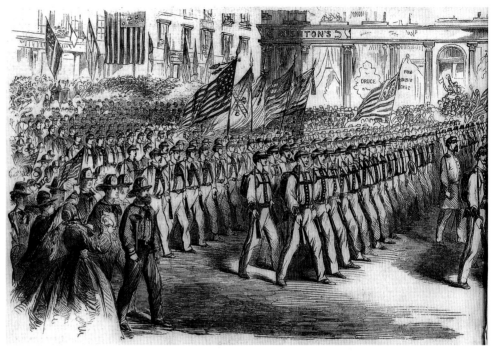

▲ *A wood engraving published in the* Illustrated Newspaper *of May 11, 1861, showing the Fire Zouave Regiment leaving New York to join the Union forces. Elmer Ellsworth organized the regiment from members of the city's fire department.*

MAY 29–JUNE 1
VIRGINIA, *LAND/SEA WAR*
The Battle of Aquia Creek. Three U.S. gunboats led by Commander James H. Ward bombard Confederate coastal batteries at the mouth of Aquia Creek for three days during the blockade of

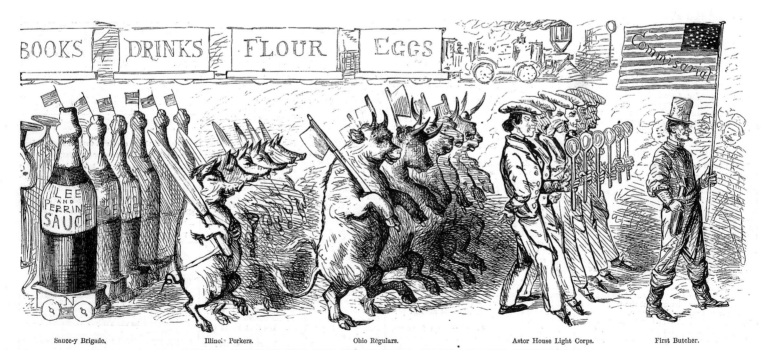

BOOKS DRINKS FLOUR EGGS

Sauce-y Brigade. Illinois Porkers. Ohio Regulars. Astor House Light Corps. First Butcher.

REINFORCEMENTS FOR OUR VOLUNTEERS ON THE MARCH SOUTHWARD.

KEY PERSONALITY

NATHANIEL BANKS

Nathaniel Prentiss Banks (1816–1894) was born in Waltham, Massachusetts, on January 30, 1816. He came from a poor family and left school to work in a factory. Later Banks studied law and became a politician, being elected to Congress in 1853 as a Democrat. He opposed the western expansion of slavery, however, and switched to the Republican Party in 1855. In 1858 he was elected governor of his home state. When war began, Lincoln needed the support of influential men and so gave them key military offices. In May 1861 he appointed Banks major general of volunteers despite his lack of military experience.

In the summer of 1861 Banks and his men were routed by Thomas "Stonewall" Jackson in the Shenandoah Valley. As the Union troops fled, they left behind valuable provisions. The grateful Confederates dubbed the Union general "Commissary Banks."

On August 9, 1862, Banks came up against Jackson again, this time at Cedar Mountain. Banks and his men gained an early advantage, but a counterattack by the Confederates won the day. The Union suffered 2,500 casualties, and the military initiative in Virginia swung in favor of the Confederates. Only Banks' friendship with Lincoln saved his job.

Later campaigns reinforced Banks' poor military reputation. In May 1863, he led the Army of the Gulf against Port Hudson on the Mississippi. The Confederates fought off the attack and dug in for a siege that lasted 48 days. Another Union assault on June 14 was unsuccessful, and the Confederates surrendered only after Vicksburg fell. The "victory" at Port Hudson cost 5,000 Union casualties. In the Red River Campaign that followed, Banks fared no better, and in 1865 he was removed from command. Banks returned to politics to serve in the House of Representatives.

Chesapeake Bay. This inconclusive encounter results in 10 casualties.

JUNE 3

VIRGINIA, *LAND WAR*
The Battle of Philippi/Philippi Races. A Union force makes a two-pronged attack against a small Confederate unit at Philippi in Barbour County. The Confederates are forced to retreat, suffering 26 casualties.

JUNE 10

VIRGINIA, *LAND WAR*
The Battle of Big Bethel/Bethel Church. Major General Benjamin F. Butler sends converging columns from Hampton and Newport News against advanced Confederate outposts at Little and Big Bethel. The 1,2000 Confederates abandon Little Bethel and fall back to

▲ *Union troops with artillery just prior to the Battle of Big Bethel. One of the first engagements of the war, it resulted in a Confederate victory.*

▲ *The coal wharf at Alexandria, Virginia, an important port and a busy trade center on the Potomac River. Union troops seized the town in May 1861, and it remained in Union hands for the rest of the war. It was a haven to slaves fleeing the South.*

their entrenchments behind Brick Kiln Creek, near Big Bethel Church. The Federals, 3,500 men under the command of Brigadier General Ebenezer Pierce, attack but are repulsed. Crossing downstream, the 5th New York Zouaves attempts to turn the Confederate left flank, but is also repulsed. Being disorganized, Union forces then retire and return to Hampton and Newport News. Confederate losses are one killed and seven wounded. Union forces suffer losses of 79.

JUNE 17

MISSOURI, *LAND WAR*
The Battle of Boonville. Some 1,700 Federals attack Missouri State Guard troops at Boonville, forcing them out of the town and establishing Union control over a stretch of the Missouri River.

JUNE 20

WEST VIRGINIA, *POLITICS*
West Virginia, its political leaders opposed to Virginia's decision to leave the Union, breaks away from the Confederacy and is admitted to the Union as a separate state.

July 2

▶ *Wisconsin soldiers in the Union army at the Battle of Hoke's Run on July 2, 1861. This Union victory, one of the first engagements of the war, took place near Hainesville in what is now West Virginia.*

July 2

WISCONSIN, *LAND WAR*
The Battle of Hoke's Run/Falling Waters/ Hainesville. Union Major General Robert Patterson's division, having crossed the Potomac River near Williamsport, marches on the main road to Martinsburg, near Hoke's Run. Thomas' and Abercrombie's Union brigades encounter the Confederate regiments of Brigadier General Thomas J. Jackson's brigade, driving them back slowly. Jackson's orders are to delay the Federal advance only, which he does, withdrawing before Patterson's larger force.

On July 3, Patterson occupied Martinsburg but then was inactive until July 15, when he marched to

KEY PERSONALITY

PIERRE GUSTAVE TOUTANT BEAUREGARD

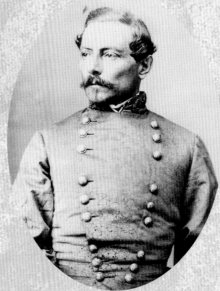

Pierre Gustave Toutant Beauregard (1818–1893) was born into a French Creole family in Louisiana. He attended the U.S. Military Academy at West Point, graduating second in his class in 1838. He served in the Mexican War (1846–1848) and was twice wounded in that conflict.

When Louisiana seceded from the Union in January 1861, Beauregard resigned from the U.S. Army and was commissioned as the first brigadier general of the Confederacy. He was ordered to South Carolina, where he commanded the attack on the garrison at Fort Sumter in April 1861.

Hailed a hero across the Confederacy after the fall of Sumter, Beauregard took command of the Confederate army in northern Virginia. At the First Battle of Bull Run on July 21 Beauregard was second-in-command to Joseph E. Johnston, facing a Union army under his former West Point classmate, Irwin McDowell. Beauregard's network of spies in Washington provided valuable information on the Union forces, and his role in the battle earned him promotion to full general.

Beauregard moved west to command the Army of the Mississippi in March 1862. He was second-in-command to Albert S. Johnston at the Battle of Shiloh in April and took charge after Johnston was fatally wounded. His retreat from Shiloh and later withdrawal from Corinth angered President Davis, who took the opportunity to fire him in June when Beauregard left his army without permission.

In August 1862 Beauregard returned to duty as the commander in Georgia and South Carolina. He organized the defense of Charleston until April 1864, when he transferred to help defend Richmond. After holding back a Union advance along the James River in May, he was assigned to overall command of the armies in Tennessee and Georgia in October 1864.

By January 1865 Beauregard was organizing the retreat through Georgia and the Carolinas. In February he ordered Charleston to be evacuated. In April, after the loss of Richmond and the Army of Northern Virginia, he was one of the senior figures who urged Davis to negotiate the surrender of the last Confederate forces to end the war.

After the war Beauregard returned to Louisiana, where he was state adjutant general for several years.

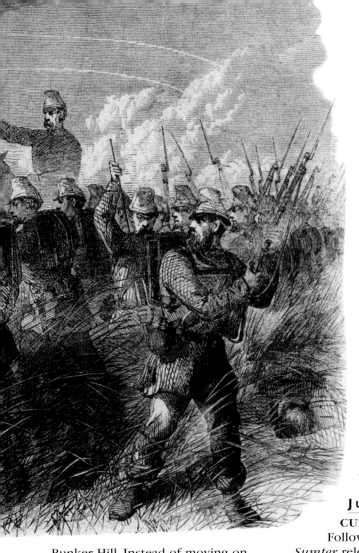

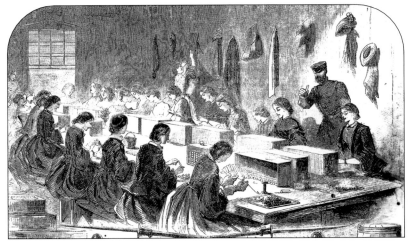

JULY 5

MISSOURI, *LAND WAR*
The Battle of Carthage. Missouri State Guard divisions under Governor Claiborne Jackson force a Union brigade into retreat around Carthage, although the Confederates lose a total of 200 men to the Union's 44 casualties.

JULY 6

CUBA, *SEA WAR*
Following raiding actions, the CSS *Sumter* releases seven captured Union vessels in Cuban waters.

▼ *A skating carnival held in Brooklyn, New York City, on February 10, 1862. Notwithstanding the conflict, life in most Northern cities went on much as usual, in contrast to Southern cities.*

▲ *An illustration from* **Harper's Weekly** *of July 20, 1861, showing women filling cartridges in the Union Arsenal at Watertown, Massachusetts.*

JULY 11

WEST VIRGINIA, *LAND WAR*
The Battle of Rich Mountain. General George B. McClellan's troops force Confederates out of defensive positions at Rich Mountain Pass and Laurel Hill—points within striking distance of the Baltimore and Ohio Railway. Union Brigadier General William S. Rosecrans leads a brigade (1,800 men) along the mountain path to seize a turnpike against the 900 Confederates under Lieutenant Colonel John Pegram. A sharp two-hour fight ensues, which ends in a Union victory. Union casualties are 46, whereas the Confederates suffer losses of 300.

JULY 21

VIRGINIA, *LAND WAR*
The Battle of First Manassas/First Bull Run. General Irvin McDowell, commander of the main Union force of 35,000, engages the main Confederate army of 20,000, commanded by Pierre G.T. Beauregard (who had been McDowell's classmate at the military academy at West Point) at Manassas Junction, only 30 miles (48km) from Washington, along a small stream called Bull Run Creek. Manassas is a key Confederate supply depot and a stop on the railroad linking northern Virginia with the Shenandoah Valley. In the Shenandoah Valley, meanwhile, Union General Robert Patterson with 18,000 troops, has orders to prevent Confederate General Joseph E. Johnston moving his 12,000 men to support Beauregard.

McDowell began his movement on July 16. He aimed to capture a

Bunker Hill. Instead of moving on Winchester, however, he turned east to Charles Town and then withdrew to Harpers Ferry. This took pressure off Confederate forces in the Shenandoah Valley and allowed Johnston's army to march to support General Beauregard at Bull Run.

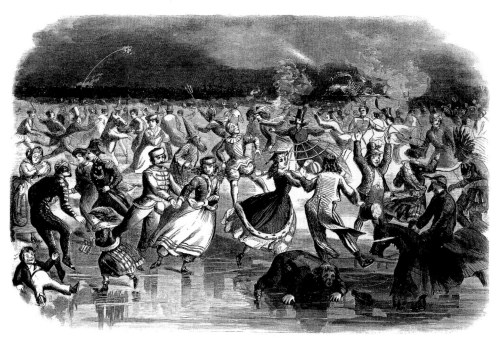

JULY 21

▶ *Wounded soldiers leave the Union lines at the First Battle of Bull Run. Similarities in the uniforms and flags of the two sides added to the confusion, and no doubt resulted in many friendly fire casualties.*

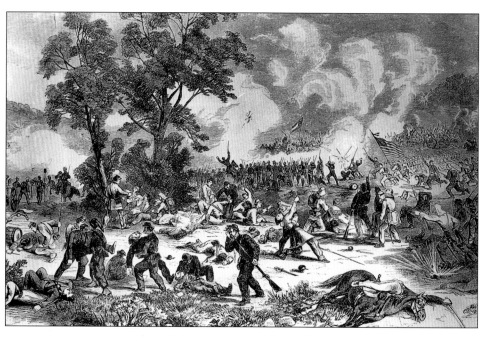

Confederate detachment at Fairfax Court House, northeast of Manassas. However, just as he had feared, his raw troops had trouble with even the simplest maneuvers. The Confederates at Fairfax escaped to the main lines at Bull Run as the Union forces approached. In response to McDowell's movement, Beauregard requested that Johnston's army come to his aid. On July 18, Johnston's Confederates managed to give Patterson the slip and began using the Manassas Gap Railroad to reinforce Beauregard. Today, the two Confederate armies were united. The movement marked the first use of railroads for the purpose of battlefield maneuver in the history of warfare.

Both McDowell and Beauregard determine on the same battle plan today—a turning of the enemy's left flank. McDowell plans to cross Bull Run via the Sudley Ford and position

his army between those of Beauregard and Johnston, forcing both the Confederates to retreat. Beauregard also plans to attack his opponent's left flank. His spies in Washington have provided him with accurate information on the strength of the Union army.

McDowell is first to attack. As Tyler's men make a diversion in the center of the Confederate line, 13,000 men under David Hunter and Samuel Heintzelman make their way around the Confederate left flank and cross Bull Run at Sudley Ford. An alert Confederate signal officer spots this movement. In the war's first use of signal flags, he alerts a Confederate force in time to send it to oppose the flanking movement. On Matthew's Hill, Confederates from

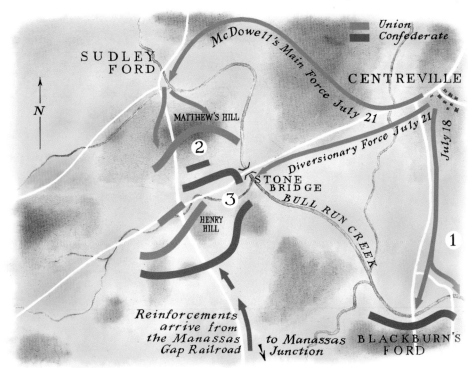

▲ **The First Battle of Bull Run**
On July 18, a Union detachment probed the fords across Bull Run. It was repulsed in a sharp skirmish that lasted all afternoon (1). On July 21, the main Union force made a flanking movement, crossing Bull Run at Sudley Ford at 09:30 hours (2). Fighting in the morning centered on Matthew's Hill. The Confederates were pushed back to Henry Hill by late morning. In the afternoon fighting continued on Henry Hill (3). The Confederates were reinforced, and Jackson attacked. By late afternoon the Union troops were in full retreat.

Georgia, South Carolina, Alabama, and Louisiana battle Union troops from Rhode Island, New Hampshire, and New York in a vicious struggle that marks the first experience of combat for many of the participants.

McDowell's army has the advantage of numbers and by late morning has pushed the Confederates back to their final defensive position on Henry Hill. By the afternoon the Confederates are on the verge of defeat. The timely arrival of reinforcements, many from Johnston's Shenandoah Valley force, turns the tide. The Confederates are rallied by Jackson's Virginia brigade. It makes a counterattack on the slopes of Henry Hill that earns Jackson his famous nickname of "Stonewall." Other Confederate brigades attack and push back McDowell's forces, who are exhausted by marching and fighting on a brutally hot day. By evening Union troops are in full retreat toward Washington. The retreat, initially reasonably orderly, descends into confusion as troops become entangled with the wagons of the many civilian spectators who had traveled from Washington, expecting to watch a Union victory. When the Confederates begin to shell the road, the confusion develops into panic, and the disorderly retreat becomes a rout.

▼ *African Americans build barricades to protect the railroad at Alexandria, Virginia, against Confederate attack in 1861. Union troops occupied the town early in the war since it lay across the Potomac River from Washington. The Union made great efforts to make the capital impregnable.*

ARMED FORCES

THE CONFEDERATE NAVY

The Confederacy's first and only secretary of the navy, Stephen R. Mallory, faced a difficult task. When his Department of the Navy came into being in February 1861, Mallory had almost no vessels under his control and only a single naval facility—little more than a coaling station—confiscated from the U.S. Navy at Pensacola, Florida. Virginia's secession two months later brought the important Norfolk naval yard into Confederate hands, but only after evacuating Union forces had damaged it. Of the 1,457 officers of the prewar U.S. Navy only 237 cast their lot with the Confederacy.

Unable to compete with the enemy numerically, Mallory substituted innovation for quantity, particularly in the area of ironclad warships. During the war the Confederate navy began construction of 50 ironclads, of which 22 were actually put into commission.

By far the most famous ironclad was the CSS *Virginia*. This ship was adapted from the hulk of the frigate USS *Merrimack*. The new ironclad rode so low in the water that it looked like the roof of a floating barn. It mounted 10 11-inch (25cm) cannons and an iron ram on the bow below the waterline. However, the *Virginia* epitomized the problems of Confederate ironclads. All too often they were slow, unwieldy, and suffered from many mechanical defects. The best that could be said of them is that they complicated the Union's task of capturing coastal areas and ports.

To defend their ports, the Confederates made great use of sea mines (then called torpedoes), which were explosive charges anchored in shipping channels. A torpedo could also be deployed by being attached to a long spar mounted on a small, fast, unarmored vessel. The spar would strike an enemy vessel, and the torpedo would explode, but the torpedo boat itself usually survived with little or no damage. The CSS *Hunley*, a submersible vessel powered by a crew of eight, attempted to destroy part of the Union fleet blockading the harbor of Charleston, South Carolina. On the night of February 17, 1864, the *Hunley* successfully rammed a spar torpedo into the side of the sloop of war USS *Housatonic*. The *Housatonic* sank in shallow water. However, it lost only five men, while the entire crew of the *Hunley* perished in the attack.

To evade the Union naval blockade of Southern ports, the Confederacy took advantage of blockade-runners—fast, steam-driven vessels often specifically designed to outrun patrol ships.

Confederate commerce raiders achieved great notoriety and in some respects great effectiveness. Many commerce raiders were built in England, secretly commissioned by a Confederate agent in London, James Bulloch. They sank a large number of Union merchantmen, forced hundreds more to seek refuge by reregistering under neutral flags, and sent insurance premiums soaring. The raider CSS *Shenandoah*, for example, crippled the New England whaling fleet in the Bering Sea—although it achieved this in June 1865, unaware that the war was over.

Although Mallory did a superb job of creating a navy, land fortifications seemed the most effective way to defend Southern ports. The commerce raiders did a lot of damage, but never enough to deflate the North's will to continue the war. Considering the vast amount of commerce carried by Northern ships, the raiders were really little more than a nuisance.

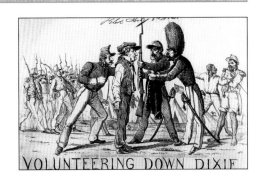

VOLUNTEERING DOWN DIXIE

▲ *A Union satirical cartoon of 1861 suggests that the Confederate army forcibly recruited "volunteers." This was untrue in 1861. Later in the war, the draft resulted in the conscription of unwilling men who later deserted.*

29

AUGUST 10

AUGUST 10

MISSOURI, *LAND WAR*
The Battle of Wilson's Creek/Oak Hills.
Brigadier General Nathaniel Lyon's
Union Army of the West has been
involved in several skirmishes with
Confederate forces, including Sterling
Price's Missouri State Guard. As the
Missouri State Guard and Confederate
allies from Arkansas move along Wilson's
Creek toward Springfield today, they
clash with Lyon's forces. Wilson's Creek
is the first major battle west of the
Mississippi River. It is bloody, with more
than 2,500 dead, injured, and missing—
among them Nathaniel Lyon. The
Confederate victory gives the South
control of the Springfield area.

AUGUST 26

WEST VIRGINIA, *LAND WAR*
The Battle of Kessler's Cross Lanes.
Confederate forces under Brigadier
General John Floyd cross over the
Gauley River and attack Colonel
Erastus Tyler's 7th Ohio Regiment at
Kessler's Cross Lanes. The Union troops
are thrown into retreat, losing 245
men. Confederate losses are 40.

AUGUST 28–29

NORTH CAROLINA, *LAND WAR*
The Battle of Hatteras Inlet Batteries/
Fort Clark/Fort Hatteras. Two thousand
Union troops make an amphibious raid
against shore batteries around Hatteras
Inlet. The Confederate garrison of 670
men surrenders on the 29th.

SEPTEMBER 2

MISSOURI, *LAND WAR*
The Battle of Dry Wood Creek/
Battle of the Mules. A
US cavalry force
of 600 men

under Colonel J.H. Lane clashes with
6,000 Confederate soldiers at Dry
Wood Creek, Vernon County, and are
forced into retreat. The Federals are
being compelled to abandon south-
western Missouri and to concentrate
on holding the Missouri Valley.

SEPTEMBER 10

WEST VIRGINIA, *LAND WAR*
The Battle of Carnifex Ferry. Three
brigades of US infantry commanded by
Brigadier General William S. Rosecrans
join U.S. troops previously defeated at
Kessler's Cross Lanes, and attack and
overcome Confederate troops under
Brigadier General John Floyd around
Carnifex Ferry. Total
casualties are
250.

SEPTEMBER 12–15

WEST VIRGINIA, *LAND WAR*
The Battle of Cheat Mountain Summit.
General Robert E. Lee is defeated by a
trenchant Union defence on Cheat
Mountain and in the Tygart Valley,
despite the Confederates being in
greater strength. Union losses are 80
men; Confederate losses are 90.

SEPTEMBER 13–20

MISSOURI, *LAND WAR*
The Battle of Lexington/the Battle of the
Hemp Bales. Some 12,000 Missouri State
Guard under Major General Sterling
Price force the eventual surrender of
3500 U.S. troops in Lexington.

SEPTEMBER 17

MISSOURI, *LAND WAR*
The Battle of Liberty/Blue Mills
Landing. Confederate forces score
another victory in their Missouri
campaign after defeating 600 Union
troops around Liberty, Clay County.

SEPTEMBER 19

KENTUCKY, *LAND WAR*
The Battle of Barbourville. Some 800
Confederates raid the (largely empty)
Union guerrilla training base at Camp
Andrew Johnson in Barbourville.

◀ *The 3rd Arkansas Infantry Regiment on
parade in Arkansas, 1861. The 3rd Arkansas
fought for four years in the war. In total,
1,353 men served in its ranks; only 150
remained at the surrender in 1865.*

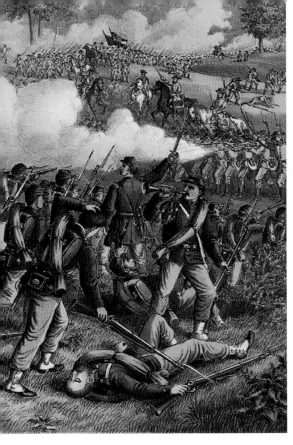

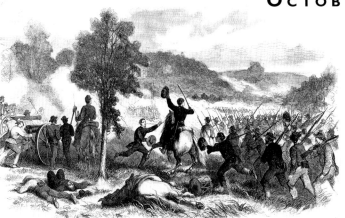

◄ *Union troops of the 1st Iowa Regiment, led by Nathaniel Lyon, make a charge at the Battle of Wilson's Creek on August 10, 1861, Missouri. Lyon was killed in the battle, making him the first Union general to die in combat in the war.*

▲ *The Battle of Wilson's Creek near Springfield on August 10, 1861, marked the start of the war in Missouri. Some 12,000 Confederates defeated 5,400 Federals.*

OCTOBER 3

WEST VIRGINIA, *LAND WAR*
The Battle of Greenbrier River/Camp Bartow. Brigadier General Joseph Reynolds leads two Federal brigades in a raid on Confederate positions at Camp Bartow on the Greenbrier River, but is unable to take the camp.

OCTOBER 9

FLORIDA, *LAND WAR*
The Battle of Santa Rosa Island. A Confederate force nearly captures Santa Rosa Island following a surprise amphibious landing, but is expelled from the island after the Union troops receive reinforcements.

OCTOBER 21

KENTUCKY, *LAND WAR*
The Battle of Camp Wildcat/Wildcat Mountain. A force of 7000 Union troops defeats Confederate troops in an action around the Union's Camp Wildcat.

MISSOURI, *LAND WAR*
The Battle of Fredericktown. Missouri Guard troops under Brigadier General M. Jeff Thompson attempt to push Union troops out of Fredericktown but are repelled, giving the Union control over southeastern Missouri.

VIRGINIA, *LAND WAR*
The Battle of Ball's Bluff/Leesburg. Union forces lose over 900 men in a badly coordinated attempt to cross the Potomac River at Harrison's Island and capture Leesburg.

OCTOBER 25

MISSOURI, *LAND WAR*
The Battle of Springfield/Zagonyi's Charge. Major Charles Zagonyi repulses Confederate forces from Springfield, but abandons the town during the night.

STRATEGY AND TACTICS

INFANTRY TACTICS

The basic objective of infantry tactics was to be able to maneuver units of troops into a position where they could deploy on the battlefield as quickly and efficiently as possible, so as to bring the maximum amount of musket fire onto the enemy and then to charge with bayonets and drive the enemy from the field. Confederate commander "Stonewall" Jackson's brigade broke the Union attack on Henry Hill using exactly these tactics in the First Battle of Bull Run (Manassas) in July 1861.

To achieve this result, infantry companies were trained to march in column, usually four men across. On an order they could change formation and direction and, without altering pace, deploy into a battle line two ranks deep 16 inches (40cm) apart facing the enemy.

This method of getting large numbers of men into combat was adaptable enough to allow infantry units of any size to deploy for action using the same maneuvers. A regiment could form a line by deploying its companies and a brigade by deploying its regiments.

The battle line itself did not form a solid wall of soldiers. To allow room for units to maneuver, tactical manuals recommended a 20-yard (18.5m) gap between regiments and a 25-yard (23m) gap between brigades. Regiments could also hold companies behind the line in reserve or advance companies forward in a skirmish line up to 500 yards (450m) ahead of the main formation.

Skirmishers operated in "open order," each man spaced a few yards from the next, taking advantage of available cover to keep the enemy line under fire. They also maintained contact with the enemy and gave warning if they began to move forward for an attack.

The most common method of attack was to advance lines of regiments or brigades one after the other in waves about 25 yards (23m) apart. Often the first wave was used as cover for the rest by advancing it up to 300 yards (275m) in front so as to take all the enemy fire: The first wave kept the succeeding units relatively safe from enemy bullets. The speed of the attack depended on the distance to be covered. There was no point in exhausting the men in the charge so that they were out of breath when they reached the enemy. Instead, an attack was made at regulation quick time, a march of 110 steps per minute, which covered about 86 yards (78m).

By 1864 soldiers were changing the way they were fighting as a result of bitter experience. Infantry attacks were now made in short rushes, with soldiers giving each other covering fire as they ran from one place of safety to another.

In defense, getting out of the way of enemy fire became the first priority, and entrenchments were widely dug. Union General William T. Sherman wrote of his men in the last year of war: "Troops halting for the night or for battle, faced the enemy; moved forward to ground with a good outlook to the front; stacked arms; gathered logs, fence-rails; anything that would stop a bullet; piled these in front, and digging a ditch behind threw the dirt forward, and made a parapet which covered their persons as perfectly as a granite wall."

NOVEMBER 7

NOVEMBER 7

MISSOURI, *LAND/RIVER WAR*
The Battle of Belmont. A Union force under Brigadier General Ulysses S. Grant ejects Confederate forces at Belmont near the Mississippi River, but withdraws after a determined Confederate counterattack.

NOVEMBER 8–9

KENTUCKY, *LAND WAR*
The Battle of Ivy Mountain/Ivy Creek/Ivy Narrows. A Union pursuit force fights an intense engagement after being ambushed around Ivy Mountain, Floyd County, and pushes the Confederates back into Virginia.

NOVEMBER 19

OKLAHOMA, *INDIAN WARS*
The Battle of Round Mountain. Unionist Creek and Seminole Indians under Chief Opothleyahola are defeated when their camp is attacked by Confederate troops commanded by Colonel Douglas H. Cooper.

▲ *A volunteer refreshment saloon for Union troops passing through the railroad station in Philadelphia, Pennsylvania. This lithograph commemorates the patriotic work of the citizens of Philadelphia.*

▶ *An overcrowded Union field hospital. During the Civil War most field hospital nurses were men, since women were thought to be too sensitive to cope with the recently injured.*

DECEMBER 9

OKLAHOMA, *INDIAN WARS*
The Battle of Chusto-Talasah/Caving Banks. Retreating Creek/Seminole Indians under Chief Opothleyahola are driven out of defensive positions on the Horseshoe Bend of Bird Creek by 1,300 Confederate soldiers.

DECEMBER 13

WEST VIRGINIA, *LAND WAR*
The Battle of Camp Allegheny/Allegheny Mountain. Federal troops fail to displace Confederates from Allegheny Mountain.

DECISIVE MOMENT

THE TRENT AFFAIR

In November 1861, James M. Mason of Virginia and John Slidell of Louisiana slipped through the Union blockade at Charleston, South Carolina, and reached Havana in Cuba, where they boarded the British steamer *Trent* bound for Europe. Mason was on his way to take up the position of Confederate minister to Britain. Slidell was bound for Paris to fulfill the same diplomatic role in France. However, Captain Charles Wilkes of the 13-gun Union sloop *San Jacinto* intercepted the *Trent* and seized Mason and Slidell.

The news of this daring move was initially greeted with jubilation in the North. But as the extent of British outrage became known, a sense of foreboding took hold. Wilkes' action was in breach of international law. When the British demanded an apology and the release of the Confederate diplomats, war with Britain seemed imminent. In the end the Union accepted that Wilkes had acted without authority, and Mason and Slidell were released. By way of compromise the British dropped their insistence on a formal apology.

▲ *The Union sloop* **San Jacinto** *forcing the British steamer* **Trent** *to "heave to" (come into the wind and stop) in November 1861. The British ship was forced to surrender two Confederate officials on board, an incident that caused outrage in Britain.*

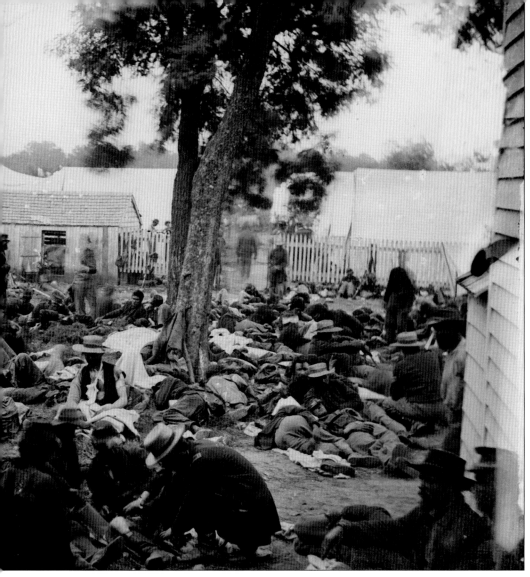

▲ *The Confederate cruiser CSS Sumter running the Union blockade of the port of St. Pierre on Martinique in the West Indies in November 1861.*

DECEMBER 17

KENTUCKY, *LAND WAR*
The Battle of Rowlett's Station/ Woodsonville/Green River. Having crossed the Green River, Union troops engage with Confederate units in the Woodsonville woodlands. Neither side wins, but the Unionists secure the flow of logistics along the Louisville & Nashville Railroad.

DECEMBER 20

VIRGINIA, *LAND WAR*
The Battle of Dranesville. As part of McClellan's continuing operations in northern Virginia, Union troops inflict a sharp local defeat on Confederate cavalry around Dranesville.

KEY PERSONALITY

JOSEPH HOOKER

Born in Hadley, Massachusetts, on November 12, 1814, Joseph Hooker (1814–1879) graduated from the U.S. Military Academy at West Point in 1837. He fought in the Mexican War (1846–1848) and reached the rank of lieutenant colonel. In 1853 Hooker resigned from the army to run a farm in California.

When the Civil War broke out in 1861, Hooker returned east and took over as brigadier general of volunteers, leading troops in the Peninsular Campaign (April 4–July 1, 1862) against Richmond. He showed great bravery in the Battle of Williamsburg on May 5, 1862, and was promoted to major general of volunteers from this date. When he appeared in a report of the battle as "Fighting Joe," the name stuck, although Hooker himself never liked his nickname. Hooker again showed courage at Second Bull Run (Manassas) in August 1862. He commanded I Corps in the Army of the Potomac at Antietam in September 1862 and was wounded in the foot.

Despite Hooker's prowess in battle, his private life was less controlled. He drank heavily and could be disagreeable and critical of his superiors. In December 1862, President Lincoln promoted Hooker to command of the Army of the Potomac following the army's defeat at Fredericksburg under General Ambrose E. Burnside.

At the Battle of Chancellorsville in May 1863 Hooker proved badly indecisive. He was outgeneraled by Robert E. Lee and his Confederate Army of Northern Virginia, who defeated the Union forces despite being outnumbered two to one. Hooker stayed in command for a short while but resigned on June 28 when he was refused reinforcements. He was replaced by General George G. Meade.

Hooker went on to serve ably in the Battle of Lookout Mountain, Tennessee, in November and under William T. Sherman in Georgia. After the war Hooker was passed over for army promotion. He retired following a stroke in 1868 and died in 1879.

1862

The Union took the offensive this year, determined to capture Richmond in the east, New Orleans and Vicksburg in the west, and Chattanooga and Atlanta in the center. New Orleans was captured and Grant won the Battle of Shiloh, but in Virginia Jackson and Lee fought the Union to a standstill. In politics, Lincoln issued his Emancipation Proclamation to end slavery.

JANUARY 3

VIRGINIA, *NAVAL WAR*
The Battle of Cockpit Point/Freestone Point. Union gunboats bombard Confederate coastal batteries at Cockpit Point on the Potomac. The Confederates have a string of batteries blockading the entrance to the Potomac.

JANUARY 5–6

MARYLAND, *LAND WAR*
The Battle of Hancock/Romney Campaign. Confederate General Thomas "Stonewall" Jackson, moving forces against the Baltimore and Ohio Railroad, bombards the town of Hancock from across the Potomac, but is unable to force the town's surrender.

JANUARY 8

MISSOURI, *LAND WAR*
The Battle of Roan's Tan Yard/Silver Creek. After days of reconnaissance, Union forces attack and rout a Confederate camp at Silver Creek in Randolf County.

JANUARY 10

KENTUCKY, *LAND WAR*
The Battle of Middle Creek. Union units commanded by Colonel James Garfield stop the Confederates' 1861 Kentucky offensive after defeating Brigadier General Humphrey Marshall's troops at Middle Creek, eastern Kentucky.

▼ *Union troops defeat the Confederates at the Battle of Mill Springs, Kentucky. This victory, together with the one at Middle Creek, wrested control of eastern Kentucky from the Confederates.*

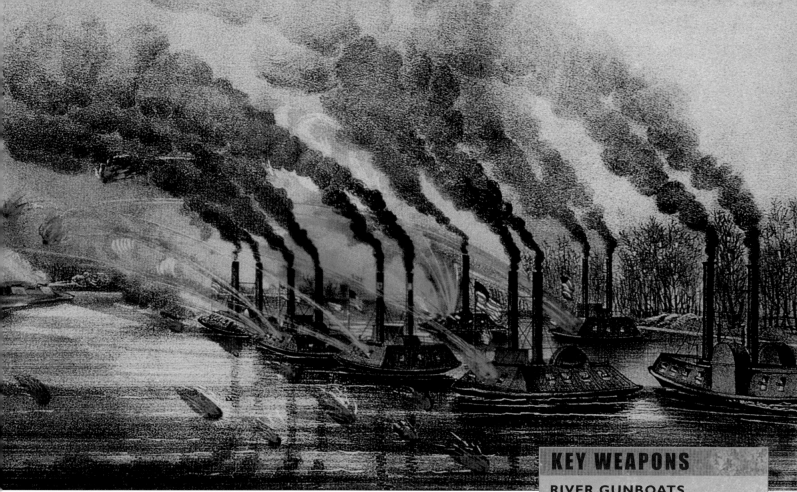

▲ Union gunboats commanded by Andrew H. Foote bombard Fort Henry from the Tennessee River, February 6, 1862. The Confederates surrendered the fort on the same day.

JANUARY 18

ARIZONA, *POLITICS*

The Confederate Territory of Arizona is formed. It is created out of the southern half of what was the old Territory of New Mexico.

JANUARY 19

KENTUCKY, *LAND WAR*

The Battle of Mill Springs/Logan's Cross-Roads/Fishing Creek. Union Brigadier General George Thomas' forces, having arrived at Logan's Crossroads on January 17, is attacked by Confederates under Major General George Crittenden at dawn. The Confederate attack is initially successful but then runs into stiff resistance. A second Confederate attack is repulsed. Union counterattacks on the Confederate right and left push the enemy back to Murfreesboro, Tennessee. Union losses are 232, Confederate 439. This battle breaks the eastern end of the Confederacy's defensive line in the West.

FEBRUARY 6

TENNESSEE, *LAND WAR*

General Ulysses S. Grant, with 17,000 men, supported by ironclad gunboats under Andrew H. Foote, captures Fort Henry. The fort was poorly sited, unfinished, and half-flooded. Confederate commander Lloyd Tilghman thus sent most of his 3,000-man force to Fort Donelson. He remained with an 80-man artillery battery to conduct a delaying action.

As Grant's infantrymen make their way toward the

◀ Confederates captured during the Union seizure of Fort Donelson (in the background) in February. It was the North's first major victory in the war.

fort, Foote's gunboats renew the attack. Tilghman strikes his colors, and Foote accepts his surrender. The Tennessee River is suddenly a Union highway as far south as Muscle Shoals, Alabama.

The loss of Fort Henry unhinged the Confederacy's western line. The overall Southern commander, Albert S. Johnston, thus evacuated his forces from Columbus and Bowling Green,

KEY PERSONALITY

JEFFERSON DAVIS

Jefferson Finis Davis (1808–1889) was born on June 3, 1808, in Kentucky. His family later moved to Mississippi and prospered in the cotton trade. Jefferson Davis grew up to believe devoutly in slavery and states' rights. Davis was also a well-known national figure; and had the Southern states not left the Union, he just might have become president of the United States.

Davis graduated from the U.S. Military Academy at West Point in 1828 and went on to serve on the frontier. He left the army in 1835 and married Sarah Knox Taylor, the daughter of his commanding officer, Zachary Taylor, on June 17, 1835. On the honeymoon they both came down with malaria, and Sarah died of the disease three months later.

Davis suffered greatly from the loss. He rarely left his plantation, Brierfield, over the next 10 years. After this long widowerhood Jefferson married Varina Howell (1826–1905) in 1845 and, in the same year, was elected to Congress as a Democrat. Varina Howell Davis was a great influence on her husband and supported his politics. The couple had six children and a happy marriage.

Davis returned to military duty to serve in the Mexican War (1846–1848) as colonel of a Mississippi mounted volunteer regiment. He became a hero at the Battle of Buena Vista, where he sustained a serious wound in his foot. After the war he served as a senator for Mississippi and, from 1853 to 1857, as secretary of war under President Franklin Pierce.

When Mississippi left the Union on January 9, 1861, Davis made a farewell speech in the Senate in which he defended secession "upon the basis that the States are sovereign."

Davis went to Mississippi, where he was appointed commander of the Mississippi militia. He wished to lead the Confederate army, but the provisional congress instead selected him as provisional president. He was inaugurated in Montgomery, Alabama, on February 18, 1861. Davis was later elected to the permanent post and inaugurated in Richmond, Virginia, on February 22, 1862.

Six weeks after Davis' appointment his new country was at war. Davis' personal role in the conduct of the war was great. He interfered continually in the War Department and went through six secretaries of war in four years. Davis made a fine decision in appointing Robert E. Lee to command the Army of Northern Virginia in May 1862. Lee also served as Davis' principal military adviser. Davis and Lee aimed to secure Confederate independence by inflicting a series of striking defeats on Union forces.

Davis also attempted to secure foreign military aid for the Confederacy. In fall 1861, following a diplomatic quarrel with the Union, the British government sent 11,000 troops to Canada in preparation for an invasion. Tempers cooled, however, and the invasion did not materialize.

Finally, Davis hoped to win by simply holding on until the Union was overcome by war weariness. That almost happened in 1864 since Lee's army seemed too tenacious to destroy. In late summer 1864 President Lincoln's chances of reelection in November looked small. But then the city of Atlanta fell to the Union, and General Philip Sheridan scored a victory in the Shenandoah Valley. Lincoln was reelected, and the Confederacy's chances evaporated.

In his military appointments Davis clung to his favorites far too long and could not work with people whom he disliked. For this reason Pierre G. T. Beauregard, a general who perhaps could have forged a victorious strategy for the Confederates, was relegated to a relatively minor role.

After the war Davis was imprisoned by the Union. After his release Davis and his wife wrote long, self-vindicating memoirs. They did not do well at the time and shed little light behind the scenes. Davis died on December 6, 1889, in New Orleans. While Robert E. Lee became almost saintlike to the Southern people during the late 19th century, some blamed the president for the Confederacy's defeat. Many others, however, revered Davis' memory.

Kentucky. He reinforces the garrison at Fort Donelson, however, so that within days 21,000 troops occupy the fort and its surrounding earthworks.

FEBRUARY 7–8

NORTH CAROLINA, *LAND WAR*

The Battle of Roanoke Island/Fort Huger. A Union amphibious landing of 7,500 men under Brigadier General Burnside captures Confederate forts on Roanoke Island, tightening the Union's Atlantic blockade.

FEBRUARY 16

TENNESSEE, *LAND WAR*

On February 12 Grant's forces marched from Fort Henry toward Fort Donelson. Within two days they surrounded Fort Donelson. Foote's gunboats bombarded the fort on the 14th but suffered damage from its well-sited cannons. Grant then waited for reinforcements before attempting to take the fort.

Confederate leadership was poor. The fort's commander, John B. Floyd, vetoed a breakout from the fort at a time when most of the garrison could easily have escaped. Then, when a surprise attack yesterday punched a hole in the Union line, his second-in-command, Gideon J. Pillow, threw away the chance to escape by trying to destroy Grant's army. Pillow's action gave Grant time to order counter-attacks that forced the Confederates back into the fort.

▼ *A dismounted parade of the 7th New York Cavalry. Some mounted troops can be seen in the background. The regiment was mustered out on March 31, 1862, and honorably discharged from service.*

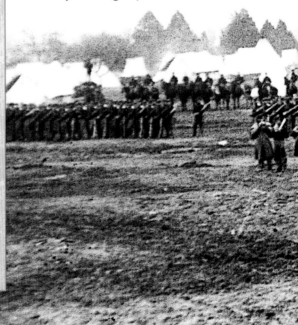

◄ *The U.S. Military Railroad engine W.H. Whiton. The Railways Act of January 1862 empowered the Union army to commandeer any railroad or rolling stock for the war effort.*

Floyd, fearing that as a former U.S. secretary of war he might be tried for treason, resolves to join part of the garrison that plans to escape from the fort under cover of night. He turns command over to Pillow, who immediately passes it to his subordinate, the fort's third-ranking officer, Simon Bolivar Buckner. Floyd, Pillow, and about 5,000 Confederate troops flee tonight.

The next morning Buckner sends a message to Grant asking for terms. Grant replies, "No terms except unconditional and immediate surrender can be accepted." About 15,000 Southerners capitulate.

FEBRUARY 20–21

NEW MEXICO, *LAND WAR*
The Battle of Valverde. Confederate Brigadier General Henry H. Sibley

makes a successful start to his New Mexico campaign, defeating Union troops that had attempted to prevent his crossing of the Rio Grande River.

FEBRUARY 25

TENNESSEE, *LAND WAR*
Having lost the protective Forts Donelson and Henry, Nashville becomes the first Confederate state capital to fall to Union forces. It is surrendered by the town's mayor.

THE UNION, *FINANCES*
The Federal Government in Washington introduces the Legal Tender Act. It issues $150 million in Treasury notes, popularly known as greenbacks. These notes are not directly backed by gold reserves. The act compels people to accept the notes for all debts, public or private, with two exceptions: customs duties and interest on government bonds.

The system made government bonds a very attractive investment. The bonds sold briskly, and not just to banks and wealthy investors. Ordinary citizens could buy bonds in notes as low as $50, and a large-scale advertising campaign worked overtime to make sure that they did.

KEY WEAPONS

CAVALRY WEAPONS

The three basic cavalry weapons used in the war were the saber, the carbine, and the pistol.

The saber, with its 3-foot-long (90cm) curved blade, was designed to be the cavalryman's principal offensive weapon. But many Confederate cavalrymen, such as the Virginia raider John S. Mosby, preferred pistols such as the six-shot Colt Navy. Union cavalry, however, continued to carry sabers throughout the conflict and found that they could still be effective in close combat.

The Union cavalry had the edge in firepower when it came to the carbine. There were various patterns of this short-barreled weapon. One of the most common types used by the Union cavalry was the Sharps. The most advanced carbine was the Spencer breechloading repeater, which could fire seven rounds before reloading. By 1865 the Union army had issued over 80,000 Sharps and 90,000 Spencers to its cavalrymen. In contrast, the Confederates began the war with muzzleloaders and even shotguns. Most of the breechloaders they used later were captured from Union forces.

FEBRUARY 28–APRIL 8

MISSOURI, *LAND WAR*
The Battle of New Madrid/Island No.10. Union forces place New Madrid and nearby Island No.10 on the Mississippi River under siege. New Madrid, having been abandoned by the Confederates, falls on March 14, and Island No.10 on April 8.

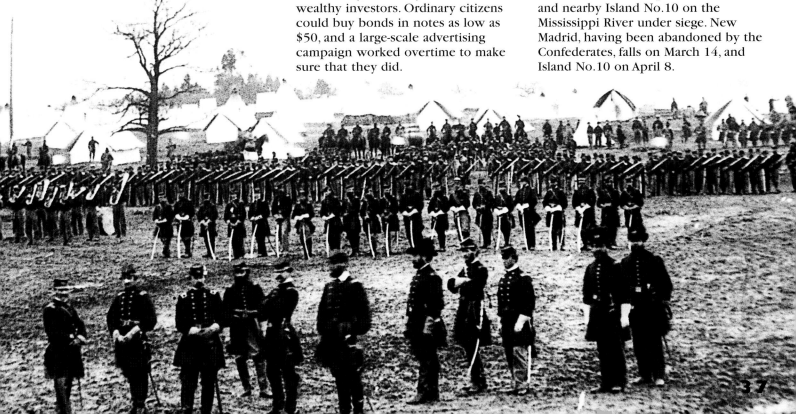

▲ *The Confederate ironclad CSS* Virginia *(right) exchanges fire with the Union iron-clad USS* Monitor *during the Battle of Hampton Roads, Virginia, in March 1862.*

MARCH 6-8

ARKANSAS, *LAND WAR*

The Battle of Pea Ridge/Elkhorn Tavern, the biggest battle to take place on Arkansas soil. Major General Sterling Price and his 8,000 Confederate troops from Missouri had been forced out of that state into northwestern Arkansas by the Union forces of Samuel R. Curtis early in 1862. Earl Van Dorn's Confederate Army of the West joined Price's troops in the Boston Mountains, and the combined force moved north again. Van Dorn resolved to attack. He decided to march around Curtis' Union Army of the Southwest on the night of March 6 and attack from the north. During the 55-mile (88km) night march in bitterly cold

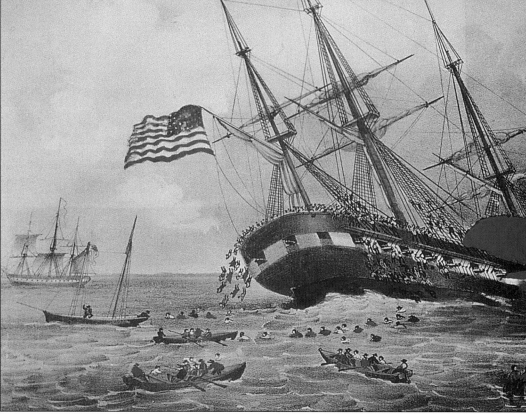

▲ *The Confederate ironclad CSS* Virginia *rams and sinks the 24-gun wooden frigate USS* Cumberland *at the Battle of Hampton Roads on March 8, 1862.*

weather, Van Dorn accidentally fell into a stream and developed a fever as a result. He had to conduct further operations from an ambulance.

The battle on the 7th was long and bloody. Since the air was cold and much of the fighting took place in a hollow, thick clouds of smoke hung low, obscuring visibility. Early exchanges favored the Confederates, but on the 8th Curtis

counterattacked before unleashing a ferocious artillery barrage. Van Dorn abandoned the battle, and the Union claimed victory. Confederate losses are 4,600 to 1,349 for the Union.

STRATEGY AND TACTICS

THE RIVER WAR

The Union navy had an ever-growing fleet of both wooden sailing ships and steamships, plus ironclad gunboats. With them it could attack and overwhelm Confederate river defenses, so preventing the South from using its rivers to transport men and supplies from place to place. Once the rivers were secured the Union could use them to move troops and supplies long distances through Tennessee, Mississippi, and Louisiana. The fledgling Confederate navy, suffering from shortages of men and materials, could not match its Union counterpart.

The river war in the West occurred roughly in three phases. The first, from January to March 1862, saw Union forces concentrate on the Tennessee and Cumberland rivers. Commodore Andrew Foote and General Ulysses S. Grant carried out a model campaign of joint army-navy operations, capturing Forts Henry and Donelson, and opening up the Tennessee and Cumberland rivers all the way to Corinth, Mississippi, and Florence, Alabama.

Phase two of the Western naval campaign, from March 1862 to July 1863, involved attempts to open the length of the Mississippi River as a line of communication for Union forces. Foote and John Pope operated against Confederate forts north of Memphis, Tennessee, in 1862, completing the capture of most of Tennessee for Union forces. Grant, Foote, and David D. Porter cooperated in 1863 to besiege Vicksburg, Mississippi, which fell on July 4, 1863. With Vicksburg in Union hands the last fort on the Mississippi at Port Hudson

surrendered, and Union naval forces had free access to the entire length of the river.

Phase three, the 1864 Red River expedition, was the least successful. Porter and General Nathaniel P. Banks decided to move up the Red River and into Texas, opening a gateway into the Confederacy's trans-Mississippi region. Porter's gunboats captured Alexandria, Louisiana, in mid-March, but Banks and his ground forces suffered a defeat at Mansfield, Louisiana, and retreated. Falling water levels in the Red River almost stranded Porter's fleet at Alexandria, but 3,000 Union soldiers hastily built dams to retain the water to allow the boats to escape.

In the Eastern theater of war the York and James rivers were crucial in McClellan's 1862 Peninsular Campaign. In March 1862 McClellan moved his entire army via Chesapeake Bay to Fortress Monroe, Virginia. He then used river transports and gunboats to establish a supply depot at White House Landing on the Pamunkey River, a tributary of the York—only 20 miles (32km) from Richmond. When McClellan retreated to Harrison's Landing on the James River, Union gunboats sheltered his army's withdrawal and kept it supplied.

Most of the rivers in Virginia run west to east, while the Union armies generally advanced north to south. As a result, any invading Union force had to contend with a series of rivers, including the Rappahannock, the Rapidan, North Anna, and Pamunkey, creating major obstacles to their progress. The same rivers formed a natural line of defense for the Confederate army.

▲ *Confederate so-called "Quaker" guns—logs mounted to deceive Union forces—in the fortifications at Centreville, Virginia, March 1862.*

▼ *Confederate fortifications at Manassas, Virginia, in March 1862. Note the gun platform in the foreground.*

ARMED FORCES

THE ARMY OF NORTHERN VIRGINIA

The Army of Northern Virginia became the enduring embodiment of the Confederacy. When General Joseph E. Johnston, the commander of the Confederacy's eastern army, was wounded at Fair Oaks, Virginia, on May 31, 1862, President Davis replaced him with Robert E. Lee. Taking command on June 1, Lee renamed his force of around 70,000 men the Army of Northern Virginia.

Within a month of taking command Lee was ready to go on the offensive, a mode of warfare for which he would become famous. In the Seven Days' Campaign, a series of frequently uncoordinated and bloody attacks, Lee's army drove the Union Army of the Potomac away from Richmond. Lee then reshuffled his command, incorporating leaders and units from all the states of the Confederacy—the largest number coming from North Carolina.

He next embarked on a remarkable series of battles, a string of campaigns that saw the army march north through Virginia, winning battles at Cedar Mountain and Second Bull Run, and into Maryland. There it suffered a tactical draw at Antietam in September 1862, and Lee was forced to withdraw into Virginia. At this point he reorganized the army into a two-corps structure, with Generals Thomas J. "Stonewall" Jackson and James Longstreet as his corps commanders.

Further victories followed at Fredericksburg (December 1862) and Chancellorsville (May 1863), the latter marred by the death of "Stonewall" Jackson. By this time Lee said of his men: "There were never such men in an army before. They will go anywhere and do anything if properly led."

Following the loss of Jackson, Lee made the second major reorganization of the army, this time into three army corps, commanded initially by Longstreet, Richard S. Ewell, and Ambrose P. Hill. This reorganized army, 75,000 strong, marched into Pennsylvania, where it suffered its most important defeat at Gettysburg in early July 1863. Some 23,000 casualties, including grievous losses among the officer corps, robbed Lee's army of its offensive striking power. For the rest of the war Lee attempted limited offensives but was generally forced to fight on the defensive, reacting to his enemy's moves.

When General Ulysses S. Grant came east in 1864 to take command of all Union armies, he made his headquarters with the Union Army of the Potomac, a tacit recognition that he regarded the Army of Northern Virginia as his most dangerous opponent. The resulting Overland Campaign, from May into July 1864, was a titanic struggle. The Battles of Wilderness, Spotsylvania, North Anna, and Cold Harbor left the exhausted armies within sight of Richmond and Lee's legions shattered by more than 30,000 additional casualties, including 37 general officers. The armies shifted into siege warfare at Petersburg for the next 10 months, but the end was near. Lee's forces held out in Petersburg until early April 1865, when successive offensives by Grant's army forced Lee to evacuate the city.

Lee attempted to link up with Confederate forces in North Carolina, but was unable to escape. Grant surrounded Lee at Appomattox Court House, Virginia. On April 9, 1865, Lee surrendered 28,000 starving, ragged men. The Army of Northern Virginia was defeated, but had earned an enviable place in the annals of military history.

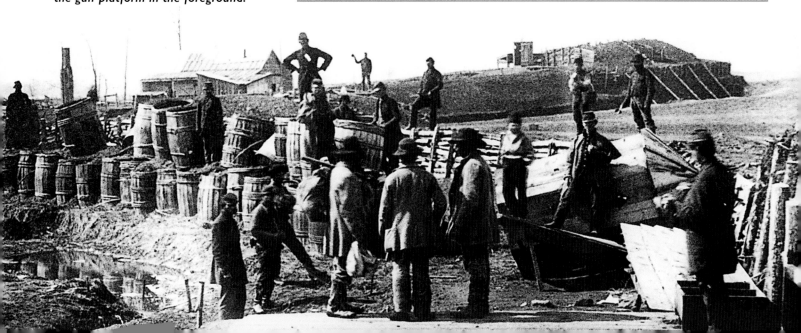

March 9

▶ *A Union battery of immense 13-inch (33cm) mortars lined up at the Siege of Yorktown, Virginia. Mortars were used to pound away at the earthworks and fortifications around towns and forts.*

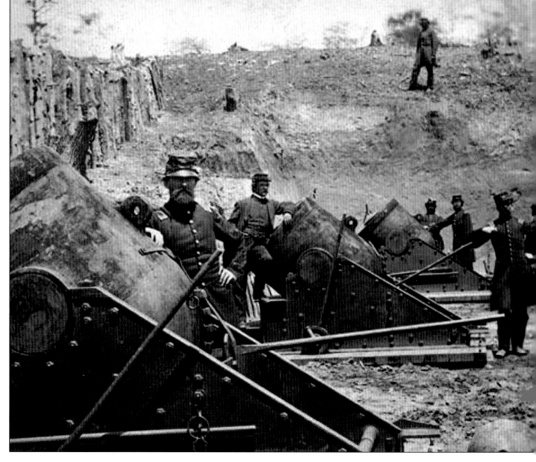

March 9

HAMPTON ROADS, *NAVAL WAR*

The Confederates, having converted a partly destroyed Union ship, the *Merrimack*, into an ironclad, with 4 inches (10cm) of iron armor plating and an iron ram mounted on its bow, and renamed it CSS *Virginia*, launched it on a trial cruise from Norfolk, Virginia, into Hampton Roads yesterday. The commanding officer, Franklin Buchanan, decided to attack Union ships blockading Chesapeake Bay. In just a few hours the *Virginia* destroyed two large Union warships, USS *Cumberland* and USS *Congress*, and damaged USS *Minnesota*. The ironclad showed that the mainly wooden and sail-powered U.S. fleet is obsolete.

This morning the *Virginia* returns to Hampton Roads to continue the battle. To the crew's great surprise, it is met by an enemy ironclad, the USS *Monitor*. Smaller than the *Virginia*, the *Monitor* features a revolving gun turret, a shallower draft, and a higher top speed, which enables it to outmaneuver the *Virginia* in the running battle that develops. The two vessels pound each other for almost four hours at close range, eventually fighting to a standstill. At nightfall the *Virginia* withdraws into the James River. It has been hit 97 times over the two days, and the *Monitor* 21 times, but neither is badly damaged. Two months later the *Virginia* was sunk by

its crew to prevent it falling into Union hands—the ironclad was trapped in the Norfolk shipyard when the Union retook it.

By fending off the *Virginia*, the *Monitor* preserved the Union blockade. Although a minor battle, Hampton Roads led to a change in naval warfare. Both sides accelerated their ironclad-building programs, though the Confederacy was unable to match the Union's ironclad production.

March 14

NORTH CAROLINA, *LAND WAR*

The Battle of New Berne. Burnside's forces from Roanoke Island capture nine forts and 41 heavy guns in an operation against Confederate fortifications at New Berne.

March 17

VIRGINIA, *LAND WAR*

General McClellan begins shipping the Union Army of the Potomac and its

▼ *Union officers on board the USS* Monitor. *Dents can be seen on the gun turret where it was hit during its duel with the CSS* Virginia.

supplies to Fort Monroe, at the tip of the Virginia "Peninsular," thus beginning the Peninsular Campaign.

March 23

VIRGINIA, *LAND WAR*

The Battle of Kernstown. Virginia's Shenandoah Valley is strategically important as a source of crops and livestock and as a route by which Confederate forces can invade the North. General "Stonewall" Jackson, as part of his mission to divert as many Union troops as possible from the Peninsular Campaign in Virginia, attacks a Union division of 9,000 men at Kernstown (Jackson has 4,500 men). Jackson loses, but Washington assumes that he would only have attacked if he outnumbered the Union force. As a

▲ *Confederate winter quarters at Manassas, Virginia. During the summer the men would sleep under canvas.*

STRATEGY AND TACTICS

RAILROADS

In August 1861 General George B. McClellan, soon to be the Union army's general-in-chief, wrote to President Abraham Lincoln: "The construction of railroads has introduced a new and very important element into war, by the great facilities thus given for concentrating … large amounts of troops from remote [locations] and by creating a few strategic points and lines of operations." He recommended that the Union army should seize these strategic points on the railroads to prevent the Confederates from concentrating their forces.

In fact the Confederates had already proved McClellan's point the previous month at the Battle of First Bull Run. Warned of an imminent Union advance on the rail center of Manassas Junction, Confederate General Pierre G.T. Beauregard sent trains west to collect reinforcements from the Shenandoah Valley. Within two days over 8,000 infantry and four batteries of artillery had arrived along Bull Run Creek to help meet the Union attack.

As the war went on, troop movements became much bigger and took place over greater distances. In July 1862 the Confederate Army of the Mississippi, under Braxton Bragg, was ordered north from Tupelo, Mississippi, to Chattanooga, Tennessee, a distance of 775 miles (1,250km). The army traveled by no less than six different railroads, taking a complicated route through Alabama and Georgia, but arrived by the end of the month to allow Bragg to launch an invasion north into Kentucky.

The ability to quickly move armies hundreds of miles produced a revolutionary change in warfare. Troops no longer needed to exhaust themselves marching across country, food and supplies could be delivered where they were needed, and the capture of major rail junctions could open up large tracts of enemy territory. The negative side to this was that armies became dependent on the railroad and had to use thousands of men to protect and maintain the lines.

An example of this came in June 1862, after Union troops had captured Corinth, Mississippi, following their victory at Shiloh. General Ulysses S. Grant's army could have advanced deeper into Mississippi but was prevented from doing so by the need to keep troops in Tennessee to protect the hundreds of miles of railroad that carried all of the army's supplies.

One of the many innovations in military technology introduced during the war was the rail gun. Heavy artillery had always been difficult to move around the battlefield because of its size and weight—a barrel weighing 7,200 pounds (3,265kg), for example, was not unusual. But in 1862 Confederates fighting the Peninsular Campaign in Virginia had the idea of putting a 32-pound (14.5kg) siege gun on a flatbed rail truck pushed by a locomotive. The idea worked, and later in 1864, during the Siege of Petersburg, the Union army used a large 13-inch (33cm) mortar mounted on a train to bombard Confederate positions.

In the same year the Union army Medical Department developed hospital trains. They were specially converted passenger cars designed to move the wounded from field hospitals to hospitals in Northern cities. They were hospitals on rails, with kitchens, dispensaries, and surgeries. The wounded were carried in bunks, while some trains could support stretchers.

In April 1862 Union General Ormsby M. Mitchel conceived a plan to advance out of central Tennessee and capture the city of Chattanooga. He would do this with the help of a daring raid into Georgia to cut the railroad south from Chattanooga to Atlanta, so making it impossible for Confederate reinforcements to reach the city.

A Union spy named James J. Andrews was to lead the raid, with 24 Union soldiers dressed in civilian clothes and armed only with revolvers. The soldiers were to rendezvous with Andrews in Marietta, Georgia, over 200 miles (320km) behind enemy lines. There they would board a train heading for Chattanooga, hijack it, and travel north, destroying rail lines, cutting telegraph wires, and burning bridges. The raid failed, though, and the plan to capture Chattanooga was canceled. The raiders were captured. Since they were dressed as civilians, Andrews and seven others were executed as spies, while the rest were imprisoned.

▶ *A railroad line ripped up by Union troops. As the war went on both sides had to deploy thousands of troops to guard railroads and rolling stock from the enemy.*

result, it will station nearly 60,000 troops to protect the valley and the region around the Union capital.

MARCH 23–APRIL 26

NORTH CAROLINA, *LAND WAR*

The Battle of Fort Macon. Burnside's North Carolina expedition places Fort Macon, 35 miles (56km) southeast of New Berne, under siege. The Confederate fort will fall on April 26.

MARCH 26–28

NEW MEXICO, *LAND WAR*

The Battle of Glorieta Pass. Union troops in New Mexico secure an important strategic victory by capturing the Glorieta Pass at the southern tip of the Sangre de Cristo Mountains.

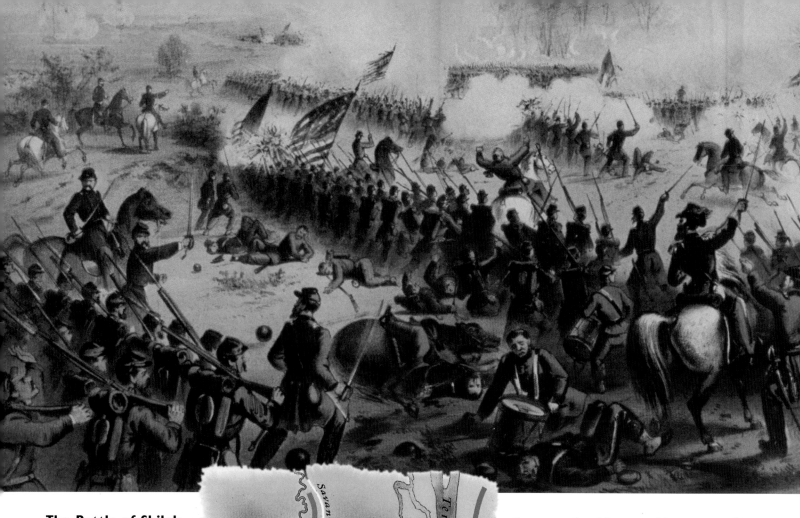

The Battle of Shiloh

General Johnston's Confederates made a surprise attack early on April 6 (1). They drove back Union troops from Shiloh Church but encountered stiff resistance at the "Hornet's Nest." In the afternoon Johnston was killed, and Beauregard took over. The Confederates pushed the Union troops back to the river by nightfall (2). During the night Union reinforcements arrived under Buell (3). On April 7 Buell counterattacked (4). The Union troops made steady progress (shown above), and in the afternoon the Confederates withdrew to Corinth.

Beauregard as his second in command. On April 3 he advanced toward Pittsburg Landing. He planned a surprise attack; but disorganization and bad weather slowed the Confederates down, and they arrived south of Grant's position on the night of April 5.

The delay did not jeopardize Johnston's plan, because Grant had not

APRIL 5–MAY 4

LAND WAR, *VIRGINIA*
The Battle of Yorktown. McClellan's march toward Richmond is stopped by Confederate works at Yorktown, behind the Warwick River. The town is placed under siege and Confederate defenders eventually retreat on May 4.

APRIL 6

TENNESSEE, *LAND WAR*
The Battle of Shiloh/Pittsburg Landing. General Ulysses S. Grant with his army of 30,000 at Pittsburg Landing, 25 miles (40km) north of Corinth, Mississippi, is attacked by General Albert S. Johnston's 45,000 men, with General Pierre G.T.

▲ *General Albert S. Johnston was wounded in the leg at the Battle of Shiloh on April 6, 1862. He ignored the wound and subsequently bled to death.*

◄ *Troops of General Buell's Federal Army of the Ohio attacking at the Battle of Shiloh on April 7.*

posted lookouts around his army. The Union soldiers have no idea they faced a Southern army until about 05:00 hours, when thousands of men in gray charge out of the woods.

The Confederates first strike the Union right, attacking William T. Sherman's division at Shiloh Church. They then attack the Union center, pushing three divisions back across Purdy Road. Southern reinforcements force Sherman's men back to the Savannah Road by 10:00 hours.

The Union right retreats, but Generals Hurlburt and Prentiss hold their ground on the center and left of the Union line in and around a peach orchard for nearly five hours. The buzzing noise of bullets gives Prentiss' position the name "the Hornet's Nest."

By early afternoon Johnston has three of his four corps in the fight. But Union resistance at the Peach Orchard and Hornet's Nest warns him that his own right flank might be threatened, so he orders forward his reserve corps. Soon afterward he is fatally wounded, and command passes to Beauregard.

As Union troops are desperately holding the line, Grant organizes reinforcements. One division advances from the north to support Sherman, and three of Buell's divisions are also on their way. The Union position comes close to collapse, and retreating soldiers crowd around Pittsburg Landing. Prentiss surrenders at about 17:30 hours. However, the Confederates are exhausted after 14 hours of fighting, and at 19:00 hours they stop to rest.

KEY PERSONALITY

GEORGE MCCLELLAN

George Brinton McClellan (1826–1885) was born in 1826 in Philadelphia. After he graduated second in his class from the U.S. Military Academy at West Point at the young age of 20, his future looked bright. He was immediately able to make his mark in the Mexican War (1846–1848). Frustrated with his slow progress within the army establishment, however, the intensely ambitious McClellan resigned his commission in 1857 to became chief of engineering for the Illinois Central Railroad. By the time the Civil War began in 1861, he was president of the Ohio and Mississippi Railroad.

At the outbreak of the war McClellan joined the Ohio Volunteers and in May 1861 was appointed a major general in the regular army (he had left it four years earlier as a captain). As commander of Union forces in the Ohio Valley, his instructions were to hold on to western Virginia (later West Virginia) for the Union. He secured the region by mid-July, having encountered little resistance, and was soon being talked up in newspapers as the "Young Napoleon of the West."

In the wake of the Union rout at First Bull Run at the end of July 1861 McClellan seemed the obvious choice to replace McDowell in command of the demoralized Union troops south of the Potomac. His first achievement was to create, name, and organize the Army of the Potomac. Throughout the winter of 1861–62 he put in 18-hour days drilling troops and boosting morale. However, he had a strange reluctance to use the superb army he had created to confront the enemy in battle.

When McClellan finally did commit his army, he proved unfit for battlefield command. Throughout the Peninsular Campaign (April–July 1862) he made repeated calls for reinforcements despite vastly outnumbering the enemy. His failure to pursue the Confederates in the aftermath of Antietam gave the president the excuse he needed to strip McClellan of command.

He challenged Lincoln for the presidency in the 1864 election but was heavily defeated and resigned from the army the same day.

APRIL 7

TENNESSEE, *LAND WAR*

The Battle of Shiloh/Pittsburg Landing. Grant stabilizes his army in the early hours. During the night Buell's divisions cross the river, artillery is concentrated above Pittsburg Landing, and gunboats fire on Confederate positions. The Federals counterattack. The Confederates lose all the ground they had won the day before and retreat to Corinth. The battle, one of the bloodiest of the conflict, cost the South 10,700 killed and wounded for no gain at all, while the North narrowly avoided defeat at a cost of 13,000 casualties.

APRIL 10–11

GEORGIA, *LAND WAR*

The Battle of Fort Pulaski. A key Union strategy is to blockade the ports of the Confederacy to strangle its economy. In

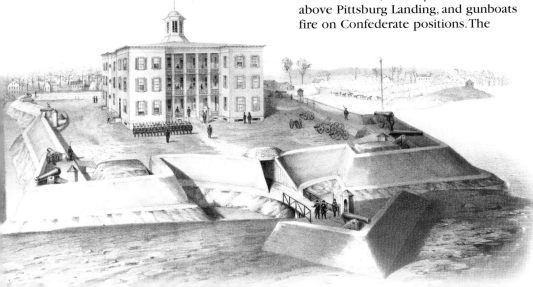

◄ *Fort Anderson, near Paducah, Kentucky, and the Union army camp of the 6th Illinois Cavalry in April 1862. The fort helped the Union to control western Kentucky, and was also a base from which to strike at Forts Henry and Donelson on the Tennessee and Cumberland rivers.*

Georgia the small ports of Darien and Brunswick are virtually unprotected and easy for the Union navy to blockade. Savannah is far better defended: any assault from the sea has to reckon with forts Walker, Pulaski, and McAllister. Today, though, Fort Pulaski falls to Union forces after a heavy bombardment from 11 batteries on nearby Tybee Island. Over two days one of the most strongly armored forts in the United States has been shattered by thousands of shells from the Union's new rifled cannon. Although the Union forces are not strong enough to assault Savannah, they can now blockade it unopposed.

APRIL 12

GEORGIA, *GUERRILLA WAR*
"The Great Locomotive Chase." The Union agent James Ambrose and 22 soldier volunteers steal a Confederate train in an attempt to destroy sections of the Western & Atlantic Railroad. The operation results in a prolonged railroad chase, but the Union insurgents were eventually captured, and James and seven others were hanged.

APRIL 16

THE CONFEDERACY, *ARMED FORCES*
The Confederacy passes the first of three conscription acts. The act enlists Southern men between the ages of 18

▶ *A recruiting poster of 1862 urging Vermont's "Green Mountain boys" to help crush the rebellion. Thousands answered the call to arms.*

and 50 and takes them from their farms. Only planters who hold public office or own at least 20 slaves are exempt from military service. As Southern men left their farms for the army, agricultural production declined. Production also suffered as slaves became increasingly reluctant to work. Slave men and women anticipated freedom.

APRIL 16–28

LOUISIANA, *RIVER WAR*
The Battle of Fort Jackson/Fort St. Philip. Union naval forces (24 gunboats and 19 mortar schooners) force a passage past Forts Jackson and St. Philip on the Mississippi to move against New Orleans. This is no easy task, for in addition to the forts themselves, the

9th Regiment.
ON TO WASHINGTON!
DOWN WITH THE REBELLION!
GREEN MOUNTAIN BOYS AWAKE!

▲ *A watercolor of the general head-quarters of the Army of the Potomac near Yorktown, Virginia. McClellan's troops occupied Yorktown on May 4.*

ARMED FORCES

THE ARMY OF THE POTOMAC

Without question the Army of the Potomac was a hard-luck outfit. In four years of combat it lost almost every major battle it fought. The army had two principal missions. Offensively, its job was to threaten the Confederate capital of Richmond, Virginia, and, in the process, to destroy the rival army protecting it. Defensively, its job was to shield Washington, D.C. Often the latter task hampered efforts to accomplish the first. Moreover, the proximity of the army to the Union capital meant that Washington politics exerted an extensive and largely negative influence over its operations.

The army's first commander was General George B. McClellan. He was also its creator, and the Army of the Potomac retained the stamp of his personality throughout the war. A story from the Battle of the Wilderness (May 5–6, 1864) illustrates the problem. On the evening of the battle's second day a report reached army headquarters that General Robert E. Lee's Army of Northern Virginia had launched a flank attack. Union General Ulysses S. Grant was traveling with the Army of the Potomac. A flustered officer approached him and said, "General, this is a crisis ... I know Lee's methods well by past experience; he will throw his whole army between us and the Rapidan [River], and cut us off completely from our communications." Grant snapped back, "I am heartily tired of hearing about what Lee is going to do. Some of you always seem to think he is suddenly going to ... land in our rear and on both of our flanks at the same time. Go back

to your command, and try to think what we are going to do ourselves, instead of what Lee is going to do."

Defensiveness remained typical of the Army of the Potomac. Even so, its troops fought valiantly in some of the war's bloodiest and most famous battles, including the Seven Days' Campaign (June 25–July 1, 1862), Antietam (September 17, 1862), Fredericksburg (December 13, 1862), Chancellorsville (May 1–6, 1863), Gettysburg (July 1–3, 1863), the Overland Campaign (May 4–June 12, 1864), and the Siege of Petersburg (June 15, 1864–April 2, 1865).

Four generals commanded the army during its career. They were McClellan, (August 20, 1861, to November 9), 1862, Ambrose E. Burnside (November 9, 1862 to January 26, 1863), Joseph Hooker (January 26 to June 28, 1863), and George G. Meade (June 28, 1863 to September 1, 1865). To this list might be added Ulysses S. Grant, who habitually made his headquarters with the Army of the Potomac and gave detailed instructions to Meade, the nominal commander.

The Army of the Potomac had three great moments. The first occurred on July 1–3, 1863, when it decisively rebuffed Lee's invasion of Pennsylvania at Gettysburg. The second took place on April 1, 1865, when it cracked open the flank of Lee's army defending the Petersburg trenches in the Battle of Five Forks. The battle set the stage for Lee's retreat from Richmond and Petersburg. The Army of the Potomac pursued, and eight days later it enjoyed a third great moment, by forcing the surrender of Lee's army at Appomattox Court House.

Confederates have placed obstructions in the river and there are a number of ships, including two ironclads, to assist in their defense. The forts surrendered on April 28.

APRIL 19

NORTH CAROLINA, *LAND WAR*
The Battle of South Mills/Camden. A Union amphibious operation to destroy the Dismal Swamp Canal locks ends

▲ *A U.S. Coast Survey map of the Potomac from Lower Cedar Point to Indian Head. Knowledge of the Potomac was critical for the defense of Washington, D.C.*

with a Union withdrawal following a heavy clash around South Mills, Camden County.

APRIL 21

VIRGINIA, *POLITICS*
The Confederate Congress passes the Confederate Partisan Ranger Act, which recognizes Southern guerrilla forces as legal military formations. The act essentially legalizes Confederate partisan warfare.

APRIL 29

LOUISIANA, *LAND WAR*
The Louisiana authorities, believing that Forts Jackson and St. Philip on the Mississippi River, 75 miles (120km) south of the city, would protect New Orleans from any Union invasion, did not retain many soldiers to protect the city itself. However, a Union fleet sailed up the river to the forts, bombarded them, and then steamed on past, losing only four ships. The forts surrendered yesterday, and New Orleans falls today with little opposition. This Union victory has opened up the rest of

▲ *Union sailors in a rowboat confront a crowd in New Orleans on April 25, 1862. The Union fleet had sailed past the two forts protecting New Orleans the previous day, so the city's surrender was inevitable.*

Louisiana and the Mississippi Valley to Union invasion, and has damaged Confederate morale.

APRIL 29–JUNE 10

MISSISSIPPI, *LAND WAR*
The Battle of Corinth. Union forces secure their positions in northern Mississippi by expelling the Confederates from Corinth after a siege action.

MAY 7

MAY 7

VIRGINIA, *LAND WAR*

The Battle of Eltham's Landing/
Barhamsville/West Point. Two brigades
of Confederates, protecting their
nearby supply trains, attack Union
forces at Eltham's Landing on the
Pamunkey River, with no clear result.

MAY 15

VIRGINIA, *RIVER WAR*

The Battle of Drewry's Bluff/Fort Dar-
ling/Fort Drewry. Five Union gunboats
probe Confederate defenses on the
James River (which leads toward
Richmond), but are forced back by
powerful gunfire from Drewry's Bluff.

MAY 15–17

WEST VIRGINIA, *LAND WAR*

The Battle of Princeton Courthouse/
Actions at Wolf Creek. Brigadier Gener-
al Humphrey Marshall's Confederate
troops defeat a Union attempt to attack
the East Tennessee & Virginia Railroad.

MAY 23

VIRGINIA, *LAND WAR*

The Battle of Front Royal/Guard Hill/
Cedarville. The Union commander in the
Shenandoah Valley, Nathaniel P. Banks,
had by late April advanced as far as
Harrisonburg. Then Jackson attacked

▼ *Lines of cavalry, infantry, and artillery
at the opening of the Battle of Hanover
Court House on May 27, 1862. This Union
victory cost the Confederates 930
casualties; Federal losses were 397.*

and defeated a Union force at McDowell
on May 8. His army was increased to
17,000 by the addition of Richard S.
Ewell's division. With this combined
force Jackson launches an attack at
Front Royal today, threatening Banks'
supply line and forcing him to retreat.

MAY 25

VIRGINIA, *LAND WAR*

The Battle of Winchester/Bowers Hill.
Winchester lays directly on an invasion
route that either the Confederacy or
the Union might use for flanking move-
ments around Washington, D.C., or
Richmond, and it offers an entry into

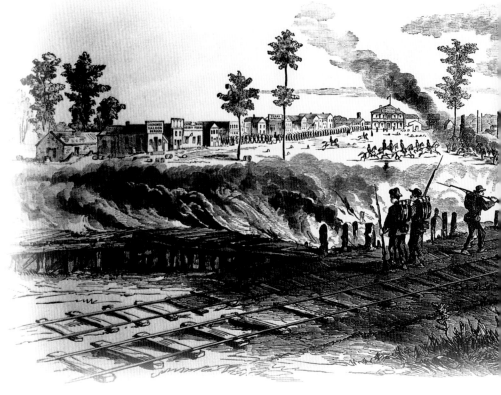

▲ *Confederate troops, having burned
what they could, evacuate the rail center
of Corinth, Mississippi, in May 1862. The
Union's capture of Corinth cut the
Confederacy's east–west railroad link.*

the Shenandoah Valley. The First Battle
of Winchester takes place today on the
hills southwest of the town. General
Thomas J. "Stonewall" Jackson's
Confederates attack Union General
Nathaniel P. Banks' troops so fiercely
that they break ranks and flee north.
Union losses are 2,019, compared to
400 Confederates. The latter have
relieved the pressure on Richmond.

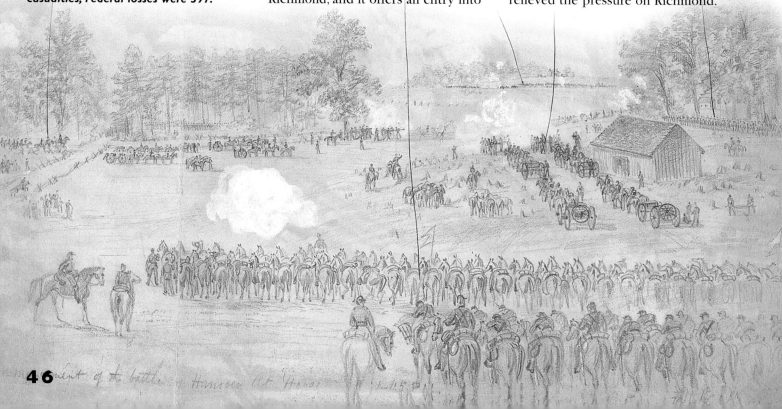

MAY 27

VIRGINIA, *LAND WAR*

The Battle of Hanover Court House/ Slash Church. Union troops under Brigadier General Fitz John Porter, driving towards the Telegraph Road in Hanover County, inflict 930 casualties on Confederates in a battle south of Hanover Court House.

MAY 31

VIRGINIA, *LAND WAR*

The Battle of Seven Pines/Fair Oaks Station. McClellan's Union Army of the Potomac has advanced up the Virginia peninsular and reached the outskirts of Richmond. McClellan has divided his army, positioning two corps south of the Chickahominy River and three corps to the north, where they can join with Union forces advancing from Fredericksburg.

Confederate leader Joseph E. Johnston sees the chance to strike while the Union army is divided. He has 75,000 troops

▶ *A poster protesting against Union General Benjamin Butler's Order 28. Butler, the occupying commander in New Orleans, ordered that any woman who insulted Union troops was to be treated as a prostitute.*

KEY PERSONALITY

BELLE BOYD

Belle Boyd (1844–1900) was born Maria Isabela Boyd in Martinsburg, Virginia (now West Virginia), in 1844. When the town was occupied by Union forces in 1861, the 17-year-old Belle charmed and befriended the officers. Posing as an innocent, she carefully noted down unguarded comments about troop movements and plans, and smuggled them out by messengers to Confederates in the field. Showing her Confederate heart and mettle, she shot dead a drunken Union soldier who barged into the family home and was attempting to raise the Stars and Stripes over the house. She was tried but acquitted, and the vivacious young Belle continued to be a favorite with the Union officers.

Belle's most famous contribution to the Confederate cause came in May 1862, when she was staying at her father's hotel at Front Royal in Warren County. She discovered that a knothole in her bedroom floor allowed her to eavesdrop on Union officers in the parlor below. One night she overheard them discussing a plan to blow up key bridges around Front Royal in order to thwart an imminent attack by Confederates led by General Thomas "Stonewall" Jackson. Belle jumped on a horse and rode 15 miles (24km) through Union positions to inform Jackson, who responded by beginning his attack early. Front Royal fell to Jackson, and the general wrote to Belle: "I thank you, for myself and for the army, for the immense service that you have rendered your country today." He also made her an honorary member of his staff, with the rank of captain.

In 1862 Belle was arrested but released a month later as part of a prisoner exchange. In 1863 she was imprisoned once again and, this time, released suffering from typhoid. In 1864 she took refuge in England. When her ship was captured by the Union, Belle charmed a Union naval officer, Sam Hardinge, into helping her. He was court-martialed and discharged, and the two later married in England.

In 1865 Belle published her memoirs, *Belle Boyd in Camp and Prison*. In England she became an actress and then made her American stage debut in 1868. She continued her life on stage as a lecturer, entertaining audiences with her experiences.

available, while there are only 31,500 troops in the two Union corps south of the river under generals Erasmus D. Keyes and Samuel P. Heintzelman.

Johnston planned to advance in four columns along the three roads that converged at Keyes' isolated position at Seven Pines. The plan was tactically sound, but Johnston made a mistake in issuing his orders orally, resulting in confusion and delay. In addition, heavy rain turned the area into a quagmire.

Today, Confederate General Longstreet takes

his troops along a road that has been assigned to other divisions, creating more chaos in the army's coordination and weakening the assault. Even after a six-hour delay only six of the 13 Confederate brigades are in position when the battle begins. Nevertheless, a Confederate assault pushes back Union troops to a third defensive line by evening. At about 19:00 hours Johnston is seriously wounded, and command falls to General Gustavus W. Smith.

Smith renewed the Confederate attack on June 1 with a series of poorly orchestrated assaults, which were repulsed. President Davis replaced Smith with Robert E. Lee, who immediately ordered a general withdrawal. The outcome of the battle was inconclusive. The Confederates suffered 6,150 casualties and the Union about 5,050 casualties.

BUTLER'S PROCLAMATION

An outrageous insult to the Women of New Orleans!

Southern Men, avenge their wrongs !!!

Head-Quarters, Department of the Gulf,
New Orleans, May 15, 1862.

General Orders, No. 28.

As the Officers and Soldiers of the United States have been subject to repeated insults from the women calling themselves ladies of New Orleans, in return for the most scrupulous non-interference and courtesy on our part, it is ordered that hereafter when any Female shall, by word, gesture, or movement, insult or show contempt for any officer or soldier of the United States, she shall be regarded and held liable to be treated as a woman of the town plying her avocation.

By command of Maj.-Gen. BUTLER,
GEORGE C. STRONG,
A. A. G. Chief of Stables

STRATEGY AND TACTICS

THE PENINSULAR CAMPAIGN

President Abraham Lincoln wanted an offensive straight through northern Virginia, but the commander of the Army of the Potomac, George B. McClellan, suggested exploiting the Union navy's control of the coast by transporting troops from the Potomac River down Chesapeake Bay to the Union-held Fort Monroe on the tip of the Virginia peninsular between the James and York rivers. The Union army would then be only 75 miles (120km) from Richmond, and could be kept supplied by sea.

Lincoln reluctantly agreed to the plan, but was concerned that Washington would be left undefended. By the end of March Confederate "Stonewall" Jackson was active in the Shenandoah Valley, which alarmed the Union authorities. Although McClellan intended to leave enough troops to defend the capital, Lincoln withdrew a whole corps from McClellan's command to remain in northern Virginia. This was the beginning of the breakdown in the relationship between McClellan and Lincoln's government that adversely affected the Peninsular Campaign.

The Army of the Potomac embarked on March 17, and by April 1 McClellan had over 60,000 men and 100 guns at Fort Monroe, with another 40,000 men on the way. The Confederates reacted quickly. General John B. Magruder, who was responsible for the defense of the peninsular, hastily built two defensive lines between the York and the James, and fooled McClellan into believing that his force of 13,000 was much larger by carrying out a series of deceptive maneuvers.

Faced with the Yorktown defenses, Mc-Clellan stalled his advance. He became convinced that he faced a Confederate army of at least 100,000; and instead of sweeping Magruder aside and racing for Richmond, he laid siege to Yorktown.

Despite telegrams from Lincoln urging him to advance, McClellan spent a month besieging Yorktown, during which time General Joseph E. Johnston came south with his army and reinforced Magruder. There were now 75,000 Confederates on the south bank of the Chickahominy River a few miles east of Richmond. now commanded by Johnston. He ordered Magruder to evacuate Yorktown. Magruder retreated on May 4, and at last Mc-Clellan began to advance, taking Williamsburg on May 5 as Johnston pulled his forces back toward Richmond.

By the end of May the armies faced one another around the villages of Fair Oaks and Seven Pines near the flooding Chickahominy, which would play a vital part in the coming battles. McClellan divided his army, concentrating 60,000 men on the north side of the river and leaving 31,500 on the south side. Communications between the two wings of the army were poor because there were few bridges.

On May 31 Johnston launched an attack on McClellan's southern wing. The attack was poorly executed, and by the end of the day the Union forces still held the ground, despite losing 5,050 men. The Confederates suffered 6,150 casualties, including Johnston, who was so badly wounded that on June 1 General Robert E. Lee took command of the Confederate army. Lee ordered an immediate withdrawal.

For the next two weeks, in torrential rain, both sides consolidated their positions. Lee ordered his new command, which he named the Army of Northern Virginia, to dig in and strengthen Richmond's defenses as he planned his first offensive. McClellan meanwhile was preparing to attack Richmond with heavy artillery, once again relying on siege tactics.

On June 12 Lee sent cavalry commander J.E.B. Stuart and 1,200 men to find out McClellan's exact location. Stuart led his men on a three-day ride around the Union army and was back in Richmond on June 15. He reported that McClellan had moved four corps south of the Chickahominy, leaving only one corps on the north bank near Mechanicsville, protecting the Union supply base at White House Landing on the Pamunkey River.

This corps and supply base were the target of Lee's first attack. The Battle of Oak Grove on June 25 was the first of the Seven Days' Campaign. Union forces were pushed back but held onto a position north of the Chickahominy, only to be attacked again on the 27th at Gaines' Mill, forcing their withdrawal south of the river.

McClellan, with his left flank now also under pressure from Lee, chose to abandon White House and any idea of attacking Richmond. On the 27th he ordered his forces to retreat south toward the James and the protection of Union gunboats at Harrison's Landing. The remaining battles of the Seven Days' Campaign were Union rearguard actions that frustrated Lee's attempts to coordinate his army into delivering a killer blow. By July 2 McClellan's army was safe back at Harrison's Landing—the Peninsular Campaign had failed.

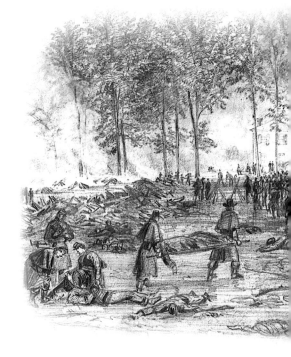

JUNE 5

NORTH CAROLINA, *LAND WAR*
The Battle of Tranter's Creek. Confederate and Union regiments clash around Tranter's Creek, Pitt County, during a Union reconnaissance. The clash ends in a Confederate retreat. Total casualties are 40, including the Confederate commander, Colonel George Singletary.

JUNE 6

TENNESSEE, *NAVAL WAR*
The Battle of Memphis, part of the Union's continuing struggle for the

▲ *Aeronaut Thaddeus Lowe makes an ascent in his balloon* Intrepid *to observe the Battle of Fair Oaks (Seven Pines).*

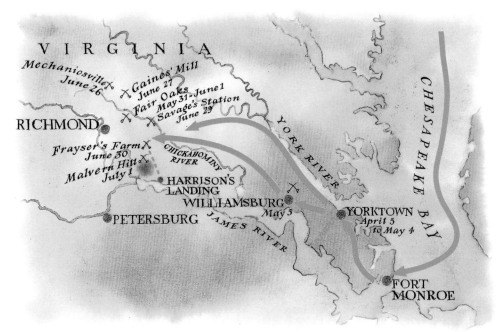

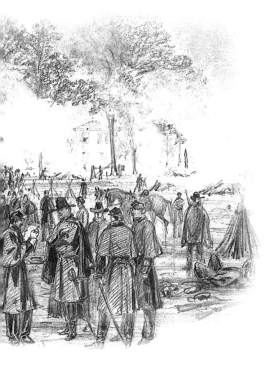

▲ *Union soldiers burying their dead comrades and burning the dead horses following the Battle of Fair Oaks (Seven Pines) on June 3, 1862.*

heartland of Tennessee. After the Confederate River Defense Fleet, commanded by Captain James E. Montgomery and Brigadier General M. Jeff Thompson (Missouri State Guard), mauled the Union ironclads at Plum Run Bend, Tennessee, on May 10, 1862, they retired to Memphis. Confederate General Beauregard ordered

troops out of Fort Pillow and Memphis on June 4 following Union Major General Henry W. Halleck's occupation of Corinth, Mississippi. Thompson's few troops, camped outside Memphis, and Montgomery's fleet were the only force available to meet the Union naval threat to the city.

Union Flag Officer Charles H. Davis and Colonel Charles Ellet launch a naval attack on Memphis after 04:00 hours today. Arriving off Memphis at 05:30 hours, the battle starts. After 90 minutes the Union boats sink or capture all but one of the Confederate vessels; *General Van Dorn* escapes. Union casualties are one, Confederate losses are 180. After the battle Union colors are raised over Memphis as the city

▲ **The Peninsular Campaign**
The Union Army of the Potomac led by George B. McClellan landed on the Virginia peninsula at Fort Monroe on March 17. McClellan besieged Yorktown for a month from early April, then took Williamsburg on May 5. The Confederates attacked at Fair Oaks on May 31 and June 1, but the Union army held its ground. After the Seven Days' Battles, fought near Richmond between June 25 and July 1, the Union army was forced to retreat to Harrison's Landing on the James River, ending the Union's Peninsular Campaign.

surrenders. The Indiana Brigade under Colonel G.N. Fitch occupies the city. Memphis, an important commercial and economic center on the Mississippi River, has fallen, opening another section of the river to Union shipping.

JUNE 7–8

TENNESSEE, *LAND WAR*
The Battle of Chattanooga. Union forces launch a two-day bombardment of the Confederate defenses around Chattanooga, after which the Union forces withdraw.

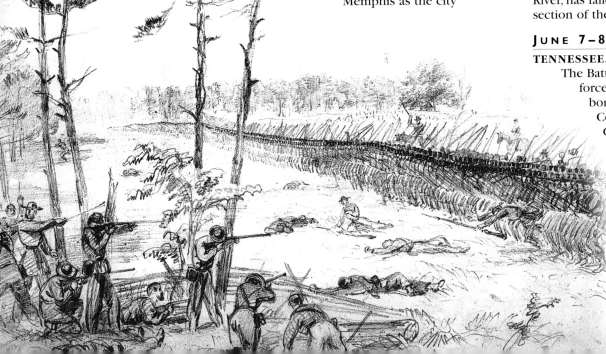

◀ *A bayonet charge of Union troops at the Battle of Fair Oaks (Seven Pines), Virginia, in June 1862. Rifled muskets and artillery made such frontal assaults without any cover suicidal.*

JUNE 8

VIRGINIA, *LAND WAR*

The Battle of Cross Keys. Jackson's Confederates were at Port Republic, a town at the southern end of the Massanutten mountain range. Union General John C. Frémont (10,500 men) was marching toward Jackson on the west side of the mountains, while Union General James Shields (10,000 men) was approaching down the east side.

Jackson sent General Richard S. Ewell's three brigades (5,000 men) to confront Frémont while he held off Shields. Ewell posted his men in a good defensive position on a ridge overlooking fields near the town of Cross Keys.

Frémont's troops approach Ewell's position and an artillery duel begins at 10:00 hours and continues until almost noon, when a Union brigade attacks the Confederate right. Here, General Isaac R. Trimble's brigade repulses it with only a few volleys of rifle fire. Then Trimble decides to attack a Union battery half a mile away. The battery escapes, but Trimble's charge carries him a mile away from Ewell. Though the Confederates are now vulnerable, Frémont does not exploit their weakness. However, Ewell decides against advancing further and holds his position. Union casualties at the battle are 684, the Confederates only 288.

KEY PERSONALITY

"JEB" STUART

Born on February 6, 1833, in Virginia, James E. B. "Jeb" Stuart (1833–1864) served with the 1st U.S. Cavalry Regiment in Kansas and Texas before the Civil War. In April 1861 he resigned his commission to join the South.

In July 1861, as a colonel of the 1st Virginia Cavalry, Stuart led a charge that greatly helped the Confederate victory at the First Battle of Bull Run. Promoted to brigadier general, he carried out scouting duties during the Peninsular Campaign, giving General Robert E. Lee valuable information about the positions of the Union forces.

His most famous exploit was his raid in June 1862 around Union General George B. McClellan's 100,000 troops camped outside Richmond, Virginia. On the three-day raid his 1,200 men rode 100 miles (160km), capturing 165 men and 260 horses. Following this raid, Stuart was promoted, at age 28, to major general in charge of all cavalry in the Army of Northern Virginia.

Later that summer Stuart raided the headquarters of Union General John Pope during the the second Bull Run campaign, making off with one of Pope's uniforms and some important documents. In October of that year he made a second raid around McClellan at Chambersburg, Pennsylvania.

In June 1863 Stuart went on a raid in Pennsylvania and lost touch with the main army, depriving Lee of crucial intelligence in the runup to the Battle of Gettysburg (July 1–3). He did not arrive until the second day of the battle. Harshly criticized for his actions, Stuart kept in close touch with Lee throughout the fall, while continuing to harass Union troops. On May 11, 1864, Stuart's cavalry encountered Union cavalry at Yellow Tavern, outside Richmond. In the ensuing clash Stuart was shot and died the next day.

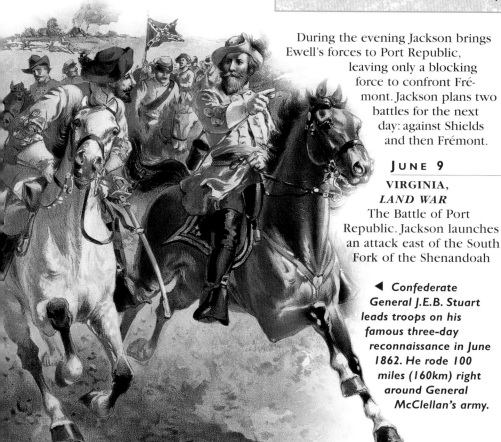

During the evening Jackson brings Ewell's forces to Port Republic, leaving only a blocking force to confront Frémont. Jackson plans two battles for the next day: against Shields and then Frémont.

JUNE 9

VIRGINIA, *LAND WAR*

The Battle of Port Republic. Jackson launches an attack east of the South Fork of the Shenandoah

◀ *Confederate General J.E.B. Stuart leads troops on his famous three-day reconnaissance in June 1862. He rode 100 miles (160km) right around General McClellan's army.*

against the isolated brigades of Tyler and Carroll of Shields' division, under the command of Brigadier General Erastus Tyler. Frontal assaults are repulsed with heavy casualties, but an attack against the Union left flank has more success. Union counterattacks fail to reestablish the line, and Tyler is forced to retreat. Confederate troops at Cross Keys march to join Jackson at Port Republic, destroying the North River Bridge behind them. Frémont's army arrives too late to assist Tyler and Carroll and is cut off across the rain-swollen river. The defeats at Cross Keys and Port Republic force a Union retreat, leaving Jackson in control of the upper and middle Shenandoah Valley. This means his army is free to reinforce Lee before Richmond.

JUNE 12

VIRGINIA, *LAND WAR*

One of the most spectacular cavalry raids takes place when J.E.B. Stuart, a Confederate brigadier general and

General Robert E. Lee's cavalry chief, takes 1,200 men on a daring three-day ride around Union General George B. McClellan's army encamped on the Virginia Peninsular outside Richmond.

Stuart wakes his cavalrymen at 02:00 hours and orders them to be in the saddle in 10 minutes. In all, the Confederates ride 100 miles (160km) around the 100,000-strong Union army, taking prisoners, plundering supplies, and sabotaging railroad tracks. Stuart also brings back valuable information to Lee about the position of McClellan's army. During the entire raid he loses only one of his men and one piece of artillery. The ride ends on June 15.

The raid is hailed as an example of Southern dash and courage, boosting Confederate morale and enhancing Stuart's reputation. One of his staff officers recalls, "Everywhere we were seen, we were greeted with enthusiasm. General Stuart's name was praised and celebrated in every manner."

JUNE 16

SOUTH CAROLINA, *LAND WAR*
The Battle of Secessionville/Fort Lamar/James Island. In the campaign for Charleston, Brigadier General Henry Benham launches an unsuccessful attack against the Confederate defenses at Fort Lamar, Secessionville.

JUNE 17

ARKANSAS, *RIVER WAR*
The Battle of Saint Charles. A Union gunboat and resupply force heading up the White River engages Confederate

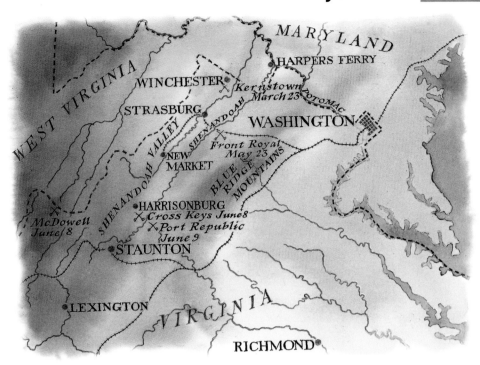

▲ The Shenandoah Valley

Confederate General "Stonewall" Jackson's campaign in the Shenandoah Valley in spring 1862 had the aim of tying up as many Union troops as possible, a strategic diversion to draw strength from McClellan's advance on Richmond (the Peninsular Campaign). The Shenandoah Valley was important to the Confederacy as a source of provisions and as a route for invading the North. It was less important to the Union: the Valley was not a suitable invasion route. Nevertheless, it was important for Washington to deny its use to the enemy. During the campaign Jackson moved up and down the valley at great speed, confusing the Union command as to his strength and whereabouts. His army of 17,000 outmaneuvered three Union forces with a combined strength of 64,000. He won five battles—Front Royal, McDowell, First Winchester, Cross Keys, and Port Republic— between May 8 and June 9, 1862.

◀ *Union troops of the 5th Ohio Infantry enter Memphis on June 6, 1862, the day the city fell to the Union following a naval battle on the Mississippi, which was watched by the civilian population from the bluffs overlooking the river.*

STRATEGY AND TACTICS

BRITISH AND FRENCH NEUTRALITY

The Confederacy's main aim was to achieve diplomatic recognition as a sovereign power. At the outset of the war the Confederate government believed that Britain would intervene in the conflict on its behalf. This faith turned out to be misplaced. The principal reason for this early conviction was the British textile industry's reliance on raw cotton grown in the American South.

By 1860 the textile industry was by far the largest industry in Britain and dwarfed textile manufacturing elsewhere in the world. There were 30 million spindles in British cotton mills devouring raw cotton, three-quarters of which came from the American South. The Confederacy was confident that Britain would never allow its textile industry to be throttled by a Union blockade. A journal representing the views of textile workers claimed that millions would starve if England did not break the Union blockade. British Prime Minister Lord Palmerston agreed with his foreign secretary, Lord John Russell, that they could not allow "millions of our people to perish to please the Northern states."

The first Confederate diplomatic mission arrived in London in May 1861. The three-man delegation was led by William L. Yancey of Alabama, and it was cordially received by Russell. When, almost immediately afterward, the British government declared neutrality and granted the Confederacy the status of a belligerent power, Yancey's hopes were high. France, the South's other big cotton customer, swiftly followed Britain's lead, and other European powers fell into line.

To be recognized as a belligerent was not the same thing as to be recognized as an independent nation, but by the terms of international law belligerent status brought important practical benefits. It meant that the Confederacy could raise loans and arms abroad, which it set about doing. Confederate agent James D. Bulloch traveled to Britain to contract for warships. The subsequent work of private British shipyards in supplying warships to the Confederacy was a matter of ongoing friction between Britain and the Union during the war.

That said, the British government was determined not to be maneuvered into a confrontation with the Union. Palmerston, in his mid-70s, had been in and out of government for more than half a century. Far from being in his dotage, however, "Old Pam" was famed for the cunning way he promoted his country's interests. Russell, a past and future prime minister, was as wily as Palmerston. They may have been sympathetic to the Southern cause and as concerned as they claimed to be about unemployed mill workers, but they cared far more about safeguarding Britain's international position. The surest way to do this, as Russell said in May 1861, was to "Keep out of it!"

The second problem that bedeviled Confederate diplomacy was at least partly of the South's own making. The Confederates placed too much confidence in the power of "King Cotton." Southern newspapers threatened "the bankruptcy of every cotton factory in Great Britain and France" unless recognition was granted. To force the issue, Southerners implemented an unofficial embargo on cotton exports. In 1862, the first full year of war, British imports of Southern cotton totaled around 3 percent of 1860 levels. British mills lasted for a time on prewar supplies of Southern cotton.

By 1862 the British and French textile industries were beginning to suffer from the shortage of raw cotton, and there was considerable agitation to do something to alleviate the situation. On the surface this played into Southern hands. All Britain had to do was break the Union blockade. However, under international law, if a blockade was successful, then it had a firm legal standing. By contrast, if it was poorly enforced and easily evaded, then there was no obligation to respect it. Southerners were quick to point out that blockade-runners (many of them privately owned British merchant ships) managed to evade the blockade every day. However, this amounted to an admission that the Confederacy was willfully holding back cotton. The last thing Confederate diplomats could do was admit to an embargo, since Russell had already declared that Britain would never submit to commercial blackmail. So the Confederacy was left unable to mount a convincing case against the legality of the blockade. Britain, meanwhile, was able to alleviate its cotton shortage by turning to new sources of supply in Egypt and India.

Finally, events on the battlefield undermined Confederate foreign policy. As late as September 1862, the two key Confederate diplomats, James Mason in London and John Slidell in Paris, were confidently looking forward to a breakthrough on the recognition issue. The reason for their confidence was a series of Confederate victories that summer that had culminated in General Robert E. Lee's long-anticipated invasion of the North. By now it was plain that Britain and France would only climb off the fence when the war's outcome was assured. Lee's imminent victory would surely, therefore, be rewarded by recognition. But Lee's invasion was halted at the Battle of Antietam (Sharpsburg) on September 17.

Antietam gave President Abraham Lincoln the opportunity to issue his preliminary Emancipation Proclamation, in which he declared all slaves in areas under rebellion free as of January 1, 1863. In neither France nor Britain was there any support for the institution of slavery. The British were very proud of having outlawed it across their vast empire in 1834 and of having used the power of their navy to suppress the African slave trade.

Southerners had portrayed the struggle as a fight for freedom against an enemy that would not let them secede peacefully. The Union's original position backed up this claim. Lincoln had made it clear that the war was about preserving the Union, not about ending slavery. Before Lincoln's proclamation, therefore, Europeans had seen the war as being almost entirely an issue of Southern independence. With the Emancipation Proclamation the nature of the war changed, and the tide of opinion began to move against the slaveholding South.

▲ *Union Secretary of State William H. Seward entertaining foreign dignitaries in New York State during the war. Seward is seated third from right.*

batteries at Saint Charles. One Union ship is blown apart, but a Union assault by the 46th Indiana Infantry on shore captures the batteries.

JUNE 21

SOUTH CAROLINA, *LAND WAR*
The Battle of Simmon's Bluff. The Union's 55th Pennsylvania Regiment

▼ *Union engineering troops building a corduroy road (logs laid side by side to facilitate movement over mud) near Richmond, Virginia, during the Peninsular Campaign in June 1862.*

conducts a raid to cut the Charleston & Savannah Railroad. The railroad remains uncut, but Confederate troops in the area are displaced.

JUNE 25

VIRGINIA, *LAND WAR*
The Battle of Oak Grove/ French's Field/King's School House. In the first of the Seven Days' Battles (a one-week Confederate counter-offensive near Richmond), General McClellan's Union advance in Henrico County is blunted.

◄ *This rough sketch by a Civil War-era newspaper artist shows Union artillery in action at the Battle of Beaver Dam Creek. In the afternoon, Hill's Confederate corps attacked a Pennsylvania division of 36 cannon frontally and suffered heavy losses.*

JUNE 26

VIRGINIA, *LAND WAR*
The Battle of Beaver Dam Creek/ Mechanicsville/Ellerson's Mill. When General Robert E. Lee took command of Confederate forces outside the Confederate capital of Richmond earlier this month, he faced an enormous strategic problem. His 70,000 men faced a Union army of more than 100,000 men under George B. McClellan. Lee's army, which he had named the Army of Northern Virginia, was entrenched just outside the capital—within sight of the city's spires. With characteristic audacity Lee decided that offense was the best way to relieve Union pressure and began a series of attacks—known as the Seven Days' Campaign (June 25–July 1).

Lee ordered Stuart to conduct a cavalry reconnaissance, which reported

▲ *An illustration from Harper's Weekly of June 14, 1862, showing the starving citizens of New Orleans being fed by the Union military authorities after they had captured the city.*

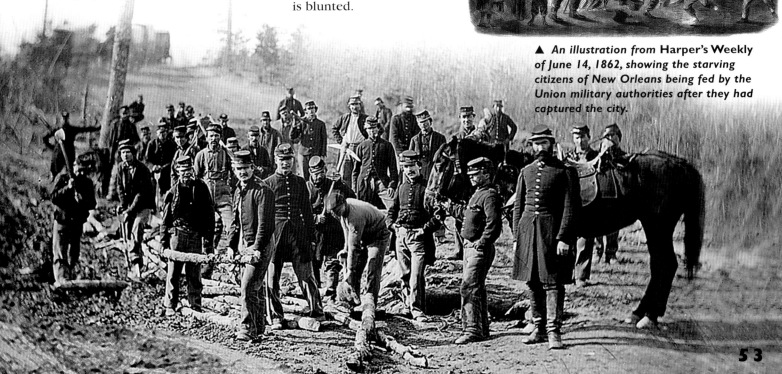

that McClellan had moved four corps south of the Chickahominy, leaving only one corps on the north bank near Mechanicsville, protecting the Union supply base at White House Landing on the Pamunkey River. Lee planned to attack the right flank of McClellan's Army of the Potomac, V Corps under Fitz John Porter, which was separated from the rest of the Union army by the rain-swollen Chickahominy River.

The Battle of Mechanicsville today is the second of the Seven Days' Campaign. Confederate General A.P. Hill attacks with his division, reinforced by one of D.H. Hill's brigades, against Porter's V Corps deployed behind Beaver Dam Creek. Confederate attacks are driven back with heavy casualties. Jackson's Shenandoah Valley divisions,

▲ *Richmond's Southern Illustrated News was set up in 1862 to rival the North's illustrated papers. It had some 20,000 subscribers.*

however, are approaching from the northwest, forcing Porter to withdraw the next morning to a position north of the Chickahominy. The battle is a Union victory, the Confederates losing 1,300 men, the Federals 400.

JUNE 27

VIRGINIA, *LAND WAR*
The Battle of Gaines' Mill/First Cold Harbor. Porter's corps, now the Union army's rearguard, takes up a strong position on high ground by a swampy tributary of the Chickahominy River named Boatswain's Creek. The troops

▼ *Union forces destroying a railroad bridge over the Chickahominy in June 1862. The bridge was fired and the train was loaded with ammunition.*

ARMED FORCES

SHARPSHOOTERS
Sharpshooters played a vital role in the Civil War. The fear of their expert marksmanship had a strong psychological effect on their enemies. They were organized into special units that could operate independently of large units, performing scouting and skirmishing duties.

At the outbreak of war both Union and Confederate armies formed sharpshooter battalions and regiments. The most famous was the 1st U.S. Sharpshooters, formed by New Yorker Hiram Berdan in November 1861. Recruits had to pass a difficult shooting test in which they had to fire 10 bullets into a 10-inch (25cm) circle 200 yards (180m) away. Berdan's Sharpshooters took part in all the

campaigns of the Army of the Potomac, exhibiting both bravery and skill.

In July 1862 the Confederate Congress authorized the formation of sharpshooter battalions within standard infantry brigades. Brigade commanders could handpick men from each regiment for this demanding and risky duty. Because of the extra training involved, they were often exempted from standard camp duties; in combat they served as advance and rearguards on the march and as skirmishers once fighting began. Confederate sharpshooters had to be able to hit a man-sized target at 600 yards (550m). Sharpshooters in both armies were usually equipped with specialized rifles, frequently with telescopic sights.

▲ *The Battle of Gaines' Mill, June 27. This Confederate victory forced McClellan to abandon his advance on Richmond during his ill-fated Peninsular Campaign.*

are positioned between Cold Harbor and Mr. Gaines' farm and mill, which gives the ensuing battle its name.

Lee's forces now include the small corps of Thomas J. "Stonewall" Jackson, which includes the Texas Brigade led by John Bell Hood. As at Mechanicsville, Lee has problems coordinating assaults, and several attempts to take the strong Union position fail. Nearing sunset, however, a bold frontal attack by the Texans succeeds in breaking through the Union position, and at nightfall

KEY PERSONALITY

ROBERT E. LEE

Born into a prominent Virginia family on January 19, 1807, Robert Edward Lee (1807–1870) was the son of General "Light Horse Harry" Lee, one of George Washington's subordinates in the American Revolution. An appointment to the U.S. Military Academy at West Point in 1825 set the course of Lee's life. He flourished at West Point and graduated second in his class in 1829 with the distinction (held to this day) of being the only Academy graduate to finish without a single demerit for misconduct. After West Point he was commissioned into the prestigious Corps of Engineers.

In June 1830 Lee married Mary Ann Randolph Custis, which connected him by marriage to the family of George Washington (Mary was the daughter of Martha Washington's grandson) and cemented his position in the Virginia aristocracy. The marriage produced seven children.

At the outbreak of the Mexican War (1846–1848) Lee accompanied General Winfield Scott's expedition to Vera Cruz in Mexico, earning battlefield distinction for scouting and staff work. He was promoted for bravery on three occasions and returned to the United States in 1848 as one of the nation's premier young officers. Lee served for three years as the superintendent of West Point and in 1855 received a permanent promotion to lieutenant colonel. Transferred to Texas, he served as second-in-command of a cavalry regiment until the outbreak of the Civil War in 1861. Scott called Lee to Washington, D.C., and on April 18 offered him command of the United States' armies.

However, when Virginia joined the Confederacy in April, he reached the agonizing, but for him unavoidable, decision to resign from the U.S. Army. Lee was immediately placed in command of Virginia's army and navy. When Virginia's forces came under the control of the Confederate government, Lee was appointed brigadier general, one of the five original Confederate general officers.

After an unsuccessful field command in western Virginia and an inspection tour of coastal fortifications in South Carolina and Georgia, Lee returned to Richmond to become chief military advisor to President Jefferson Davis. After Joseph E. Johnston was wounded in fighting against an advancing Union army, Lee assumed command of Confederate forces defending Richmond. His creation of the Army of Northern Virginia in June 1862 cemented his path to military glory.

In June 1862 Lee immediately took the initiative, defeating the Army of the Potomac in the Seven Days' Battles and thus saving Richmond. After dealing with McClellan, he turned his attention to John Pope's Union Army of Virginia, crushing it at the Second Battle of Bull Run. He suffered a tactical stalemate at the hands of McClellan at the Battle of Antietam on September 17 and had to retreat back to Virginia. Lee then dealt the Union stinging defeats at Fredericksburg (December 1862) and Chancellorsville (May 1863). His aggressive methods continued to result in victories, but at a high cost in casualties the army could ill afford.

Ever mindful of growing Union numerical superiority and the limits of Confederate manpower and resources, Lee determined once again to invade Northern territory in June 1863. At Gettysburg on July 1–3 he suffered a major defeat, an expensive setback that forever robbed the Army of Northern Virginia of its offensive striking power.

From May 1864 Lee waged a titanic campaign against the adversary who finally defeated him, Union General Ulysses S. Grant. Lee eventually surrendered at Appomattox Court House on April 9, 1865.

For the rest of his life Lee served as an example of reconciliation for all Americans, working to heal the wounds of civil war. He was elected president of Washington College in Lexington, Virginia, in August 1865. After his death in 1870 Lee was mythologized by Southern "Lost Cause" advocates, but he is also loved and honored worldwide as both a great soldier and a good man.

JUNE 27–28

The Seven Days' Campaign ▶

The Union Army of the Potomac was only a few miles outside the Confederate capital, Richmond, when Confederate General Robert E. Lee seized the initiative and attacked an isolated Union corps north of the Chickahominy River on June 26 at Mechanicsville. In the next few days Lee's Army of Northern Virginia fought McClellan's army at Gaines' Mill, Savage's Station, Frayser's Farm, and Malvern Hill, as well as in numerous skirmishes. McClellan, his army becoming more and more demoralized, gave up his attempt to besiege Richmond and retreated to Harrison's Landing on the James River. Richmond was safe for the moment, and away from the battlefield reports of Lee's and Jackson's achievements began to sway European opinion behind the Confederacy.

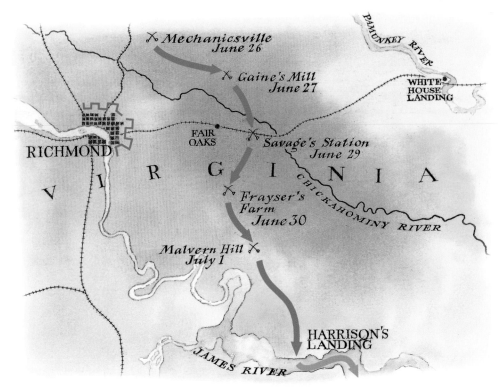

Porter's corps joins in the Union army's general withdrawal. At a cost of 8,750 casualties (Union loses are 6,800) Lee has earned his first battlefield victory of the Civil War. The battle also cements the reputation of Hood's Texas Brigade as an accomplished and successful unit.

JUNE 27–28

VIRGINIA, *LAND WAR*

The Battle of Garnett's Farm/Golding's Farm. Union and Confederate forces make a largely inconclusive exchange of fire south of the Chickahominy River near Golding's Farm.

JUNE 29

VIRGINIA, *LAND WAR*

The Battle of Savage's Station. Part of the Seven Days' Battle, the main body of the Union army, under Major General Edwin Sumner, withdrawing toward the James River, is pursued along the railroad and the Williamsburg Road by Confederates under Major General John Magruder. The Confederates hit Sumner's Corps (the Union rearguard) with three brigades near Savage's Station. Confederate Brigadier General Richard Giffith is killed during the engagement. Jackson's divisions are held north of the Chickahominy, but

Union forces continued to withdraw across White Oak Swamp. As they do so they abandon supplies and 2,500 wounded soldiers in a field hospital. Total battle casualties are 4,700.

JUNE 30

VIRGINIA, *LAND WAR*

The Battle of Glendale/Frayser's Farm/Riddell's Shop. This is the fifth of the Seven Days' Battles. The Confederate divisions of Huger, Longstreet, and A.P. Hill converge on the retreating Union army in the vicinity of Glendale or Frayser's Farm. Longstreet's and Hill's attacks rout

▲ *Haxall's House on the James River, near Glendale, Virginia. This wooden frame house was used as a hospital after the Battle of White Oak Swamp on June 30, 1862. This inconclusive battle, more an artillery duel, resulted in 500 casualties.*

▼ *A drawing by Alfred Waud of a division of the Army of the Potomac led by George A. McCall at Beaver Dam Creek, near Mechanicsville, Virginia, fighting off attacks by Confederate troops on June 26.*

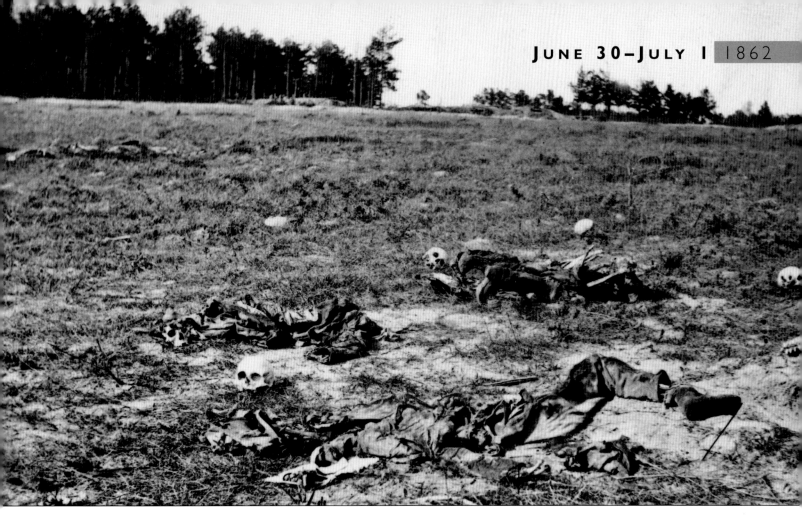

McCall's division near Willis Church (McCall is captured). Union counter-attacks by Hooker's and Kearny's divisions manage to restore the Union line of retreat along the Willis Church Road. Huger's advance is stopped on the Charles City Road. The forces of Jackson are delayed by Franklin at White Oak Swamp. Confederate Major General T.H. Holmes attempts to turn the Union left flank at Turkey Bridge but is driven back by Federal gunboats on the James River. It is a drawn battle, allowing McClellan to establish a strong position on Malvern Hill. Total casualties in the battle are 6,500.

VIRGINIA, *LAND WAR*
The Battle of White Oak Swamp. With a large-scale battle being fought 2 miles (3.2km) away at Glendale Farm, Union and Confederate units engage in an artillery duel across the White Oak

▲ *The grisly aftermath of the Battle of Gaines' Mill. Both sides made efforts to collect the dead after a battle to give the corpses a decent Christian burial. These corpses were missed after the battle.*

Bridge crossing. Total casualties in this engagement amount to 500.

June 30–July 1

FLORIDA, *COASTAL WAR*
The Battle of Tampa. A Federal gunboat makes an unsuccessful attempt to force the surrender of Tampa by a sporadic offshore bombardment.

July 1

THE UNION, *ECONOMY*
The government introduces the Internal Revenue Act. This places a tax on the income of those earning more than $600 a year and also brings in a series of internal taxes on goods. The act is intended "to provide Internal Revenue to support the Government and to pay Interest on the Public Debt."

As one of a rash of new taxes imposed to help fund the war, a Federal tax is placed on distilled spirits.

Revenue from taxes helped the Union government pay for the war effort without ruinous inflation. By the end of the Civil War, for example, prices in the Union stood just 80 percent above their levels in 1861.

VIRGINIA, *LAND WAR*
The Battle of Malvern Hill/Poindexter's Farm. Lee's last chance to stop McClellan during the Seven Days'

▼ *Union artillery in action at the Battle of Malvern Hill, Virginia, fought on July 1, 1862. It was the last battle of the Peninsular Campaign, ending McClellan's attempt to capture Richmond.*

Campaign comes today at Malvern Hill. Despite facing a defensive position bolstered by more than 100 guns, Lee makes a series of frontal assaults in an attempt to win a decisive victory. Infantry charges are met by barrages of Union artillery fire that Confederate artillery is unable to counter. The battle ends in defeat for Lee and leaves his army exhausted. Total casualties in the battle are 8,500, of which 5,300 are Confederate. McClellan withdraws to entrench firmly at Harrison's Landing on

▲ *John Hunt Morgan's Confederate cavalry raiders bivouac in Paris, Kentucky, after levying contributions from the town's inhabitants. This was one of a number of raids by Morgan beginning in July 1862.*

the James River, where his army is protected by gunboats.

July 7

ARKANSAS, *LAND WAR*
The Battle of Hill's Plantation/Cache River/Cotton Plant. Confederate troops

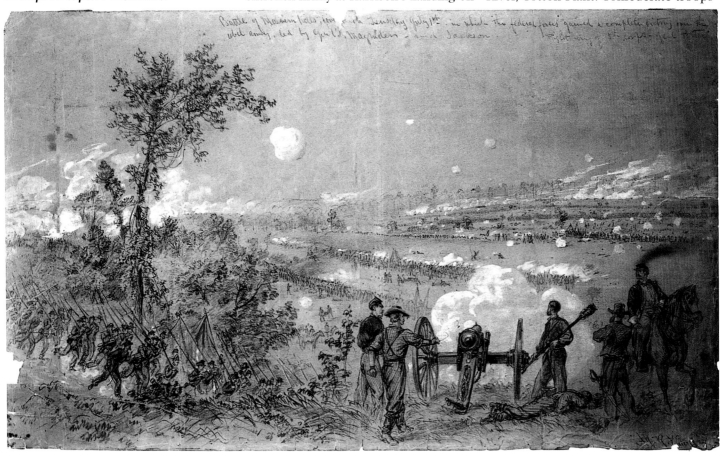

attempt to stop Union forces turning Helena, Arkansas, into a supply base, but are defeated in a battle on the Cache River.

JULY 11

UNION FORCES, *COMMAND*

On the back of Lincoln's unhappiness with McClellan's performance, Major General Henry Halleck is named general-in-chief of the Union army.

JULY 13

TENNESSEE, *LAND WAR*

Battle of Murfreesboro. As part of an offensive toward Nashville, Confederate forces attack a Union supply depot at Murfreesboro. They cause some damage, but little significant disruption.

WASHINGTON, D.C., *POLITICS*

Lincoln reads his initial draft of the Emancipation Proclamation to Secretaries William H. Seward and Gideon Welles. Both are lukewarm. Lincoln will raise the issue again at the cabinet meeting on July 22.

JULY 15

MISSISSIPPI, *RIVER WAR*

The CSS *Arkansas*, a Confederate ironclad, attacks and damages three Union ships at Vicksburg and swings

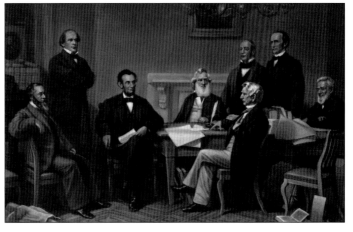

◀ *A painting by F.B. Carpenter depicting Lincoln reading the Emancipation Proclamation to his cabinet in July 1862. Secretary of State William H. Seward is seated in profile on the right, and Treasury Secretary Salmon P. Chase, who personally disliked Lincoln, stands on the left.*

naval power on the Mississippi back toward the Confederates.

JULY 17

THE UNION, *ARMED FORCES*

Two new laws passed by Congress come into force today. The Confiscation Act and Militia Act brings black people officially into the Union war effort and opens the way for the formation of black units in the army. The Confiscation Act states that all escaped slaves who come under Union control will be freed, and that they can be employed by the Union to suppress the Confederate rebellion. The Militia Act gives the presi-

dent the power to enroll "persons of African descent" for "any war service," including service as soldiers.

Within weeks black regiments under white officers were being raised throughout the Union and in the Southern territories it controlled. In New Orleans, Louisiana, the occupying Union governor, Benjamin Butler, raised three regiments of black militia, enlisting both freedmen and escaped slaves. On the South Carolina coast former slaves formed the 1st South Carolina Volunteer Regiment, while in the North freedmen joined the 54th Massachusetts Infantry.

▼ *The Union army's supply base at White House Landing, which, together with the corps guarding it, was the target of General Robert E. Lee's attack on June 26, 1862, during the Seven Days' Campaign that relieved Richmond.*

AUGUST 5

▼ *James McPherson was a very able commander. He was Grant's chief engineer during the battles at Shiloh, Tennessee, and Iuka. He was given command of the Army of Tennessee in March 1864, and was killed in the Battle of Atlanta four months later.*

AUGUST 5

LOUISIANA, *LAND/RIVER WAR*
The Battle of Baton Rouge/Magnolia Cemetery. A combined Confederate land/naval force attempts to recapture Baton Rouge. The attempt is repelled, and the Confederates lose the ironclad ram CSS *Arkansas*.

AUGUST 6–9

MISSOURI, *LAND WAR*
The Battle of Kirksville. US cavalry and artillery forces chase the Confederate Missouri Brigade into Kirksville, then defeat the rebels in a town battle.

AUGUST 9

VIRGINIA, *LAND WAR*
The Battle of Cedar Mountain/ Slaughter's Mountain/Cedar Run. When Robert E. Lee contemplated his course of action following the Seven Days' Campaign in June 1862, he looked to one of his chief subordinates,

"Stonewall" Jackson, to help him solve a strategic problem. As Lee faced the Union Army of the Potomac near Richmond, another Union army was forming under John Pope near Washington, D.C. A unit of this new Army of Virginia was led by a political appointee, Nathaniel P. Banks.

In late July Pope sent Banks with 12,000 soldiers to threaten the Virginia Central Railroad, a vital Confederate supply line. Lee reacted by sending Jackson with three divisions, totaling 22,000 troops, to deal with Banks. Jackson and Banks were old rivals. A few months earlier the two generals had faced off in the Shenandoah Valley.

▼ *At the Battle of Baton Rouge on August 5, 1862, Confederate forces attacked Baton Rouge, the capital of Louisiana, held by Union forces since May, but failed to retake the city. Confederate losses were 478, the Federals losing 371.*

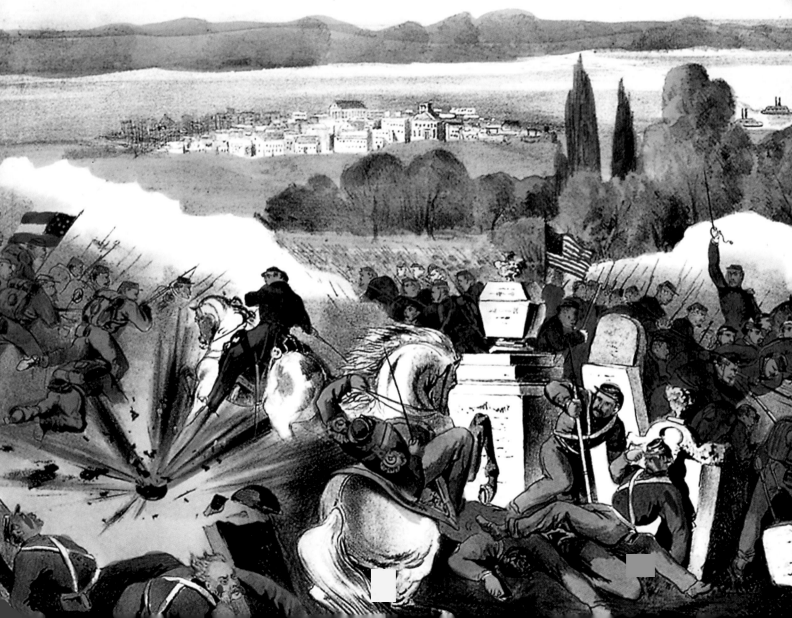

Now Jackson relished the chance to strike at his Union enemies again.

Today he deploys his troops on the northwest of Cedar Mountain in anticipation of a battle. Jackson has out-maneuvered and defeated Banks before, but this time things begin differently. Jackson's secretiveness over his orders causes confusion, and the Confederate forces arrive on the battlefield in a piecemeal condition. Jackson himself adds to the confusion by spending hours placing artillery pieces on the right side of his line. Charles S. Winder is left to deploy his division on the Confederate left flank in some trees.

The artillery of both sides begin the battle and carries out an inconclusive duel while the infantry deploys. Banks attacks the left of Jackson's infantry line as it is forming. Winder is killed almost

immediately, and the troops under his command crumble in the face of an energetic Union attack from a unit only a fraction of their size. For a time the Confederate position is critical, as the advancing Union forces under Samuel J. Crawford threaten to separate Winder's and Jubal A. Early's divisions from that of Ambrose P. Hill, which is still arriving on the field. On the march to Cedar Mountain, Hill and Jackson had quarreled, but this disagreement is forgotten for the moment. The arrival of Hill's division turns the tide. His five brigades march straight into battle.

In a stirring display of bravery, Jackson rallies his retreating troops in person. At one point he tries to pull his sword from its scabbard, only to find that it has rusted in place. Removing his sword and its scabbard from his belt and waving it in the air, he then takes a battle flag from a soldier and waves it, shouting, "Jackson is with

▲ *Simon Bolivar Buckner (1823–1914) was a friend of Ulysses S. Grant before the war. Joining the Confederate army in 1861, he fought at Perryville, Kentucky, and Chickamauga, Georgia. He was a pallbearer at Grant's funeral in 1885.*

KEY PERSONALITY

JAMES LONGSTREET

James Longstreet (1821–1904) was born in 1821 in South Carolina, but his family moved to Georgia when he was very young. Longstreet graduated from the U.S. Military Academy at West Point in 1842 and fought in the Mexican War (1846–1848), where he was wounded. At the outbreak of the Civil War Longstreet resigned from the U.S. Army and headed to Richmond, where he was commissioned brigadier general in the Confederate army.

Longstreet was assigned to the staff of General Pierre G.T. Beauregard and fought in the First Battle of Bull Run (Manassas) in July 1861. At Second Bull Run on August 29–30, 1862, Longstreet was slow to attack at first but distinguished himself with a ferocious counterattack that shattered the Union army on August 30.

Following the Battle of Antietam on September 17, 1862, Longstreet was promoted to lieutenant general and given command of I Corps in General Robert E. Lee's Army of Northern Virginia. In that capacity he took part in the Confederate victory at Fredericksburg on December 13, 1862, and the decisive Confederate defeat at Gettysburg in July 1863. Longstreet went on to receive a severe shoulder wound in the Wilderness Campaign in May 1864, but returned to command with a paralyzed arm and surrendered with Lee at Appomattox in April 1865.

After the war Longstreet was disliked in the South because he joined the Republican Party and accepted a succession of appointments from president and former Union general Ulysses S. Grant. Many Southerners also blamed Longstreet for the defeat at Gettysburg, in particular for his delay in making an attack on July 2. Longstreet spent his later years back in Georgia, where he ran a hotel and raised turkeys. In 1896 he published his memoirs, which defended his actions at Gettysburg. He died in 1904.

you!" His example, combined with arriving reinforcements, turns temporary Union success into defeat. The attacking Union forces, tired and disorganized from marching and fighting on a hot day, give way before the Confederate attack and leave the field by nightfall. At a cost of 1,400 casualties Jackson's force has defeated Banks, inflicting 2,500 Union casualties in the process.

Although Jackson later declared that Cedar Mountain was "the most successful of his engagements," it was actually Hill's counterattack that led to victory. Jackson's own faulty dispositions and failure to attend to his left flank had almost cost him defeat at the hands of an enemy whom he outnumbered by two to one. Two days later Jackson fell back to his base at the railroad junction at Gordonsville, where he awaited the arrival of Lee and the rest of the Army of Northern Virginia.

AUGUST 11

MISSOURI, *LAND WAR*

The Battle of Independence. A Confederates force (which includes William Quantrill) raids and captures the Union base at Independence, securing for the time being Confederate control in the Kansas City area.

▼ *Minnesota troops engaged against rebellious Sioux in August 1862. Troops badly needed on the battlefields of the Civil War were diverted to fight the disaffected Sioux people. After the rebellion 38 Sioux were hanged at Mankato.*

AUGUST 14

VIRGINIA, *LAND WAR*

The Army of the Potomac begins withdrawing from Harrison's Landing, thus ending the Peninsular Campaign.

AUGUST 15–16

MISSOURI, *LAND WAR*

The Battle of Lone Jack. A Union force of 800 men defeats a camp of 1,600 Confederates at Lone Jack, Jackson County, on August 15, before being forced to retreat by Confederate reinforcements the next day.

AUGUST 17

NAVAL WAR, *TECHNOLOGY*

The CSS *Florida* is officially designated. The *Florida* is the first foreign-built warship constructed for the Confederate States (it was manufactured in Liverpool, Britain).

▲ *"California Joe," a famous marksman in the Union army unit known as Berdan's Sharpshooters, shown in a Harper's Weekly illustration of August 1862. A trained sharpshooter could fire as many as 6–8 rounds per minute.*

AUGUST 20–22

MINNESOTA, *INDIAN WARS*
The Battle of Fort Ridgely. Rebellious Santee Sioux in Minnesota force Union soldiers and civilians into Fort Ridgely, where they repel many Indian attacks.

AUGUST 22–25

VIRGINIA, *LAND WAR*
The Battle of Rappahannock Station/Waterloo Bridge. A series of skirmishing

▲ *Union General Samuel J. Crawford's brigade advances at the Battle of Cedar Mountain. Greatly outnumbered, the brigade's determined attack almost prevailed against the Confederate forces. However, the battle was a Union defeat.*

actions along the Rappahannock River costs both sides a total of around 225 casualties.

AUGUST 28

VIRGINIA, *LAND WAR*
The Battle of Thoroughfare Gap/Chapman's Mill. The Confederates push through the Thoroughfare Gap. Although a minor action, it allows the two Confederate forces to unite for victory at the Second Battle of Manassas.

AUGUST 29

VIRGINIA, *LAND WAR*
The Battle of Second Manassas/Second Bull Run. The Union commander, John Pope, planned to use his new Army of

◀ *A Union battery fords a tributary of the Rappahannock River at the Battle of Cedar Mountain. Union artillery along Mitchell's Station Road suffered heavily from Confederate artillery deployed on the shoulder of Cedar Mountain.*

▲ A sketch of Confederate soldiers of Jackson's army manning breastworks at the Battle of Rappahannock Station, August 22–25, 1862.

Virginia, combined with reinforcements from the Army of the Potomac, to attack the Confederate capital, Richmond, from the north. Pope, a brash general from the Western theater, promised his troops that they would soon see the backs of their retreating enemies. Confederate General Robert E. Lee had recently completed his defeat of the Army of the Potomac in the Seven Days' Campaign of June 1862. However, Lee found himself in a strategically dangerous position. His army was positioned between the two much larger forces of McClellan and

Pope. McClellan's forces were not yet ready to advance, however. Lee used the chance to confront Pope.

Lee devised a risky plan to deal with Pope, whom he personally disliked. In direct contradiction to accepted military strategy, he divided his forces, leaving a small detachment of his army outside Richmond to contain the Army of the Potomac. He sent "Stonewall" Jackson with 24,000 men to advance into central Virginia to confront Pope. Jack-

son defeated part of Pope's army at Cedar Mountain on August 9. Lee then rejoined Jackson with the rest of the army along the Rappahannock River.

Facing Pope across the river, Lee divided his army again, with the

▼ Soldiers of the 22nd New York State Militia at drill in Harpers Ferry. First organized in April 1861, during its war service the regiment lost 11 officers and 62 enlisted men killed on the battlefield, and one officer and 28 enlisted men killed by disease.

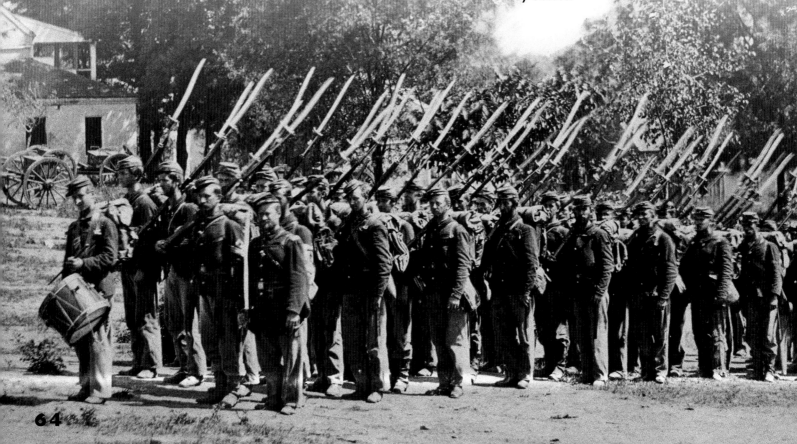

STRATEGY AND TACTICS

BLOCKADE RUNNING

On April 19, 1861, President Abraham Lincoln proclaimed a naval blockade of the Deep South states of Texas, Louisiana, Florida, Georgia, and South Carolina. On April 27 he extended the proclamation to include North Carolina and Virginia.

At first the blockade existed mainly on paper. The Union navy did not have nearly enough vessels to screen the 187 ports and navigable inlets on the long coastline between Chesapeake Bay and the Rio Grande. However, by arming almost any vessel that would float, Gideon Welles, Union secretary of the navy, rapidly built up a respectable force. The blockade consisted of hundreds of warships, eventually numbering some 600, that patrolled the Confederate coast. Most stayed close to harbors, watching for any vessel that ventured in or out. When they spotted one, they would give chase. For much of the time, however, blockade duty could be very dull.

To support the blockade, the Union navy captured bases on the Southern coast to serve as stations where its vessels could put in for coal and repairs. It also captured the forts that guarded Confederate ports or seized the ports outright. The first major port to fall was also the South's largest city: New Orleans, Louisiana, which capitulated to a Union fleet under David G. Farragut on April 25, 1862. Union forces systematically neutralized or captured other Southern ports, so that by the end of December 1864 the only major port still open was Wilmington, North Carolina. When it too was sealed off on January 15, 1865, the Confederacy lost its last significant access to the outside world.

Lacking the ability to construct a fleet large enough to break the blockade, the Confederacy tried to gain the same result by building a few ironclad vessels, such as the CSS *Virginia* and *Albemarle*. Such vessels, however, proved neither strong enough nor seaworthy enough to do the job effectively. A more practical tactic was simply to elude the blockade.

During the course of the war about 300 vessels attempted to run the blockade. At first they were mainly fast sailing vessels, but gradually ships specially designed for the task were built, many of them in Britain. Called blockade-runners, they typically had shallow drafts so they could navigate small inlets and low silhouettes and gray paint to make them difficult to spot. Their engines burned anthracite, a form of coal that produced little smoke, and they had pipes to

expel steam underwater to make them less visible. Above all, they were fast. Shielded from Union lookouts by a cloudy or moonless night, a blockade-runner could sneak past patrolling warships undetected. If that failed, it could simply outrun them.

Blockade-runners did not have to sail all the way to Europe. Instead, their usual destinations were the neutral ports of Nassau, Bahamas; St. George, Bermuda; Havana, Cuba; and St. Thomas in the Virgin Islands. There cotton was transferred to regular merchantmen for the voyage to Europe, while the blockade-runners loaded their cargoes for the dash back to the South through the Union blockade.

At the start of the war the best enforcer of the blockade was the Confederacy itself. Until 1863 it was government policy not to sell cotton abroad but rather to observe an embargo intended to starve European textile mills of their vital raw material. Confederates hoped that the embargo would compel support for the Confederacy from key European powers, especially Britain. The embargo failed, and the Confederacy had missed the chance to export cotton at a time when most of its ports were open and the Union blockade was weakest.

Even after it curtailed the embargo, the Confederate government was slow to make blockade-runners give cargo space to military supplies. Most blockade-runners operated entirely for profit, transporting luxury goods. Right to the end of the war blockade-runners satisfied the desire of Southerners for luxury goods.

The blockade affected both sides' relations with other countries. Union warships sometimes harassed or even fired on neutral shipping, or waited just beyond the 3-mile (5km) limit of blockade-runner destinations, such as Nassau or Havana, establishing what was in effect an illegal blockade of a foreign port. Other countries, especially Britain, protested such actions.

The effectiveness of the blockade remains a matter of dispute. Judged by the proportion of blockade-runners that got in and out of Confederate ports, it was never completely effective. In 1861, for example, vessels made the trip successfully nine times out of ten, though the ratio fell to five in ten in 1865. The blockade appears more effective when the volume of wartime shipping is compared to prewar levels. Viewed from this perspective, the blockade reduced Confederate seaborne supply by more than two-thirds.

▲ An engraving of Union sailors observing the movements of a Confederate ship trying to run the Union blockade. The Union deployed 600 blockade vessels.

objective of defeating Pope's army before it could be reinforced by McClellan. Beginning on August 25, Jackson led 24,000 men around Pope's right flank. Confederate General James Longstreet followed the next day. By nightfall on the 26th, after a 60-mile (96km) march, Jackson had cut the Orange and Alexandria Railroad, Pope's supply line from Washington, and had seized and destroyed the Union supply depot at Manassas Junction. Jackson then moved his force onto the site of the First

AUGUST 29–30

▶ *The ruins of the Henry House on Henry Hill, near Bull Run. It was at the center of the First Battle of Bull Run and was again fought over in the second battle in 1862.*

Battle of Bull Run and waited for Longstreet. Pope moved to counter Jackson's flanking march, and the two forces clashed near Groveton, a few miles from Manassas, on August 28. The next day Longstreet arrived, and Lee's army was reunited.

The Second Battle of Bull Run is fought on much of the same ground as the first battle in July 1861. Jackson has entrenched his Confederates in the shelter of an unfinished railroad bed. They fight a desperate battle against attacking Union forces under Sigel, Reno, and Heintzelman. At one point Confederate soldiers who had run out of ammunition resort to throwing rocks at their adversaries. Their line holds, however, because the Union attacks are poorly coordinated.

AUGUST 29–30

KENTUCKY, *LAND WAR*
The Battle of Richmond. The Confederate offensive into Kentucky scores a victory over Federal troops at Richmond, driving back the opposition and capturing 4,000 Union soldiers.

AUGUST 30

VIRGINIA, *LAND WAR*
The Battle of Second Manassas/Second Bull Run. The second day's fighting

◀ *A sketch of Union artillery at the Battle of Richmond, Kentucky. Kirby Smith's Confederates decisively defeated the Federals in a two-day action.*

opens with more Union attacks on Jackson's position at the railroad, this time by Fitz John Porter's corps, sent to reinforce Pope from the Army of the Potomac. Meanwhile, Longstreet launches a massive attack at 16:00 hours, and the result is decisive. The Union left flank is quickly crushed. Pope's army begins withdrawing from the field. As night falls, a final Union position holds firm on Henry Hill, site of the final Confederate defense a year earlier. This defense by part of Pope's force allows the bulk of the army to escape. The next day Jackson attempts once again to encircle and cut off the Union army at Chantilly, but fails in a

driving thunderstorm. Pope and his defeated army retreat to the fortifications around Washington.

Second Bull Run was the most complete of Lee's victories. At the cost of 9,500 casualties he inflicted 14,500 casualties on Pope's army and ended another Union attempt to capture Richmond. It is the high point of a summer that has seen Lee take command of the Army of Northern Virginia and defeat two Union armies. The initiative now in his hands, Lee decides to invade the North in hopes of another decisive victory.

▲ Confederate fortifications about Manassas Junction, Manassas, in 1862.

◄ Confederate troops at Manassas Junction, having captured the large Union supply depot there on August 26, 1862. They feasted on the stores, then destroyed anything they could not take with them on the march.

▼ The bedraggled Union army following its defeat at Second Manassas. Only a spirited rearguard action prevented a total rout of Pope's Union Army of Virginia.

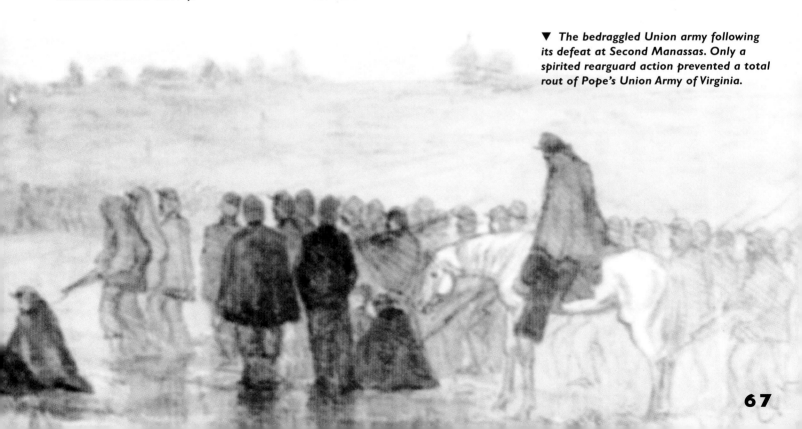

SEPTEMBER 14

MARYLAND, *LAND WAR*

The Battle of South Mountain/Fox's Gap/Crampton's Gap/Turner's Gap. When Confederate General Robert E. Lee's Army of Northern Virginia crossed the Potomac River into Maryland in early September, Union General George B. McClellan moved out of the Washington defenses in pursuit. On September 9 Lee split his army into four parts, three of which were sent to capture the Union garrison at Harpers Ferry. A lost copy of Lee's orders came into McClellan's possession on September 13, putting the fragmented Army of Northern Virginia in great peril.

McClellan planned to force his way through three passes in South Mountain—Crampton's Gap, Fox's Gap, and Turner's Gap. From there he would engage Lee's army and also relieve Harpers Ferry. Warned of McClellan's pursuit, Lee began to gather his army at Sharpsburg. He ordered a small division

under Daniel H. Hill to defend a ridge along South Mountain to the east.

McClellan's corps commanders spend the early hours getting into position. The Union VI Corps strikes at Crampton's Gap and brushes aside a Confederate defensive line. At dusk they encounter a desperate Confederate counterattack, which slows the Union assault and condemns Harpers Ferry to capture.

The fighting at Fox's and Turner's Gaps is equally frustrating for the attacking Union troops. Hill's brigades succeed in blocking the gaps until nightfall, as Union General Ambrose E. Burnside commits troops of I and IX Corps in a piecemeal fashion, allowing Hill time to shift his defenses and make way for reinforcements under James Longstreet. As night falls, the Union army has opened Crampton's and Fox's Gaps, but Longstreet's men block Turner's Gap until dawn.

Despite the Union victory at South Mountain, Hill's desperate defense had delayed the Union for a crucial day. The Army of the Potomac will now have to face a reunited Army of Northern Virginia on the banks of Antietam Creek near Sharpsburg.

SEPTEMBER 14–17

KENTUCKY, *LAND WAR*

The Battle of Munfordville/Green River Bridge. As part of the Confederate Kentucky offensive, General Braxton Bragg takes the important Union railroad supply station at Munfordville.

SEPTEMBER 16

MARYLAND, *LAND WAR*

The Battle of Antietam/Sharpsburg. Yesterday Lee, realizing that McClellan was advancing between the two halves of his army, ordered Jackson back from Harpers Ferry and pulled his own forces toward the Potomac. The Confederates would concentrate near Sharpsburg between the Potomac and Antietam Creek.

◀ **General John McNeil became infamous when he ordered 10 Confederate prisoners to be shot in retaliation for the presumed murder of a local Union man. McNeil became known as the "Butcher of Palmyra." He led Union forces in Missouri until he resigned his command in April 1865.**

▲ *Iuka, Mississippi, was occupied by Sterling Price's Confederate Army of the West on September 14, 1862. Five days later, Price was attacked at Iuka by William S. Rosecrans' Army of the Mississippi.*

Lee's position is not promising. He has only 18,000 men stretched along a 3-mile (4.8km) line on high ground above Sharpsburg, with his back to a bend of the Potomac River. The far left of the line lays along the Hagerstown Pike about 2 miles (3.2km) north of the village at an area called the West, East, and North Woods. His far right lays barely a mile south of the village on the Harpers Ferry Road. The center is split by the Boonsboro Pike. It is an exposed position, mostly running through cornfields and fruit orchards with little natural cover. Antietam Creek might have offered some defense but it is crossed by three bridges and a number of fords. Lee's only line of retreat is over a single ford across the Potomac. Facing Lee is McClellan's army of over

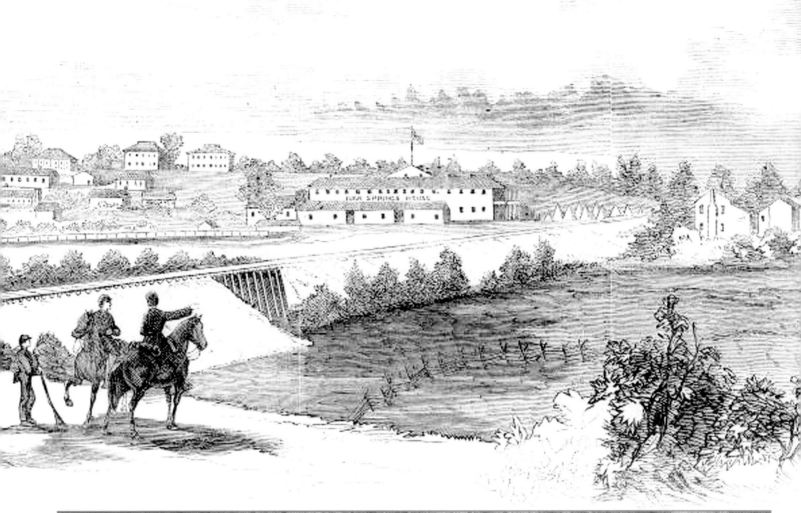

KEY PERSONALITY

AMBROSE HILL

Ambrose Powell Hill (1825–1865) was a native of Virginia and an 1847 graduate of the U.S. Military Academy at West Point. Hill gave his allegiance to his native state when the Civil War broke out in 1861 and accepted a command in the Confederate army. He rose quickly to brigade, and then division, command in Lee's Army of Northern Virginia. Hill fought under "Stonewall" Jackson from July 1862 until Jackson's death at the Battle of Chancellorsville in May 1863. The two men had a deep and ongoing quarrel, which at one time led to Hill being briefly arrested.

Hill's division earned the nickname the "Light Division" for its fast marching and aggressive attacks. During the Confederate invasion of the North in 1862 Hill's men made a forced march on September 17 to the Antietam battlefield, arriving in time to deliver a devastating counterattack to a part of the Union Army of the Potomac. Lee said of Hill in 1862 that after Longstreet and Jackson, "I consider General A.P. Hill the best commander with me. He fights his troops well and takes good care of them."

When Lee reorganized his army in May 1863 after the death of Jackson, he looked to Hill to command his newly created III Corps.

As a division commander Hill had been a great success, but as a corps commander he surpassed the limits of his effectiveness. The lingering effects of a venereal disease contracted at West Point left him irritable and prone to bouts of illness. He was unequal to the task of corps command at Gettysburg and in the following Virginia campaigns. At the Battle of Bristoe Station in October 1863, for example, he led his corps into a disastrous ambush by Union troops. In the absence of other qualified generals, however, Hill stayed in corps command until he was killed by a Union sniper at Petersburg, Virginia, on April 2, 1865.

SEPTEMBER 17

75,000 men advancing from the north and east.

Fighting begins at dusk when Joseph Hooker's Union I Corps attacks from the north down the Hagerstown Pike toward the North Woods. "Stonewall" Jackson and the first of his units begin to arrive, and by nightfall the Confederates have repulsed Hooker's advance.

SEPTEMBER 17

MARYLAND, *LAND WAR*
The Battle of Antietam/Sharpsburg. At 06:00 hours McClellan begins the battle with an artillery bombardment.

Hooker's corps attacks again. Ten brigades hit the Confederate left and

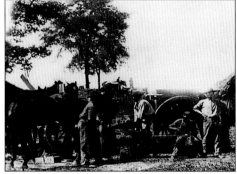

▲ *A Union army blacksmith and forge of an unidentified cavalry regiment, Antietam, September 1862.*

▶ *A Union 10-pounder Parrott cannon about to be fired during a training exercise. The bucket on the ground holds water for keeping the sponge on the rammer moist.*

push their line back to the West Woods. Jackson counterattacks at 07:00 hours and throws the Union forces back, but Hooker receives reinforcements from Mansfield's XII Corps. The battle now centers on the struggle for the possession of the Dunker Church, in the West Woods.

Three divisions of Sumner's II Corps come forward from the Union right to help Mansfield. Attacking into the West Woods, one of the divisions advances straight into a line of Confederates and suffers more than 2,500 casualties in 20 minutes, including General John Sedgwick, the division's commander. Falling back nearly a mile, the Union troops take up defensive positions. The fighting for the West Woods is at a stalemate.

Meanwhile, another of Sumner's divisions loses its way and heads for the

Confederate center. At 09:30 hours it attacks brigades holding the sunken road between the Boonsboro and Hagerstown Pikes, later called Bloody Lane. Fighting continues here for four hours as first one Union division and then a second makes repeated charges.

At about the same time on the Union right flank, IX Corps under Ambrose E.

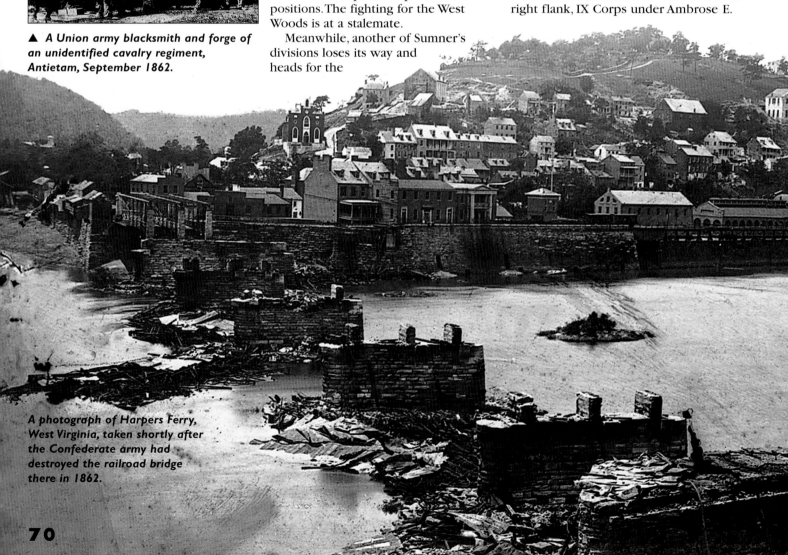

A photograph of Harpers Ferry, West Virginia, taken shortly after the Confederate army had destroyed the railroad bridge there in 1862.

ARMED FORCES

NAPOLEON 12-POUNDER

The most versatile and widely used artillery piece of the war was the Model 1857 12-pounder Napoleon. This field gun was developed from a French design named for the Emperor Napoleon III. It was designed to replace the Model 1841 six-pounder (2.7kg) cannon; but as the Civil War broke out, only five Napoleons were in service. U.S. arsenals were still stocked with the old six-pounders, and it was they that the Confederates seized when they captured federal arsenals in 1861.

The six-pounder cannon was the main Confederate field gun in the first year of the war, but it did not have the range or power of the Napoleon. By July 1862 it was being withdrawn from service, and the main Confederate gun foundry, the Tredegar Works in Richmond, Virginia, had begun casting the 12-pounder. By the end of the war the Confederacy had produced more than 450 Napoleons, a figure outstripped by the 1,127 produced in the Union.

The Napoleon was a muzzleloaded smoothbore cannon with a bronze barrel 5 ft. 6 in. (168cm) long. It had a range of up to 1,600 yards (1,463m) and could fire four different types of shot for use against different targets.

Burnside begins attacking across the creek at the Rohrbach Bridge, later renamed Burnside Bridge. Burnside sends in brigade after brigade but is held off by a Confederate force of just 400 Georgians. They hold the bridge until 13:00 hours, when one of Burnside's division commanders has the good sense to use a nearby ford and flank the Confederate position.

By early afternoon the Confederate line is on the verge of collapse. Reinforcements have been arriving from Harpers Ferry all day. But Lee only has one division in reserve, and by noon he has committed most of that to help defend the sunken road. At 13:00 hours the sunken road falls, and the Confederates fall back toward Sharpsburg. By now most of Burnside's forces have crossed Antietam Creek. At 15:00 hours they start to advance.

McClellan still has two corps in reserve. If he sends them forward he will win the battle—but he hesitates. His timidity costs the Union victory. As Burnside's men advance, an attack hits their left flank. Confederates who have marched from Harpers Ferry arrive at that moment to stop Burnside's attack and force it back toward the creek.

▲ Lincoln reads his Emancipation Proclamation to his cabinet. Attorney General Edward Bates (second from right) was a Virginian and only mildly opposed the extension of slavery before the war.

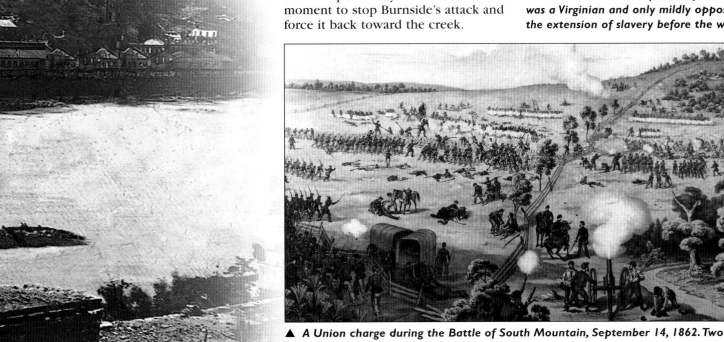

▲ A Union charge during the Battle of South Mountain, September 14, 1862. Two Union regiments are attacking a North Carolinan regiment on the slopes.

SEPTEMBER 18

▲ A photograph of the small town of Sharpsburg, Maryland, which became the scene of the war's bloodiest day when the Battle of Antietam took place there on September 17, 1862.

At nightfall the battle ends in a standoff among the dead and dying. McClellan has lost a total of 12,400 dead, wounded, or missing, while Lee has suffered more than 10,000 casualties. September 17, 1862, is the bloodiest day of the entire war. Although the battle is a draw in tactical terms, it is a strategic victory for the Union because the Confederate invasion of the North has been halted.

Lee considered counterattacking, but his officers argued against the idea. Both sides held their positions the next day. On the 19th Lee led his army back across the Potomac. President Lincoln interpreted the battle as a Union victory.

SEPTEMBER 18

MISSOURI, *ATROCITY*
The Massacre at Palmyra. Ten Confederate prisoners are executed in retaliation for the abduction and presumed murder of a local Union man.

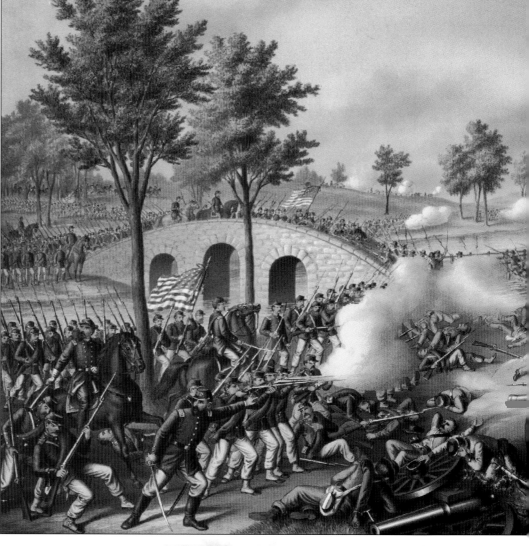

▲ The Union forces at the Battle of Antietam attacked from the north and east, but numerous delays limited the effectiveness of their assaults.

The Battle of Antietam ▶
Union commander McClellan planned to attack both Confederate flanks at once. Union forces launched a dawn attack from the north on the Confederate left flank, and there was fierce fighting in the North, East, and West Woods and around the Dunker Church (1). The battle shifted south to the center of the Confederate line. At the sunken road (later called Bloody Lane on account of the horrific amount of blood on this road) the Confederates held off repeated Union attacks for nearly four hours. They were forced to retreat at about 13:00 hours (2).
Ordered to attack the Confederate right flank at 08:00 hours, Union commander Burnside finally crossed the creek and started his attack at 15:00 hours, pushing the Confederates back toward Sharpsburg. The arrival of Confederate reinforcements forced the Union troops to retreat and ended the battle in a bloody draw (3). During the night, both armies consolidated their lines. On the 18th Lee continued to skirmish with McClellan, who did not renew the assault. After dark, though, Lee ordered the battered Army of Northern Virginia to withdraw across the Potomac.

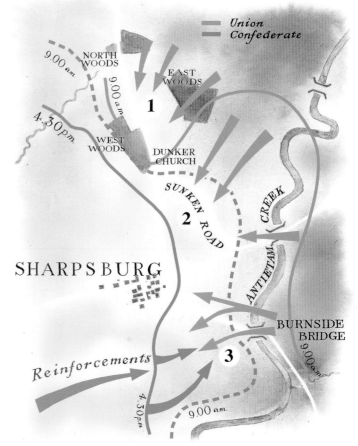

Union
Confederate

NORTH WOODS
9.00 am
9.00 a.m
4.30 p.m
EAST WOODS
1
WEST WOODS
DUNKER CHURCH
SUNKEN ROAD
2
CREEK
ANTIETAM
SHARPSBURG
BURNSIDE BRIDGE
9.00 am
Reinforcements
3
4.30 p.m
9.00 am

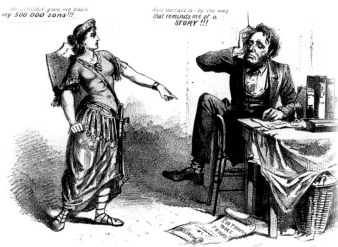

◀ A cartoon against Lincoln published at election time in fall 1862 shows public concern about the human toll of the war. The cartoonist also refers to a damaging rumor that Lincoln made a joke on the battlefield at Antietam.

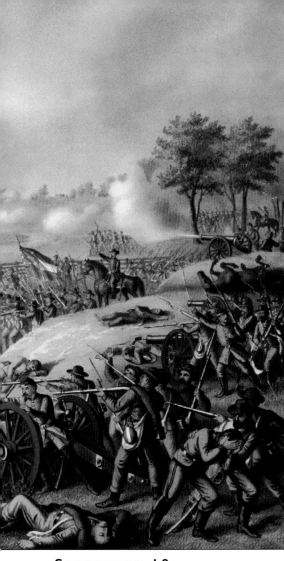

SEPTEMBER 19

MISSISSIPPI, *LAND WAR*
The Battle of Iuka. A Confederate attempt to prevent Union forces massing reinforcements against their Kentucky offensive results in a Confederate defeat around Iuka.

SEPTEMBER 19–20

WEST VIRGINIA, *LAND WAR*
The Battle of Shepherdstown/Boteler's Ford. Brigadier General Fitz John Porter's V Corps attacks Confederate forces on the Potomac then attempts to push a bridgehead across the river. The bridgehead operation is so costly that the Union forces do not pursue the retreating Confederates.

▶ A Union signal tower on Elk Mountain, overlooking the battlefield of Antietam. Signalmen, operating from prominent positions, were vulnerable to enemy snipers.

SEPTEMBER 22

WASHINGTON, D.C., *POLITICS*
After the Union "victory" at Antietam, Lincoln issues the preliminary version of his Emancipation Proclamation, which specifies that the final document will take effect on January 1, 1863.

SEPTEMBER 23

MINNESOTA, *INDIAN WARS*
The Battle of Wood Lake. Union Colonel Henry Hastings and 1,500 men fight off an ambush from 700 Santee Sioux Indians.

SEPTEMBER 24–25

TEXAS, *NAVAL WAR*
The Battle of Sabine Pass. Three Union gunships conduct a successful bombardment of a Confederate coastal battery in Sabine Pass, Jefferson County. The town surrendered and the battery was destroyed on September 25.

SEPTEMBER 24

TENNESSEE, *ATROCITY*
Union General William Sherman orders his subordinates to destroy every house in Randolph, Tennessee, in retaliation for Confederate shelling of his supply steamboats.

SEPTEMBER 30

MISSOURI, *LAND WAR*
The Battle of Newtonia. Confederate forces moving into southwestern Missouri defeat a major Union attack by the Army of Kansas at Newtonia. However, the Union buildup in the region would eventually restrict the Confederates in this area to mounting raiding columns.

FLORIDA, *RIVER WAR*

The Battle of St. John's Bluff. Confederate coastal batteries on the St. John's River near Jacksonville are abandoned after a Union amphibious operation.

OCTOBER 3–4

MISSISSIPPI, *LAND WAR*

The Battle of Corinth. A combined Confederate army of 22,000 men is defeated attempting to crush heavily

▲ *An illustration from Frank Leslie's* **Illustrated Newspaper** *of November 23, 1862, showing Union foraging parties returning to camp near Annandale Chapel, Virginia.*

defended Corinth, spoiling plans for a Confederate drive into mid-Tennessee.

OCTOBER 4

TEXAS, *NAVAL WAR*

The Battle of Galveston. The port of Galveston is forced to surrender by U.S.

gunboats and tough Union diplomacy after a lengthy period of blockade.

OCTOBER 5

TENNESSEE, *LAND WAR*

The Battle of Hatchie's Bridge/Davis Bridge/Matamora. Following their defeat at Corinth, elements of Major General Earl Van Dorn's Confederate Army of West Tennessee are pushed back across the Davis Bridge over the Hatchie River.

OCTOBER 8

KENTUCKY, *LAND WAR*

The Battle of Perryville. As part of the South's fight for Kentucky, in September generals Braxton Bragg and Kirby Smith launched an invasion from Tennessee. By October 4 Bragg secured the state capital of Frankfort and set up a new Confederate state government. It was shortlived, though. Today, the Union Army of the Ohio led by Don Carlos Buell meets Bragg's Army of the Mississippi. After a morning assault by Union troops, after noon a Confederate division hits the Union left flank and forces it back. More Rebel divisions join the battle, eventually forcing back the Union line. Union troops on the left flank, reinforced by two brigades, stabilize the line. A Confederate attack

KEY PERSONALITY

AMBROSE BURNSIDE

Ambrose Burnside (1824–1881) graduated from the U.S. Military Academy at West Point in 1847 and served on the Western frontier, where he was wounded fighting the Apaches.

In May 1861, Burnside became colonel of the 1st Rhode Island Infantry and was assigned to defend Washington, D.C. By June he was commanding a brigade in the 2nd Division of the Army of Northeastern Virginia.

In August Burnside was promoted to brigadier general and sent to command an expeditionary force along the coast of North Carolina. Successes at Roanoke Island and inland at New Bern in mid-February 1862 led to his promotion to major general. In July Burnside sailed with reinforcements to help the Army of the Potomac, which was fighting along the James River. Taking command of IX Corps, Burnside took part in the last actions of McClellan's Peninsular Campaign.

In mid-September 1862, Burnside was in command of both IX and I Corps. On September 14 this wing of the army opposed the Confederate invasion of Maryland at the Battle of South Mountain and on September

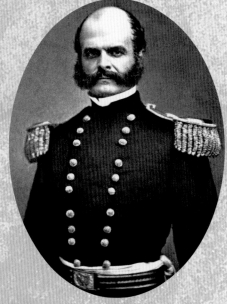

17 at the Battle of Antietam. At Antietam Burnside, commanding IX Corps, was ordered to advance at 08:00 hours but took most of the day to force his way over a bridge at Antietam Creek—later called Burnside Bridge.

After Antietam Burnside was offered command of the Army of the Potomac. He felt unequal to the post, but he took control on November 9, 1862. He reorganized the army's six corps and cavalry into three Grand Divisions, Right, Center, and Left, and ordered a march on Richmond.

Burnside was stopped at Fredericksburg. The battle was a failure, and on January 25, 1863, he was replaced by Joseph Hooker.

Sent west to command the Department of the Ohio in March 1863, by August Burnside was in charge of Army of the Ohio. In April 1864 Burnside was transferred back to the Army of the Potomac, where he again took charge of IX Corps. Acting as a subordinate officer, Burnside did well in the battles of May and June: Wilderness, Spotsylvania, North Anna, and Cold Harbor. Only when he made an independent attack did he fail once again. The Battle of the Crater on July 30 was in Grant's words "a stupendous failure. It cost us about 4,000 men, all due to the inefficiency of the corps commander." Burnside's career did not recover. He was sent on leave and never recalled to service.

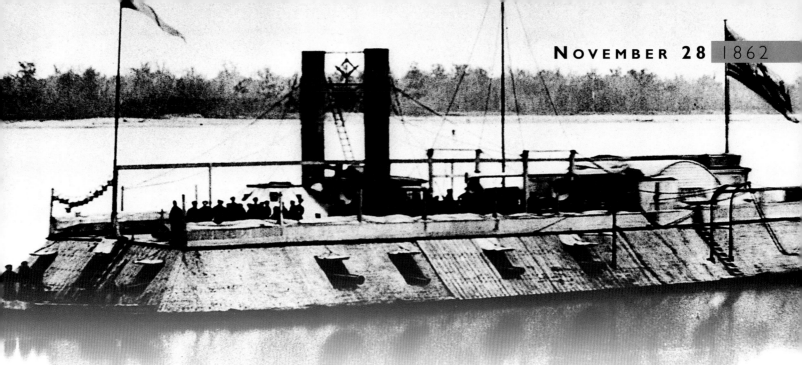

▲ The ironclad gunboat, USS St. Louis (later renamed the USS Baron De Kalb). She was sunk on July 13, 1863 by a Confederate torpedo (mine) in the Yazoo River in Mississippi.

against a Union division on the Spring-field Pike is repulsed, the attackers retreating back to Perryville. Union troops pursue into the town. With his left flank threatened, Bragg withdraws and retreats into East Tennessee. Union losses are 4,211; Confederate 3,196.

OCTOBER 22

OKLAHOMA, *LAND WAR*
The Battle of Old Fort Wayne/Beaty's Prairie. The Confederate 1st Brigade loses 150 men and much equipment during a defeat at Old Fort Wayne.

OCTOBER 27

LOUISIANA, *LAND WAR*
The Battle of Georgia Landing/Labadieville/Texana. A Union expedition

to take control of the Bayou Lafourche leads to a decisive defeat of Confederate troops around Labadieville.

NOVEMBER 7

THE UNION, *ARMED FORCES*
President Abraham Lincoln appoints Ambrose E. Burnside commander of the Union Army of the Potomac in place of

▼ Scouts and guides of the Army of the Potomac, Berlin, Maryland, October 1862. Note the mix of civilian and military dress.

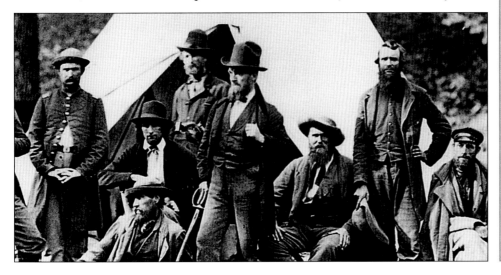

◄ A contemporary engraving shows Ambrose Burnside issuing orders to his staff soon after taking command of the Army of the Potomac in November 1862.

George B. McClellan, who he felt was not aggressive enough.
MISSOURI, *LAND WAR*
The Battle of Clark's Mill/Vera Cruz. A Union force of 100 men occupying Clark's Mill, Douglas County, surrenders after battling 1,000 Confederate troops.

NOVEMBER 28

ARKANSAS, *LAND WAR*
The Battle of Cane Hill/Boston Mountains. Federal forces defeat the rebels at Cane Hill, thus extending Union control in the Trans-Mississippi region.

DECISIVE MOMENT

THE ERLANGER LOAN

In 1863 the Confederate government struck a deal with the French banking house of Emile Erlanger & Company (signed on October 28, 1862, and modified on January 3, 1863). The bank agreed to sell $15 million worth of Confederate bonds (paper money) to private investors. The so-called Erlanger loan was unusual because the bonds were guaranteed not by gold but by "white gold"—cotton. Investors could exchange the bonds for cotton after the war at a good rate. The loan was hugely popular, attracting a host of high-profile investors in England, including the future prime minister, William Ewart Gladstone. The Confederate government used the money to buy vitally needed armaments and supplies for the troops.

DECEMBER 7

▶ J.E.B. Stuart (far right) and his Confederate cavalry in the area around Culpepper Courthouse. In the background, at right, cavalry are skirmishing with Union troops.

DECEMBER 7

TENNESSEE, *LAND WAR*
The Battle of Hartsville. Union troops guarding the Hartsville Crossing on the Cumberland River are overwhelmed by a large-scale Confederate attack. The Union defeat allows more extensive Confederate raiding into West Tennessee and Kentucky.

ARKANSAS, *LAND WAR*
The Battle of Prairie Grove/Fayetteville. Confederate forces are forced to retreat after a bloody engagement in Washington County, giving the Federal forces control over northwest Arkansas.

DECEMBER 13

VIRGINIA, *LAND WAR*
The Battle of Fredericksburg/Marye's Heights. Eager to prove his aggressiveness as the commander of the Army of the Potomac, Burnside planned a winter offensive toward Richmond, Virginia, aiming to cross the Rappahannock River at Fredericksburg. Burnside had an army of 120,000 men. He reorganized it into three Grand Divisions—Right, Center, and Left—each of two army corps plus attached cavalry. By November 19 the Union army was occupying Falmouth to the north of Fredericksburg and the Stafford Heights overlooking the river. It

was a great achievement to get such a large army moving so fast; but once at the Rappahannock, the Union forces halted. The bridge had been destroyed, and Burnside's army had to wait a month for pontoon bridges to arrive.

Lee's Confederate army took full advantage of the delay. On November 19 James Longstreet's corps (41,000 men) arrived on Marye's Heights, a ridge overlooking the city, and began digging in.

"Stonewall" Jackson's corps of 39,000 began to arrive and were posted to Longstreet's right flank, extending the Confederate position 7 miles (11km) south to Prospect Hill. Lee was assembling an army of 90,000 men

The Battle of Fredericksburg ▶

On December 11 Union forces built six pontoon bridges across the river under continuous fire from the last Confederates in Fredericksburg. Union forces occupied and looted the city on the 12th (1). On December 13, in the Union assault on Prospect Hill, only two small divisions attacked due to mismanagement. One division, commanded by Major General George G. Meade, was in the van; Major General John Gibbon's division was in support. Meade's troops actually broke through an unguarded gap in the Confederate lines, but Jackson's men expelled the unsupported Federals. The Confederates pushed the Union troops back to the river (2). At 12:00 hours the Union assault on the Confederate forces entrenched on Marye's Heights began. Wave after wave of Federal attackers were mown down by Confederate troops firing from a strong position in a sunken road protected by a stone wall. Indeed, no fewer than 14 successive Federal brigades charged the Confederate position. They continued until dark with no effect (3). Burnside retreated across the river on December 15.

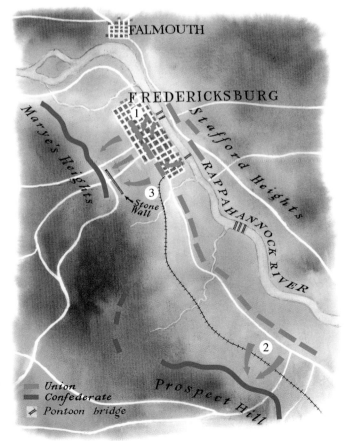

Union
Confederate
Pontoon bridge

entrenched on heights from which they could fire on almost every inch of ground to the river.

Not until December 11 was Burnside able to bridge the river. His forces built six pontoon bridges under fire from Confederates in the city. By nightfall they were occupying Fredericksburg. On December 12 Edwin V. Sumner's Union Right Grand Division formed up among Fredericksburg's streets, while William B. Franklin's Left Grand Division marched downstream to cross.

Franklin makes an assault today with the aim of taking Prospect Hill. By 09:00 hours just two small divisions have advanced, only to be pinned down by Confederate fire. By the afternoon they are still at the foot of the ridge. A counterattack drives the Federals back. Franklin's assault is over for no gain.

Burnside's second attack is toward Longstreet. From 12:00 hours brigade after brigade of Sumner's Grand Division advances out of the city, trying to cover the 800 yards (730m) of open

ground to the Confederate guns on Marye's Heights positioned behind a stone wall. There are 14 successive charges, but not one Union soldier gets within 100 feet (30m) of the wall. By evening 6,500 Union troops lay dead and dying.

DECEMBER 14

VIRGINIA, *LAND WAR*
The Battle of Fredericksburg/Marye's Heights. Burnside orders renewed attacks, but is persuaded by his officers that they would be futile. He orders his troops back across the river. His losses are awful. Over 12,000 are killed or wounded. Confederate losses are 4,700. The battle proves to be one of the South's most overwhelming victories. Once again the Union army's advance to Richmond has failed. The defeat lowers morale in the Army of the Potomac and throughout the North.

NORTH CAROLINA, *LAND WAR*
The Battle of Kinston. A Union expedition towards the Wilmington &

Weldon Railroad at Goldsborough pushes aside tough Confederate opposition at Kinston Bridge.

DECEMBER 16

NORTH CAROLINA, *LAND WAR*
The Battle of White Hall/Whitehall/White Hall Ferry. Federal troops of the Goldsborough expedition fix Confederate forces on the Neuse River while the mass of Union troops continue their march.

KEY WEAPONS

MODEL 1861 RIFLE MUSKET
One of the most widely issued rifles was the U.S. Model 1861 Rifle Musket, of which over a million were produced, most of them at the Union Arsenal at Springfield, Massachusetts. They were issued to the Union army, but the Confederates got hold of huge numbers of them after some of the Union's worst defeats. During July and August 1862, Confederate General Robert E. Lee's Army of Northern Virginia picked up 55,000 new rifles after beating the Army of the Potomac during the Seven Days' Battles and the Second Battle of Bull Run, when Union soldiers threw away their weapons in retreat.

▼ *A lithograph of the Union Army of the Potomac crossing the Rappahannock River to Fredericksburg under fire from Confederate snipers in December 1862.*

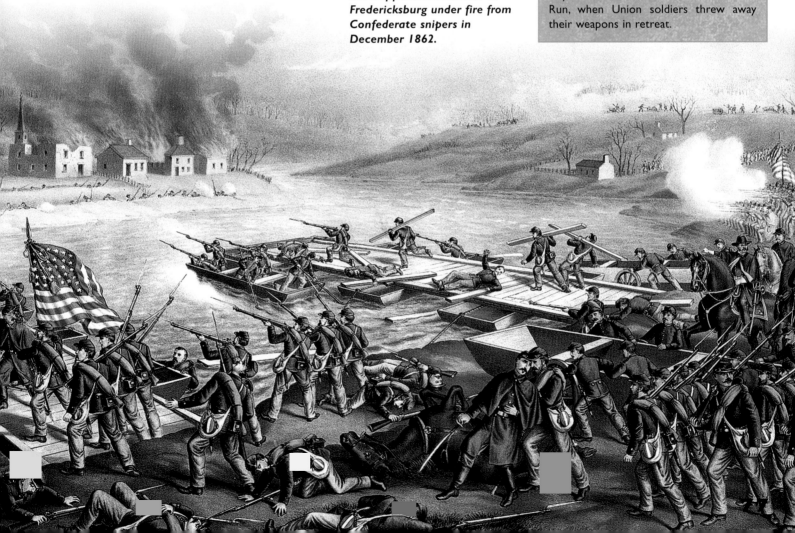

DECEMBER 17

▶ *Union and Confederate forces fighting at the Battle of Murfreesboro. The Confederates initially forced the Union troops to fall back, but the last day of the battle resulted in victory for the North.*

DECEMBER 17

NORTH CAROLINA, *LAND WAR*
The Battle of Goldsborough Bridge. Brigadier General John G. Foster's Goldsborough expedition reaches its destination, destroying railroad track and the Goldsborough Bridge.

DECEMBER 19

TENNESSEE, *LAND WAR*
The Battle of Jackson. General Nathan Bedford Forrest attacks Union railroad supply lines near Jackson.

DECEMBER 26–29

MISSISSIPPI, *LAND WAR*
The Battle of Chickasaw Bayou/Walnut Hills. The Union assault towards Vicksburg is stopped and suffers 1,776 casualties when it runs into Confederate defenses in the Walnut Hills.

DECEMBER 31

TENNESSEE, *LAND WAR*
The Battle of Parker's Cross Roads. A Union attempt to cut off Nathan Forrest's men from retreating across the Tennessee River fails, despite having caught Forrest in a pincer attack.

▼ *The Union right flank under attack at the Battle of Murfreesboro, December 31, 1862. Here, General Rousseau's division (foreground) has arrived to reinforce the endangered Union flank.*

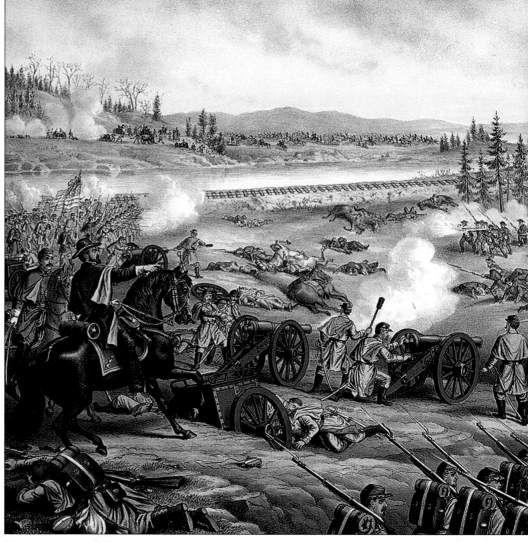

DECEMBER 31–JANUARY 2

TENNESSEE, *LAND WAR*
The Battle of Murfreesboro/Stones River. In December 1862 Rosecrans ordered his Union Army of Cumberland out of its winter quarters near Nashville to advance south to Murfreesboro, where Braxton Bragg's Confederate Army of Tennessee was assembled. By December 30 the two armies faced each other near Stones River. Each general planned to attack the other's right flank, hoping a successful assault would lead to the rout of the opposing army. The Confederates struck at dawn the next day, and enjoyed considerable success as seven brigades fell on two Union brigades guarding Rosecrans' flank. But

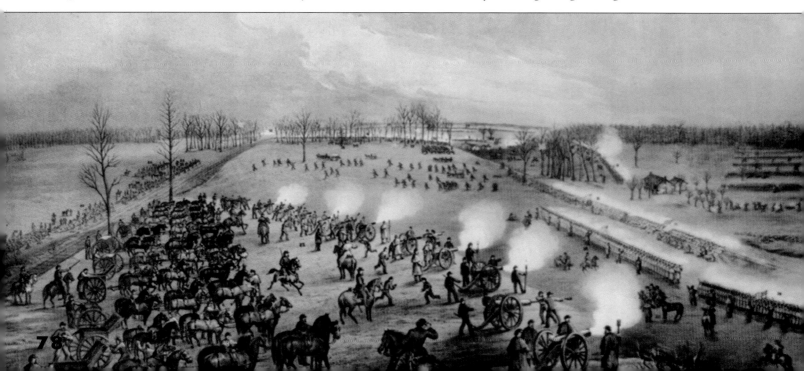

▲ *The Confederate cavalry commander Nathan Bedford Forrest. His attack at Jackson was little more than a feint while two other mounted columns destroyed railroad track north and south of Jackson.*

the spirited attack did not lead to a rout; instead, the Union army conducted a fighting retreat.

Throughout today the Army of Tennessee repeatedly assaults the Union forces, while Rosecrans and his

▼ *A smashed Union army limber lies in the Chickasaw Bayou following Union General Sherman's defeat at the battle of the same name in December 1862. This clash halted the Union drive on Vicksburg.*

staff desperately try to hold their ground. By the time darkness falls, the Confederates have succeeded in driving their opponents back more than 2 miles (3.2km). Bragg wires to Richmond that the Union army is in retreat.

But to Bragg's surprise the dawn's light reveals Rosecrans' army waiting to renew the fight. Little happened on New Year's Day, but fighting resumed on January 2, when Bragg ordered a frontal assault on an isolated Union

position. An initial success turned into the repulse of the Confederates. Bragg ordered a retreat on the morning of January 3, although his decision was swayed by the false impression that the Union army had been reinforced.

The battle was among the hardest fought of the Civil War. Of Bragg's 35,000 troops, 27 percent were killed or wounded. The Union forces lost 23 percent of their 41,400 men. The battle was a strategic victory for the Union forces, which secured control of Kentucky while increasing their hold on Tennessee. It also boosted morale after the disaster at Fredericksburg. Lincoln telegraphed his battered but unyielding troops a heartfelt "God bless you."

1863

This year was the turning point in the Civil War. On the battlefield the South was defeated at the Battle of Gettysburg, thus bringing to an end the Confederacy's ability to mount strategic offensives. More importantly, perhaps, Lincoln's Emancipation Proclamation turned the war into a moral crusade to abolish slavery. This made European military or diplomatic support for the South impossible.

THE UNION, *ECONOMY*

The Homestead Act comes into effect today. The first Federal law to encourage enterprise, it grants a farmer 160 acres of federal land in the West after he or she has lived on the land for five years and made improvements to it. A total of 80 million acres will be allocated in this way, and the Homestead Act will give a major push to western migration.

THE UNION, *CIVIL RIGHTS*

President Lincoln's Emancipation Proclamation comes into effect today, thus ensuring that the Civil War becomes a war of black liberation in addition to a struggle to save the Union.

Lincoln has repeatedly asserted that his responsibility as president is to suppress the South's rebellion, not to free its slaves. However, the issue of slavery lies at the heart of the conflict and has to be addressed sooner or later. Lincoln judges that there is enough public support for emancipation to incorporate it into national policy.

The timing is right for such action for several reasons. The Civil War has reached a military stalemate, and morale is low in the North. The military successes of the Confederacy have depended to a significant degree on slaves, who provide the labor that supplies the Southern armies, freeing up white men to serve in the ranks. The Union desperately needs men to fill depleted regiments. There is also the fear that Britain might recognize the Confederate government.

▼ *The Union began to recruit black troops at the end of 1862. This photograph shows men of the 4th U.S. Colored Infantry at Fort Lincoln—part of the Washington defenses.*

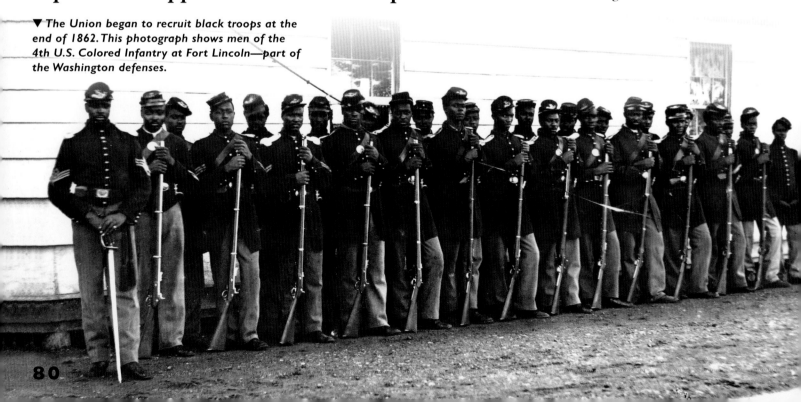

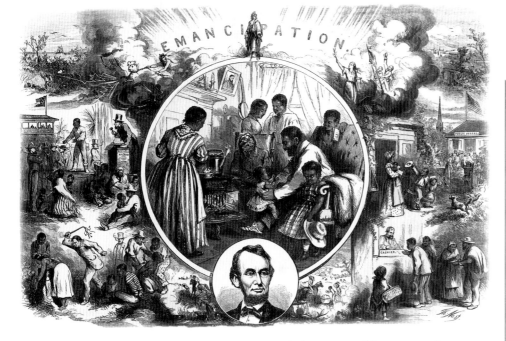

▲ *A celebration of the emancipation of Southern slaves. The central scene shows an idealized freedman's home. Scenes of black life under slavery (left) are contrasted with scenes of freedmen after the war (right).*

Lincoln did not want to make the proclamation while the North was in a weak position militarily. The Union's tactical victory at the Battle of Antietam provided the breakthrough he needed. Five days later, on September 22, 1862, he issued his preliminary Emancipation Proclamation. In it he gave the rebellious states an ultimatum. If they did not stop fighting and reaffirm their allegiance to the United States by the end of the year, their slaves would be declared free. When Lincoln's deadline came and went and not a single Confederate state had surrendered, emancipation of the South's slaves became a major war aim.

Confederate President Jefferson Davis states the proclamation is an "effort to excite servile war within the Confederacy." He blasts it as "the most execrable measure recorded in the history of guilty man," one that will lead to insurrection by the slaves and to their ultimate "extermination." Davis declares that "all negro slaves captured in arms" and their white officers will be tried under Confederate laws.

Across the Mason–Dixon line, however, abolitionists, African Americans, and others welcome the proclamation. Leading abolitionist Frederick Douglass congratulates Lincoln on "this amazing approximation toward the sacred truth of human liberty." "We are all liberated … by the Emancipation Proclamation," Douglass says. "The white man is liberated, the black man is liberated, the brave men now fighting … against rebels and traitors are now liberated."

▼ *A Union camp in the Eastern theater. The soldiers have built wooden huts to last the winter using trees from the surrounding woodland. Hardtack boxes were used as tables inside the huts.*

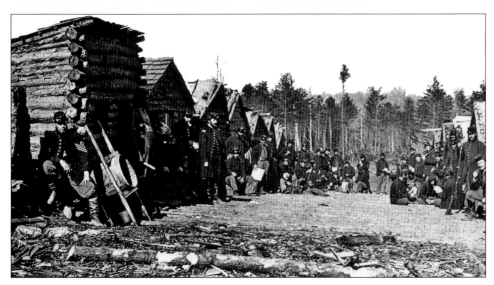

DECISIVE MOMENT

EMANCIPATION PROCLAMATION

"That on the first day of January, in the year of our Lord one thousand eight hundred and sixty-three, all persons held as slaves within any State, or designated part of a State, the people whereof shall then be in rebellion against the United States, shall be then, thenceforward, and forever free; and the Executive Government of the United States, including the military and naval authority thereof, will recognize and maintain the freedom of such persons, and will do no act or acts to repress such persons, or any of them, in any efforts they may make for their actual freedom.

"Now, therefore, I, Abraham Lincoln, President of the United States, by virtue of the power in me vested as commander-in-chief of the army and navy of the United States, in time of actual armed rebellion against the authority and government of the United States, and as a fit and necessary war measure for suppressing said rebellion, do, on this first day of January, in the year of our Lord one thousand eight hundred and sixty-three, and in accordance with my purpose so to do, publicly proclaimed for the full period of 100 days from the day first above mentioned, order and designate as the States and parts of States wherein the people thereof, respectively, are this day in rebellion against the United States, the following, to wit:

"Arkansas, Texas, Louisiana (except the parishes of St. Bernard, Plaquemines, Jefferson, St. John, St. Charles, St. James, Ascension, Assumption, Terre Bonne, Lafourche, St. Mary, St. Martin, and Orleans, including the city of New Orleans), Mississippi, Alabama, Florida, Georgia, South Carolina, North Carolina, and Virginia (except the forty-eight counties designated as West Virginia, and also the counties of Berkeley, Accomac, Northampton, Elizabeth City, York, Princess Anne, and Norfolk, including the cities of Norfolk and Portsmouth), and which excepted parts are for the present left precisely as if this proclamation were not issued.

"And by virtue of the power and for the purpose aforesaid, I do order and declare that all persons held as slaves within said designated States and parts of States are, and henceforward shall be, free; and that the Executive Government of the United States, including the military and naval authorities thereof, will recognize and maintain the freedom of said persons."

JANUARY 8

Many, however, are disappointed that Lincoln bases his proclamation on military necessity, rather than a commitment to racial equality. They point out that the proclamation is very limited, freeing slaves only in areas still under Confederate control—not in the loyal border states or in Union-controlled parts of the Confederacy.

The final Emancipation Proclamation decrees that freed slaves "will be received into the armed service of the United States to garrison forts, positions, stations, and other places, and to man vessels of all sorts." This signals a major change in policy, because since 1861 the Union army has turned away free black volunteers.

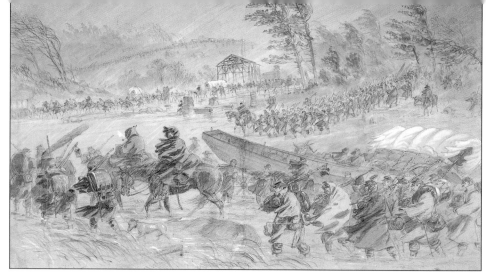

▲ Students at the Academy of Fine Arts in Philadelphia making a flag during the war. The voluntary activities of Union civilians helped keep up morale.

By 1865 the army had raised 180,000 black soldiers. The Emancipation Proclamation thus began the process of freeing and arming the South's slaves. It did not end slavery—that was not achieved until the Thirteenth Amendment to the Constitution in December 1865—but it gave the Union cause a moral force and strengthened the Union both militarily and politically. It also ended any chance of foreign intervention—no European country was prepared to oppose a crusade against slavery.

TEXAS, *LAND WAR*
The Battle of Galveston. Galveston, garrisoned by three companies of the Union 42nd Massachusetts Volunteer Infantry Regiment under the command of Colonel Isaac S. Burrell, is recaptured by a combined land/sea assault by the

▲ The "Mud March" of January 1863—the Union Army of the Potomac's fruitless attempt to cross the Rappahannock River after suffering defeat at Fredericksburg.

Confederates. But the Union blockade remains in place.

JANUARY 8

MISSOURI, *LAND WAR*
The Battle of Springfield. Union troops occupying the major supply depot at Springfield repel

large-scale Confederate attacks, inflicting 240 casualties on the Rebels.

JANUARY 9-11

MISSOURI, *LAND WAR*

The Battle of Hartville. Elements of John S. Marmaduke's Confederates raid into Missouri and drive Union troops out of Hartville on two occasions, the second time as Union forces attempt to surround the Confederates.

ARKANSAS, *LAND WAR*

The Battle of Arkansas Post/Fort Hindman. A Union combined force envelops and captures Fort Hindman, a major hindrance to Union shipping on the Mississippi. Union losses are 1,047. Over 5,000 Confederates surrender.

JANUARY 20-22

VIRGINIA, *LAND WAR*

The Union Army of the Potomac begins its march to quickly cross the Rappahannock River above Lee's left and attack that flank of the Confederate position. However, it begins to rain relenetlessly, turning the whole area into a sea of mud. The "Mud March" ends with Burnside ordering his army to return to their camps across the river from Fredericksburg.

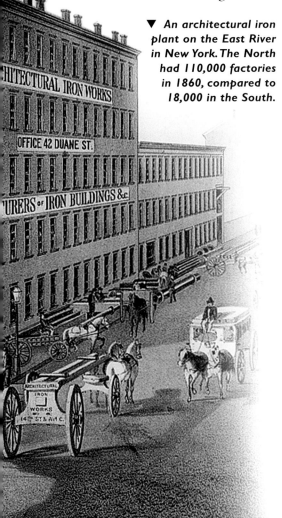

▼ *An architectural iron plant on the East River in New York. The North had 110,000 factories in 1860, compared to 18,000 in the South.*

JANUARY 29

IDAHO, *INDIAN WARS*

The Battle of Bear River/Massacre at Boa Ogoi. Union retaliation against the Shoshoni tribe kills over 380 Native Americans at their Boa Ogoi camp.

JANUARY 30-31

SOUTH CAROLINA, *NAVAL WAR*

Confederate ironclads CSS *Chicora* and CSS *Palmetto State* disperse the Union blockade fleet in front of Charleston.

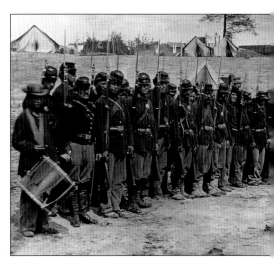

▶ *Men of Company C, 110th Pennsylvania Volunteer Infantry, which fought in the Battle of Fredericksburg and took part in the notorious "Mud March."*

KEY PERSONALITY

JOHN MOSBY

John Singleton Mosby (1833–1916) and his men have acquired a mythical status over the years, especially in the South. Mosby was born in 1833 in Powhatan County, Virginia. While at the University of Virginia, he engaged in an argument with a fellow student, whom he then shot. After seven months in jail Mosby was pardoned in 1853 and began studying law. After qualifying, he joined the bar, married, and settled in Bristol, Virginia.

When Virginia seceded and was accepted into the Confederacy, Mosby left his law practice and moved to the Richmond area, where he enlisted in the army and spent a short time in a training camp. Sent almost immediately to the Shenandoah Valley, Private Mosby reported for duty with the 1st Virginia Cavalry Regiment, commanded by Lieutenant Colonel J.E.B. Stuart. Stuart and Mosby got along well, and Stuart made it a practice to assign the young private difficult scouting missions. After soldiering with Stuart in 1862, in March 1863 Mosby was commissioned a captain and formed a unit of partisan rangers in northern Virginia.

Mosby's unit grew in size until the Confederate government designated it the 43rd Battalion Virginia Cavalry. Most people knew the outfit instead as "Mosby's Rangers." Mosby planned and executed raids on Union outposts in the northern Virginia counties around Washington, D.C. He used the area around Warrenton as his base, but continually moved his headquarters to avoid Union retaliatory attacks. His rangers frequently served in raiding parties and melted back into the local populace afterward. From 1863 to 1865 Mosby is estimated to have captured more than 1,000 Union prisoners, more than 1,000 horses, large amounts of weapons and ammunition, and hundreds of thousands of dollars in U.S. currency.

Mosby caused little or no diversion of troops from the fighting fronts. Although the "Gray Ghost" controlled the roads and fields of "Mosby's Confederacy," his actions did not have any effect on the eventual outcome of the war. Unwilling to surrender with Robert E. Lee, Mosby disbanded his partisan rangers on April 21, 1865, 11 days after Lee's surrender at Appomattox.

After the war Mosby prospered. He became a personal friend of U.S. presidents Ulysses S. Grant, Rutherford B. Hayes, William McKinley, and Theodore Roosevelt, all of whom used their influence to secure various U.S. government positions for him. Among them was the ambassadorship to Hong Kong. Returning to Virginia in his old age, Mosby died in May 1916.

DECISIVE MOMENT

IMPRESSMENT

The act that gave the Confederate government the right to impress private property for the maintenance of the army and navy was passed on March 6, 1863. All private property could be impressed by the army for public use, although breeding livestock was exempted in March 1865.

Impressment officers were appointed by state governors to seize cattle, clothing, food, horses, iron, railroads, domestic and industrial property, slaves, and even freedmen. Compensation for the impressed property was set by a price schedule and by two independent parties, one chosen by the impressment officer, the other appointed by the property owner. Impressment of freedmen was like a draft—the laborers were compensated personally with an established minimum wage.

At the beginning of the war the Union government already had the power to impress private property in military emergencies. However, the government seldom took advantage of the right because the Union was not as short of supplies as the Confederacy.

The Confederate law of March 1863 simply legalized established practice and was an attempt to regulate the behavior of army units. Confederate armies already used impressment in emergencies and paid for the goods later when the owner brought compensation claims. Nevertheless the law was widely unpopular. Many Southern governors complained to the War Department, taking the view that the power of impressment violated state and individual rights. Governor Zebulon B. Vance of North Carolina described impressment, in particular when imposed by an undisciplined cavalry unit, as a "plague worse than all others."

In spring 1863 the Confederate government took another unpopular measure to sustain the army, passing a 10 percent "tax in kind" on farm produce. Southerners regarded this as impressment under another name.

Opposition to impressment grew in the last months of the war, when the price schedule was abandoned. Impressment officers needed only to give a "just price" for impressed goods. The "just price" took no account of the rapid inflation of Confederate currency. Many people believed the vagueness of the phrase allowed officers to make personal profit.

FEBRUARY 3

TENNESSEE, *LAND WAR*
The Battle of Dover/Fort Donelson. Having failed in a mission to disrupt shipping on the Cumberland River, Confederate cavalry make an unsuccessful and bloody attempt to crush the Union garrison at Dover.

MARCH 3

THE UNION, *ARMED FORCES*
The Union government issues the National Conscription Act. It is deeply unpopular with those who cannot afford to hire a substitute or pay a $300 fee to avoid military service. But opposition to the draft also grows out of racial tensions in Union cities. The war's deprivations have hit hard the poor working classes, in particular the Irish Catholic immigrant community. After the announcement of the Emancipation Proclamation in January 1863, some question waging a war for black freedom.

GEORGIA, *NAVAL WAR*
The Battle of Fort McAllister I. Three Union ironclads make an eight-hour test bombardment of the Confederate defenses at Fort McAllister.

MARCH 5

TENNESSEE, *LAND WAR*
The Battle of Thompson's Station. A Union infantry brigade attacks Major General Earl Van Dorn's Confederate I Cavalry Corps, but ends up surrounded and forced to surrender.

MARCH 6

CONFEDERACY, *POLITICS*
A Confederate impressment law is passed, giving army officers the right to

◄ An impressment receipt for a 22-year old slave. The power of the Confederate army to impress slaves and other private property for the war effort was bitterly opposed by many Southerners.

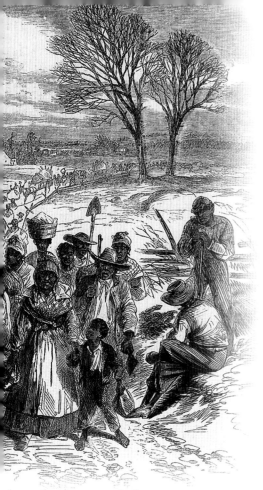

▲ An illustration in Harper's Weekly of freedmen coming into Union lines following the Emancipation Proclamation.

▶ A marriage at the camp of the 7th New Jersey Volunteers of the Army of the Potomac, March 1863. Note the regimental title above the couple and the standards.

men mount a raid behind enemy lines to Fairfax Court House, only a few miles from the Union capital, Washington, D.C. Mosby finds and captures Union General Edwin Stoughton, commander of the division garrisoning the Fairfax area. Mosby plus his men, the general, 33 other prisoners, and 58 captured horses are safely back in Warrenton by dawn.

MARCH 13–15

NORTH CAROLINA, *LAND WAR*
The Battle of Fort Anderson/Deep Gully. Major General D.H. Hill takes a division of Confederate troops against the Union's Fort Anderson, but is repelled by heavy infantry and gunboat fire. There are only a total of seven casualties in this engagement.

▼ A drawing by Alfred Waud of St. Patrick's Day sports in the Irish Brigade of the Union Army of the Potomac in 1863. This brigade, commanded by Thomas F. Meagher, was the most famous Irish unit.

take food from farmers at prescribed rates. It is immediately unpopular.

MARCH 8

MARYLAND, *LAND WAR*
Confederate partisan leader John Mosby and 29 of his

MARCH 20

TENNESSEE, *LAND WAR*
The Battle of Vaught's Hill/Milton. A Union reconnaissance force success-fully maintains a defence against a Confederate cavalry division on Vaught's Hill, Rutherford County.

MARCH 25

TENNESSEE, *LAND WAR*
The Battle of Brentwood. A Confederate show of strength forces the surrender of a Union garrison at Brentwood, a station on the Nashville & Decatur Railroad.

MARCH 30–APRIL 20

NORTH CAROLINA, *LAND WAR*
The Battle of Washington. A Confederate force besieges Washington in North Carolina but, unable to prevent seaborne supplies being landed, is eventually forced to withdraw.

▼ The cover of Harper's Weekly on March 14, 1863, showed a Union officer training black recruits to use a rifle.

APRIL 2

THE CONFEDERACY, *ECONOMY*
Despite the Confederate government's best efforts, increasing desperation is leading to civilian protests across the South. The crops from the last year's drought-ravaged season are running out. Prices are spiraling out of control. A family's weekly grocery bill for staples such as flour and butter has risen from a prewar $6.55 to $68.25. Civilians suspect that storekeepers and the government are hoarding supplies, and in a dozen or more places starving women stage bread riots.

The worst of these riots occurs in Richmond, Virginia, today, where several hundred women—later joined by men and boys—begin to smash store windows and seize food and clothing. Confederate President Jefferson Davis himself arrives on the scene to calm the rioters. But despite Davis's appeal to Southern patriotism, the crowd refuses to leave. Eventually he warns them to go home or he would order the militia to fire, and the crowd disperses.

APRIL 7

SOUTH CAROLINA, *NAVAL WAR*
The Battle of Charleston Harbor. Charleston is well protected by Fort Sumter and other lesser fortifications,

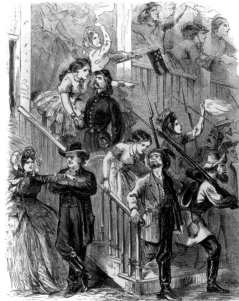

▲ *A Northern engraving of Southern women persuading their husbands to go to war (left) and then, later, dressed in rags, rioting for bread (right).*

and has withstood several naval assaults earlier in the war. Union Rear Admiral Samuel F. Du Pont launches a major assault on the city with a flotilla of seven monitor warships and two other ironclads. However, the ships are driven back by 77 Confederate cannon on Fort Sumter and run into the harbor's mines and obstructions. Du Pont is forced to withdraw. He decides against renewing his attack the next day after one of the ironclads, the USS *Keokuk*, sinks during the night. Union land and sea forces will besiege Charleston during the next 20 months.

APRIL 10

TENNESSEE, *LAND WAR*
The Battle of Franklin. A reconnaissance by Confederate cavalry of Major General Earl Van Dorn turns into a defeat and withdrawal after an major engagement around Franklin.

APRIL 11

ALABAMA, *LAND WAR*
Union Colonel Abel Streight raids into Alabama and Georgia in an attempt to cut the Western and Atlantic Railroad. He fights a rearguard action at Day's Gap, Cullman County, against the

▼ *Alfred Pleasonton (right) and George A. Custer (left), two of the Union army's cavalry commanders, photographed in Falmouth, Virginia, in April 1863.*

Confederates led by Nathan B. Forrest. Streight's entire command of 1,500 men will be captured on May 3.

APRIL 11–MAY 4

VIRGINIA, *LAND WAR*
The Battle of Suffolk/Fort Huger/Hill's Point. A Union force takes Fort Huger on the Nansemond River but is repulsed when moving against Fort Dix.

APRIL 12–13

LOUISIANA, *LAND WAR*
The Battle of Fort Bisland/Bethel Place. The Confederate strongpoint at Fort Bisland falls to a Union expedition up Bayou Teche in western Louisiana. The expedition's ultimate objective is Alexandria, which is now vulnerable.

APRIL 13–15

VIRGINIA, *LAND/NAVAL WAR*
The Battle of Suffolk/Norfleet House Battery. An inconclusive Confederate siege of Suffolk, Virginia, costs a total of 1,160 casualties.

APRIL 14

LOUISIANA, *LAND WAR*
The Battle of Irish Bend/Nerson's Woods/Franklin. Union forces, attempting to cut off a Confederate retreat from Fort Bisland, defeat Rebel troops at Nerson's Woods, about 1.5 miles (2.2km) from Franklin.

APRIL 17

MISSISSIPPI, *LAND WAR*
Union Colonel Benjamin H. Grierson leads the 2nd Iowa, 6th Illinois, and 7th Illinois Cavalry, and several artillery batteries, out of La Grange, Tennessee, south into Mississippi. This raid is part of General Ulysses S. Grant's plan for the cavalry raiders to divert the attention

▲ *African Americans at a recruitment center volunteering for the Union army. The Union only started actively recruiting African Americans in spring 1863.*

KEY PERSONALITY

THOMAS JACKSON

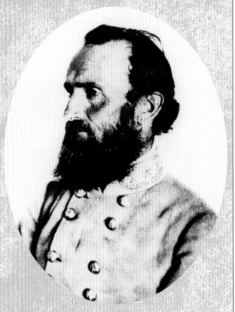

Thomas Jonathan Jackson (1824–1863) was born on January 21, 1824, in Clarksburg, Virginia (now West Virginia). He was orphaned at an early age and was brought up by relatives. Jackson had little formal education until he entered the U.S. Military Academy at West Point in 1842. After graduating in 1846, he fought in the Mexican War (1846–1848), during which he was breveted three times for bravery.

After the Mexican War Jackson left the army, finding peacetime service unrewarding. In 1851 he was appointed professor of artillery tactics and natural philosophy at the Virginia Military Institute (VMI) in Lexington, where he remained for 10 years. He became a Presbyterian, and his faith had a profound influence on him for the rest of his life—he was sometimes called "Deacon Jackson."

Jackson had several eccentricities; for example, he imagined that one side of his body weighed more than the other and so often walked or rode with one arm raised to keep his balance. During his time at VMI he married twice. His first wife, Elinor Junkin, died in childbirth. In 1857 he married Mary Anna Morrison, who bore him his only surviving daughter, Julia, in 1862. In 1859 Jackson witnessed the execution of the abolitionist John Brown, when he accompanied a group of VMI cadets to stand guard at the hanging. He later wrote that he was so moved by Brown's plight that he petitioned for his pardon.

Jackson joined the Confederate army when the Civil War started out of loyalty to his home state, Virginia. He earned his nickname of "Stonewall" at Bull Run (Manassas) in July 1861, the first major battle of the war. As his brigade stood firm in the face of a Union onslaught, a fellow officer, General Barnard Bee, rallied his troops by pointing out the conduct of Jackson and his brigade: "There is Jackson, standing like a stone wall!" For his actions Jackson was promoted to major general in October 1861.

In early 1862 Jackson led a campaign in the Shenandoah Valley, during which he defeated Union generals whose combined strength was several times his own. His orders were to keep Union General Nathaniel P. Banks from joining forces with General George B. McClellan, who was fighting the Peninsular Campaign. During the six-week campaign his diversionary tactics succeeded brilliantly. The speed with which Jackson's troops were able to march earned them the nickname of Jackson's "Foot Cavalry."

Jackson then joined Robert E. Lee, who had taken command of Southern forces in Virginia and reorganized them into the Army of Northern Virginia. In the ensuing Seven Days' Campaign of June 1862 Jackson became slow and ineffective, probably due to physical exhaustion. He soon recovered, however, and at Second Bull Run (Manassas) he marched with 20,000 men over 50 miles (80km) in two days, destroying the Union supply base at Manassas Junction on August 27. At the battles of Antietam (Sharpsburg) on September 17 and Fredericksburg on December 13 his troops fought hard, making a great contribution to a string of Southern victories. In October 1862 Jackson was promoted to lieutenant general, and Lee gave him command of II Corps of the Army of Northern Virginia. The two men worked well together: Jackson said he trusted Lee so much he would follow him blindfolded.

In May 1863 Jackson won his greatest victory at Chancellorsville, Virginia. Lee sent him on a wide flanking march to attack the right wing of Joseph Hooker's Union army from the rear, which Jackson accomplished with devastating effect. But the battle had a tragic aftermath. Scouting between two frontline Confederate regiments on the evening of May 2, Jackson's party was mistaken for enemy troops, and he was shot by his own men. The wound was not fatal, but his arm had to be amputated. He contracted pneumonia and died eight days later, on May 10, 1863. Jackson's death was a bitter loss for the Confederate cause and particularly for Robert E. Lee, who mourned: "I know not how to replace him."

of Confederate forces protecting Vicksburg so that he can move his army south of the vital river city. If the cavalry does its job, Grant will be able to cross the Mississippi River and attack Vicksburg.

Grierson's men soon encounter Southern militia. Although the Confederate cavalry try to intercept the Union raiders, Grierson manages to deceive and confuse them repeatedly. On three occasions he ignores conventional military tactics and divides his 1,700-man force, even though he is deep in enemy territory.

Reports of Grierson's elusive movements tricks General John C. Pemberton, commander of Confederate forces at Vicksburg, into moving troops away from the Mississippi River to trap the Union raiders. At one time 20,000 Confederate troops are committed to stopping Grierson—men who were therefore unable to oppose Grant's river crossing. Grierson's men also succeed in

Grierson's Raid ▶

Union Colonel Benjamin Grierson led 1,700 cavalry on a raid into Mississippi. His report afterward stated: "During the expedition we killed and wounded about 100 of the enemy, captured and paroled over 500 prisoners, many of them officers, destroyed between 50 and 60 miles of railroad and telegraph, captured and destroyed over 3,000 stand of arms. Much of the country through which we passed was almost entirely destitute of forage and provisions, and it was but seldom that we obtained over one meal per day. Many of the inhabitants must undoubtedly suffer for want of the necessaries of life."

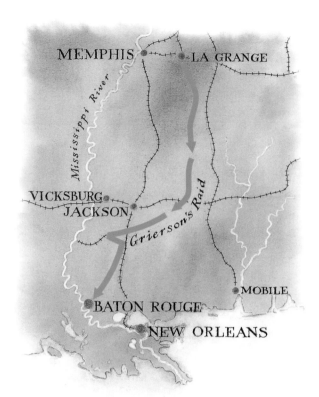

KEY PERSONALITY

NATHAN BEDFORD FORREST

Tactically aggressive and fearless in action, Nathan Bedford Forrest (1821–1877) was under fire at least 179 times in the war, during which he is believed to have killed 30 men in single combat, had 29 horses killed under him, and been wounded three times. One of the wounds came at the hands of a subordinate officer, who during an argument in June 1863 shot Forrest in the hip. Forrest responded by stabbing the man fatally with a penknife and then pursuing his dying would-be assassin through the streets with two loaded pistols as he tried to escape.

Forrest had very little formal education and no military training at all before the Civil War broke out in 1861, by which time he was one of the richest men in Tennessee. The state governor soon persuaded him to personally finance a new cavalry unit, and in October he became lieutenant colonel of Forrest's Tennessee Cavalry Battalion.

Forrest first saw action during the defense of Fort Donelson, Tennessee, in February 1862. When the fort surrendered, he led his men to safety through Union lines. Forrest was promoted to full colonel in March and took command of the 3rd Tennessee Cavalry. After the Battle of Shiloh in April he fought as part of the rearguard. During the retreat to Corinth, Mississippi, he was seriously wounded for the first time.

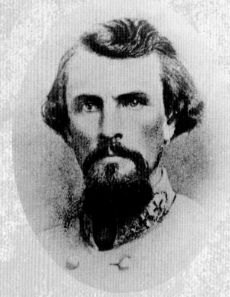

When he recovered, Forrest was given command of a cavalry brigade with which he launched a raid, attacking and overwhelming the Union garrison at Murfreesboro, Tennessee, on July 18. He was promoted to brigadier general three days later. During the winter of 1862–1863 Forrest continued raiding into western Tennessee and toward the Union garrison at Nashville. He also supported Braxton Bragg's advance into Kentucky in September and covered his retreat the following month.

In April 1863 Forrest and a small force of cavalry pursued a Union column of 1,500 mounted infantry under Abel Streight, which was raiding out of Nashville. At Cedar Bluff, Alabama, Forrest called for Streight's surrender. Fooled by the Confederate's self-confident demand, Streight surrendered his entire force to Forrest's cavalry, which by that time numbered barely 600 men.

Forrest was given a cavalry division in the Army of Tennessee in the summer and was promoted within weeks to the command of the cavalry corps. He distinguished himself at the Battle of Chickamauga and in December was promoted to the rank of major general.

On April 12, 1864, during Forrest's capture of Fort Pillow, Tennessee, his men killed both wounded black troops as they lay and others that had surrendered.

By June Forrest was in Mississippi. On the 10th he destroyed a Union column of 8,000 men under Samuel D. Sturgis at Brice's Crossroads. He followed this victory with a brief occupation of Memphis in August. By the end of 1864 Forrest and his cavalry were raiding Union supply depots and supply lines across Tennessee.

In his last campaign in 1865 he was defeated at Selma, Alabama, in April and finally surrendered at Meridian, Mississippi, on May 9. After the war Forrest was a leading organizer in the Ku Klux Klan, a secret society aiming to restore white supremacy.

▶ *By 1863 the South had lost 175,000 soldiers in the first two years of the war, losses it could ill-afford. Here, Southern women tend the graves of Confederate soldiers in Charleston, South Carolina, in 1903.*

doing much damage to bridges and railroads behind Vicksburg. They tear up the Southern Mississippi Railroad, the only rail link between the eastern and western parts of the Confederacy.

Southern troops never caught Grierson's men. After ravaging 600 miles (960km) of Confederate territory, Grierson once more did the unexpected: He escaped back behind Union lines by riding south to Union-held Baton Rouge, Louisiana, rather than north.

LOUISIANA, *LAND WAR*
The Battle of Vermillion Bayou. Confederate forces retreating from defeats at Fort Bisland and Irish Bend are defeated in an artillery duel action on the Vermillion Bayou, and retreat toward Opelousas.

APRIL 26

MISSOURI, *LAND WAR*
The Battle of Cape Girardeau. Brigadier General John S. Marmaduke's expedition into Missouri suffers a defeat when it attacks a heavily fortified Union position at Cape Girardeau.

APRIL 29

MISSISSIPPI, *LAND/NAVAL WAR*
The Battle of Grand Gulf. Seven Union ironclads are unable to subdue Confederate shore batteries at Grand Gulf, Claiborne County, despite a five-and-a-half-hour bombardment. However, this setback does not hamper Grant's Mississippi offensive.

▼ *A baseball game between Union prisoners at Salisbury prison, North Carolina. By fall of 1864, 10,000 men were held there in insanitary conditions.*

APRIL 29–MAY 1

MISSISSIPPI, *RIVER WAR*
The Battle of Snyder's Bluff/Snyder's Mill. A Union action on the Chickasaw Bayou against Rebel batteries at Drumgould's Bluff is unable to overwhelm the Confederate positions. A combination of swampy terrain and artillery fire force the Union troops to retire.

MAY 1

VIRGINIA, *LAND WAR*

The Battle of Chancellorsville. Joseph Hooker, commander of the Army of the Potomac, devised a new plan as the Army of the Potomac and the Army of Northern Virginia faced one another across the Rappahannock River at Fredericksburg. Instead of attempting a frontal attack on the Confederate positions overlooking Fredericksburg, Hooker divided his army and took half of it—three corps totaling 75,000 men—to cross the river at fords upstream and come around in a wide sweep to hit Lee from behind. John Sedgwick stayed at Fredericksburg with 40,000 men to pin the Confederates.

By April 30 the Union troops had crossed the river and were in a dense area of woodland called the Wilderness. The center of their position was a crossroads at Chancellorsville, Virginia. Hooker's plan had worked

smoothly so far, but now things started to go wrong.

Lee realized that Hooker was trying a flanking march. On April 29 he sent two brigades toward Chancellorsville to discover the size of the threat. Once they confirmed the Union army was at Chancellorsville, he went on the attack.

— THREE HEROES —

◀ *A drawing entitled "Three Heroes" of great Confederate generals. In the center is Robert E. Lee, flanked by "Stonewall" Jackson (right) and J.E.B. Stuart (left).*

Like Hooker, Lee divided his forces, leaving 10,000 men under Jubal A. Early to hold Fredericksburg and marching his remaining 50,000 men west to meet Hooker.

Hooker is taken by surprise today when the Confederates start an attack on his lead divisions at noon. The Union commander begins to lose his nerve. In midafternoon he halts the advance and orders his forces back to Chancellorsville to take up defensive positions.

MISSISSIPPI, *LAND WAR*

The Battle of Port Gibson/Thompson's Hill. Having crossed the Mississippi, Grant's forces moving against Vicksburg defeat a Confederate attempt to hold the river line at Port Gibson.

MAY 1–2

ARKANSAS, *LAND WAR*

The Battle of Chalk Bluff. General John S. Marmaduke calls off his Missouri expedition following heavy rearguard losses crossing the St. Francis River.

▼ *The carnage of war. A Confederate caisson and eight horses destroyed by Union heavy artillery at Fredericksburg in May 1863.*

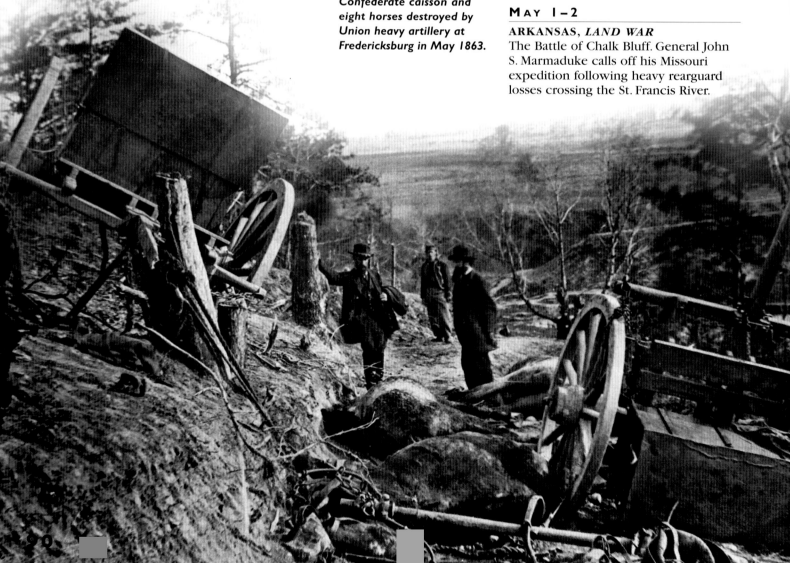

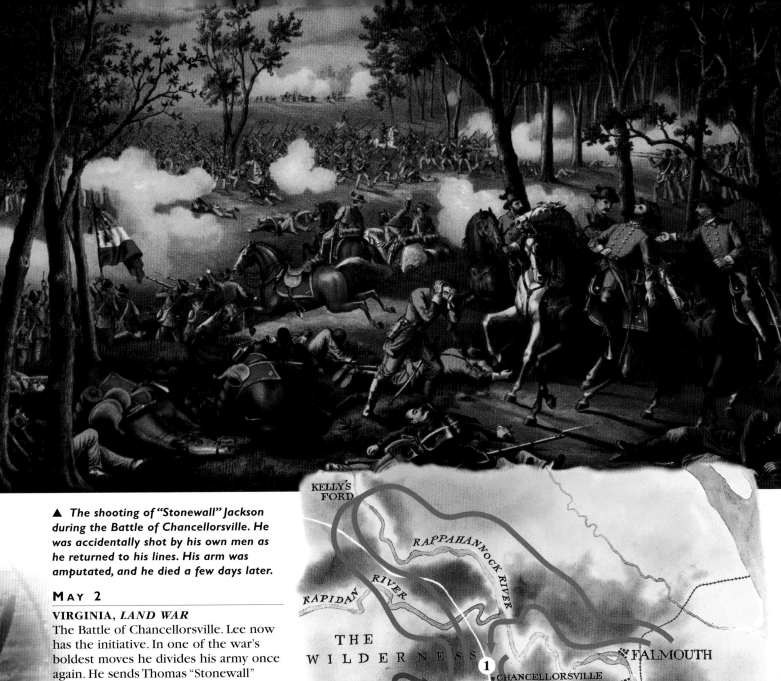

▲ *The shooting of "Stonewall" Jackson during the Battle of Chancellorsville. He was accidentally shot by his own men as he returned to his lines. His arm was amputated, and he died a few days later.*

MAY 2

VIRGINIA, *LAND WAR*
The Battle of Chancellorsville. Lee now has the initiative. In one of the war's boldest moves he divides his army once again. He sends Thomas "Stonewall" Jackson and 28,000 men on a 12-mile (19km) march to strike Hooker's right flank, while his remaining troops face three Union corps.

The march takes all day, but at 18:00 hours Jackson attacks the Union XI Corps, which is routed. Only nightfall saves Hooker's army. During the evening Jackson is shot by his own men who mistake his party for Union cavalry.

MAY 3

VIRGINIA, *LAND WAR*
The Battle of Chancellorsville. J.E.B. Stuart takes over Jackson's command and reopens the attack while Lee strikes from the south. The Union line is pushed back from Chancellorsville toward the river. Hooker is stunned when a shell explodes near him and hands over command to Darius Couch.

▲ The Battle of Chancellorsville
In a brilliant maneuver the Union army marched north from Fredericksburg, crossed the river, and took up positions around the Chancellorsville crossroads by April 30 (1). On May 2, Jackson surprised and routed the Union right flank, though in doing so he was shot by one of his own men (2). On May 3, fighting took place at both Chancellorsville and Fredericksburg, where Union forces attacked and drove the Confederates away and advanced to Salem Church (3). Lee turned his army around to stop this advance and defeated the Union troops on May 4 (4). Fortunately for Lee, Hooker remained totally inactive during the battle for Salem Church. By May 5, Lee was able to march back to face the main Union force under Hooker near Chancellorsville. That night Hooker began withdrawing his men to the north bank of the Rappahannock River.

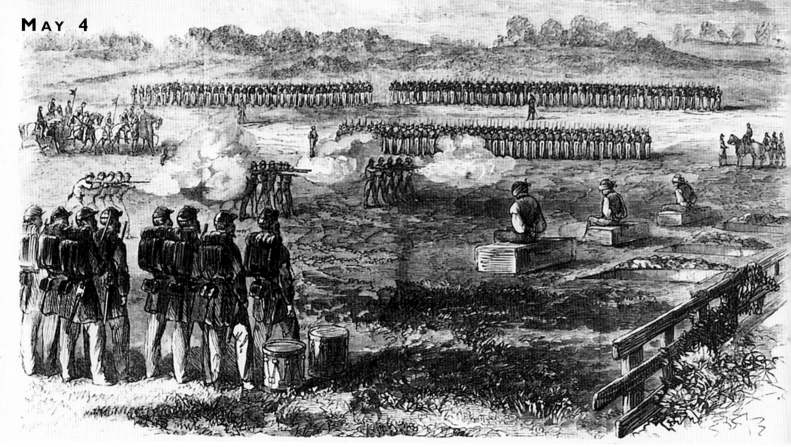

MAY 4

▲ *An illustration from Harper's Weekly, August 1863, showing the execution of deserters from the Army of the Potomac. Few deserters were actually executed.*

VIRGINIA, *LAND WAR*
The Battle of Fredericksburg II/Marye's Heights. With Lee's main army moving to meet a Union offensive toward Chancellorsville, Union troops push out a holding force from Fredericksburg.

MAY 4

VIRGINIA, *LAND WAR*
The Battle of Chancellorsville. The Union troops are facing total defeat.

However, at Fredericksburg yesterday the remaining Union troops under Sedgwick attacked and drove away Early's troops. Sedgwick now advances west to come to Hooker's aid. With Hooker in retreat, Lee turns to attack Sedgwick. At Salem Church the Confederates halt the Union advance.

Hooker withdrew across the river on the night of May 5. His defeat by an army half his size has cost more than

▼ *A skirmish between Confederate and Union cavalry during a raid. Both sides carried out raids behind enemy lines, raising morale by their daring exploits.*

▼ *Union General Marsena R. Patrick, provost marshal of the Army of the Potomac, and his staff in Culpeper, Virginia, in 1863.*

ARMED FORCES

DESERTION

Many of the reasons for desertion were common to both Union and Confederate armies. Cowardice was always a major consideration, but it was by no means the main one. More influential was the lack of such necessities as food, clothing, and equipment. Other important contributory factors included battle fatigue and general despondency at the course and duration of the war. In addition a significant number of soldiers deserted because they did not believe in the cause. Others resented the coercion, both of themselves and others: For example, many Northern troops objected to the Federal government's attempts to bring the secessionist states back into the Union by force. Yet more soldiers were overwhelmed by concern for their loved ones back home.

Throughout most of the war conditions in the Union army were bad. Some of the adversities—the fear of dying, the low morale that followed defeat, the boredom of military routine—were foreseeable consequences of war, but others were particular to the Civil War. Thirst, starvation, extreme heat, and disease were rife. The men were often further demoralized by lack of confidence in their officers and by the habitual delays in payment. Forced marches were often so long and hard that only the fittest could keep up.

Many soldiers who felt oppressed by one or more of these hardships made active decisions to desert. Others simply got lost as an army moved across country, and they were neither well trained nor motivated enough to find their way back. A small but significant minority simply lacked the self-discipline needed for life in the armed forces.

In December 1862, 180,000 Union soldiers were absent, either with or without leave. In 1863 Union General Joseph E. Hooker reckoned that no fewer than 85,000 officers and men had deserted from his Army of the Potomac.

Although there are no authoritative figures for the number of Union deserters, the consensus among modern historians is that there were over 200,000 deserters from the Union army, including nearly 45,000 from New York, more than 24,000 from Pennsylvania, and 18,000 from Ohio.

The chief method of desertion was to take the opportunity of sick leave or a furlough (leave of absence) to go away and never return. Others deserted by straggling (slipping to the rear during a march or in battle) or by offering themselves for capture to the enemy, who treated them honorably. Very few deserters changed sides.

Many of the privations that drove men away from the Union armies were the same as those that inspired desertions from the South's armies. In addition, the Confederate army had numerous conscripts—among them Northerners and Mexicans—who had no interest in the Southern cause and no sympathy for slavery. When conditions became intolerable, these draftees were among the first to desert.

Confederate wages were sometimes as many as 14 months late in payment, and army camps were notorious for their lack of sanitation. Many men decided that they were more use at home protecting their families than in the army (especially after their homes became behind Union lines and families were pleading for help). In some parts of the South the fear of Native Americans on scalping tours was even greater than that of Union soldiers. Even a mere rumor in camp that Indians were in the area was often enough to provoke large-scale desertions.

Many of the camp followers who tagged along behind the armies were profiteering at the soldiers' expense, and this further lowered morale. The classic soldier's complaint was that the conflict between the states was "the rich man's war and the poor man's fight."

Desertion was widespread. There is some anecdotal evidence that whole companies, garrisons, and even regiments decamped at the same time. As in the North, some Confederate deserters became outlaws, robbing remote settlements and military bases, and rustling cattle.

The Confederate army went to great lengths to punish such men, but the decision of the high command to send soldiers in pursuit of deserters reduced the numbers available to fight in battles and contributed greatly to the final defeat of the Confederacy. Of the deserters who were captured, few were executed because the army needed every man it could get.

17,000 casualties. Lee's losses are 12,800, including the irreplaceable Jackson, who dies a few days later.

MAY 12

MISSISSIPPI, *LAND WAR*
The Battle of Raymond. A Confederate task force slows, but is unable to stop, a much larger Union force crossing Fourteen Mile Creek.

MAY 14

MISSISSIPPI, *LAND WAR*
The Battle of Jackson. Jackson, the state capital, is an important transportation hub 38 miles (60km) east of Vicksburg.

On April 30, 1863, Union General Ulysses S. Grant's Army of the

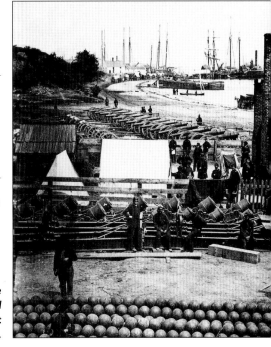

▶ *Union artillery waiting to be transported in May 1863, including solid shot (foreground), coehorns, and Parrott guns (background).*

Tennessee began crossing the Mississippi at Bruinsburg, 30 miles (48km) south of Vicksburg. Grant did not advance directly on the city. Instead, he sent his army east to mislead the Confederate commander, John C. Pemberton, and to prevent Pemberton's army from receiving reinforcements.

Grant's 40,000 troops outnumbered Pemberton's 30,000. On May 9 an alarmed President Davis ordered Joseph E. Johnston to march to Pemberton's aid, and drive away Grant's army. But Johnston quickly concluded that he had no chance of rescuing Pemberton. Instead, he withdrew his own force, leaving 6,000 men under John Gregg to cover the retreat.

Gregg places his force just west of Jackson and waits for the Union attack. Grant's XVII Corps under James B. McPherson locates Gregg's troops and deploys for battle. Meanwhile, William T. Sherman's XV Corps moves up from the

▼ *An 1863 recruitment poster for the 36th New York Infantry. Volunteers were offered a nine-month term of enlistment and "the usual bounty."*

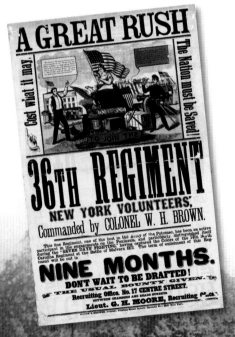

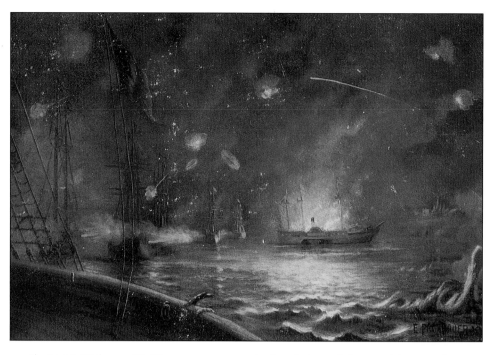

south. At 11:00 hours McPherson launches his first assault, which drives Gregg's men back to a defensive line near the town. He is preparing a second attack when word arrives that the Rebels have abandoned the field. At 16:00 hours Union forces enter Jackson—the fourth Southern state capital to fall.

Although hardly a pitched battle—Confederate losses total 850 men, Union losses are 300—the victory has two important results. First, it allows Grant's troops to destroy much of Jackson's railroads and war factories. Second, it means that Pemberton's army, outnumbered and outgeneraled, has to face Grant alone. The stage was set for Pemberton's defeats at Champion Hill

▼ *A Union army wagon park near Brandy Station, May 1863. Each army was usually followed by hundreds of wagons carrying essential supplies.*

▲ *A painting of the naval bombardment by Union gunboats of Port Hudson in May 1863. The ensuing siege lasted for 48 days before the garrison surrendered.*

and Big Black River. Pemberton's army retreated into Vicksburg on May 18 and Grant began to besiege the city.

MAY 16

MISSISSIPPI, *LAND WAR*
The Battle of Champion Hill/Bakers Creek. A tactically confused Confederate force is crushed at Champion Hill, the survivors fleeing across Baker's Creek. The Confederates are being driven back towards Vicksburg.

MAY 17

MISSISSIPPI, *LAND WAR*
The Battle of Big Black River. The Rebels lose 2,000 men (mostly prisoners), having failed to stop the Union advance to Vicksburg at the Big Black River.

▼ The Confederate ironclad CSS Manassas. Ironclads carried a variety of weapons, from conventional cannons to innovative rams and "spar torpedoes"—explosive charges attached to long poles.

MAY 18

MISSISSIPPI, *LAND WAR*

The siege of Vicksburg. Grant's armies commence the siege of Vicksburg, entrapping Pemberton's Confederates.

MAY 21

LOUISIANA, *LAND WAR*

The Battle of Plains Store/Springfield Road. As part of the Port Hudson campaign, Union troops secure a landing base on the Baton Rouge, despite Confederate counterattacks. The last Confederate escape route from Port Hudson is now closed.

Port Hudson is the logical next step in a progressive Union attempt to move upriver in the direction of Vicksburg, Mississippi. General Nathaniel P. Banks now attacks Port Hudson but it is a difficult target. Confederate General Franklin Gardner has turned the town into a system of fortified positions facing both over the river and toward the landward approaches.

Land and naval forces under Banks move out of Baton Rouge in a concerted attack. Gardner has only 7,500 men against over 30,000 Union troops, but he uses them skillfully, and for two weeks holds off a series of assaults.

KEY WEAPONS

IRONCLADS

The Confederate and Union navy secretaries knew that warships needed iron armor to withstand the powerful new 19th-century artillery. Britain and France each had an ironclad in 1861, but the Civil War hastened the development of these warships, which formed a transitional phase between the old wooden sail-powered warships and the battleships of the late 19th century.

In 1861 Union Secretary of the Navy Gideon Welles commissioned Swedish inventor John Ericsson to build the first Union ironclad. Ericsson completed his revolutionary ship, the USS *Monitor*, in January 1862. Some 172 feet (52m) long and armed with two 11-inch (28-cm) Dahlgren guns in a revolving iron turret, the *Monitor* was technically in advance of any warship afloat when launched. Its armor plating was 8 inches (20cm) thick. Since it was almost impossible to make iron plates this thick, the armor of the Monitor, like most later ironclads, was made of 1-inch (2.5cm) plates bolted together.

The craft had a strange appearance since it had a very low freeboard—the deck of the ship was only 1 foot (30cm) above the waterline. Though barely seaworthy, the *Monitor* became the pattern for one of the most popular types of ironclad. Of the 52 coastal ironclads contracted for by the Union during the war, 48 were "monitors" that followed this design.

The Union also contracted for 24 ironclads to patrol internal waters. They did not have gun turrets. Instead, they were built with a casemate—an iron-plated box that protected the guns and crew of the ship. Casemate ironclads often had sloping sides, which presented a thicker layer of armor to direct shot. The first of these Union casemate ironclads was launched in October

1861. It was one of seven ironclads designed by Samuel M. Pook for the Union and known as "Pook Turtles." The Pook Turtles contributed to Union victories on Western rivers in 1862 and 1863.

The Confederacy had only one major shipyard in New Orleans and one ironworks—Tredegar Ironworks in Richmond, Virginia. However, when Virginia seceded from the Union in 1861, Confederate forces took over the U.S. Navy's Norfolk shipyard in the state. With this action the Confederates gained the U.S. Navy's new steamship, the *Merrimack*, which Union troops had partly burned and sunk before leaving.

Engineers raised the *Merrimack* and built on its hull a large armored casemate. An iron ram was mounted on its bow. The Confederacy named its new casemate ironclad the CSS *Virginia*, and it set sail in March 1862. The *Virginia* was designed to operate both in coastal waters and on rivers. On March 9, 1862, the first ever battle between ironclads took place in Hampton Roads, Virginia, when the USS *Monitor* and CSS *Virginia* pounded each other in a four-hour duel that ended inconclusively.

In the fall of 1862 the Confederacy began constructing a remarkable 18 ironclads. The Confederacy also planned to defeat the Union with more technically advanced ships built in Europe. At the end of the war two large rams were actually under construction in England. However, they never reached the Confederacy.

Enthusiasm in the South had waned by early 1863. In all, the Confederacy completed 22 ironclads during the war while the Union built more than 40. The Union was able to capitalize on its strengths in industry, skilled labor, and access to iron to far outstrip the South in ironclad production.

JUNE 7

▶ *Union Major General John Sedgwick was a corps commander at Gettysburg. He was killed at Spotsylvania on May 9, 1864, by a Confederate sharpshooter.*

JUNE 7

LOUISIANA, *LAND WAR*
The Battle of Milliken's Bend. A Confederate attack ejects Union troops from Milliken's Bend near Vicksburg. The retreat is reversed by two Union gunboats.

JUNE 9

VIRGINIA, *LAND WAR*
The Battle of Brandy Station. Two groups of Union cavalry under General Alfred Pleasanton cross the Rappahannock River. They plan to rendezvous near Brandy Station and attack Confederates in the area. One group under John Buford surprises William Jones' Confederate cavalry in their camps near the river. The fighting grows intense as Jones and his men establish a defensive position and hold it until reinforcements arrive. Much of the fighting on this part of the battlefield takes place dismounted, as Union and

Confederate cavalrymen fight as infantry from behind stone walls.

Meanwhile, the other Union force of 5,000 men under David M. Gregg crosses the Rappahannock several miles south of Buford, splits into two groups, and attacks toward Fleetwood Hill, site of the headquarters

of Confederate cavalry commander J.E.B. "Jeb" Stuart. Gregg's attack forces Jones to fall back to Fleetwood Hill as well. In a smaller battle 4 miles (6.5km)

▼ *Confederate guns of the stronghold of Port Hudson fire on Union warships on the Mississippi River. The fort fell on July 8, 1863, after a 47-day siege.*

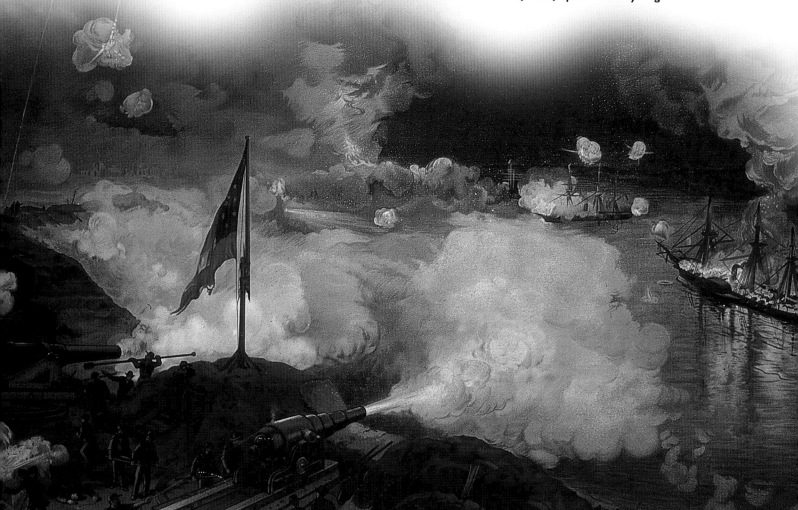

south at Stevensburg, however, Union forces are unable to break through to assist Gregg's advance.

Fleetwood Hill becomes the scene of a remarkable battle, as thousands of cavalrymen participate in massed charges and countercharges, with neither side able to gain an immediate advantage. As the afternoon wears on, however, casualties mount, and the northernmost Union forces under Buford and Pleasanton begin to withdraw across the Rappahannock, pushed on by a series of Confederate counterattacks. Union forces near Fleetwood Hill also begin to withdraw, leaving Stuart's cavalrymen in possession of the field.

"Jeb" Stuart can legitimately claim victory in the Battle of Brandy Station. His troopers held their positions and inflict almost twice as many casualties (866) as they suffered themselves (485). This is not the whole story, however. Stuart had carried out a grand review of his cavalry on the day before the raid and was taken by surprise by the bold Union attack. In spite of their final retreat, Pleasanton's Union cavalrymen have fought well. This battle, and a skirmish at Kelly's Ford along the Rappahannock the previous March, signals the

great improvement of the fighting spirit and skill of the Union cavalry. It will also lead "Jeb" Stuart to take extra risks during the coming Gettysburg campaign to redeem his reputation.

▲ *A newspaper vendor with General George G. Meade's army in Virginia, 1863. Newspapers both took news of the war back to the rest of the country, and brought news from home to the soldiers.*

KEY PERSONALITY

GEORGE MEADE

George Gordon Meade (1815–1872) was born in Cadiz, Spain, where his father was an American naval agent. After the family's return to their native land George Meade entered the U.S. Military Academy at West Point, graduating in 1835. After working as a civil engineer, he rejoined the U.S. Army in 1842 and fought in the Mexican War (1846–1848). He was then put in charge of a survey of the Great Lakes.

When the Civil War broke out, Meade was appointed brigadier general of volunteers and given command of a Pennsylvania brigade. He participated in General George B. McClellan's Peninsular Campaign in spring 1862 and the Seven Days' Campaign at the end of June, where he was seriously wounded. He was not fully recovered when he returned to command his brigade at the Second Battle of Bull Run (August 1862). In recognition of his service there, and at Antietam a month later, Meade was promoted to major general of volunteers. In that capacity he commanded a division in the disastrous Union defeat at Fredericksburg (December

1862) and V Corps in a further Union defeat at the Battle of Chancellorsville (May 1863).

Despite these defeats, Meade's overall combat record was good. President Lincoln appointed him commander of the Army of

the Potomac in June 1863, replacing General Joseph Hooker. Meade found himself up against Confederate General Robert E. Lee's Army of Northern Virginia, which had invaded Pennsylvania with the intention of delivering a knockout blow to the Union. At the Battle of Gettysburg (July 1–3) Meade showed great tactical skill, and after a titanic struggle Lee withdrew, his army shattered. Meade was criticized for not pursuing Lee's army after the victory. Nevertheless, the following January Meade received a congressional message of thanks for his success at Gettysburg, which was a turning point in the war.

Meade remained in command of the Army of the Potomac for the rest of the war. But when General Ulysses S. Grant was made general-in-chief of all Union forces in March 1864, Meade found himself effectively demoted and subject to Grant's orders. In August 1864, Meade was promoted to major general in the regular army and after the war remained in charge of various military departments until his death from pneumonia in 1872.

JUNE 14

▲ At the Battle of Gettysburg, General Sickles made an advance without orders that left his own men and another Union corps exposed. He never accepted blame for the heavy losses that resulted.

For the first two years of the conflict Union cavalry units had suffered from poor leadership and training and were completely outclassed by Rebel cavalry. Many Union cavalrymen, born and raised in towns and cities, knew little about horses. Indeed, many had to learn to ride once they enlisted. In contrast, cavalrymen from the more rural South had more experience with caring for and riding horses. Also, many Confederate cavalrymen fought in their own localities, giving them a great advantage in an age when few detailed maps of the United States existed.

Over time the gap in quality between Union and Confederate cavalry units narrowed. By the time of the Battle of Brandy Station Northern superiority in resources and manufactured goods allowed Union cavalry to be better armed and better supplied with mounts. The fighting spirit of the individual Union cavalryman was never in doubt either, and leaders such as Buford turned their units into successful combat forces. After June 1863 the cavalry played an increasingly effective role in the Union war effort.

JUNE 14

VIRGINIA, *LAND WAR*
The Second Battle of Winchester. During the Confederate Army of Northern Virginia's invasion of Pennsylvania,

▼ Confederate prisoners at Camp Morton, near Indianapolis, Indiana, in 1863. The camp typically held about 3,500 Confederate soldiers.

▲ A Union cavalry officer at winter quarters near Brandy Station, 1863–1864.

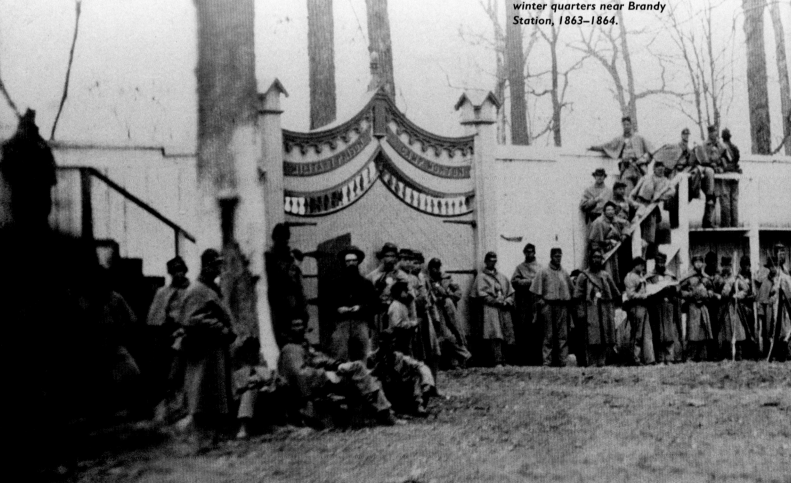

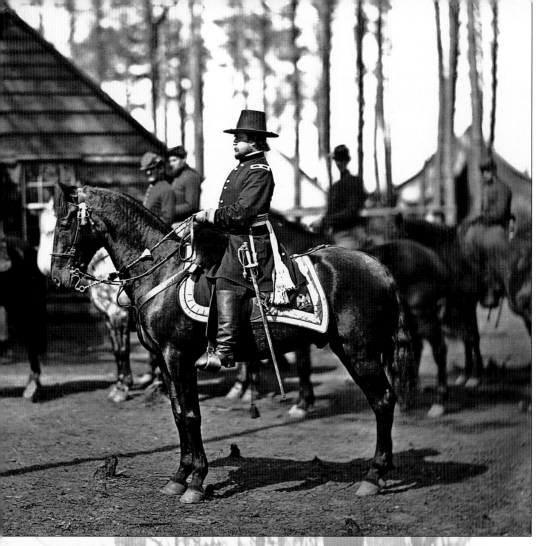

KEY PERSONALITY

JOHN BUFORD

An 1848 graduate of the U.S. Military Academy at West Point, John Buford (1826–1863) served on the western plains, where he fought the Sioux and participated in the 1858 Mormon War in Utah.

After serving in the defense of Washington, D.C., in July 1862, he assumed command of a cavalry brigade in John Pope's Army of Virginia. Although wounded in the Second Battle of Bull Run, he recovered to serve as chief of cavalry of the Army of the Potomac during the Antietam and Fredericksburg campaigns in late 1862. He was praised for his role in the Chancellorsville campaign, and in June 1863 he received command of the 1st Division, Cavalry Corps.

The evening of June 30, 1863, found Buford's division posted north and west of the market town of Gettysburg. Buford correctly deduced that the Confederate army was concentrating in his direction. Although outnumbered, he prepared to hold the town until reinforcements could arrive. Fighting dismounted, his troopers fended off the Confederates for over three hours. Buford's correct pinpointing of the location of the invading Confederate army, coupled with his skillful defense of the ridges west of the town on July 1, 1863, helped ensure that the battle was fought on terms favorable to the Union.

The battle was John Buford's final contribution to the Union cause. In the fall of 1863 he fell mortally ill with typhoid fever. On his deathbed he was promoted to major general, a rare honor. It was backdated to July 1, 1863, in recognition of his great day at Gettysburg.

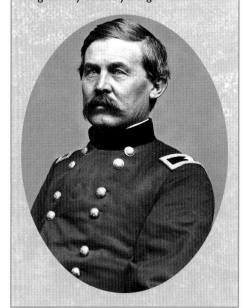

JUNE 16

▶ *The citizens of Baltimore, Maryland, build barricades on hearing the news of Confederate General Robert E. Lee's advance into Pennsylvania in June 1863.*

Confederate General Richard S. Ewell's II Corps attacks a Union garrison from the Army of the Potomac led by General Robert H. Milroy, which is blocking the Confederate advance and endangering the army's communications and supply lines. The Confederates' victory at Winchester clears a path for their invasion.

JUNE 16

THE CONFEDERACY, *STRATEGY*
Robert E. Lee orders the Army of Northern Virginia across the Potomac to begin its second invasion of the North. The plan is to march through Maryland and into Pennsylvania and win a decisive battle there, and perhaps even take Washington, D.C. Three Confederate army corps are involved: II Corps under Richard S. Ewell, I Corps under James Longstreet, and III Corps under Ambrose P. Hill. Together with J.E.B. Stuart's cavalry corps Lee's army numbers about 75,000 men.

◀ *The besieging Union army used explosives to blow a crater (top center) in Fort Hill, part of the defenses around Vicksburg, Mississippi, in June 1863. The Union troops suffered heavy losses as they became trapped in the crater while trying to rush through the defenses.*

JUNE 17

VIRGINIA, *LAND WAR*
The Battle of Aldie. Federal cavalry under Brigadier General Judson Kilpatrick run into J.E.B. Stuart's cavalry, which is screening the Confederate infantry as it marches north behind the Blue Ridge, at Aldie in a surprise clash. The outnumbered Confederates fight well, but after four

▼ *Refugees in Wrightsville, Pennsylvania, fleeing from the advance of the Army of Northern Virginia on June 28, 1863. Three days later the army was to confront Union forces at Gettysburg.*

STRATEGY AND TACTICS

CAVALRY TACTICS

The breechloading carbine was one of the reasons why cavalry tactics changed so much as the war went on. In 1861 it was still believed that a line of saber-wielding troopers could drive infantry off the battle-field in a single charge. The Confederate cavalry commander J.E.B. Stuart achieved this feat at the First Battle of Bull Run (Manassas) on July 21, 1861, when his 1st Virginia Cavalry routed the 11th New York Zouaves, though this had more to do with the Union infantrymen's inexperience in combat. Later in the war veteran infantry would stand firm behind cover and rely on the range and power of their rifle muskets to fend off a cavalry charge. In previous wars infantry with smoothbore muskets were more vulnerable when facing a charge of cavalry, but Civil War infantry with rifled muskets accurate up to 300 yards (275m) could turn a cavalry attack into a suicide charge.

H. Kyd Douglas, a Confederate officer, described one such experience in the Shenandoah Valley in 1862: "Just as these hundred men had reached the fence, the cavalry came thundering by, but a deadly volley stopped their wild career. Some in front, unhurt, galloped off, on their way, but just behind them horses and riders went down in a tangled heap. The rear, unable to check themselves, plunged on in, over upon the bleeding pile, a roaring, shrieking, struggling mass of men and horses, crushed, wounded and dying. It was a sickening sight, the worst I had ever seen then, and for a

moment I felt a twinge of regret that I had ordered that little line to that bloody work."

Denied their traditional role as shock-troops and battle-winners, by 1862 the cavalries of both armies were struggling to find a new contribution to make. The Union cavalry was still a young and inexperienced force and was mainly used to guard supply lines and encampments. The Confederate cavalry, which had better leadership and finer horsemen, began to specialize in large-scale raids and reconnaissance operations, such as J.E.B. Stuart's ride around George B. McClellan's Union army. As the war went on, the Confederates government authorized the raising of units of "partisan rangers."

Raids behind enemy lines, distracting and confusing the enemy, did wonders for the cavalry's reputation and raised morale. However, while the cavalry was raiding, it could not concentrate on its other vital but less glamorous task of keeping a watch on the enemy's movements. This failure had serious consequences in later battles. At Chancellorsville in May 1863, Union General Joseph Hooker sent his cavalry away on a raid and, as a result, was not warned of the arrival of Lee's army from Fredericksburg. Two months later in Pennsylvania Lee himself was let down by J.E.B. Stuart, who, in an attempt to repeat his exploit on the peninsular was not in a position to warn his commander that the Union army was concentrating at Gettysburg.

These failures were partly responsible for the cavalry's poor reputation among the

infantry of both sides, who were doing most of the fighting and dying. "Whoever saw a dead cavalryman?" was a common infantry jibe, while in 1864 one disgruntled Confederate soldier wrote: "I do wish the Yankees would capture all the cavalry … they never will fight so I think it is useless to have them in the army eating rations."

During 1863 the Confederate cavalry began to decline, as its numbers and fighting quality suffered through a lack of new recruits, horses, and weapons. The Union cavalry, on the other hand, was growing in number, confidence, and experience, and was taking a more offensive role by adopting the tactics of mounted infantry. Their horses gave the troopers mobility on the battlefield, while the carbine, especially the Spencer, gave them the firepower to hold positions against Confederate infantry when fighting on foot.

Two brigades of John Buford's 1st U.S. Cavalry Division, fighting in this way, held off two Confederate divisions on the first day of the Battle of Gettysburg on July 1, 1863. From cover behind a stone wall the cavalrymen fought for two hours until reinforced by infantry, making sure that the Army of the Potomac held the high ground that in the end proved decisive to the outcome of the battle.

This was not classic cavalry warfare with saber and lance, but it suited the Civil War soldier and the kinds of battle he fought in North America. In later decades it helped change cavalry tactics around the world.

hours, during which both sides make mounted assaults by regiments and squadrons, are forced to withdraw to Middleburg. Hooker orders his cavalry to continue striking the Confederates, adding infantry to the attacking force. Although the Federals are unable to annihilate Stuart's troopers, they still slow down a now-concerned Lee's move north, while pushing the Confederates farther west toward Lee's marching lines.

JUNE 17–19

VIRGINIA, *LAND WAR*
The Battle of Middleburg. Union and Confederate cavalry forces skirmish

▶ *An etching by Adalbert Volck showing Confederate sympathizers in Maryland secretly loading a rowboat with medical supplies bound for the South.*

JUNE 20

The Siege of Vicksburg ▶

In March–April 1863, General Grant took his army down the Union-held Louisiana side of the Mississippi River and crossed the river at Bruinsburg with 30,000 men in David Porter's fleet of troop transports. The Union army then moved eastward, fighting a number of battles on the way, and captured Jackson, the state capital of Mississippi, on May 14. Grant then turned toward Vicksburg and defeated Pemberton's troops at Champion Hill and Big Black River before besieging the city. Finally, Pemberton surrendered on July 4, 1863. Interestingly, Grant offered parole to the defenders of Vicksburg instead of an unconditional surrender of the city and garrison. The fall of Vicksburg, together with the defeat of Confederate General Robert E. Lee at the Battle of Gettysburg on July 1–3, marked the turning point of the Civil War.

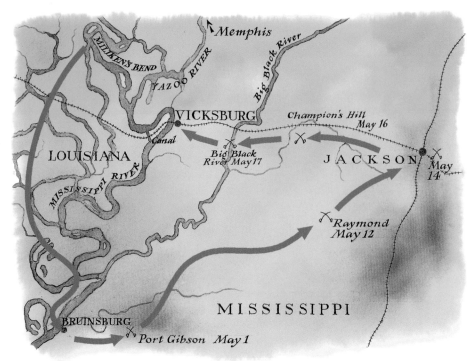

around Middleburg as the Confederates make a screening action for Lee's Pennsylvania campaign.

JUNE 20
WASHINGTON, *D.C., POLITICS*
West Virginia is admitted to the Union following a presidential proclamation.

JUNE 20–21
LOUISIANA, *LAND WAR*
The Battle of LaFourche Crossing. A Confederate raiding expedition is fought off by Union troops, costing 219 Rebel dead against 48 Union dead.

JUNE 21
VIRGINIA, *LAND WAR*
The Battle of Upperville. Union troops skirmish with the left flank of Lee's northern offensive.

JUNE 24–26
TENNESSEE, *LAND WAR*
The Battle of Hoover's Gap. The Union Army of the Cumberland launches an offensive that overcomes a fortified Confederate line along the Duck River, forcing the defenders to fall back to Tullahoma. The Federals also rip up the railroad track around Decherd.

JUNE 28
LOUISIANA, *LAND WAR*
The Battle of Donaldsville. General Taylor's West Louisiana operations suffer a setback when Confederate troops fail to take Fort Butler near Donaldsville, costing over 300 lives.

▲ *The Union transport Chattanooga loaded with supplies for the Army of the Cumberland in 1863. The Army of the Cumberland was the main Union force in Tennessee between November 1862 and November 1863.*

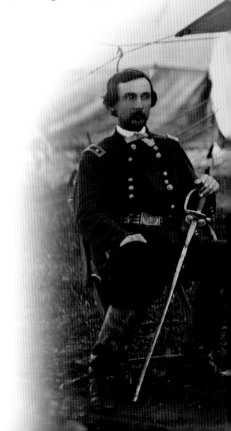

▶ *A drawing by Adalbert Volck of Confederate guerrillas recruiting ruined Southern farmers into their band in 1863.*

UNION ARMY, *COMMAND*

General George Meade becomes the Army of the Potomac's commander.

JUNE 29–30

The Battle of Goodrich's Landing/The Mounds/Lake Providence. Confederate raiding troops destroy crop plantations, worked by former Southern slaves, along the Louisiana River, but cause little overall disruption to Union operations in the area.

JUNE 30

PENNSYLVANIA, *LAND WAR*

The Battle of Hanover. J.E.B. Stuart's cavalry, attempting to circle around Union forces and link up with Lee's army, is diverted and delayed by Union General Farnsworth's cavalry brigade at Hanover.

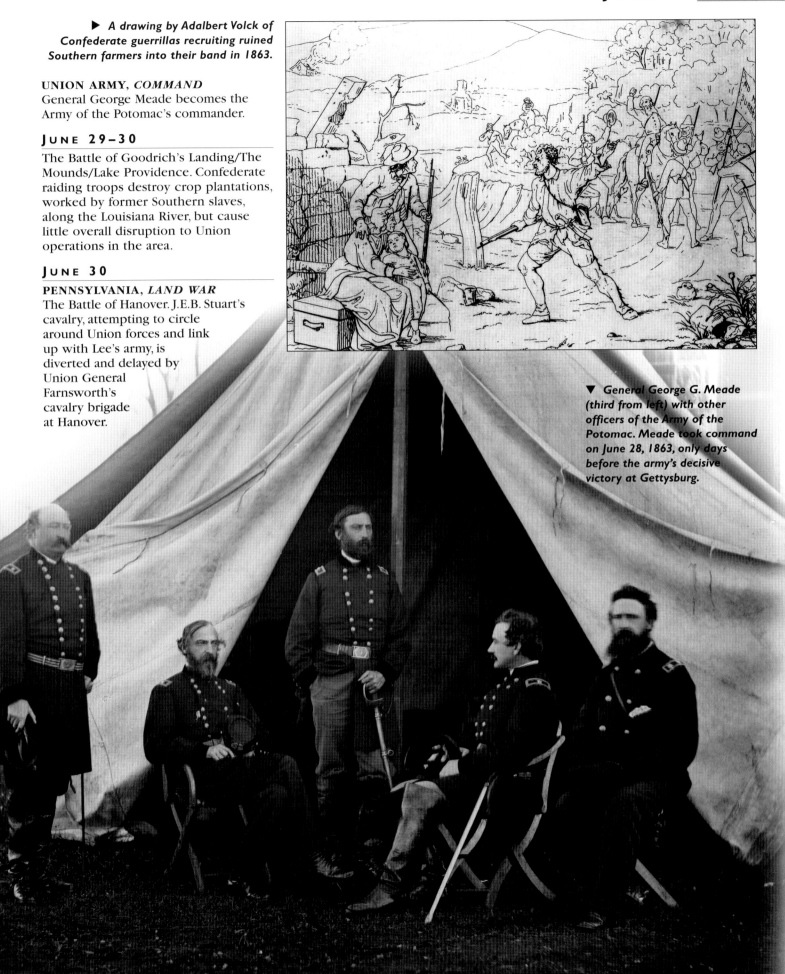

▼ *General George G. Meade (third from left) with other officers of the Army of the Potomac. Meade took command on June 28, 1863, only days before the army's decisive victory at Gettysburg.*

JULY 1

PENNSYLVANIA, *LAND WAR*

The Battle of Gettysburg. The encounter that develops into the largest battle of the Civil War begins almost by chance. On June 29 one of A.P. Hill's divisions under Harry Heth went foraging toward Gettysburg, Pennsylvania. Today, it runs into a Union cavalry brigade from John Buford's 1st Cavalry Division, posted about 4 miles (6.5 km) west of the town across the Chambersburg Pike.

Gettysburg is strategically important because it lies at the junction of roads running out to Washington and Baltimore to the south and east and to Harrisburg, the capital of Pennsylvania, to the north. Once Lee and George G. Meade learn that their armies have met there, both generals quickly order their forces to concentrate on the town.

Lee's Confederates begin arriving from the north and northwest, while Meade's lead corps begin arriving from the south. By midmorning A.P. Hill is reinforcing Heth, while John F. Reynolds, commander of the Union I Corps, establishes a defensive line across the Chambersburg Pike at McPherson's

◀ *The label from a tobacco packet featuring Union General George B. McClellan in a dashing pose.*

Ridge. Reynolds is killed, and Abner Doubleday takes over his command.

Fighting develops north of the town with the arrival of Oliver O. Howard's Union XI Corps in the afternoon. It is pushed back through the town by two divisions of Ewell's corps led by Jubal A. Early and Robert E. Rodes. The retreating Union forces are on the verge of defeat, but are rallied south of the town on Cemetery Hill by the arrival of Winfield Scott Hancock and the lead unit of his II Corps. With the McPherson's Ridge position now outflanked, Doubleday also withdraws to Cemetery Hill. By the end of the day the Confederates hold the town, but Union forces are secure on Cemetery Hill and also on Culp's Hill a little to the east.

JULY 1–2

OKLAHOMA, *LAND WAR*

The Battle of Cabin Creek. A Union supply train led by the 1st Kansas Colored Infantry battles off a Confederate attempt to cut off the train at Cabin Creek on the Grand River.

▲ *Alfred Waud made this sketch at Gettysburg on July 3. It shows swaths of smoke hiding the Union forces just before the Confederates launched Pickett's Charge.*

DECISIVE MOMENT

THE SIEGE OF PORT HUDSON

After the fall of New Orleans in April 1862, Port Hudson was the logical next step in a progressive Union attempt to move upriver in the direction of Vicksburg, Mississippi. As Union General Ulysses S. Grant continued his efforts to capture Vicksburg in early 1863, Union General Nathaniel P. Banks formed a plan to move against Port Hudson. It would be a difficult target. Confederate General Franklin Gardner had been steadily receiving reinforcements and had turned the town into a system of fortified positions facing both over the river and toward the landward approaches.

The first attempt to capture Port Hudson was a naval attack by gunboats under David G. Farragut, but it ended in failure. On May 11, 1863, land and naval forces under Banks moved out of Baton Rouge in a more concerted attack. Gardner had only 3,500 men against over 30,000 Union troops, but

he used them skillfully, and for two weeks held off a series of bloody and uncoordinated assaults, some of them by African American units recruited in New Orleans.

The failure of these head-on attacks convinced Banks to settle into a siege in late May. Gardner had no hope of victory at this point; Confederate forces in Vicksburg were under siege themselves, so there was no prospect of relief from the outside. Food, medicine, and ammunition gradually ran out, while Banks' army remained well-supplied. When word reached Gardner that Vicksburg had surrendered on July 4, he saw no point in continuing to resist, and so he also surrendered.

The defense had failed, but to his credit Gardner had succeeded in tying down over 30,000 Union troops who could have been used to assist in the siege of Vicksburg. The Union victories at Port Hudson and Vicksburg secured Union control of the Mississippi River for the remainder of the war.

▲ Confederate troops use the huge boulders on Culp's Hill as cover during the Battle of Gettysburg, July 1863. Culp's Hill lay on the extreme right of the Federal line and was the scene of heavy fighting.

JULY 2

PENNSYLVANIA, *LAND WAR*
The Battle of Gettysburg. Meade has over 90,000 men consolidating their position on the high ground, which extends in a fishhook-shaped line from Culp's Hill around Cemetery Hill and south along Cemetery Ridge. On the Confederate side Hill and Ewell have been joined by Longstreet, whom Lee orders to deploy along Seminary Ridge next to Hill's corps on the Confederate right. Lee plans to attack both Meade's flanks. Longstreet will begin the attack by a strike at the Union left.

The fighting begins in the afternoon with a Union disaster. Daniel E. Sickles, leading III Corps, advances without orders from Cemetery Ridge toward the Emmitsburg Road. Caught in open ground by Longstreet's troops, III Corps is cut to pieces around the Peach Orchard and Devil's Den. The Union left flank is now exposed, and a Confederate division under John Bell Hood advances toward the hill position of Little Round Top, which dominates the south of Cemetery Ridge. Fortunately for Meade, Gouverneur K. Warren spots the importance of Little Round Top and orders it occupied. Hood's attacks on the hill reach the lower slopes but fail to break through to the top. On the Confederate left attacks by Ewell's corps on Cemetery Hill and Culp's Hill do not begin until early evening and have made no gains by the time darkness falls. The Confederate flank attacks have been piecemeal and uncoordinated; both have failed. Meade still holds his ground.

JULY 3

PENNSYLVANIA, *LAND WAR*
The Battle of Gettysburg. Lee makes an all-out bid to break the Union center on Cemetery Ridge. He concentrates his artillery—some 150 guns—on Seminary Ridge and orders three infantry divisions, totaling 15,000 men, to make a frontal assault across nearly a mile

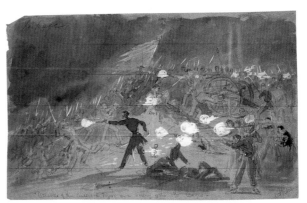

▲ The attack by the Confederate Louisiana Tigers on a battery of the Union XI Corps on the second day at Gettysburg. The soldiers fought hand-to-hand using bayonets, clubs, rocks, and fists.

The Battle of Gettysburg ▶

On July 1 the Confederates advanced from the north but were stopped as both sides sent troops forward quickly. The Confederates sent the divisions of Major General Henry Heth and Major General William Pender of Hill's Corps to take Gettysburg, which was occupied by Brigadier General John Buford's division of Federal cavalry, and Union forces fell back to the high ground to the south of the town (1). On July 2, to the north, elements of a division of the Confederate III Corps advanced to the slopes of Cemetery Ridge before they too were forced to retire. The Union line held. In the late afternoon Confederates made piecemeal attacks on Cemetery Hill and Culp's Hill but made no headway (2). Union forces were pushed back as fierce fighting took place around the Devil's Den and Peach Orchard. The Confederates advanced to the base of Little Round Top, but Federal reinforcements, including elements of VI Corps, halted their attack (3). On July 3, 15,000 Confederates made a doomed frontal assault against the Union center, later known as Pickett's Charge (4). The failure of this attack marked the effective end of the battle.

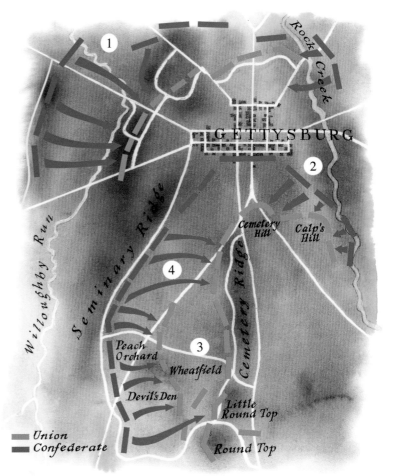

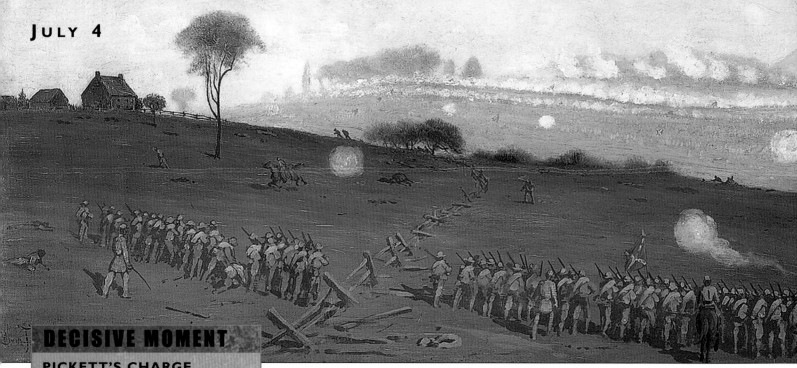

DECISIVE MOMENT

PICKETT'S CHARGE

On July 3, 1863, the third day of the Battle of Gettysburg, Confederate General Robert E. Lee ordered a frontal assault on the center of the Union position along Cemetery Ridge. This attack would be Lee's final chance to get on that high ground and win the battle.

The attack was spearheaded by George E. Pickett's division. Supported by just under 15,000 Confederate troops, Pickett was to break the Union hold on the ridge, which lay about a mile (1.6km) from Southern lines.

To weaken the Union line, Lee brought up all his 150 guns to his position on Seminary Ridge, and at 13:00 hours they opened fire and began a two-hour bombardment. At about 15:00 hours the guns fell silent, and the Confederates advanced over the tract of open land that separated the two armies. However, the bombardment had not done its job. Union infantry were still in position behind a long stone wall, and the Union artillery was waiting behind the ridge.

As the Confederate brigades marched up along the line of the Emmitsburg Road below, 80 Union guns opened fire with shell, shot, and canister, causing terrible carnage. Through this onslaught the Confederates kept coming, aiming apparently for a position on the ridge known later as the Copse of Trees.

Holding it were the men of the 69th and 71st Pennsylvania Infantry. The Confederate troops were within 200 yards (183m) of the wall when the Pennsylvanians opened fire, mowing down the Confederate line. Barely 100 Southerners reached the wall before the attack finally broke.

(1.6km) of open ground toward the Union positions ranged above them behind a stone wall. At 13:00 hours the guns open up and start the biggest Confederate artillery bombardment of the war. It lasts two hours, during which the leading Confederate division commanded by George E. Pickett moves into position. At about 15:00 hours the guns fall silent, and Pickett begins his charge.

Union artillery opens up on the Confederates until the survivors are within 200 yards (180m) of the Union front line. Then the infantry open up with volleys of musket fire. Only a handful of men reach the stone wall. All Lee can say as he rides out to meet the shattered survivors is, "It's all my fault. It is I who have lost this fight," in admission of his own gross tactical error.

On July 4 Lee ordered his defeated army back to Virginia. More than 20,000 Confederates were killed, wounded, or missing, while the Union total was 23,000. Between them the two armies left more than 6,000 dead at Gettysburg.

▲ *Confederate troops advancing across open ground toward the Union forces on Cemetery Ridge at Gettysburg, in the attack known as Pickett's Charge.*

After this defeat the Confederacy was never again able to mount a large-scale invasion of the North.

JULY 4

ARKANSAS, *LAND WAR*
The Battle of Helena. A Confederate attempt to relive pressure on Vicksburg by attacking Helena fails, costing the Rebels 1636 casualties.
MISSISSIPPI, *LAND WAR*
Vicksburg surrenders to General Grant's Union

▶ *A sketch by Alfred Waud showing the death of Union General John F. Reynolds at Gettysburg on July 1. Waud excelled at capturing the events of battle in quick sketches.*

▼ *Union General John Gibbon's Iron Brigade fought frequently and sustained heavy losses. Gibbon himself was wounded at Gettysburg.*

forces. This is a disaster for the Confederacy. Vicksburg is located on well-defended high bluffs on a loop in the river, and dominates the trade of a vast area between New Orleans and Memphis. By June 1862 both New Orleans and Memphis had fallen to the Union, leaving Vicksburg as the city linking the two halves of the Confederacy together. If Vicksburg fell, the South would be split in two. Confederate President Jefferson Davis had ordered it to be held at all costs.

In December 1862, Grant had planned a two-part assault on Vicksburg from the north. William T. Sherman would sail down the Mississippi River and land

◀ *Confederate prisoners taken at Gettysburg. One of the residents of Gettysburg described the appearance of the men of Lee's army thus: "Clad almost in rags, covered with dust".*

north of Vicksburg near the Yazoo River, while Grant himself would march overland from Memphis. However, Grant was halted when Confederate raiders destroyed his main supply base at Holly Springs, Mississippi, on December 20. Sherman withdrew on the 29th after he failed to capture high bluffs north of the city.

The Mississippi protected the city to the west, and so the only hope for Grant was to maneuver his army through the flooded lowland swamps out of sight of Confederate guns, ferry it across the river, and attack from the high ground to the east. Throughout the winter he made three attempts to get the army in behind Vicksburg using river transport. They all failed.

At the end of March Grant changed tactics. He ordered the army to cut its way through the swamps to cross the

Mississippi 30 miles (48km) to the south. Meanwhile, Union gunboats under David D. Porter successfully ran the gauntlet of Vicksburg's guns by night to meet with Grant's army south of the city. On April 30 the gunboats transported the Union forces to the east bank, while Sherman made a diversionary attack north of the city.

Once across the river, Grant marched east, aiming to keep apart the Confederate army under John C. Pemberton based at Vicksburg and the one under Joseph E. Johnston at Jackson. Moving rapidly and living off the land, Grant's army met with Johnston's army at Jackson on May 14 and drove it back. Grant then turned west to advance on Pemberton's army in front of Vicksburg. On May 16 Grant defeated Pemberton at Champion Hill and the next day at Big Black River. Pemberton retreated into Vicksburg on May 18, and after two failed assaults on May 19 and 22 Grant besieged the city.

▲ *A painting by Edwin Forbes of Union troops on the summit of Little Round Top in the early evening of July 3, 1863, the final day of the Battle of Gettysburg. The Confederates had failed to capture Little Round Top the day before.*

The Union army dug 15 miles (24km) of trenches and brought up 220 heavy guns to bombard the city day and night. Inside Vicksburg the civilian population suffered as badly from the shelling as the soldiers. Many took refuge in caves dug out of the hillsides behind the city. Food began to run out, and by late June mule and rat meat was all that was left.

▲ *Robert Gould Shaw, colonel of the Union 54th Massachusetts Infantry Regiment, who was killed on July 18.*

Pemberton was reluctant to give in, even though he was running out of ammunition and could expect no help from Johnston. Grant initially demanded unconditional surrender, but modified his terms and agreed to let the Confederates sign paroles agreeing not to fight again until they had been exchanged for captured Union soldiers. Thus Pemberton surrenders Vicksburg today.

JULY 6–16

MARYLAND, *LAND WAR*
The Battle of Williamsport/ Hagerstown/Falling Waters. Lee's retreating army establishes a defensive line at the Potomac, while forging a crossing. Fighting is constant; in one action the Confederates lose 500 men as prisoners.

JULY 8

MARYLAND, *LAND WAR*
The Battle of Boonsboro. Confederate cavalry fight a rearguard action against troops of the Union 1st and 3rd Cavalry Divisions and infantry.

JULY 9

LOUISIANA, *LAND WAR*
Confederate General Franklin Gardner surrenders Port Hudson. Under siege since late May, Gardner had no hope of relief; Confederate forces in Vicksburg have been under siege themselves.

Medicine, ammunition, and food has run out. When word reached Gardner that Vicksburg had surrendered, he saw no point in continuing to resist. During the siege Union forces have suffered 5,000 casualties. Confederate losses are 7,208.

▼ *The Colored Orphan Asylum in New York, set on fire by rioters on July 13. The Draft Act of March 1863 had angered many Northerners, and they directed much of their anger against blacks.*

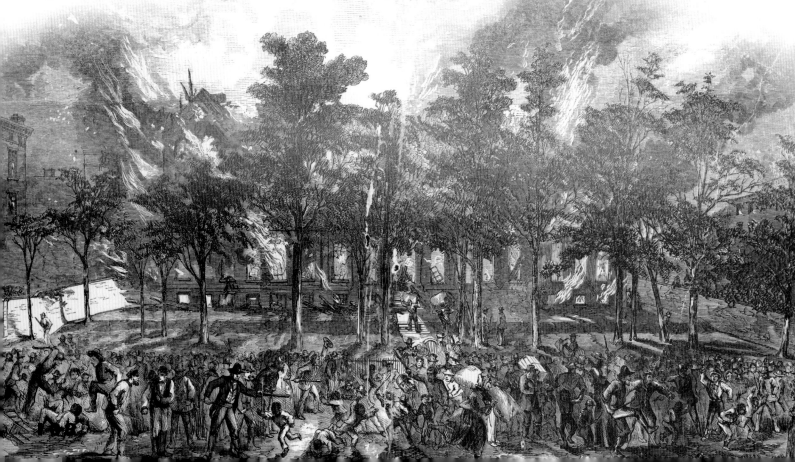

▶ *David D. Porter, whose daring naval command helped Grant to victory at Vicksburg. His boats ran past the Vicksburg batteries at night so that they could ferry the Union army across the river.*

To his credit Gardner has succeeded in tying down over 30,000 Union troops who could have been used to assist in the siege of Vicksburg. The fall of Port Hudson opens the Mississippi River to Union navigation from its source to New Orleans.

INDIANA, *LAND WAR*
The Battle of Corydon. A Confederate raiding force under Brigadier General John Hunt Morgan captures around 400 Home Guard at Corydon.

JULY 12–13

LOUISIANA, *LAND WAR*
The Battle of Kock's Plantation/Cox's Plantation. A Union expedition up the Bayou Lafourche is stopped and pushed back by a smaller Rebel force. The Union loses 430 troops as opposed to only 33 Rebels.

JULY 13

NEW YORK, *CIVIL DISTURBANCES*
Antidraft incidents have erupted across the North, from small towns in Vermont and New Hampshire to Port

▲ *An African American man is lynched during the New York draft riot of July 1863. The riot remains the most violent civil disorder in American history.*

DECISIVE MOMENT

BATTLE FOR THE MISSISSIPPI RIVER

The Mississippi is the second longest U.S. river, after the Missouri, and the largest—a third of all American streams empty into it. The Mississippi was used by Native Americans for trade and transportation for centuries before European colonization began. In the 17th century French settlers used it in the fur trade. By the 1800s the river was the principal outlet to the sea for the newly settled areas of the central United States. Goods were floated downstream to New Orleans and then shipped abroad. Imports were dragged upstream on rafts. The introduction of steamboats in 1811 meant that goods could be transported against the current much faster and led to a boom in river trade. This era was described in Mark Twain's *Life on the Mississippi* (1883).

Before engineers tamed the river in the decades after the Civil War, sailing on the Mississippi could be hazardous. The river was continually shifting its course, throwing up new sandbars and snags. The water level rose and fell at different times of the year. Submerged trees and other obstacles could tear a hole in the bottom of a boat.

At the outbreak of the Civil War the Union general-in-chief Winfield Scott put forward a military strategy, dubbed the Anaconda Plan, that aimed to starve the Confederacy into submission by cutting it off from the outside world. Scott planned to send 60,000 men down from Illinois to seize control of the Mississippi. If the Union could gain control of the river, the Confederacy would be cut in half and would struggle to survive. The plan was never fully implemented, but control of the Mississippi remained an essential objective for the Union. It was important both politically and economically for President Abraham Lincoln for the North to have an outlet to the Gulf of Mexico to open up commerce for the states on the upper reaches of the Mississippi, where opposition to the war was strong.

The Confederacy needed to defend the vital transportation route and the rich agricultural lands of the lower Mississippi Valley. Although the South had fewer vessels than the North, it only needed to hold one strongpoint on the river to prevent any Northern commerce with the outside world. The Confederates fortified strategic points on the Mississippi with forts and gun emplacements and laid mines, then known as torpedoes, along the river.

A wide variety of craft were used in the many battles on the Mississippi. Both sides had a number of rams—vessels whose chief weapon was an iron pole at the front—to hole and sink enemy ships. In 1861 the Union built ironclad gunboats at St. Louis known as "Pook Turtles" for their designer, James Pook, specifically to do battle on the lower Mississippi. The Union also used converted steamers with iron armor which was only 1 inch (2.5cm) thick. This light armor was enough to protect against rifle fire from the river banks and allowed the tinclads to operate in shallower waters than heavily armored ironclads.

The Union combined navy and army forces to take the Mississippi. The navy transported troops and supplies, and bombarded forts, as well as fighting other vessels. For example, the fortified Island Number 10 near New Madrid, Missouri, was captured in April 1862 in a combined assault by troops and a fleet of gunboats and mortar boats.

The most important battles fought on the Mississippi were two great Union victories—the capture of New Orleans in April 1862 and of Vicksburg in July 1863 after a campaign lasting almost a year. Five days after Vicksburg fell, Port Hudson surrendered, and the length of the Mississippi River was in Union hands.

After the war river traffic resumed along the Mississippi, but by then much of the trade had been lost to the expanding railroad network.

Washington, Wisconsin, where citizens burned draft records. By far the most violent episode takes place in New York City. On July 11, days after word reached the city of the Union victory at Gettysburg, New York held its first draft lottery (the drawing of draftees' names) without incident. However, public meetings on July 12 raised antidraft feeling, and today a crowd of angry workers burns the city draft offices.

By the second day of the riots the crowd is made up largely of Irish immigrants, whose rage at poverty, ethnic discrimination, and an unfair draft find a range of targets, including the homes of leading Republicans, the offices of antislavery newspapers, and even the elite Brooks Brothers

▶ *An 1863 painting of a Union bugler by William Morris Hunt. Bugle calls carried to large units spread over a wide area.*

department store. The rioters soon target New York's African Americans, who are blamed as a cause of the war. Rioters lynch at least 11 people, burn the city's Colored Orphan Asylum, and force hundreds of blacks to flee the city.

The Union sends 20,000 troops to quell the uprising. More violence follows as soldiers killed at least 82 rioters. Two policemen and eight soldiers are also killed. Order is restored by July 16, and conscription in the city resumes on August 19; but bitterness between the communities in New York City remains.

JULY 16

SOUTH CAROLINA, *LAND WAR*
The Battle of Grimball's Landing/James Island/Secessionville. The Confederates make an abortive attack on a Union amphibious landing at Grimball's Landing, near Charleston.

▲ *Members of the U.S. Christian Commission at a camp near Germantown, Maryland. The commission distributed food and aid and cared for wounded soldiers.*

JULY 17

OKLAHOMA, *LAND WAR*
The Battle of Honey Springs/Elk Creek/ Shaw's Inn. Major General James G. Blunt's District of the Frontier troops defeat the 1st Brigade, Native American troops, at Honey Springs, resulting in Union control of Indian Territory north of the Arkansas River.

JULY 18

SOUTH CAROLINA, *LAND WAR*
The Union 54th Massachusetts charges the Confederate stronghold at Fort Wagner. Although the assault fails, the regiment's courage under fire proves to

KEY PERSONALITY

JUBAL EARLY

Jubal Anderson Early (1816–1894) was born in Virginia in 1816. An 1837 graduate of the Military Academy at West Point, Early fought in the Seminole Indian War in Florida (1835–1837) before resigning his commission to begin a career as an attorney and politician. He returned to serve in the Mexican War (1846–1848) as a major of volunteers.

At the outbreak of the Civil War Early entered Confederate service as colonel of the 24th Virginia Infantry. He was promoted to brigadier general after First Bull Run (July 21, 1861) and served with the Army of Northern Virginia from 1862 to 1864. During this period he developed a reputation as a hard fighter and one of Robert E. Lee's best division commanders. Because of Early's temper, hard-drinking, and imaginatively profane speech, Lee referred to him as "my bad old man."

The first day of the Battle of Gettysburg (July 1, 1863) was one of Early's best days of the war. His division pushed back a Union division right through the town from north to south. After the battle he criticized his superior officer, Richard S. Ewell, for failing to attack the Union position on Cemetery Hill.

Following the removal of Ewell during the 1864 Virginia campaign, Early took command of II Corps and led it on an invasion of Maryland. After reaching the outskirts of Washington, D.C., his forces were defeated and dispersed in the Shenandoah Valley by Union troops under Philip H. Sheridan. Lee relieved Early of his command following this embarrassment, and "Old Jubilee" was not present at the Appomattox surrender 10 days later.

After the war Early lived for a time in Mexico and then in Canada. He returned to Virginia to practice law and continued to fight the Civil War with pen and printing press. Early became a leading advocate of the Lost Cause—the idea that the Confederates' cause had been noble but doomed. As the first president of the Southern Historical Society, Early promoted the reputation of Lee. He wrote critically of many other Confederate commanders, most notably Longstreet, whom he held to blame for the defeat at Gettysburg. Early's war memoirs are remarkable for their insights and biting comments. He died in Virginia in 1894, an "unreconstructed Rebel" to the end.

whites the fighting quality of black soldiers. Black soldiers, though, are not paid equally for their service. A white Union soldier receives on average $13 a month plus a $3.50 clothing allowance; a black soldier receives $10 a month less a $3 clothing deduction. In addition, black soldiers receive no financial bounty on enlistment as white volunteers do.

JULY 19

OHIO, *LAND WAR*

The Battle of Buffington Island/St. Georges Creek. A force of 2,460 cavalry under Confederate Brigadier General John H. Morgan has been raiding Ohio, pursued by an increasing number of Union troops and Ohio militia. Today, Morgan attempts to recross the Ohio River into West Virginia, but is blocked and badly

▲ *A Union battery at drill in Georgia. A battery had between four and eight guns. Three or more batteries made up a battalion, two battalions a regiment.*

defeated by a combined force of 3,000 Union troops and gunboats. In the largest and almost only battle fought on Ohio soil, Morgan's men suffer 820 casualties, including 700 prisoners. Union losses are 25. Morgan flees with a remnant as far north as West Point, near Steubenville, Ohio, where he and his men are captured. In retaliation for the poor treatment of Union prisoners of war in the South he and his officers were put in the Ohio Penitentiary as common criminals.

JULY 23

VIRGINIA, *LAND WAR*

The Battle of Manassas Gap/ Wapping Heights. A Union attack through the Manassas Gap in

the Shenandoah Valley fails to cut off Lee's retreating Confederates.

JULY 24–25

NORTH DAKOTA, *INDIAN WARS*

The Battle of Big Mound. Union Brigadier General Henry Hastings Sibley defeats a large Sioux Indian force at Big Mound during operations against the Indians in North and South Dakota.

JULY 26

OHIO, *LAND WAR*

The Battle of Salineville/New Lisbon Road/New Lisbon/Wellsville. Rebel Brigadier General John Hunt Morgan's Kentucky raiders (364 men in total) are surrounded by a force of 2,600 Union cavalry and forced to surrender while attempting to cross the Ohio River. During his raid Morgan captured 6,000 Union soldiers, destroyed 34 bridges, and disrupted the railroads at more than 60 places.

NORTH DAKOTA, *INDIAN WARS*

The Battle of Dead Buffalo Lake. Sibley continues his pursuit of the Sioux with another victory over Indian forces in North Dakota.

JULY 28

NORTH DAKOTA, *INDIAN WARS*

The Battle of Stony Lake. The Sioux are repulsed after attacking Sibley's camp around Stony Lake.

◀ *The Union 54th Massachusetts Volunteer Infantry attacks Fort Wagner, South Carolina, on July 18. The 54th was one of the Union army's first black regiments.*

SOUTH CAROLINA, *COASTAL WAR*

The siege of Fort Sumter/ Charleston Harbor/Morris Island. Union batteries on Morris Island bombard Confederate defenses at Fort Sumter and Charleston.

AUGUST 21

TENNESSEE, *LAND WAR*

The Battle of Chattanooga. Union forces conduct a bombardment of Chattanooga, causing much damage and diverting attention from major Union crossings of the Tennessee River.

KANSAS, *LAND WAR*

The Battle of Lawrence/Lawrence Massacre. Guerrillas under William Quantrill attack Lawrence, well known as a hotbed of antislavery sentiment. On Quantrill's orders they burn the town and murder every adult male they encounter, as well as a small garrison of Union soldiers. In all, over 150 people are killed and 200 dwellings destroyed.

Quantrill has been declared an outlaw by the Union but holds a captaincy in the Confederate army. Among those who fight in his band are Frank and Jesse James and "Bloody Bill" Anderson. Quantrill and his men have a policy of "no quarter" with regard to Jayhawkers and Union soldiers.

AUGUST 25

MISSOURI, *HOME FRONT*

General Order No. 11 is issued by Union Brigadier General Thomas Ewing, forcing the evacuation of people from four counties in western Missouri.

▲ An illustration in Harpers' Weekly of Confederate partisan raider John S. Mosby and his band attacking a sutlers' wagon train in September 1863.

▼ Armies on the battlefield at Chickamauga. The area was a large natural amphitheater. The terrain was mainly flat and covered by thick forest.

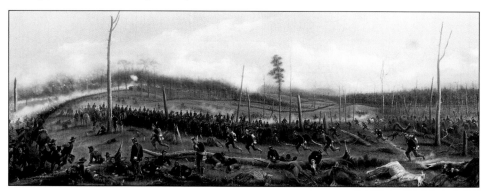

SEPTEMBER 1

ARKANSAS, *LAND WAR*

The Battle of Devil's Backbone/ Backbone Mountain. Confederate forces temporarily check a Union pursuit of Rebels from Fort Smith, but are eventually forced to retreat in disorder to Waldron.

SEPTEMBER 6–8

SOUTH CAROLINA, *COASTAL WAR*

The Battle of Charleston Harbor. Confederate forces around Charleston lose Fort Wagner and Battery Gregg to Union forces, but manage to fend off a combined marine/infantry assault against Fort Sumter.

SEPTEMBER 8

TEXAS, *LAND WAR*

The Battle of Sabine Pass/Fort Griffin. A Union flotilla of four gunboats and 18 troop transports, carrying 6,000 troops, steams into Sabine Pass and up the Sabine River with the intention of

reducing Fort Griffin and landing troops to begin occupying Texas. However, the Davis Guards (49 men and six cannon in Fort Griffin) sinks two of the gunboats, kill or wound more than 100 Union troops, and take 300 prisoners, successfully turning back the invasion. The Confederates suffer no losses.

SEPTEMBER 10

ARKANSAS, *LAND WAR*

The Battle of Bayou Fourche/Little Rock. Union troops take Bayou Fourche and Little Rock, consolidating Union control in the Trans-Mississippi area.

SEPTEMBER 18

TENNESSEE, *LAND WAR*

The Battle of Chickamauga. General Rosecrans, commander of the Union Army of the Cumberland (62,000 men), orders George H. Thomas to position his corps north of Thomas L. Crittenden's corps to prevent Confederate General Braxton Bragg and his 65,000 men from cutting off the Union army from Chattanooga, a key rail junction on the main Confederate east-west railroad. Not realizing that Thomas now forms the left flank of the Union army, Bragg crosses his forces over Chickamauga Creek and makes camp after some skirmishing with two Union cavalry brigades. The opposing battle lines are set, but due to the thickly wooded terrain along the creek, neither side is aware of it.

SEPTEMBER 19

TENNESSEE, *LAND WAR*

The Battle of Chickamauga. A single Union division initiates the battle this morning. It advances believing that it has trapped a small Confederate force west of Chickamauga Creek. The fighting is inconclusive, with both sides suffering heavy casualties. A late afternoon attack by John Bell Hood's Confederates threatens to split the Union line, but reinforcements plug the gap at the last moment. Rosecrans plans to fight on the defensive tomorrow and has his men dig trenches for their protection.

SEPTEMBER 20

TENNESSEE, *LAND WAR*

The Battle of Chickamauga. Initial Rebel attacks begin four hours late due to poor staff work and make little headway against Thomas' well-situated defensive line on the Union left. At 11:00 hours, Rosecrans pulls Thomas Wood's division out of the right of his line to plug what he thinks is a gap farther north. Fortunately for the Confederates, three of their divisions under Longstreet launch an attack into the gap left by Wood at precisely the same time. The Union's defensive position is shattered. As Longstreet's men come close to cutting his line of communication with Chattanooga, Rosecrans orders a retreat.

Not all Union forces are through fighting. Troops under George H.

Thomas make a stand on Snodgrass Hill, a wooded ridge on the northern end of the Union line. Thomas and his force succeed in holding Bragg at bay as Rosecrans and the bulk of the Union army withdraw into Chattanooga. For his efforts Thomas earns the Medal of Honor and is thereafter known as the "Rock of Chickamauga." In stark contrast to Thomas, Rosecrans is inconsolable as he is carried along into Chattanooga by the wreckage of his army.

Chickamauga is a hollow victory for the Confederates: Bragg is unable to follow it up with the final defeat of the Army of the Cumberland. At a cost of over 18,000 casualties, Bragg can only push Rosecrans back to Chattanooga— he is unable to destroy him or force the surrender of his army by a siege.

SEPTEMBER 22

TENNESSEE, *LAND WAR*

The Battle of Blountsville. During Burnside's moves into East Tennessee, Union forces overcome the 1st Tennessee Cavalry Regiment at Blountsville.

SEPTEMBER 29

LOUISIANA, *LAND WAR*

The Battle of Stirling's Plantation/ Fordoche Bridge. Confederate troops act against a Union thrust toward Texas, defeating a 1,000-strong force at Stirling's Plantation/Fordoche Bridge. Total battle casualties are 575.

KEY PERSONALITY

BRAXTON BRAGG

An 1837 graduate of the U.S. Military Academy at West Point, Bragg (1817–1876) served in the Mexican War (1846–1848), where he fought with Jefferson Davis, the future Confederate president. In 1856 Bragg resigned his army commission to be a sugar planter.

When the Civil War broke out, Bragg was made a brigadier general in the Confederate army. At the Battle of Shiloh on April 6–7, 1862, he served as a corps commander in the Army of Tennessee (then called the Army of the Mississippi). Two months later President Davis appointed him the Army of Tennessee's top commander in place of Pierre G.T. Beauregard. Bragg held the post until December 1863.

At first Bragg did well. He restored discipline, then organized a remarkable campaign that carried the army from northern Mississippi into Kentucky. It briefly appeared as if Bragg might reach the Ohio River, but an

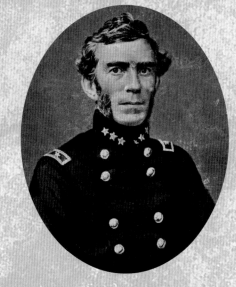

inconclusive battle at Perryville on October 8, 1862, caused him to withdraw into central Tennessee. The retreat gave him the

reputation of being a general who could snatch defeat from the jaws of victory.

Bragg's poor reputation dipped lower in December, when he attacked William S. Rosecrans' Union troops at the Battle of Stones River. Initial success was again followed by defeat, although Bragg mauled the Union forces so badly that Rosecrans did not resume the offensive for six months. When he did, however, Rosecrans outwitted Bragg, capturing Chattanooga, a crucial railroad center, almost without firing a shot.

Bragg then counterattacked. At the Battle of Chickamauga, September 19–20, 1863, he defeated the Union forces and besieged Chattanooga, only to be repulsed two months later. After this defeat President Davis reluctantly removed him from command but as a show of confidence appointed Bragg his military adviser. Bragg was briefly recalled to military service by Lee, who took command of the army in 1865.

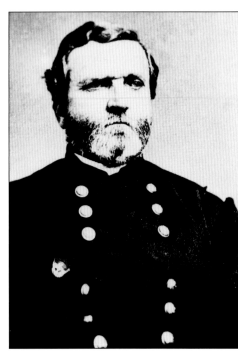

▲ *George H. Thomas was a native of Virginia who chose to fight for the Union. At Chickamauga he saved the Union army from destruction and was afterward given command of the Army of the Cumberland.*

OCTOBER 5

SOUTH CAROLINA, *NAVAL WAR*
The CSS *David*, a Confederate torpedo boat, explodes a spar torpedo against the side of the USS *New Ironsides* in Charleston harbor, causing significant damage to the Union vessel.

OCTOBER 6

KANSAS, *LAND WAR*
The Battle of Baxter Springs. Lieutenant Colonel William Quantrill massacres 103 Union troops around the Union post of Baxter Springs.

OCTOBER 10

TENNESSEE, *LAND WAR*
The Battle of Blue Springs. Confederate troops, on a raid toward Bull's Gap on the East Tennessee & Virginia Railroad, are checked at Blue Springs. The Kentucky Rebel cavalry are eventually forced out of Tennessee.

OCTOBER 13

VIRGINIA, *LAND WAR*
The Battle of Auburn/Catlett's Station/ St. Stephen's Church. Confederate troops under "Jeb" Stuart skirmish with the Union's III Corps near Auburn.

▶ *The Union gunboats* Sachem *and* Clifton *are disabled and captured by a small Confederate force at Sabine Pass, Texas, during the Union invasion attempt of September 1863.*

OCTOBER 14

VIRGINIA, *LAND WAR*
The Battle of Bristoe Station. Lee, in an effort to turn Meade's right flank and put himself between the Union army and its supply base at Centreville, led his army across the Rapidan River and moved toward Culpeper. Meade, however, discerned his opponent's straegy and ordered a retreat.

As the corps of General A.P. Hill comes to high ground in full view of Bristoe Station, Hill himself sees thousands of retreating Federals crossing the fords of Broad Run. Hill then sends

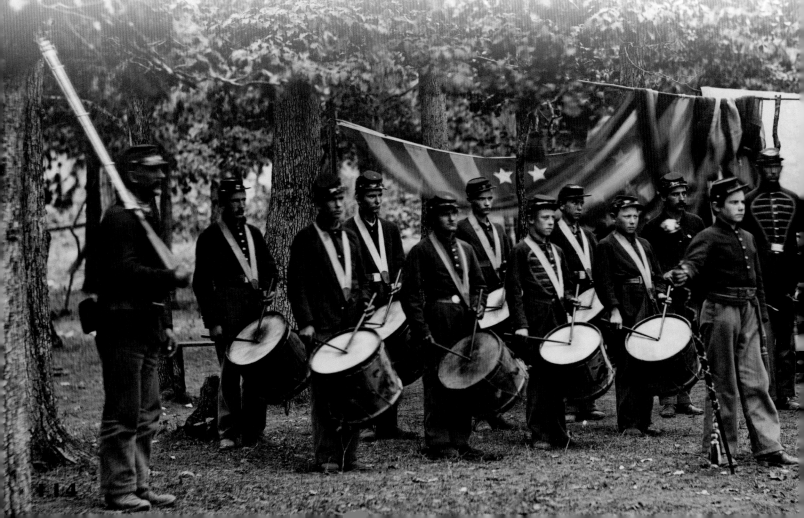

battalion, McIntosh's, and word that Anderson's division, in the rear of Heth, should hurry forward to cover Heth's right flank. He also orders the brigade on the right of the attack to watch the flank, and its commander reacts promptly, refusing his right with one regiment that drives off the Federal skirmishers.

Hill orders the run to be crossed without making any effort to reconnoiter the railroad cut on his right. As the Confederates advance, suddenly thousands of Union troops emerge from behind the railroad embankment, catching the Confederates in fire from several angles. Well-placed Federal artillery adds its support. Hill rushes up two artillery battalions to cover his infantry, but as the Federals retreat Hill's losses are considerable. In all, he suffers 1,381 dead, wounded, and captured.

Meade continues to fall back and his men dig-in at Centreville, where Lee realizes that his position is too tough to overrun and that there is no easy way of supplying his troops if they besieged the Federal lines.

OCTOBER 15

SOUTH CAROLINA, *NAVAL WAR*
The Confederate submarine *H.L. Hunley* sinks for a second time during training exercises, killing seven crew members.

OCTOBER 16–18

FLORIDA, *COASTAL WAR*
The Battle of Fort Brooke. Union gunboats bombard Fort Brooke in

back to hurry his lead unit, Heth's division, forward to cross the run in pursuit. Hill orders Heth to form his three brigades into a line of battle the instant he is within striking distance, keeping a fourth brigade in column as his reserve. But Heth cannot comply quickly enough for Hill, and can only deploy

two brigades, with a third one struggling to catch up in the rear, while Poague's artillery battalion deploys to cover them. Hill suddenly notices skirmishers on the southern side of the run, spreading southward near the railroad and parallel to the Rebel right. Hill thinks all the Union troops are well across the run, but, suddenly uncertain, he sends back for an additional artillery

▼ A fife-and-drum band of the Union army. Fife-and-drum bands were effective for marching and on the battlefield, and the fifes were not as heavy to carry as brass instruments.

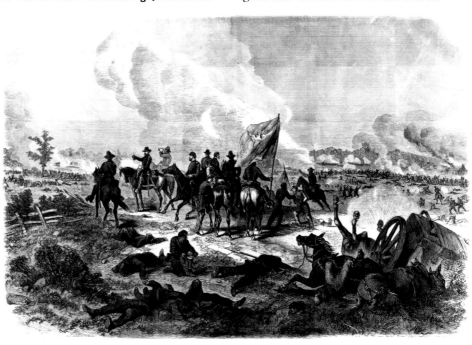

▼ A drawing of the bloody Battle of Chickamauga. Bragg's Confederate army forced the Union army led by Rosecrans to retreat into Chattanooga, Tennessee.

KEY PERSONALITY

ULYSSES SIMPSON GRANT

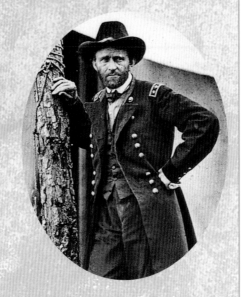

Ulysses Simpson Grant (1822–1885) graduated from the U.S. Military Academy at West Point in 1843 and went on to serve in the Mexican War (1846–1848). His early career as a soldier was spoiled by rumors of drunkenness, and he resigned his captaincy in 1854. After several failed business ventures, in 1861 Grant was working as a clerk in the family store in Galena, Illinois.

When war broke out in April 1861, Grant offered his services to the War Department. He was initially refused but, with the aid of a supportive senator, was given command of the 21st Illinois Volunteers in June. In July he was promoted to brigadier general of volunteers and given command of the District of Southeast Missouri, with headquarters at Cairo, Illinois.

Grant's first major success was on the Cumberland River at Fort Donelson, Tennessee, in February 1862. The defeat and capture of the Confederate garrison brought him to the notice of the Northern press and public for the first time. His brilliant battle tactics and refusal to accept any terms except unconditional surrender thrilled the Union public.

The success was shortlived, however. Grant commanded Union forces at the Battle of Shiloh, along the Tennessee River on April 6, 1862. It was only with the aid of William T. Sherman and substantial reinforcements that he avoided defeat after a Confederate attack under Albert S. Johnston took him by surprise. This near-failure and a row with his superior, Henry W. Halleck, took Grant from field command for a while. He was reinstated with the support of President Abraham Lincoln, who commented, "I can't spare this man—he fights."

Given command of the Army of the Tennessee in October 1862, Grant's next objective was Vicksburg, the key to Confederate control of the lower Mississippi River. In a combined operation with Union navy gunboats, Grant advanced on Vicksburg and laid siege to it. The city surrendered on July 4, 1863, to huge rejoicing in the North. The victory was a turning point in Grant's career. He was rewarded with a promotion to major general.

On October 16, 1863, he took command of all Union forces from the Mississippi River to the Appalachian Mountains. He at once went to assist the Union army besieged at Chattanooga, Tennessee. Victory there during the battles of November 23–25 secured Grant the thanks of his president and a move

by Congress to award him the specially revived rank of lieutenant general. He went to Washington, D.C., in March 1864 to receive both his promotion and the post of general-in-chief of all Union armies.

Grant's strategy was to grind down the Confederate armies in a war of attrition and at the same time finish off the Southern economy by destroying its rich farm lands. In May 1864 he traveled with the Army of the Potomac, under George G. Meade, toward Robert E. Lee and Richmond. The six-week Overland Campaign was a bloody affair that resulted in 60,000 casualties. Despite the high cost in men and repeated tactical reverses, Grant kept moving forward relentlessly.

The Army of the Potomac forced Lee's army back to Petersburg and besieged it for 10 months. Meanwhile, Grant's subordinate, Sherman, marched through Georgia from Atlanta to the sea, destroying enemy supply lines and cutting a swath of destruction through the state. By the time Sherman reached the coast, his troops had caused $100 million in damage. Sherman then turned north and desolated the Carolinas.

On April 2, 1865, Lee withdrew from Petersburg, and Richmond had to be evacuated. After a running fight of seven days Grant cornered Lee at Appomattox, where he accepted Lee's surrender. Lee acknowledged the generosity of Grant's surrender terms.

Grant was promoted to full general in 1866. In 1868 he was elected U.S. president, serving two terms that were marred by scandals. His reputation was restored by the publication of his memoirs, which are among the finest written about the Civil War. They were completed a week before his death in 1885.

Tampa while a Union raiding party is landed and then attacks Confederate shipping on the Hillsborough River.

OCTOBER 19

VIRGINIA, *LAND WAR*

The Battle of Buckland Mills/Buckland Races/Chestnut Hill. Confederate troops ambush Union cavalry that were pursuing Lee's retreating army, following its defeat at Bristoe Station and an aborted advance on Centreville. The Union forces are chased for 5 miles (8km), hence the action is sometimes called the "Buckland Races."

OCTOBER 25

ARKANSAS, *LAND WAR*

The Battle of Pine Bluff. A company of Union cavalry heading for Princeton are forced back by Confederate troops to Pine Bluff, which the Union troops successfully defend. The Confederates themselves then retreat.

▶ *Wounded soldiers recuperating under the trees on Marye's Heights, Virginia, in 1863. Marye's Heights was the scene of two fierce battles during the war.*

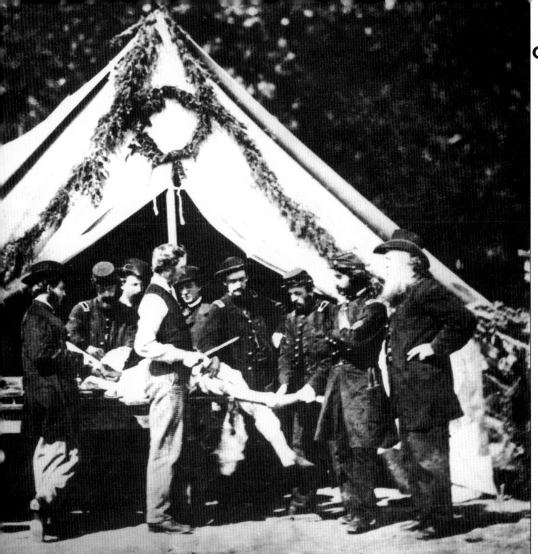

◀ *A surgeon amputating a limb at a field hospital. Amputations were carried out without anaesthesia, and many patients died from either shock or infection.*

OCTOBER 27

THE UNION, *ARMED FORCES*

The first sanitary fair is held in Chicago (many Northern cities will hold sanitary fairs to raise funds to buy medical supplies for wounded soldiers and other types of relief). The organizers—Mary Livermore and Jane Hoge of the U.S. Sanitary Commission—encourage people to donate items of interest that they can sell to raise funds. The Chicago fair will run for two weeks and draw 5,000 visitors. The entrance price is 75 cents, and the items on sale include artwork, musical instruments, toys, and clothes. President Lincoln donates the original draft of the Emancipation Proclamation, which is the fair's main attraction and sells at auction for $3,000. The Chicago fair will raise a total of $100,000.

Following its success, other major Northern cities held fairs. The largest sanitary fair was held in New York in April 1864. Visitors could buy trinkets made by Confederate prisoners of war or even bid for a tame bear or a shipload of coal.

OCTOBER 28–29

TENNESSEE, *LAND WAR*

The Battle of Wauhatchie/Brown's Ferry. In a night action aimed at preventing relief forces reaching Chattanooga, Confederate forces attack Union defenses at Wauhatchie, but without success. Union losses are 420; Confederate 408.

▲ *A drawing by Edwin Forbes of the Union army's VI Corps at the Battle of Rappahannock on November 7, where over 1,600 Confederates were captured.*

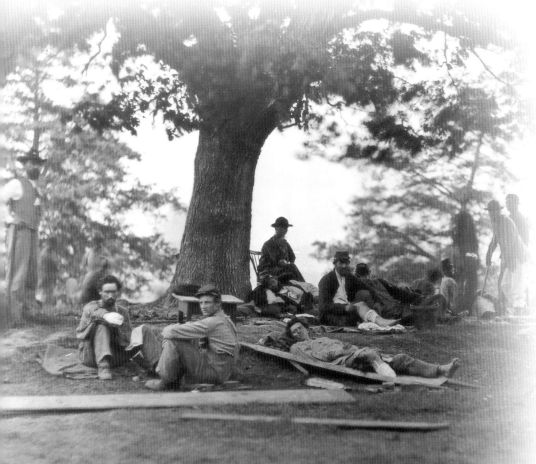

NOVEMBER 3

NOVEMBER 3

TENNESSEE, *LAND WAR*

The Battle of Collierville. The Union 3rd Cavalry Brigade (850 men) stops a Confederate attempt by 2,500 cavalrymen under Brigadier General James R. Chalmers to cut the Memphis & Charleston Railroad behind the Union XV Army Corps, which is heading to relieve Chattanooga.

▲ The Robert E. Lee *ran the Union blockade 21 times, exporting 7,000 bales of cotton in exchange for military supplies. The ship was captured in 1863.*

▶ *Hanover Junction Railroad Station in November 1863. Abraham Lincoln changed trains here on his way to Gettysburg. The man in the tall hat is believed to be Lincoln.*

NOVEMBER 6

WEST VIRGINIA, *LAND WAR*

The Battle of Droop Mountain. A Confederate brigade is defeated during a Union action into Virginia against the Virginia & Tennessee Railroad.

NOVEMBER 7

VIRGINIA, *LAND WAR*

The Battle of Rappahannock Station. Over 1,600 Confederate soldiers are captured at Rappahannock Station as the Union forces forge two crossings of the Rappahannock River.

NOVEMBER 14

TEXAS, *NAVAL WAR*

The Confederate blockade runner *Terista*, carrying 298 bales of cotton, is captured by the USS *Granite* near the mouth of the Rio Grande.

DECISIVE MOMENT

GETTYSBURG ADDRESS

The Battle of Gettysburg had been fought on July 1–3, 1863, four and a half months before Lincoln's visit. Although the battle turned back a Confederate invasion of the North, the Union victory came at a heavy cost. After the battle the Pennsylvania governor appointed a local businessman, David Wills, to purchase the land and arrange for the burial of the bodies. Wills formed a commission to collect funds from all the Union states to pay the expenses. He planned to have the cemetery officially dedicated in late October.

Funeral oration was a highly developed type of public speech, and David Wills believed that the Gettysburg dedication deserved the country's greatest orator. Accordingly, he invited Edward Everett of Massachusetts to present the keynote address. Everett was a noted scholar and former secretary of state, and widely believed to be the nation's finest orator. Everett accepted the invitation, and the date of the ceremony was set for November 19.

Several weeks later Wills issued an invitation to President Lincoln to join in the ceremonies. Lincoln accepted and soon came to see the occasion as a way to explain his views on the larger significance of the war. The program consisted of music, prayers, and Everett's oration. Lincoln's role was to make a few remarks and to open the cemetery.

November 19, 1863, was a crisp, clear, fall day, ideal conditions for the outdoor event. The ceremonies began at around noon. After the opening musical pieces and the prayers Everett stood and spoke from memory for two hours. Following Everett's well-received speech, a hymn was sung, and the president rose to make his remarks.

Unfolding a paper from his coat pocket, Lincoln delivered the 272-word address in his high, clear Kentucky-accented voice. Speaking slowly and loudly enough to be heard by the crowd of more than 10,000, he took about three minutes to make the speech.

Lincoln began with a reference to the birth of the United States. The Declaration of Independence, he explained, had "dedicated" the nation "to the proposition that all men are created equal." He then turned to the current war, which he said was putting that proposition to its greatest test. After praising the "brave men, living and dead," who had fought at Gettysburg, Lincoln called attention to the fact that the living must "be dedicated here to the unfinished work" that the soldiers had begun. He closed by calling on Americans to "highly resolve that these dead shall not have died in vain—that this nation, under God, shall have a new birth of freedom and that government of the people, by the people, for the people, shall not perish from the earth."

Several stories surround the writing of the Gettysburg Address. The most common is that Lincoln jotted his comments hurriedly on the back of an envelope shortly before the dedication. In fact, Lincoln prepared his remarks in advance, in Washington, and the speech went through several revisions. The president was a dedicated wordsmith who wrote carefully, weighing each word, and devoting much thought to his speeches.

The address did not cause a sensation at Gettysburg or even when it was published in the newspapers. However, supporters of the Union cause soon came to understand the revolutionary nature of Lincoln's words.

Many Northerners, including Lincoln, had entered the war arguing that secession must be put down in order to preserve the Constitution—a Constitution that also allowed slavery to exist in states that wished it. In his address Lincoln proposed a new America, one based on the assertion in the Declaration of Independence that "all men are created equal." The Civil War, terrible though it was, offered an opportunity for the nation to live up to that "proposition." Lincoln did not mention any battles by name, no individuals, and neither side in the war. Instead, by dedicating the nation to "a new birth of freedom," Lincoln elevated the struggle to a test of whether true democracy and equality had a future in the world.

▼ The Battle of Chattanooga

On October 26, Union forces established the "cracker" line to supply the Army of the Cumberland besieged in Chattanooga (1). On November 23 Union troops dislodged the Confederates from their position on Orchard Knob, a foothill below Missionary Ridge (2). Union troops then attacked Lookout Mountain in thick fog on November 24 and drove away Confederate forces (3). Union forces converged on Missionary Ridge on November 25 and by 16:00 hours had routed Bragg's Confederates (4). Not only had one of the Confederacy's two main armies been routed, but the Federals now securely held Chattanooga, the "Gateway to the Lower South," which would become the supply and logistics base for Sherman's 1864 Atlanta Campaign.

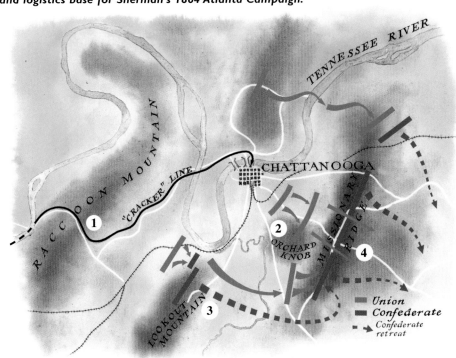

NOVEMBER 16

TENNESSEE, *LAND WAR*

The Battle of Campbell's Station. Burnside's Union Department of the Ohio troops beat Longstreet's Confederate forces in East Tennessee in a race to Knoxville, and conduct a successful defensive action.

NOVEMBER 19

VIRGINIA, *POLITICS*

U.S. President Abraham Lincoln makes his famous "Gettysburg Address." (see box on page 118).

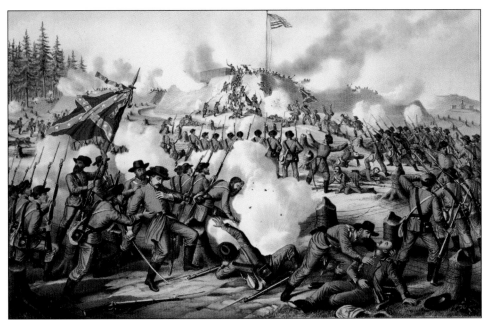

NOVEMBER 23

TENNESSEE, *LAND WAR*

The Battle of Chattanooga. Chattanooga in southeastern Tennessee lies at the rail junction linking Virginia with Tennessee, Georgia, and points west.

Without this vital rail terminus Confederate troops moving between different theaters of war would have to use a roundabout series of railroads in the Deep South. For the Union, Chattanooga is an objective because it could serve as a base for an attempt to capture Atlanta.

As the war has gone on, it has become clear that whoever controls Chattanooga controls Tennessee, Georgia, and Alabama. Between June and August 1863, Union General William S. Rosecrans and his Army of the Cumberland have opened up central and eastern Tennessee and driven Confederate General Braxton Bragg and his Army of Tennessee out of Chattanooga. The Confederates checked the Union advance at the Battle of Chickamauga (September 19–20), forcing the Army of the Cumberland back to Chattanooga. Bragg then laid siege to the city.

◄ *Confederate troops attack Fort Sanders, Tennessee, on November 29. The abortive 20-minute assault by three brigades sustained 780 casualties.*

NOVEMBER 24

The outlook for the Union forces was grim, as their supplies quickly began to run out. The Confederates were unable to muster the strength to attack, though, and Lincoln reinforced the city with additional troops. In October Ulysses S. Grant arrived to resolve the situation.

Today, the Union army crosses the Tennessee River at several points in an attempt to break the Confederate siege. The offensive succeeds. Elements of Grant's army scale Lookout Mountain.

NOVEMBER 24

TENNESSEE, *LAND WAR*
The Battle of Chattanooga. Grant's Union army fights what becomes known as the Battle above the Clouds, which forces Bragg out of a key position above Chattanooga. Following defeat at Lookout Mountain, Bragg entrenches on Missionary Ridge, a strong position stretching south from the Tennessee River. Bragg's generals place their men in poor positions, however.

NOVEMBER 25

TENNESSEE, *LAND WAR*
The Battle of Chattanooga. In one of the war's most stunning victories, Union troops under George H. Thomas storm Missionary Ridge and defeat the Confederates. With no safe positions left, Bragg retreats south along the rail line to Atlanta in order to protect that key supply artery.

The battles for Chattanooga are over. In six months Union armies have taken control of the "Gateway to the South" and changed the course

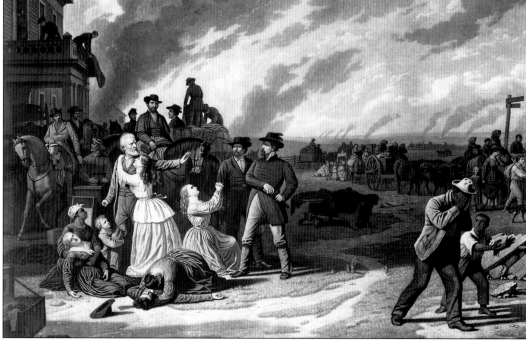

of the war. Union forces under William T. Sherman now have the supply base and jumping-off point they need to initiate a campaign against Atlanta. For the Confederacy the loss of Chattanooga completes the South's loss of the rail networks, food supplies, and manpower of central Tennessee.

NOVEMBER 27

GEORGIA, *LAND WAR*
The Battle of Ringgold Gap/Taylor's Ridge. Three divisions of pursuing Union infantry fail to dislodge one division of Confederates (who were fleeing defeat at Missionary Ridge) from Taylor's Ridge, Catoosa County.

NOVEMBER 27–DECEMBER 2

VIRGINIA, *LAND WAR*
The Battle of Mine Run/Payne's Farm/New Hope Church. With Union forces attempting a flanking action south of the Rapidan River, an inconclusive action at Payne's Farm results in 1272 U.S. and 680 Confederate casualties.

▲ *A painting depicting Missouri settlers being ordered out of their homes by Union General Thomas Ewing (in the center) in retaliation for guerrilla raids in 1863.*

NOVEMBER 29

TENNESSEE, *LAND WAR*
The Battle of Fort Sanders/Fort Loudon. A Confederate move to take Knoxville is defeated by a vigorous Union defense of nearby Fort Sanders/Fort Loudon.

NOVEMBER–DECEMBER

The Siege of Knoxville. Running from November 24 to December 9, the

Confederate siege of Knoxville brings an eventual Confederate withdrawal in the face of U.S. reinforcements.

DECEMBER 14–15

TENNESSEE, *LAND WAR*

The Battle of Bean's Station. General Longstreet pushes Union Brigadier General J.M Shackelford's 4,000 infantry and cavalry out of Bean's Station in a two-day engagement. This battle ends the Confederacy's failed Knoxville Campaign.

DECEMBER 29

TENNESSEE, *LAND WAR*

The Battle of Mossy Creek. A cavalry engagement in the vicinity of Dandridge, Jefferson County, sees rebel forces eventually pushed back and the Union in control of Mossy Creek.

▼ *The Union river gunboat USS* Fort Hindman *patrolled the Mississippi River. It was a sidewheel steamer converted into a gunboat known as a "tinclad." It was lightly armored and with a shallow draft of 2–3 feet (0.6–1m).*

KEY PERSONALITY

WILLIAM SHERMAN

Born in Lancaster, Ohio, on February 8, 1820, William Tecumseh Sherman (1820–1891) was one of 11 children. His father died when he was only nine years old. Unable to cope with such a large family, his mother sent him to live with Thomas Ewing, a wealthy and politically prominent neighbor. Ewing raised him as a foster son and gave him the name William. At age 16, thanks to Ewing's influence, Sherman gained admission to West Point, graduating in 1840. He married Ellen Ewing (his foster sister), and in 1853 left the army to become a banker.

The bank failed, though, and in 1859 friends got him the job of superintendent of the Louisiana Military Academy, a post he held when Louisiana seceded in January 1861. Sherman joined the Union army and led a brigade at the First Battle of Bull Run.

In the autumn of 1861 Sherman was put in charge of the Department of the Cumberland, where his request for more troops led him to be labeled "crazy" in the press. He became agitated and depressed, and asked to be relieved of his command.

In March 1862, he received a new assignment as commander of the Fifth Division in Major General Ulysses S. Grant's Army of the Tennessee, which was encamped near Pittsburg Landing, Tennessee. When a Confederate army attacked the Union army on April 6, 1862, Grant and Sherman were both taken by surprise. But Sherman held up well under the pressure of combat. His performance at the Battle of Shiloh gave him new confidence.

In December 1862 Grant ordered him to assault Chickasaw Bluff just north of the fortress of Vicksburg on the Mississippi. Grant himself was supposed to support the assault but failed to show up. Sherman attacked anyway. Although the attempt failed, Sherman played a key role in the Union victory at Vicksburg on July 4, 1863.

After the fall of Vicksburg Sherman replaced Grant as commander of the Army of the Tennessee. Just over two months later the Union Army of the Cumberland was surrounded at Chattanooga, Tennessee. Grant, Sherman, and much of the Army of the Tennessee went to its rescue. The ensuing Battle of Chattanooga was a dramatic Union success. When Grant became Union general-in-chief in March 1864, Sherman once more replaced him, this time becoming head of the Military Division of the Mississippi.

Grant's plan for the 1864 campaign called for a concerted offensive by all Union armies at one time. Sherman controlled three of them—the armies of the Tennessee, the Cumberland, and the Ohio—and Grant instructed him to use this massive force to "break up" the Confederate Army of Tennessee. Grant also ordered Sherman to inflict as much damage as possible on Confederate supplies and war resources.

Sherman advanced on the industrial and transportation center of Atlanta, Georgia, 100 miles (160km) southeast of Chattanooga. It took from May to September 1864, but eventually Sherman fought his way into the city. Sherman decided to abandon the city and march to a new base at the port of Savannah, Georgia, on the Atlantic coast. The march would take several weeks, but Sherman reasoned his troops could live off the countryside through which they passed.

Sherman left Atlanta with 60,000 men on November 15, 1864. On December 21 Sherman captured Savannah. After resupplying his army, Sherman began a march through the Carolinas on February 1. This second march was intended to link up with Grant's army. Before this happened, Lee surrendered on April 9, 1865.

Sherman's adversary, General Joseph E. Johnston, then began surrender talks. Sherman reached an agreement with Johnston for a general peace agreement between the Union government and the former Confederate states. President Andrew Johnson and Secretary of War Edwin Stanton, however, instructed him to deal only with a strictly military capitulation of Johnston's army.

Sherman emerged from the war as a Union hero second only to Grant. Sherman died in New York City on February 14, 1891.

1864

▲ Hard times in the South: The auction of a gold piece at Danville, Virginia, February 1864. The Confederate currency suffered severe inflation as the war went on.

This year saw the military and economic might of the Union force the Confederacy onto the defensive. Logistics were now having a crippling effect on the South's armies. At the start of the year the Army of Northern Virginia could muster only 40,000 men, and the Army of Tennessee counted a bare 36,000. The armies of the North, meanwhile, grew in strength and purpose, especially after General Grant assumed supreme command. And Grant was determined to grind the Confederacy down in a remorseless war of attrition.

JANUARY 17

TENNESSEE, *LAND WAR*
The Battle of Dandridge. Confederate forces eject Union troops from the Dandridge area after a fierce battle, although the Union force remains intact to fight another day.

JANUARY 26

ALABAMA, *LAND WAR*
The Battle of Athens/Alabama. A two-hour attack by the Confederate 1st Alabama Cavalry fails to take Athens, Alabama, despite superior numbers.

JANUARY 27

TENNESSEE, *LAND WAR*
The Battle of Fair Garden. A further Confederate incursion against Union forces around Dandridge is stopped with 165 Confederate casualties in an action on the French Broad River.

FEBRUARY 6–7

VIRGINIA, *LAND WAR*
The Battle of Morton's Ford/Rapidan River. Union crossings of the Rapidan

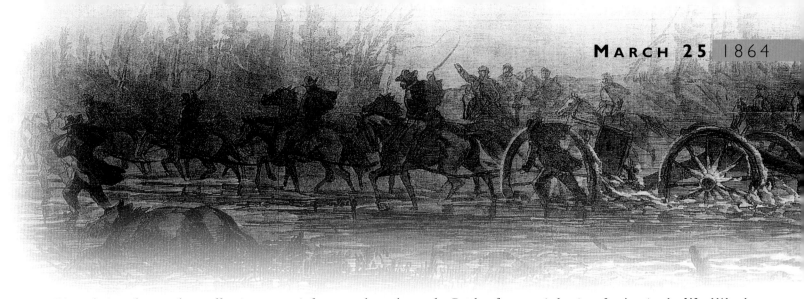

River, designed to mask an offensive toward Richmond, result in skirmishing at Morton's and Robertson's Fords.

FEBRUARY 13

OKLAHOMA, *LAND WAR*
The Battle of Middle Boggy Depot. A chance encounter between Union and Confederate troops at Middle Boggy Depot, Indian Territory, results in a Union victory and 47 Confederate deaths.

FEBRUARY 14–20

MISSISSIPPI, *LAND WAR*
The Battle of Meridian. Major General William T. Sherman leads a successful raid to destroy an important railroad junction at Meridian, Lauderdale County.

FEBRUARY 20

FLORIDA, *LAND WAR*
The Battle of Olustee/Ocean Pond. Union commander Quincy A. Gillmore leads an expedition into the Jacksonville area to disrupt supply lines and liberate slaves. Troops under the command of Gillmore and Truman Seymour join forces at Baldwin and clash with Confederate

infantry and cavalry at the Battle of Olustee. The Union troops are forced to retreat to the coast. Union casualties are heavy, with 203 killed, 1,152 wounded, and 506 missing. Many of the casualties are black soldiers of the 8th Regiment of United States Colored Troops.

FEBRUARY 22

GEORGIA, *LAND WAR*
The Battle of Dalton. Part of the Union Army of the Cumberland under the command of George Thomas clashes with Confederate General Joseph E. Johnston's forces at Crow Valley, near Dalton, Georgia. Neither side is able to get the upper hand, and Thomas eventually retreats.

MISSISSIPPI, *LAND WAR*
The Battle of Okolona. A Union force moving toward Memphis after the Meridian campaign comes under attack around Okolona. The Union troops are harassed all the way to the state line and Jeffrey Forrest, brother of Confederate General Forrest, is killed.

MARCH 2

VIRGINIA, *LAND WAR*
The Battle of Walkerton/Mantapike Hill. An abortive Union raid against

▲ *A print of a drawing by Alfred Waud showing Union troops dragging artillery through the mud in March 1864. Rain turned dirt tracks into quagmires.*

Richmond's defenses ends in the destruction or capture of much of attackers. Captured papers refer to the burning of Richmond and killing of President Davis as primary objectives.

MARCH 2

THE UNION, *ARMED FORCES*
Lieutenant General Ulysses S. Grant is made commander of all the armies of the United States.

MARCH 14

LOUISIANA, *LAND WAR*
The Battle of Fort DeRussy. Advancing into the Rebel Trans-Mississippi Department, Union troops take Fort DeRussy, opening the way to Alexandria.

MARCH 25

KENTUCKY, *LAND WAR*
The Battle of Paducah. Confederate cavalry assault the city of Paducah on the Ohio River. However, on the 26th the attackers retreat, having suffered heavy casualties.

◀ *A religious service on the deck of the USS Passaic in 1864.*

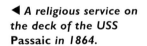

▶ *A Harper's Weekly illustration showing the Confederate evacuation of Brownsville, Texas, in 1864. Brownsville was the "back door to the Confederacy," from where goods were traded across the border with Mexico.*

APRIL 3-4

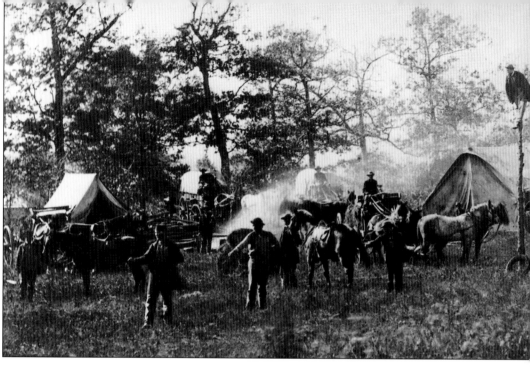

▶ *A Timothy O'Sullivan photograph of operators constructing telegraph lines at a Union camp in April 1864. During the war over 15,000 miles (24,000km) of lines were laid specifically for military purposes.*

APRIL 3-4

ARKANSAS, *LAND WAR*
The Battle of Elkin's Ferry/Okolona. During the Union's Camden Expedition, Confederate troops fail to prevent Union forces from crossing the Little Missouri River at Elkin's Ferry.

APRIL 8

LOUISIANA, *LAND WAR*
The Battle of Mansfield/Pleasant Grove/Sabine Crossroads. When General Ulysses S. Grant took command of the Union armies in early 1864, he planned a series of offensives, one of which, under General Nathaniel P. Banks, would move from New Orleans, Louisiana, against the port of Mobile in Alabama. Banks had other ideas. He decided to embark on a campaign northwest up the Red River. He envisioned a combined army and navy force, with troops and gunboats under David D. Porter, moving up the Red River to cooperate with another Union force under General Frederick Steele in capturing Shreveport, Louisiana, a major supply depot and gateway to Texas. Banks hoped to capture large supplies of cotton as well.

Banks and Porter got underway from St. Martinville, Louisiana, on March 12,

▼ *A high-angle view of Richmond. As well as being the political center of the Confederacy, the city was a medical and manufacturing center, and the main supply depot for troops operating on the South's northeastern frontier. It was thus a primary target for the Union army.*

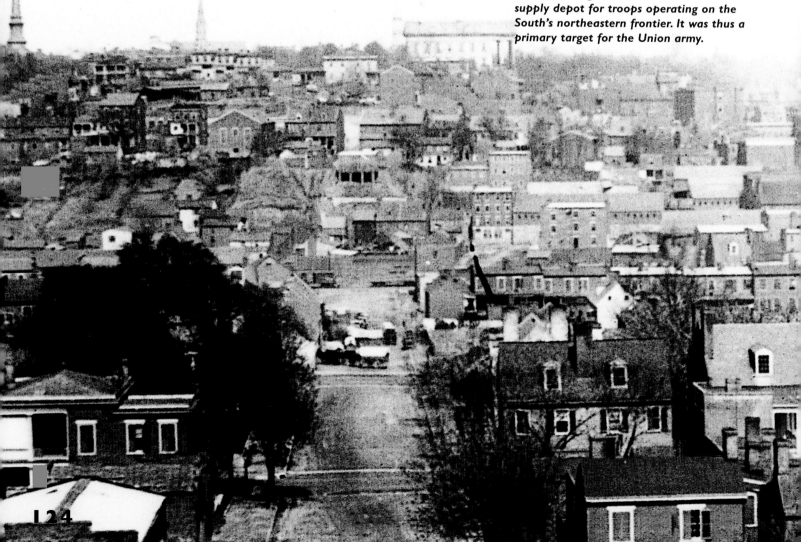

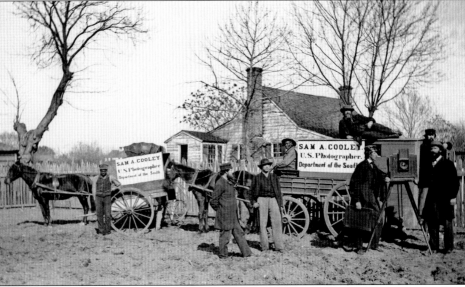

▲ *Northern photographers and their equipment. Photographers followed the armies with portable darkrooms, allowing them to develop photographs in the field.*

with the troops loaded on slow-moving transport boats. Porter's gunboats moved more quickly and on March 16 captured Alexandria, Louisiana, which was roughly halfway to Shreveport. It took Banks and his transports almost two weeks to catch up. As Porter moved to Shreveport, Banks marched his men along the west side of the Red River.

Today, a Confederate force traps and defeats Banks at Mansfield, south of Shreveport. And then Steele fails to march to support him as originally planned. Banks falls back and decides to turn the entire

expedition around and retreat to New Orleans. Porter's naval flotilla is stranded by falling river levels at Alexandria and is almost lost to Confederates firing on the fleet from the banks of the river. Only the heroic construction of river dams near Alexandria by 3,000 soldiers, sailors, and marines rescue the marooned boats and allows them to escape.

The Red River Campaign thus ends in complete failure.

APRIL 9

LOUISIANA, *LAND WAR*

The Battle of Pleasant Hill. Union forces, retreating after the Mansfield defeat, stop and turn to face a major Confederate attack near Pleasant Hill. Both sides lose over 1,500 troops.

▲ *A sketch published in* Harper's Weekly *on March 26, 1864, showing liberated slaves leaving a Southern farm on horseback to join Union forces (seen in the background).*

KEY WEAPON

REPEATING RIFLES

From 1864 the single-shot rifle musket was being steadily replaced. The Union army began to be issued with new rifles such as the Spencer, which was a breechloader that could fire six to eight rounds before it needed to be reloaded.

The Spencer cartridge was made up of a copper case containing a lead bullet and powder charge with its own primer. This made it more reliable than other ignition systems, such as those requiring primer caps or tapes. The Confederates could not match this kind of firepower. Even if they managed to salvage abandoned breechloading rifles from the battlefield, they did not have the industrial resources in the South to manufacture the new kind of metal cartridges they fired. As one Union soldier wrote of his new repeating rifle, "I think the Johnny [Rebs] are getting rattled. ... They say we are not fair, that we have guns that we load up on Sunday and shoot all the rest of the week."

APRIL 10–13

APRIL 10–13
ARKANSAS, *LAND WAR*

The Battle of Prairie D'Ane/Gum Grove/Moscow. A major clash at Prairie D'Ane sees Union forces eventually gain the upper hand over four days of fighting and go on to take Camden.

APRIL 12
TENNESSEE, *LAND WAR*

The Union garrison at Fort Pillow, on the Mississippi River, made up of 295 white Tennessee troops and 262 U.S. colored troops, all under the command of Major Lionel F. Booth, is attacked by Confederates under Major General Nathan Bedford Forrest with a cavalry division of 2,500 men. Forrest seizes the older outworks, with high knolls commanding the Union position, and surrounds Booth's force. Rebel sharpshooters on the knolls

▼ *A* New York Herald *wagon and reporters in the field. The most widely read daily newspaper in New York, the* Herald *spent freely on coverage of the conflict, and sent 63 reporters to the various battlefields.*

fire into the fort, killing Booth, but the garrison cannot depress its artillery enough to cover the approaches to the fort. The Confederates launch an attack at 11:00 hours, occupying more strategic locations around the fort. Forrest demands unconditional surrender. The garrison refuses and the Confederates renew the attack, overrunning the fort and driving the Federals down the river's bluff. Only 60 of the Union colored troops survive the fight (the Confederates are accused of massacring the black troops). The Confederates evacuate Fort Pillow in the evening.

◄ *Confederate blockade-runners and a cargo of cotton in Nassau in the Bahamas in 1864. A steamer carrying 800 bales could earn $420,000 on a successful round trip.*

"Remember Fort Pillow" becomes a rallying cry among black troops in the last year of the war.

APRIL 12–13
LOUISIANA, *LAND/RIVER WAR*

The Battle of Blair's Landing/Pleasant Hill Landing. Brigadier General Tom Green's Confederate cavalry attack grounded Union transport boats at Pleasant Hill on the Red River. Gunboat and withering infantry fire beat off the attack and kill Green.

APRIL 17–20
NORTH CAROLINA, *LAND/NAVAL WAR*

The Battle of Plymouth. Opposing land and naval forces fight a major engagement. The Confederates secure an important victory on the Atlantic coast when Plymouth falls on the 20th.

APRIL 18

ARKANSAS, *LAND WAR*

The Battle of Poison Spring. A Union raid out of Camden, sent by Major General Fred Steele, to acquire corn is crushed by the Confederates on its return journey at Lee's Plantation, the Union force losing 198 supply wagons.

APRIL 23

LOUISIANA, *LAND WAR*

The Battle of Monett's Ferry/Cane River Crossing. Retreating Union troops of the Red River Campaign overthrow a Confederate cavalry division set in defense around Monett's Ferry.

APRIL 25

ARKANSAS, *LAND WAR*

The Battle of Marks' Mills. A Union supply train of 240 wagons is captured by Confederate forces. This defeat forces Steele to look to save his army rather than unite with the forces of Nathaniel Banks on the Red River.

▶ *The 26th United Colored Volunteer Infantry in Camp William Penn, Pennsylvania. Many of the Union's main military camps and supply depots were located in the state. Camp William Penn was in operation between July 4, 1863, and August 3, 1865.*

APRIL 30

ARKANSAS, *LAND WAR*

The Battle of Jenkins' Ferry. Union Major General Fred Steele's worsted army successfully crosses the swollen Saline River, despite Confederate attempts to finish off the Union force at Jenkins' Ferry. Union losses are 521; Confederate 443.

▲ *An army hospital in Beaufort, South Carolina, in 1864. Wounded soldiers who reached a general hospital like this had a better chance of survival, although there remained an ever-present danger of infection or gangrene in injured limbs and disease. Note the members of the local fire service and their fire engine in the right foreground.*

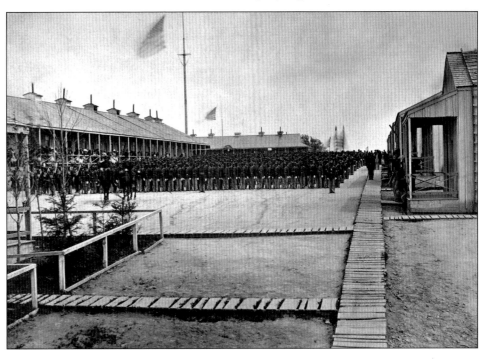

MAY 3

VIRGINIA, *LAND WAR*
The Battle of Wilderness/Furnace/Todd's Tavern. The Union Army of the Potomac begins moving south over the Rapidan River. Grant plans to bring General Lee's army out from its trenches and fight on the open ground to the south; but first his 120,000-strong army has to get through the Wilderness—a marshy area of dense woodland and scrub close to where the Union army suffered a crushing defeat last year at the Battle of Chancellorsville.

MAY 4

VIRGINIA, *LAND WAR*
The Battle of Wilderness/Furnace/Todd's Tavern. Union troops move into the Wilderness along the Germanna Plank Road and Ely's Ford Road. When Lee learns of the Union presence, he decides to attack, knowing that fighting in the thick undergrowth of the Wilderness will neutralize Grant's superior numbers. Lee orders Richard S. Ewell's corps to advance down the Orange Turnpike, while Ambrose P. Hill is to attack down the Orange Plank Road. James Longstreet's corps, located 30 miles (48km) away, is ordered up but will not arrive until tomorrow.

ALABAMA, *LAND WAR*
The Battle of Day's Gap/Sand Mountain. A Union raid to cut the Western & Atlantic Railroad fights off Confederate interdictions, although it will eventually be forced to surrender.

GEORGIA, *LAND WAR*
Union General George Thomas begins to move slowly east along the Western and Atlantic Railroad from Ringgold, thus beginning Sherman's Atlanta Campaign.

MAY 5

VIRGINIA, *LAND WAR*
The Battle of Wilderness/Furnace/Todd's Tavern. The battle begins early with Confederate attacks along the Orange Turnpike and Plank Road. The two sides are barely yards apart in places, but are hidden from one another by thick undergrowth and clouds of smoke from musket fire. The battle continues all day, but Union forces hold on and by nightfall are in a position to attack Lee's right.

NORTH CAROLINA, *NAVAL WAR*
The Battle of Albemarle Sound. The CSS *Albemarle* attacks Union blockade ships on the Roanoke River. The action is inconclusive, with damage to both sides.

MAY 6

VIRGINIA, *LAND WAR*
The Battle of Wilderness/Furnace/Todd's Tavern. At dawn both sides attack again. By 07:00 hours, Union forces are about to break the Confederate line when they are counterattacked by Longstreet's troops, which have arrived overnight. With Union troops in retreat, Longstreet takes advantage of his men's local knowledge to mount a surprise attack along the concealed roadbed of an unfinished railroad. The Federals are caught off guard, and the Confederates are soon in a position to push back the whole of the Union left, but their attack stalls in the thick undergrowth. Longstreet's corps becomes muddled with Hill's, and Longstreet himself is shot and seriously wounded in the shoulder by one of his own side. He will be out of action for several months.

By late afternoon fresh troops have arrived on the Union line, and Grant orders a new attack down the Plank Road. Lee strikes first, however, with a frontal assault over Union breastworks.

Darkness ends the fighting on the Plank Road, but it suddenly flares again north of the Orange Turnpike with a Confederate attack on the Union right. Panic races through the Union ranks as

KEY PERSONALITY

JOHN GORDON

John B. Gordon (1832–1904) attended the University of Georgia, studied law, and engaged in a coal-mining venture before the Civil War. He began his Confederate service in 1861 by raising a company of volunteer infantry known as the Raccoon Roughs. When the governor of Georgia declined his services because the state had filled its quota of volunteers, Gordon took his men to Alabama to enlist them as part of the 6th Regiment. As colonel of the 6th Alabama, Gordon took part in the Seven Days' Battles around Richmond in June 1862, earning a reputation for fearlessness in combat.

Gordon's reputation increased following the Battle of Antietam in September 1862. There his regiment occupied the center of the sunken road that later became known as Bloody Lane and resisted determined Union attacks. During the battle Gordon suffered four wounds, the last a head wound that almost killed him. Shortly after Antietam he was promoted to brigadier general.

Gordon served as a brigade commander at the Battle of Gettysburg in July 1863. He planned and carried out a brilliant attack at the Battle of the Wilderness in May 1864 and was promoted to major general on May 14.

Gordon's abilities, combined with losses among Lee's officers, led to his promotion to division, and later army corps, command. At all levels he performed brilliantly. By April 1865 Gordon was in command of over half of Lee's remaining troops. He surrendered along with Lee at Appomattox on April 9, 1865.

After the war Gordon returned to Georgia, where he was elected U.S. senator three times and governor of Georgia once. He was a driving force behind the Confederate veterans' movement and wrote an influential memoir of his wartime service.

▼ A drawing by Edwin Forbes of the Union army's VI Corps fighting in the dense undergrowth of the Wilderness during the two-day battle of the same name.

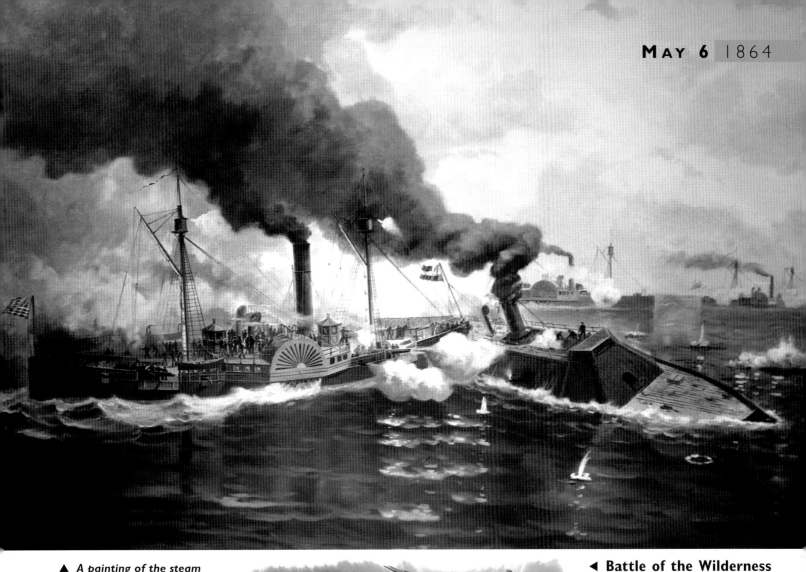

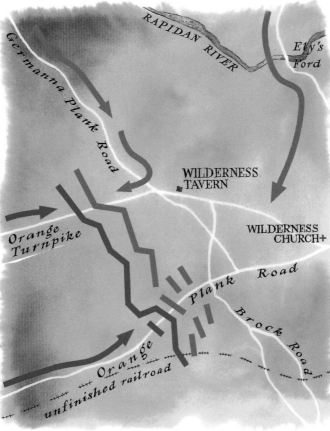

▲ A painting of the steam gunboat USS *Sassacus* ramming the ironclad CSS *Albemarle* in the Roanoke River on May 5, 1864. The *Albemarle* managed to disengage and fire two shells at close range, hitting the *Sassacus'* boiler, which exploded, seriously scalding several crew members.

◄ **Battle of the Wilderness**
On May 4, Union troops entered the Wilderness along the Germanna Plank Road and across Ely's Ford. On May 5, the battle began when troops under Confederate General Richard S. Ewell attacked along the Orange Turnpike. Confederate General Ambrose P. Hill attacked down the Orange Plank Road. Hill was unable to break through. Fighting continued in the dense under-growth until evening. On May 6 the battle was renewed. Union troops were about to break the Confederate line when reserves counterattacked. More Union reserves arrived in the afternoon, and fighting continued until nightfall. During the battle brush fires became such a problem that the fighting stopped at several points by mutual consent while soldiers of both sides cooperated in trying to save the wounded. The battle ended in a tactical draw, but was a strategic victory for the Union, as Grant continued to march south.

▲ *Union gunboats navigate through one of the dams built by Union soldiers at Alexandria, Louisiana. The dam raised the water level so the trapped vessels could escape approaching Confederate forces.*

unpleasant memories of their defeat at Chancellorsville resurface. However, Grant's refusal to be overawed by Lee's reputation and the arrival of fresh reserves stops the rout.

The inconclusive battle costs Lee 8,700 casualties. Grant suffers 17,000 dead and wounded, but the heavy losses do not shake his resolve. For the first time, instead of ordering the Army of the Potomac to retreat—the usual move after initial Union defeats in Virginia—Grant orders his troops to continue the

◀ *Union troops advancing at the Battle of Spotsylvania, Virginia. The two sides fought during a severe rainstorm. The rain- and blood-soaked spot became known thereafter as "Bloody Angle."*

advance south toward Spotsylvania. Lee will not shake off Grant until his surrender at Appomattox.

MAY 6–7

VIRGINIA, *LAND WAR*
Port Walthall Junction. A Union force of 33,000 cuts the Richmond–Petersburg Railroad at Port Walthall Junction.

MAY 7–13

GEORGIA, *LAND WAR*
The Battle of Rocky Face Ridge/Mill Creek/Dug Gap. A Union movement to cut the Western & Atlantic Railroad at Resaca encounters the enemy on Rocky Face Ridge, which the Confederates are forced to relinquish on the 12th.

MAY 9

VIRGINIA, *LAND WAR*
The Battle of Cloyd's Mountain. Three brigades of Union raiders in southwestern Virginia fight violent hand-to-hand actions on Cloyd's Mountain, resulting

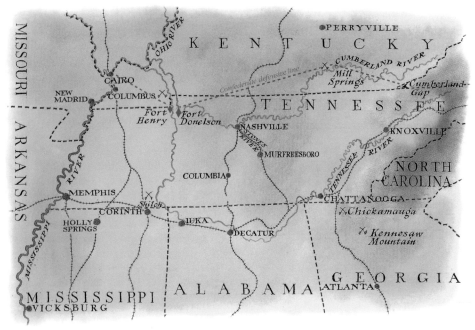

◀ The Civil War in the West

The Western theater encompassed Kentucky and Tennessee, most of Mississippi and Alabama, and part of Louisiana—everything, essentially, between the Mississippi River and the Appalachian Mountains. The Confederate defensive line at the beginning of the war stretched from the Mississippi River to the Cumberland Gap in the Appalachian foothills. The strategic importance of the rivers and railroads in the West meant that many major battles were fought in the Western theater, and by 1864 it extended all the way to the Pacific Ocean.

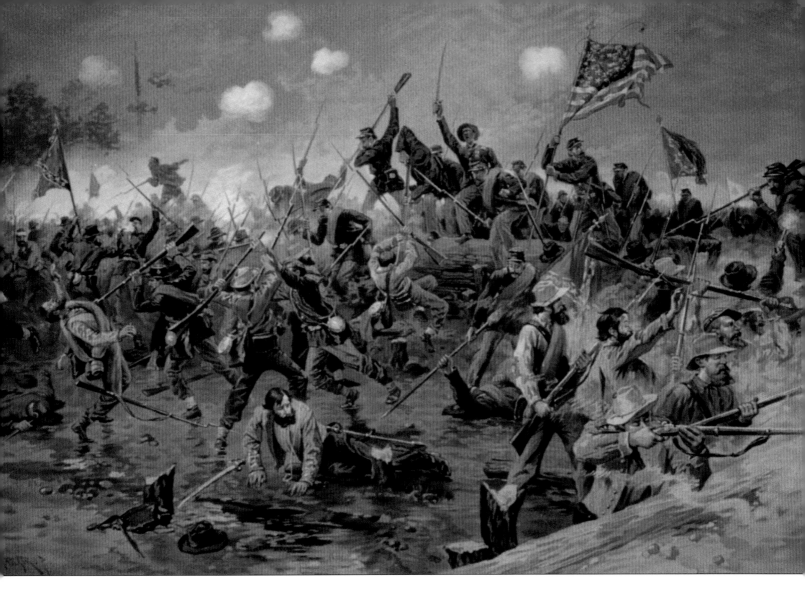

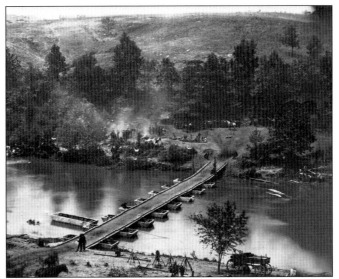

▲ *Fighting at the breastworks during the Battle of Spotsylvania. Some of the most ferociously sustained combat of the Civil War took place during the battle; yet neither side could claim victory.*

◄ *A pontoon bridge on the North Anna River at Jericho Mills, Virginia. It was built in May 1864 by the 50th New York Engineers during the advance on Richmond.*

in a narrow Union victory and the death of the Confederate commander, Brigadier General Albert Jenkins.

MAY 9

VIRGINIA, *LAND WAR*
The Battle of Swift Creek/Arrowfield Church. A Union push toward Petersburg by Major General Benjamin Butler defeats a Confederate counterattack at Arrowfield Church. Butler does not pursue the defeated Confederates.

MAY 10

VIRGINIA, *LAND WAR*
The Battle of Chester Station. The Confederates push back a Union raid that was in the process of destroying the railroad at Chester Station.
VIRGINIA, *LAND WAR*
The Battle of Cove Mountain. Rebel forces withdraw after attempting to stop

the Crook-Averell Raid on the Virginia & Tennessee Railroad at Cove Mountain.

MAY 11

VIRGINIA, *LAND WAR*
The Battle of Yellow Tavern. A Union cavalry raid against Richmond leads to the defeat of Confederate cavalry at

Yellow Tavern. During the battle "Jeb" Stuart is mortally wounded.

MAY 12

VIRGINIA, *LAND WAR*
The Battle of Spotsylvania Court House/Corbin's Bridge. After the inconclusive Battle of the Wilderness, General Grant and the Union Army of the Potomac attempted to move south and east toward Richmond. Grant's objective was the road junction at Spotsylvania Court House, from where he could cut Lee's line of supplies and prevent his retreat to the Confederate capital.

ARMED FORCES

MEDICAL FACILITIES

In the 1860s, doctors knew little more about the causes of infection and disease than they had known hundreds of years earlier. The existence of bacteria and viruses was still undiscovered. Surgeons operated with dirty instruments in filthy conditions, so even when injured soldiers had bullets removed or wounds sewed up, they were likely to face deadly infections. Combat wounds were not the greatest killers of Civil War soldiers, however. Disease took far more lives, and it created a huge problem that neither side in the war was able to solve.

When the war began in 1861, the United States army had only 113 surgeons in its ranks, 24 of whom resigned to support the South. Some doctors had attended medical schools, but many others had simply studied with other doctors and lacked the most basic knowledge of treating illness or injury.

For the Union, medical matters fell under the authority of the Army Medical Bureau, which was led by an 80-year-old veteran of the War of 1812, Surgeon General Thomas Lawson. When he died in May 1861, he was replaced by Clement A. Finley, who did little to improve the bureau. Finley held the surgeon general's job until April 1862, when 33-year-old William A. Hammond took his place. Hammond would bring much better leadership to the Medical Bureau, expanding its size and improving its professionalism.

The Union army did at least start the war with an existing medical service; the Confederates had to build theirs from nothing. The Confederate Medical Department was established by Samuel Preston Moore, who recruited doctors and nurses, set up procedures for treating the sick and wounded, founded hospitals, and eventually gave the Confederacy a medical service similar to that of the Union. Moore's task, though, was hampered by shortages caused by the Union naval blockade. Given the circumstances, Moore performed admirably in creating an effective medical department.

Civil War commanders would have faced a tough job even if they had started the war with healthy troops. But many of the men who joined both armies were physically unfit. Early in the war men eager for military glory often tried to hide any illnesses or disabilities that might disqualify them from military service. As the war went on, and both sides became desperate for manpower, recruiting officers would overlook all but the most obvious physical handicaps. However, commanders soon learned that physically unfit troops were not merely useless in combat; caring for them took away valuable manpower and resources from the military effort. In 1862 an investigation in the Union army found that 25 percent of the soldiers were unfit for military duty.

The greatest threat to a soldier's life was disease. Historians estimate that diseases killed at least twice as many Civil War soldiers as combat wounds. That would mean that of the 620,000 soldiers who died in the Civil War, around 207,000 died from wounds and 413,000 from disease.

Disease did more than just reduce the number of men available to fight; it had a direct effect on many military campaigns. The Union's first attempt to take the city of Vicksburg in Mississippi in 1862 failed largely because more than half the troops were sick. Disease also figured in Lincoln's decision to abandon the Peninsular Campaign in Virginia that same year.

The treatments for disease were often as bad as the diseases themselves. The most common treatment for many diseases was calomel, a medicine whose main ingredient was mercury. Calomel depleted the body's vital fluids—already a major problem in diarrhea—and in large doses it could cause mercury poisoning. Some doctors still believed in the ancient practice of bleeding sick patients, which served only to weaken them further. Not surprisingly, many soldiers tried to avoid seeing a doctor unless they were on the verge of death. One of the few effective drugs available in the war was quinine, which could prevent and treat malaria.

For those healthy enough to go into combat, a wound often meant death or the loss of a limb. Civil War muskets fired a very large lead bullet that traveled at a relatively slow speed, so bullets caused terrible wounds. Soldiers with a head or gut wound were often left for dead. For arm and leg wounds amputation was the usual treatment to prevent death from gangrene infection. Some wounded soldiers were lucky enough to be treated by a surgeon supplied with chloroform or ether, anesthetics that made operations more bearable. Those less lucky—especially in the poorly supplied Confederate armies—could expect only whiskey and a bullet to bite on for the pain. Opium was also widely used as a painkiller.

The war's main contributions to medicine were to train a new generation of surgeons and to open up the nursing profession to women. It also led to the creation of an ambulance corps.

▲ *Ulysses S. Grant (on extreme left, leaning over the pew) with Union commanders at the Army of the Potomac's HQ at Massaponax Church, Virginia, May 1864.*

Both armies emerged from the tangled woodlands of the Wilderness on the night of May 7, but it was the Confederates who won the race to Spotsylvania. Lee established a strong, well-fortified defensive line north of the village, but his position had one weakness. A bulge, or salient, where his line followed a piece of high ground offered a tempting target for assault. After inconclusive attacks on the 8th and 9th, Union Colonel Emory Upton led an assault on this salient that temporarily pierced the Confederate line before being driven back.

Grant attacks again today, achieving a second breakthrough and capturing almost an entire division of Lee's army. The Confederates manage to plug the gap, and there follows 24 hours of hand-to-hand combat in drenching rain. This fight at the "Bloody Angle" is among the most desperate of the war.

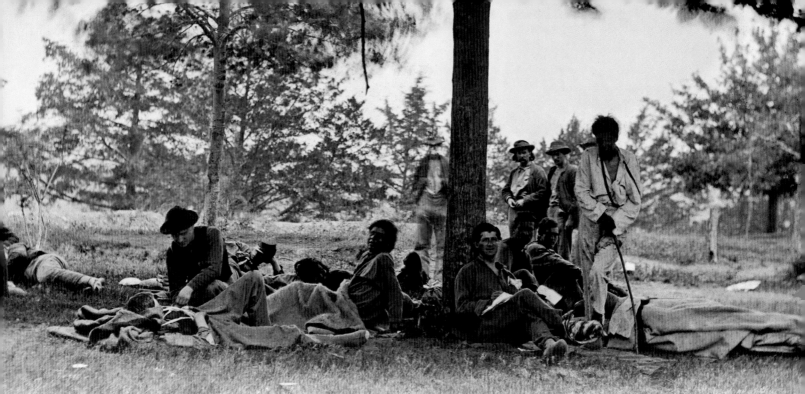

An oak tree with a 20-inch (50cm) diameter standing in the defensive lines is literally sawn down by bullets, and thousands of killed and wounded soldiers litter the earthworks. Bold Confederate counterattacks, at one point personally led by Lee, eventually restore the situation, but Lee is convinced of the need to withdraw to a stronger position. He does so beginning on May 14, and subsequent attacks by both armies on different parts of this new line are unsuccessful.

Inconclusive fighting continued until May 19, when Grant disengaged to move east in another attempt to outflank Lee. Like the Battle of the Wilderness, Spotsylvania was a draw.

▼ *Black laborers on a wharf on the James River, Virginia. The Confederacy operated the James River Squadron on the river until the surrender of Richmond in 1865.*

MAY 12–16

VIRGINIA, *LAND WAR*

The Battle of Proctor's Creek/Drewry's Bluff/Fort Darling. Major General Benjamin Butler, having advanced at a snail's pace during his mission to threaten Richmond, suffers a series of defeats against the Confederates around the Bermuda Hundred Line, into which he eventually withdraws.

▼ *An 1864 etching by Adalbert Volck of Southern women spinning, weaving, and sewing to make clothes for increasingly threadbare Confederate soldiers.*

▲ *Wounded Native American soldiers of the Union army at Fredericksburg, Virginia, in May 1864. An estimated 3,600 Native Americans fought in the Union armies.*

MAY 13–15

GEORGIA, *LAND WAR*

The Battle of Resaca. General Joseph E. Johnston (Confederate) is forced from defensive positions on the hills around Resaca after Union forces engaged in the Atlanta Campaign threaten his railroad supply line. However, in three days of fighting General Sherman has lost 6,800 men.

MAY 15

VIRGINIA, *LAND WAR*

The Battle of New Market. As part of Grant's mission to destroy the railroad and canal complex at Lynchburg, Major General Franz Sigel advances up the Shenandoah Valley along the Valley Pike with 10,000 men. At New Market he is attacked by a makeshift Confederate army of about 4,100 men commanded by Major General John C. Breckinridge. At one stage in the battle a Union battery withdraws from the line to replenish its ammunition, leaving a gap that Breckinridge exploits. He orders his entire force forward, and the Union line collapses. Threatened by Confederate cavalry on his left flank and rear, Sigel orders a general withdrawal. He retreats to Strasburg, having suffered 840 casualties. Confederate losses are 540.

MAY 16

LOUISIANA, *LAND WAR*

The Battle of Mansura/Smith's Place/ Marksville. Confederate forces launch an attack against Nathaniel Banks' Red River Expeditionary Force at Mansura, but are unable to halt the Union force.

MAY 17

GEORGIA, *LAND WAR*

The Battle of Adairsville. Johnston's Army of Tennessee fight a successful delaying action against pursuing Union forces at Adairsville.

MAY 18

LOUISIANA, *LAND WAR*

The Battle of Yellow Bayou/Norwood's Plantation. Union troops of Banks' Red River Campaign fight a delaying action at Yellow Bayou, allowing the bulk of

▶ *The USS Onondaga was the first double-turreted monitor in the Union navy. It saw service on the James River.*

the Union forces to escape across the Atchafalaya River.

MAY 20

VIRGINIA, *LAND WAR*

The Battle of Ware Bottom Church. Confederate forces make a major attack against the Bermuda Hundred Line near Ware Bottom Church, pushing back the Federal troops into their defenses and freeing up soldiers to provide reinforcements for Lee at Cold Harbor.

MAY 23–26

VIRGINIA, *LAND WAR*

The Battle of North Anna/Jericho Mill/ Hanover Junction. Union troops attempt to break Lee's defensive line on the North Anna River. Grant ultimately outflanks the position to advance on Richmond.

MAY 24

VIRGINIA, *LAND WAR*

The Battle of Wilson's Wharf/Fort Pocahontas. Major General Fitzhugh Lee's cavalry attacks a Union supply depot at Wilson's Wharf, but is beaten off by two African-American regiments.

MAY 25–26

GEORGIA, *LAND WAR*

The Battle of New Hope Church. General Joseph E. Johnston's Army of Tennessee inflicts a defeat on a Union corps as the Federals attempt to move on Dallas.

MAY 26–JUNE 1

GEORGIA, *LAND WAR*

The Battle of Dallas/Pumpkinvine Creek. The Confederates are forced to abandon defensive lines around Dallas

▲ *A sailor poses next to a Dahlgren gun on the USS Hunchback. The gun is mounted on a Marsilly carriage; the rope is to contain the gun's recoil.*

after several days of heavy fighting and a Union move toward the railhead at Allatoona Pass.

MAY 27

GEORGIA, *LAND WAR*

The Battle of Pickett's Mills/New Hope. In the Atlanta fighting, Confederate forces repel a Union attack against General Johnston's right flank.

MAY 28

VIRGINIA, *LAND WAR*

The Battle of Enon Church. The Army of the Potomac has been probing Confederate positions before pulling

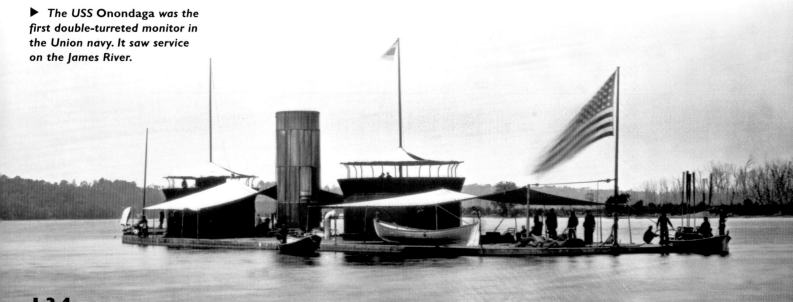

out and recrossing the North Anna for yet another swing to the Confederate left. Grant has moved his army along the Pamunkey River toward Hanovertown, only 15 miles (24 km) from Richmond. With Lee and his subordinates ill, Grant has been able to steal a march, reaching Hanovertown—from where he had a number of options—to head toward Richmond, with three infantry corps in position by this afternoon. No Confederate infantry are there to oppose him. The Confederates gather at Atlee, a station only 9 miles (14 km) from Richmond along the Virginia Central Railroad and 10 miles (16 km) west from the Federals at Hanovertown.

Lee puts together a cavalry force with Fitzhugh Lee's two brigades on one wing and Wade Hampton's on the other. He then sends this force to

▲ A company kitchen in a Union army camp, 1864. There were no trained army cooks and little cooking equipment. Soldiers on both sides usually prepared and ate their food together.

KEY PERSONALITY

MATHEW BRADY

Mathew Brady (1823–1896) was born near Saratoga Springs, New York. At age 16 he left home and moved to the town of Saratoga, where he enrolled as an art student under the portrait painter William Page. At the end of 1839 teacher and pupil traveled to New York City, where Page introduced Brady to the celebrated Samuel Morse. Morse had invented the telegraph, which would later make him famous, but at this time he was better known as a painter and a professor of painting and design at New York University.

Morse had just returned from Paris, where he had been introduced to a pioneering photographic process—the Daguerreotype—by its French inventor Louis Daguerre. Convinced that photography would become a sensation of the age, Morse set up a studio in New York and began giving classes in the daguerreotype method. Brady studied under Morse, working long hours in a department store to pay for his tuition. He thus found himself in the fortunate position of being in at the beginning of a brand-new profession.

In 1844 Brady opened a Daguerreotype studio on the corner of New York's Fulton St. and Broadway, and very quickly built up a large clientele for his high-quality portraits. Not content with commercial success, Brady conceived a grand ambition to record the country's history through Daguerreotype images of its most famous citizens. His growing reputation gained him access to past presidents such as John Quincy Adams and Andrew Jackson, as well as current politicians. In 1850 he published 24 such lithographs made from Daguerreotypes in a volume entitled *Gallery of Illustrious Americans*. Brady became the most famous photographer in the United States. He opened lavish new premises at 10th and Broadway and eventually a studio in Washington, D.C.

At the outbreak of the Civil War Brady approached the Lincoln administration with a proposal to make a photographic record of the conflict. The idea was approved, but Brady had to finance the ambitious undertaking himself. During months of preparation he assembled a large team of camera operators and technical support staff, and purchased and outfitted wagons with the bulky cameras and the chemicals essential to the photographic process. Brady then deployed his photographers throughout the war zone. From the First Battle of Bull Run in July 1861 to Lee's surrender to Grant in April 1865 Brady's photographers assembled an incomparable record of the terrible conflict.

Brady's images were very much affected by the technical realities of photography at the time. Not only was the camera equipment heavy and cumbersome, but the exposure time for a photograph was measured in seconds. This meant that the photographers could realistically only record static scenes.

Brady's effort to create an enduring record of the Civil War brought him nothing but misery. His professional ethics were criticized by some of his photographers, who felt it was unfair to have "Photograph by Brady" stamped on every photograph they took. That was always the Brady way, however. No matter who took a photograph—and he took very few himself during the Civil War—if Brady owned it, it was a "Photograph by Brady." This practice went beyond putting his famous name to the work of his colleagues and employees. In his desire to create a total record of the war he tracked down and bought thousands of photographs taken by other studios and photographers. Every time such photographs were reprinted, they also bore the credit "Photograph by Brady."

Brady's Civil War activities ruined him financially. After the war there seemed nothing people wanted less than reminders of those dreadful days. Brady had sunk into the project his entire fortune of $100,000, a huge sum at the time. When a market for his work failed to materialize, he was forced into bankruptcy. Finally, in 1875 Congress bought the entire archive for $25,000, but that sum was quickly eaten up by Brady's creditors. Brady died nearly blind and penniless in 1896, but his work, now a national treasure, remains the greatest record of the war.

DECISIVE MOMENT

PROPAGANDA

The war was fought mainly on Confederate soil. The Confederacy could only maintain the war effort with the support of its population, and it could not draw on the traditions of loyalty and patriotism that were open to the Unionists. Yet, despite the obvious need to enlist public opinion in support of the Confederacy, President Jefferson Davis seems to have given little attention to propaganda.

Unofficial propaganda in the South was hardly more effective. The press was subject to very little regulation or censorship, to the extent that military information useful to the enemy often appeared in the columns of Southern newspapers. Some newspapermen did give the Davis administration steady support, but they were outnumbered by critics who wrote with little restraint.

The church proved a more successful conduit for unofficial propaganda in the South. Southern society was deeply religious, and religion proved to be a key factor in stirring and maintaining enthusiasm for the war. The clergy offered solace to the bereaved and injured, while deserters and speculators were condemned as both offensive to God and detrimental to the war effort. Confederate victories were seen to confirm Southerners' status as God's chosen people.

In the Union propaganda activities were scarcely better organized. There was no official program aimed to maintain enthusiasm for the conflict. President Abraham Lincoln's finely crafted speeches were important in rallying public opinion to the Union cause, but Lincoln himself showed little interest in the potential of propaganda.

Most Union propaganda was produced by nonofficial organizations, notably the Union Leagues, which were maintained by middle-class enthusiasts. The first such league was formed in Philadelphia in 1862.

Within a year the league movement had spread over 18 Northern states and even begun to make an appearance among Unionists in the South. The Loyal Publication Society, established by the Union League of New York, raised nearly $30,000 during the three years of its existence and published 900,000 copies of 90 different pamphlets. They were distributed to league organizations across the Union and to soldiers serving at the front.

As in the South, the conflict was staunchly supported from the pulpit, but disagreements over emancipation made the notion of a holy war more difficult to countenance. Likewise,

there was little regulation of the press by the Lincoln administration. Newspapers and periodicals flourished in the Union—most were fiercely partisan and packed as much with rumor and speculation as with concrete news of the conflict. They expressed a spectrum of opinion both sympathetic to and critical of the administration.

Although the administrations of North and South paid little attention to propaganda within their own borders, the importance of the battle for opinion in Europe (especially Britain and France) was clear to all. From the beginning of the conflict European intervention was seen as a key factor that could win or lose the war. Both the Confederacy and the Union accompanied their diplomatic overtures to Europe with propaganda. The Lincoln administration dispatched a steady stream of visitors to Europe during the course of the war, many especially selected to appeal to European pressure groups or interests. Union representatives included John Hughes, the Catholic archbishop of New York, whose mission was to gain the support of the papacy and the Catholic rulers of Europe; Bishop McIlvaine of the Protestant Episcopal Church, who was to lobby the English clergy; and the New York political operator Thurlow Weed, who was to try to promote the Union cause among European journalists. Despite Lincoln's domestic reluctance to make the war an antislavery crusade, the issue was a trump card in European countries, which had abolished slavery within their own colonies decades previously. Union representatives helped organize public meetings in Britain, which passed resolutions endorsing emancipation.

The South used cotton to try to pressure countries such as Britain and France to support the Confederacy. By starving the European countries of raw cotton, on which they were heavily dependent, it was hoped the British and French would be induced to enter the war on the Confederate side. More subtle efforts were also made to win over European public opinion. They were masterminded by the chief Confederate propaganda agent, Henry Hotze. English writers were employed to publicize the Confederate cause in newspapers. Favorable books and pamphlets were printed and freely distributed to politicians and others in positions of influence. Most importantly, Hotze was responsible for *The Index*, a newspaper published in London to present Southern views. It provided copy for many other papers in Britain and elsewhere.

▲ *An execution of a deserter from the Union army. In general, the death penalty for desertion was only applied to a few unfortunates, as an example to others.*

Haw's Shop to probe the enemy. It runs into Union cavalry which, on seeing the Confederates, organizes a charge. The Confederates dismount and form a battle line on either side of a road at a clearing around Enon Church. There, from behind fence rails piled up as a defensive work, they drive back the Federal charges again and again. The Union cavalry is reinforced by another division, and its Michigan Brigade is sent in with a dismounted charge that finally overruns the Confederate lines. The Confederates make their way back to their horses and dash off while the exhausted Federals watch them go and made no attempt to pursue. In this inconclusive battle Union losses are 344, Confederate 400.

MAY 28–30

VIRGINIA, *LAND WAR*

The Battle of Totopotomoy Creek/Shady Grove Road. Three days of heavy fighting occurs between Lee's and Grant's forces around Totopotomoy Creek, costing 1,100 casualties on each side.

MAY 29

VIRGINIA, *LAND WAR*

The Battle of Cold Harbor. The Army of the Potomac is just 11 miles (18km) northeast of Richmond. Lee has Grant's line of march south covered, but to the east, on his far right flank, lays the Cold Harbor crossroads. Named for an old tavern, Cold Harbor is only a few miles north of the Chickahominy River, the last natural obstacle between the Union troops and Richmond. If Grant gains control of it, his route south is open once again. His far left flank is at

▲ *A signal tower at Cobb's Hill, near New Market, Virginia. Signal officers, alone on top of a tower or hill with no weapon, were very vulnerable to enemy fire.*

▲ *The ironclad river monitor USS Ozark, which was built at Peoria, Illinois. She was commissioned in February 1864 and spent her entire career serving as part of the Mississippi Squadron.*

Bethesda Church, several miles north of Cold Harbor. Both Grant and Lee begin to concentrate their armies around it.

Totopotomoy Creek to the east, a main highway to Richmond that leads to Mechanicsville. The Confederate General Early sees an opportunity to turn its flank and receives permission from Lee to try it. Most of Early's men move to around Bethesda Church on the Old Church Road, parallel to the road. Then they attack, brushing through skirmishers in their drive to roll up the Union flank. Federal infantry and artillery quickly come to the assistance of the threatened post. Early's men are forced to retire to Old Cold Harbor, allowing Sheridan, chief of cavalry, to capture the crossroads the next day.

MAY 31

VIRGINIA, *LAND WAR*
The Battle of Cold Harbor. Two Union

Potomac's cavalry chief Philip Sheridan advance south from Bethesda Church and drive off Confederate cavalry holding the Cold Harbor crossroads. They are then counterattacked by two divisions of infantry ordered up by Lee. Meade tells Sheridan to hold the crossroads "at all hazards" and orders the Union VI Corps to Cold Harbor to support Sheridan. After an overnight march of nine hours, VI Corps relieves

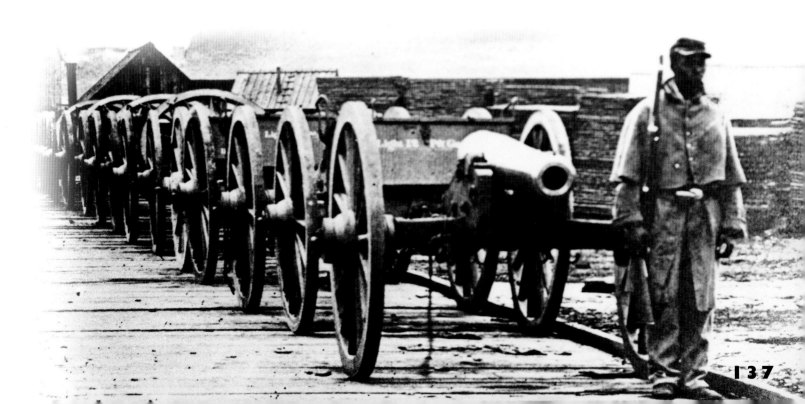

JUNE 1

▶ *Confederate railroad lines in Atlanta. In 1864 Hood and Sherman battled for control of the railroad lines around the city. It was a battle that Sherman won, forcing Hood to destroy supplies he could not transport and abandon the city.*

JUNE 1

VIRGINIA, *LAND WAR*

The Battle of Cold Harbor. A 7-mile (11km) front has formed, extending from Bethesda Church to the Chickahominy River with Cold Harbor in the center. Lee's 58,000-strong army is in position first. Two Union corps launch a fierce attack but are repulsed. Grant's army of five corps—more than 112,000 men—takes longer to maneuver into position, marching on unfamiliar roads in the heat and dust.

JUNE 3

VIRGINIA, *LAND WAR*

The Battle of Cold Harbor. The major Union attack begins at 04:30 hours. It is a disaster from the start. Only three corps at the southern end of the Union line press forward. They are met by a

devastating crossfire from entrenched Confederate infantry and artillery. One division alone loses more than 1,000 men. A Union captain remembers "the dreadful storm of lead and iron seemed more like a volcanic blast than a battle." One Confederate general just calls it murder. Within half an hour the assault

stops under the sheer weight of fire, but Grant does not call off the attack until midday, ordering his men to dig in where they can. The two armies confront each along these battle lines until June 12. Grant later wrote that he regretted that the last attack at Cold Harbor was ever made.

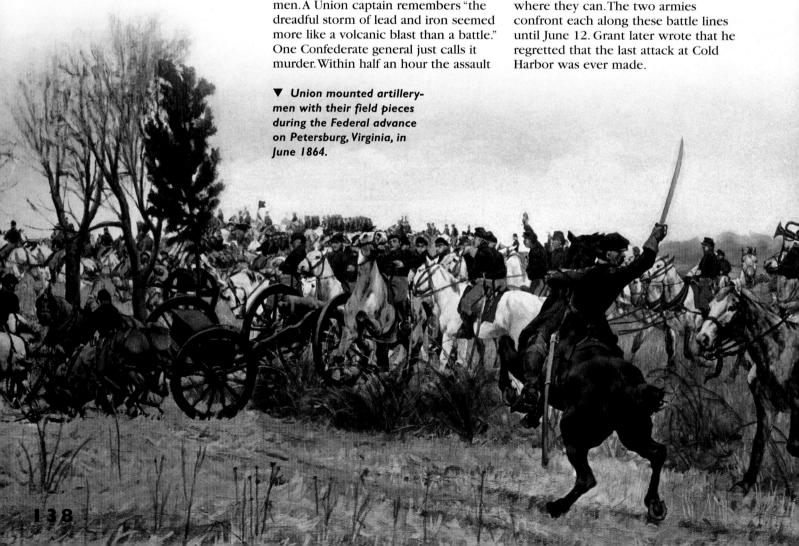

▼ *Union mounted artillerymen with their field pieces during the Federal advance on Petersburg, Virginia, in June 1864.*

Cold Harbor cost the Union army 7,000 casualties for no gain at all. The Confederates only suffered about 1,500 casualties. Lee had held Grant once again, but despite the slaughter could not stop the Union advance. On June 12, Grant began to withdraw his troops and advance once again toward the south, crossing the James River to threaten Petersburg.

JUNE 5

VIRGINIA, *LAND WAR*

The Battle of Piedmont. Around 8,500 Union troops under General David Hunter defeat 5,500 Confederates under General "Grumble" Jones at Piedmont. Jones is killed and the Federals take nearly 1,000 prisoners. Piedmont is a disaster for the Confederates in the Shenandoah Valley. Hunter advances unimpeded to Staunton, where he is reinforced by Brigadier General George Crook's Army of West Virginia marching from the west. The combined Union force then advances on Lynchburg. In response to Piedmont, Robert E. Lee rushes J. C. Breckinridge's division back to Rockfish Gap on June 7 and is then forced to detach II Corps of the Army of Northern Virginia under General Jubal Early to confront Hunter at Lynchburg. These moves limit Lee's

▶ Stephen Mallory, Secretary of the Navy of the Confederacy, was a firm advocate of ironclad ships for the navy. However, his efforts to purchase ironclads from Britain and France came to nought. After the war Mallory was for a time imprisoned, before resuming his law practice in 1866.

ability to undertake operations around both Richmond and Petersburg.

JUNE 6

ARKANSAS, *LAND WAR*

The Battle of Old River Lake/Ditch Bayou/Lake Chicot. Two brigades of the U.S. XVI Army Corps advance to Lake Village, fighting Confederate delaying actions as they do so.

JUNE 9–JULY 3

GEORGIA, *LAND WAR*

The Battle of Marietta/Pine Hill/Ruff's Mill. Sherman maneuvers Johnston's Confederate troops out of defensive positions in mountainous territory of Cobb County, in his Atlanta Campaign.

JUNE 9

VIRGINIA, *LAND WAR*

The siege of Petersburg. A Union attempt to take Petersburg is beaten off by Confederate Home Guard forces under General P.G.T. Beauregard.

JUNE 10

MISSISSIPPI, *LAND WAR*

The Battle of Brices Cross Roads/ Tishomingo Creek. A Confederate cavalry corps under Nathan Forrest defeats a much larger Union force under Brigadier General Samuel Sturgis.

JUNE 11

VIRGINIA, *LAND WAR*

The Battle of Trevilian Station. As a Federal force under Major General

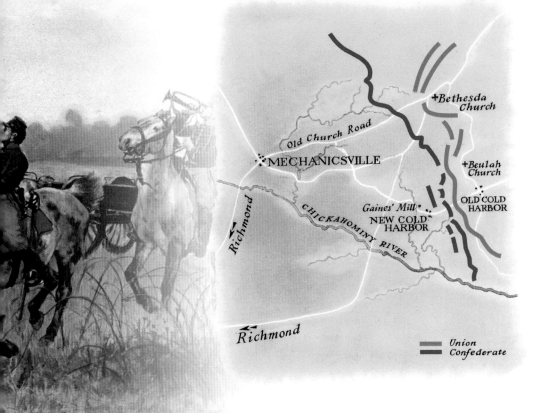

◀ **The Battle of Cold Harbor**
On May 31, Union cavalry captured the Old Cold Harbor crossroads from Confederate cavalry. Two divisions of Confederate infantry counterattacked, but Union reinforcements secured the crossroads by the morning of June 1. There was some fighting on the next two days, but both armies spent much of their time adjusting their battle lines. Early on June 3 Union troops, II and XVIII Corps, followed later by IX Corps, launched their attack. They suffered losses of about 7,000 troops in just 20 minutes. Stunned, they were unable to continue their assault. Grant arrived on the battlefield at midday and called off the attack. The two sides dug in, and both stayed in position until June 12, when Grant began to withdraw his troops.

◀ A poster of 1864 showing the most influential men in the Confederate government. President Davis is shown in the center with Vice President Stephens above him.

David Hunter now occupies Staunton, western terminus of the Virginia Central Railroad, General Grant sends his cavalry commander, Major General Philip Sheridan, with two divisions to join him. To meet this threat, Lee sends two brigades west under Breckinridge, as well as most of his cavalry under Wade Hampton. Hampton's cavalry heads off on a route parallel to Sheridan's, sending a part of his force on to Trevilian Station, 28 miles (45km) west of Charlottesville, where he plans to meet Sheridan's troops. Hampton's plan is to have Fitzhugh Lee attack Sheridan's men from the east. As Lee is on the move, however, he is hit by a Union cavalry division, led by a brigade commanded by a young brigadier general, George A. Custer, that drives his brigades back, and captures a number of wagons.

Hampton is outnumbered and falls back, to be joined by Fitzhugh Lee on the 11th. Both sides prepared to renew the fight the next day. The Federals attacked, the Confederates held, and at the end of the day Sheridan fell back to Grant, his mission of joining Hunter foiled. Confederates casualties were heavy, with 800 lost from Hampton's division alone. But the railroad was safe and Hunter's forces unreinforced.

JUNE 11–12

KENTUCKY, LAND WAR
The Battle of Cynthiana/Kellar's Bridge. A large Confederate attack force attempts to take the town of Cynthiana. It captures around 1,300 Federal prisoners today, but will be pushed back by Union reinforcements tomorrow.

▼ Ulysses S. Grant (standing in the center, in front of a tree) with his staff in June 1864 in Virginia during the Overland Campaign. By this time Grant was general-in-chief of all Union forces.

KEY PERSONALITY

JOSHUA LAWRENCE CHAMBERLAIN

Joshua Lawrence Chamberlain (1828–1914) was born at Brewer, Maine, on September 8, 1828, and educated at Bowdoin College and Bangor Theological Seminary. For years he taught natural theology and logic at Bowdoin, but in 1862 he volunteered for military service and joined the 20th Maine Infantry as a lieutenant colonel. The 20th Maine served with the Army of the Potomac through most of its engagements in the Civil War.

At Fredericksburg Chamberlain and his men came under continuous Confederate fire for hours on the night of December 13, 1862. This was just the beginning of Chamberlain's outstanding war. At the Battle of Gettysburg (July 1–3, 1863) he led his regiment in defense of Little Round Top, a small wooded hill on the far left of the Union line. For holding this key position in the face of repeated enemy attacks, and for leading a bayonet charge when his men ran out of ammunition, Chamberlain was awarded the Congressional Medal of Honor in 1893.

During Union assaults on Petersburg in June 1864, Chamberlain so impressed Ulysses S. Grant with his bravery that Grant promoted him to brigadier general in the field. Although wounded during the battle, Chamberlain soon returned to the front. On April 12, 1865, he was breveted major general. On the same day he had the honor of receiving the formal surrender of Robert E. Lee's men. As the Confederates handed over their arms, Chamberlain brought his own men to attention in salute.

After the Civil War Chamberlain refused a commission in the regular army. Instead, he served as governor of Maine (1866–1870) and was then president of Bowdoin College from 1871 to 1883. He spent his later years as a businessman and was involved in the construction of a railroad in Florida. He also wrote extensive reminiscences of the war, including *The Passing of the Armies* (1915). Chamberlain died in Portland, Maine, on February 24, 1914.

▶ *Winslow Homer's* **Drum and Bugle Corps.** *Homer was an illustrator of* Harper's Weekly *who followed the Army of the Potomac. He was drawn to scenes of everyday soldier life and produced a number of oil paintings in the genre.*

JUNE 15

VIRGINIA, *LAND WAR*

Union Major General Benjamin F. Butler and his Army of the James land at Bermuda Hundred, a neck of land north of City Point at the confluence of the James and Appomattox rivers, only 15 miles (25 km) south of Richmond.

Meanwhile, Union General Grant sends 100,000 men of the Army of the Potomac south from Cold Harbor across the James River to swing west through Petersburg and attack Lee from the rear. However, the Union forces are stopped at Petersburg by a

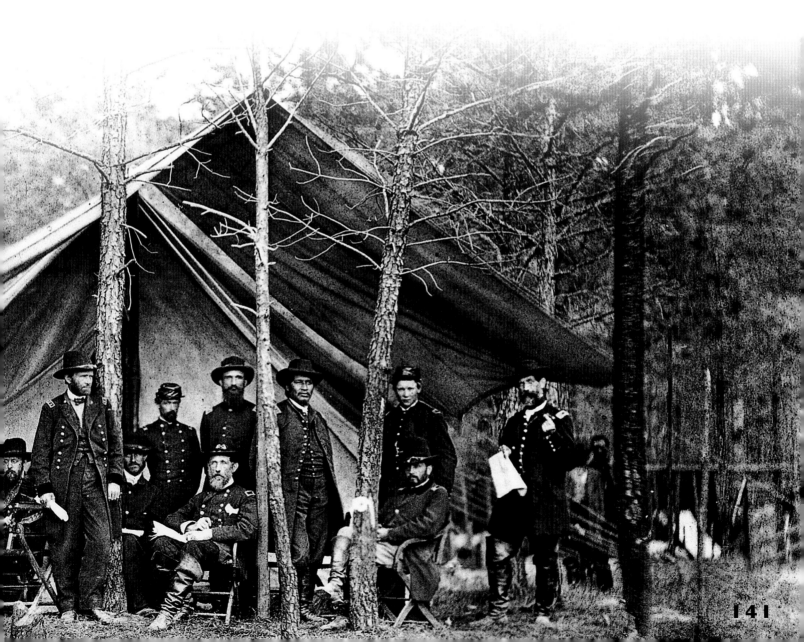

▲ A tenement building on Mulberry Street on the Lower East Side, Manhattan. Tenements were notorious for being over-crowded and unhealthy. One way of escaping them was to join the army.

Confederate force hastily organized by General P.G.T. Beauregard.

Two days later, Lee orders most of his army south to reinforce Petersburg, which is a vital rail center. Confederate forces set up lines of fortifications southeast of the city that cannot be breached by frontal assault. Instead, Grant keeps his army attacking to the west and south. His objectives are the two railroads that are supplying Lee's army and the Appomattox River, which marks Lee's line of retreat to the west.

In late August Union forces cut the railroad running south. Grant attacked again in late September and late October, extending the siege lines to 35 miles (56km) and threatening the last rail line open to Lee. Lee's position was now desperate.

JUNE 17–18

VIRGINIA, *LAND WAR*
The Battle of Lynchburg. A Union attempt to take the Confederate rail and canal depots at Lynchburg fails through lack of supplies, and opens the Shenandoah Valley for a Rebel offensive into Maryland.

JUNE 19

ATLANTIC, *NAVAL WAR*
The Southern commerce raider CSS *Alabama*, commanded by Captain Raphael Semmes, is sunk outside

Cherbourg, France. Built in England, the *Alabama* mounted eight guns and could reach a speed of more than 13 knots under steam. Starting in August 1862, it destroyed 68 Union vessels in 22 months—without injuring the crews. The sailors boarded the enemy merchantmen and took their seamen prisoner before destroying the vessels.

▼ General George Thomas, commander of the Union Army of the Tennessee, and a group of officers at a council of war near Ringgold, Georgia, in 1864.

MORTARS

The mortar was a type of artillery used during the war. Mortars had a short, stubby barrel that could throw shells in a high arc at short range into fortifications. This made them ideal for sieges, and they were used in large numbers by the Union army. The largest mortars had a caliber of 13 inch (33cm) and were sometimes mounted on railroad flatcars.

A much smaller bronze mortar, called the coehorn, was also used in sieges. It weighed about 290 pounds (131kg) and could be carried by four men. The coehorn was used in the trenches around Petersburg, Virginia, in the fighting and siege of 1864 and 1865.

▲ *The Confederate commerce raider CSS Alabama, which destroyed 68 Union vessels in 22 months. She was sunk by the Union frigate USS Kearsarge in June 1864.*

When the *Alabama* grew too crowded, Semmes would designate the next captured merchantman a "cartel ship," place the prisoners on board, and let them sail to the nearest port.

The Union frigate USS *Kearsarge* cornered the raider in the port of Cherbourg, France. The *Kearsarge* waited outside the port. The *Alabama*

◄ *Contrabands (freed Southern slaves) at Cobbs Mill, Virginia, in 1864. Many contrabands contributed to the Union war effort by working as laborers in the army.*

sails out to fight but is sunk in a one-hour battle. Semmes goes over the side but is picked up by the *Deerhound*, a yacht filled with sightseers. They take him to England to avoid capture.

JUNE 21–24

VIRGINIA, *LAND WAR*
The Battle of Jerusalem Plank Road/First Battle of Weldon. The Union's II and IV Corps move to cut the Weldon Railroad, a supply line to Petersburg. They do not reach the railroad, but increase the extent of their siege lines.

JUNE 22

GEORGIA, *LAND WAR*
The Battle of Kolb's Farm. Sherman seeks to envelop Confederate defensive

lines, protecting the Western & Atlantic Railroad, along Kennesaw Mountain. The attack fails, but costs the Confederacy over 1,000 men.

JUNE 24

VIRGINIA, *LAND WAR*
The Battle of Saint Mary's Church/Nance's Shop. Major General Wade Hampton's Confederate cavalry fail to cut off Union cavalry returning from a raid to Trevilian Station.

JUNE 25

VIRGINIA, *LAND WAR*
The Battle of Staunton River/Blacks and Whites. Union cavalry spend three days tearing up Confederate rail lines, but are prevented from destroying lines

over the Staunton River Bridge by the Confederate Home Guard.

JUNE 27

GEORGIA, *LAND WAR*
The Battle of Kennesaw Mountain. On May 5, General Sherman and his three Union armies, totaling nearly 100,000 men, began moving south out of Tennessee toward Atlanta, Georgia. Johnston's 60,000 Confederate troops tried to block the Union advance by entrenching across its path and inviting an assault against their prepared defenses. The campaign became one of maneuver as Sherman moved to get behind Johnston, and the latter shifted to block him. For a month the two forces moved deeper into Georgia as they battled each other, yet Sherman avoided committing his troops to a full attack. Instead, he used his superior numbers to turn Johnston out of his

▲ *Digging the Dutch Gap Canal on the James River, Virginia, in 1864. The intention was to bypass a bend in the river dominated by Confederate forts that protected Richmond. The work was carried out under the direction of General Benjamin Butler.*

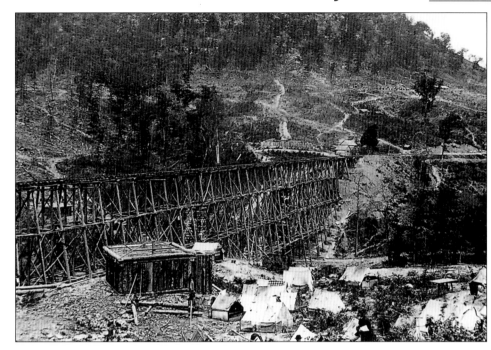

▲ A view of Kennesaw Mountain, near Marietta, Georgia. Confederate General Joseph E. Johnston established an 8-mile (12km) defensive line that included the slopes of the mountain.

defenses. By mid-June Johnston's troops had fallen back to a ridgeline anchored by Kennesaw Mountain, west of Marietta, Georgia. Believing that Johnston's line was stretched too thin, Sherman decided to attack.

At dawn today, Union formations advance toward the well-entrenched Confederates. Diversionary attacks against the Confederate flanks have little effect. An assault against Pigeon Hill, south of Kennesaw Mountain, is met by deadly fire, forcing the attackers to withdraw. The main assault occurs just south of Pigeon Hill, where 8,000 Union troops are ordered to advance at a run using only fixed bayonets. The

advance soon degenerates into confusion as men are halted by concentrated fire from the earthworks to their front. By noon Sherman's men can take no more. The battle has proved to be a disaster. Union casualties for the day total 3,000; Confederate losses are 552.

After the battle Sherman decides to return to his strategy of maneuver, flanking Johnston to the west and racing for the Chattahoochie River and Atlanta. Johnston has no choice but to move south, hoping once again to entice Sherman into battle on ground favorable to defense.

JUNE 28

VIRGINIA, *LAND WAR*
The Battle of Sappony Church/Stony Creek Depot. Union cavalry from the failed Staunton River Bridge attack are chased and engaged by pursuing Confederate forces.

▼ A blacksmith's forge used by the Union Army of the Potomac during the siege of Petersburg in Virginia (June 1864–April 1865). Each cavalry regiment had its own blacksmith who shod the horses in camp.

▲ The four-tiered, 780-foot-long railroad trestle bridge built by Federal engineers at Whiteside, Tennessee. This bridge, on the Nashville & Chattanooga Railroad, was only a few miles from Chattanooga. Note the guard camp in the foreground.

JUNE 29

VIRGINIA, *LAND WAR*
The Battle of Ream's Station. A Union raid destroys 60 miles (96km) of track of the Weldon Railroad, but loses large numbers of men (around 600) in a major engagement at Ream's Station. Despite this and other local successes, it is clear that Lee's army is now pinned down around Richmond, and is growing steadily weaker.

JULY 9

▶ *A Union station on the James River established for extracting gunpowder from Confederate torpedoes. There was also a Union communication line along the river.*

JULY 9

MARYLAND, *LAND WAR*

The Battle of Monocacy. Robert E. Lee, was desirous of another Jacksonian assault up the Shenandoah Valley, into Maryland if possible, to force the authorities in Washington to weaken Grant's army significantly to shore up the city's defenses. Thus Lee ordered Early to drive toward Washington. Early's II Corps, amounting to a quarter of the entire Army of Northern Virginia, moved into the Valley on June 23. He turned north, and quickly reoccupied Winchester on July 2. Early then sent part of his army to Harpers Ferry, while the rest headed toward Martinsburg, West Virginia. Then, he united his command in Maryland, just across the Potomac River. Early sent one cavalry brigade to Baltimore to try to free some 18,000 Confederates held prisoner at Point Lookout, while the rest marched on Washington. He stopped in

Hagerstown long enough to receive $20,000 in ransom, then went to Frederick where he took another $200,000.

But Early does not move with the speed of Stonewall Jackson. Federals

▼ *Captain John A. Winslow (third from left) and officers on board the frigate USS* **Kearsarge** *after sinking the CSS* **Alabama** *in June 1864.*

largely drawn from the Baltimore garrison under regional commander Major General Lew Wallace rush to get between Early and Washington. At the Monocacy River southeast of Frederick, Wallace draws up his battle lines and clashes with Early's men. Wallace's makeshift force, which includes some nine-months regiments from Ohio, fights surprisingly well. They fall back across the river after some hard

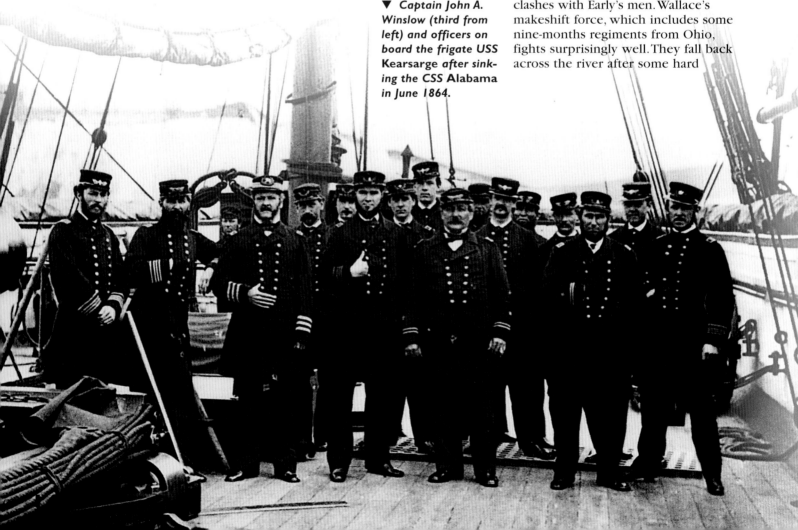

▲ *Major General George Meade in front of his tent in June 1864. The commander of the Army of the Potomac was nicknamed "goggle-eyed snapping turtle."*

fighting, and the Confederates manage to cross the river after them. Finally, Gordon's men sweep the Union troops aside and take the field. However, it is too late to continue forward; Wallace has bought a full day for Washington to prepare its defenses. Monocacy is called the "Battle that Saved Washington."

JULY 11

WASHINGTON, D.C., *LAND WAR*
Within the city there is serious concern at the approach of Early's corps, but not the same level of panic as there had been in 1862 and 1863. Veteran Reserve Corps units made up of men physically unable to survive campaign life but still able to do duty, man the forts as Grant detached his VI Corps and sends it north. This afternoon Early's men reach the city limits and scout the Federal positions. They can tell they are too strong to take, especially as the veterans of VI Corps file into position among the earthworks. As word comes that the attempt to free the Point Lookout prisoners has failed, Early withdraws slowly back into the Valley and easily repulses a feeble attempt at pursuit. The move on Wash-

ington has, however, been a success. Grant's forces have been reduced in number and, with attention drawn back north, have been stalemated. The Valley is in Confederate hands once again.

▲ *A Union bombproof restaurant set up during the siege of Petersburg, Virginia (June 1864–April 1865). Sieges comprised long periods of boredom punctuated by shorts bursts of terror.*

STRATEGY AND TACTICS

ESPIONAGE

Compared to modern-day espionage, the work of Civil War spies was carried out in a surprisingly amateur way. Spies in both the North and South were also greatly helped by the carelessness of officials and civilians alike regarding security. In February 1861, two months before the war broke out, the new Confederate government took steps to safeguard the security of the Southern states by jailing potential enemies. President Davis was authorized to suspend *habeas corpus* (the fundamental law that forbids arrest and imprisonment without trial) and was given the right to allow the army to impose martial law in Richmond and other towns in Virginia that were in danger of Union attack. Martial law gave the power of arrest to the army's provost marshal.

The Union government did not follow the Confederate example until war broke out in April 1861. By the end of the month Washington, D.C., was on the verge of panic. The institutions of government seemed to be collapsing as members of Congress and judges resigned to go over to the Confederacy. Army and navy officers were resigning for the same reason. No one knew whom they could trust.

Matters were worsened by the discovery of a Confederate plot to assassinate President Abraham Lincoln in Baltimore, Maryland, on his way to Washington for his inauguration in March. The conspiracy was only uncovered by the swift action of railroad detectives. The incident heightened fears that Confederate agents were everywhere in the Union.

Lincoln needed to bring the situation under control quickly. There was no police service he could call on, and so on April 27 he too withdrew the right of *habeas corpus* and handed the task of internal security over to the army's provost marshal.

Such measures gave the government a huge amount of power. The rule of law was suspended. Senior officials in Lincoln's administration need only sign a paper to have someone arrested. An estimated 13,000 U.S. citizens were arrested on suspicion of involvement with the Southern cause during the course of the war. It was in this climate of fear that the spying organizations of North and South were founded.

The first Union espionage service was established by Allan Pinkerton in August 1861. Pinkerton had set up a successful detective agency in Chicago in 1852 and was the chief detective who had foiled the Baltimore assassination plot in March.

Pinkerton began his war service spying for his friend, Union General George B. McClellan, in Ohio. When McClellan was summoned east to Virginia to command the Army of the Potomac, Pinkerton went with him to organize an intelligence service.

The task of Pinkerton's agents was to infiltrate behind enemy lines to discover Confederate troop strengths and provide information on lines of communication such as roads, railroads, telegraph lines, and canals. Pinkerton employed both men and women as agents. Several were former slaves and freedmen who could move around inside Southern territory without arousing too much suspicion.

Pinkerton's intelligence work in the field was a failure. He consistently overestimated Confederate troop strengths. This proved disastrous in the Peninsular Campaign of 1862, when McClellan, a timid commander at the best of times, received reports that the Confederates had as many as 200,000 men. In fact, his opponent, General Robert E. Lee, fielded barely 70,000 men. McClellan, relying on the intelligence he received, fought on the defensive and ultimately lost the campaign.

Pinkerton achieved more success in counterespionage, when he could use his talents as a detective to uncover Confederate spies. Perhaps his greatest success was the capture of the leading Southern agent, Rose O'Neal Greenhow, in 1861.

Greenhow was an attractive widow who moved in the highest circles of Washington society. She used her contacts to gain valuable military intelligence. She is credited with providing General Pierre G.T. Beauregard with information on Union troop movements that helped the Confederate victory at the First Battle of Bull Run in July.

In August 1861 Pinkerton caught up with Greenhow. Posing as an army major, Pinkerton gained entry to her home and arrested her, while his agents carried out a thorough search for evidence. She was placed under house arrest for some months, then moved to prison in Washington. In June 1862 she was deported to the Confederacy.

Pinkerton's career was tied too closely to that of McClellan—when McClellan was fired in November 1862, Pinkerton's work as Union spymaster also ended. He returned to Chicago and his detective agency. After Pinkerton left, a new secret service was set up under Lafayette Curry Baker, who later wrote one of the first U.S. accounts of the world of the spy, *The History of the United States' Secret Service* (1867).

The Confederate spy service was run out of an anonymous office in Richmond next to the offices of President Jefferson Davis and the secretary of state. Because of its work on codes and ciphers it was officially part of the army's signal corps, which was led by Colonel William Norris. His command extended to patrols watching for enemy movements along the Potomac River and to agents operating in Northern cities, such as Washington, D.C., New York, and Baltimore.

It was an effective service. Norris described his agents as "gentlemen of high social position, who, without compensation, have voluntarily devoted their time and energies to this work." They were also clearly reliable—Norris stated that he received "information regularly from the United States on Mondays, Thursdays, and Saturdays."

Such efficient spying was helped by the fact that the Confederacy could gain huge amounts of information from simply reading war reports in Northern newspapers, which were not censored. Similarly, the Union gained information from the Southern papers. Norris' office was receiving packets of Northern newspapers every week, which were then assessed and passed on to the various Confederate army commands. General Braxton Bragg is said to have changed his tactics at Chickamauga, Tennessee, in 1863 because he read the Union battle plan printed in the *New York Times*.

Women were some of the most successful spies on both sides. The most effective female Union spy was Elizabeth Van Lew, who operated in Richmond, but there were many others, including Pauline Cushman. An actress, Cushman gained the confidence of Southern officers by toasting Confederate President Jefferson Davis on stage, for which she was fired. She then stayed with the Confederate army and gathered information to send to the Union authorities.

Although the punishment for spying was execution, female spies were not hanged if caught. In practice, many other spies were also only imprisoned.

Many escaped slaves also spied for the Union. They were often able to get close to sources of information because as servants their presence was ignored by officials and officers discussing war matters. John Scobell was an effective black agent employed by Pinkerton in the Union secret service. Harriet Tubman, better known for her prewar work as a conductor on the Underground Railroad helping runaway slaves to freedom, also spied for the Union during the war.

Until Hood's appointment the campaign had been primarily one of maneuver; as soon as he took charge, it changed to one of headlong battle. Today, Hood attacks part of William T. Sherman's force, George H. Thomas' Army of the Cumberland, at Peachtree Creek. The determined assault by the Confederate Army of Tennessee threatens to overrun the Union troops at various locations. However, the Union troops hold, and the Confederates are forced to retire. Hood loses nearly 5,000 men compared to fewer than 2,000 Union casualties.

VIRGINIA, *LAND WAR*
The Battle of Rutherford's Farm. Early is forced to adopt defensive positions on Fisher's Hill after Major General S.D. Ramseur's Confederate division is routed at Rutherford's and Carter's farms.

JULY 22

GEORGIA, *LAND WAR*
The Battle of Atlanta. Following his defeat at Peachtree Creek, Hood withdraws his main army from Atlanta's outer line to the inner line as a bait for Sherman to follow. He also sends William J. Hardee with his corps to attack the unprotected Union left and rear, east of the city. However, Hardee is

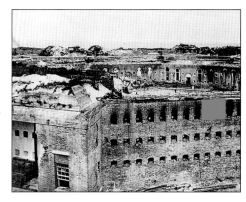

▲ *Fort Morgan, Mobile Point, Alabama, showing damage to the south side of the fort following the Union siege. The garrison surrendered on August 23, 1864.*

Grant has decided that he is unable to destroy Lee's army in the field north of Richmond. Instead, he will head south, link up with the Army of the James and capture Petersburg, south of Richmond, forcing Lee to fight there.

JULY 13

VIRGINIA, *LAND WAR*
Jubal Early's Confederate troops begin to pull back from Washington, D.C., having penetrated the city's suburbs.

JULY 14–15

MISSISSIPPI, *LAND WAR*
The Battle of Tupelo/Harrisburg. A Union force under Major General A.J. Smith fights a major engagement with Confederate troops at Tupelo. The U.S.

▼ *The photographer Mathew Brady under fire with a Union battery before Petersburg, Virginia, in late June 1864. Brady is in the foreground wearing a straw hat.*

▲ *Arlington Mansion, the home of Robert E. Lee. Lee was at Arlington on April 20, 1861, when he made his decision to resign his commission in the U.S. Army.*

troops beat back Confederate attacks, but fail in their primary mission of destroying Forrest's command.

JULY 17–18

VIRGINIA, *LAND WAR*
The Battle of Cool Spring/Island Ford/Parkers Ford. The Union pursuit of Jubal Early's retreating soldiers suffers a setback after a heavy defeat at Cool Spring Plantation, suffering 422 casualties.

JULY 20

GEORGIA, *LAND WAR*
The Battle of Peachtree Creek. Confederate President Davis considered the defense of Atlanta by Confederate General Joseph E. Johnston unacceptably passive. On July 17, therefore, he replaced Johnston with John Bell Hood, a commander known for his aggressiveness.

JULY 24

unable to attack until afternoon. Although Hood outmaneuvers Sherman, two of his divisions are repulsed by Major General James B. McPherson's reserves. The Confederate attack stalls on the Union rear but begins to roll up the left flank (at this time a Confederate soldier kills McPherson when he rides out to observe the fighting). Determined attacks continue, but the Union forces hold. At 16:00 hours, Confederate forces in the center are repulsed by 20 cannon on a knoll near Sherman's headquarters. Major General John A. Logan's XV Army Corps then counterattacks to restore the Union line. Hood is forced to stop his attacks. He loses 8,000 casualties. Union losses are 3,600.

JULY 24

VIRGINIA, *LAND WAR*
The Battle of Winchester II. As Early returns to the Valley from his Maryland raid, he receives orders to prevent reinforcements from being sent to Grant from the Valley. Marching north, his 13,000 Confederates engage Brigadier General George Crook's three divisions and some cavalry at Winchester. After an hour of resistance at Pritchard's Hill, the Federal line collapses and the 10,000 Union troops fall back in disarray through the streets of Winchester. Union losses are 1,200; Confederate 600. As a result of this defeat and the burning of Chambersburg, Pennsylvania, on July 30, Grant returns the VI and XIX Corps and appoints Sheridan as commander of Union forces in the Valley.

JULY 27–29

VIRGINIA, *LAND WAR*
The Battle of Deep Bottom I/ Strawberry Plains/Gravel Hill. Union troops cross the north side

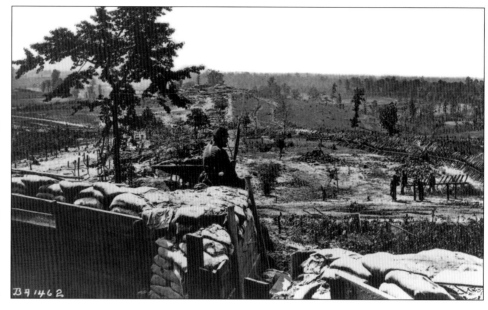

▲ *Fortified Confederate lines south of Atlanta, Georgia. Union General William T. Sherman captured the city on September 2, 1864, after a four-month campaign.*

of the James River to threaten Richmond. They are forced back by Confederate counterattacks, but leave a bridgehead at Deep Bottom.

JULY 28

GEORGIA, *LAND WAR*
The Battle of Ezra Church/Battle of the Poor House. Major General O.O. Howard's Army of the Tennessee attempts to cut the railroad line between East Point and Atlanta. The attack ultimately fails, but

very heavy Confederate casualties are inflicted at Ezra Church.

JULY 28–29

NORTH DAKOTA, *INDIAN WARS*
The Battle of Killdeer Mountain/ Tahkahokuty Mountain. The final strength of Sioux resistance in North Dakota is broken after a pitched battle results in a 9-mile (14km) pursuit of the routed Native Americans

JULY 30

VIRGINIA, *LAND WAR*
The Battle of Crater/The Mine. The Union troops of the 48th Pennsylvania Infantry were stuck in trenches outside

▼ *A nurse cares for wounded Union soldiers during the Civil War. Despite initial resistance from the Army Medical Bureau, more than 3,000 women in the Union served as nurses for the fighting men during the conflict.*

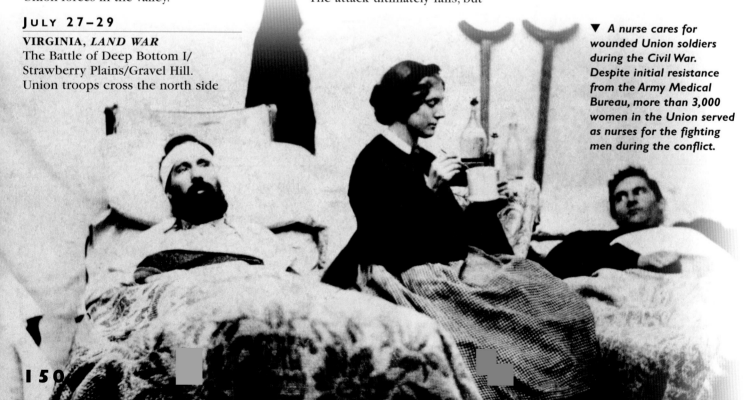

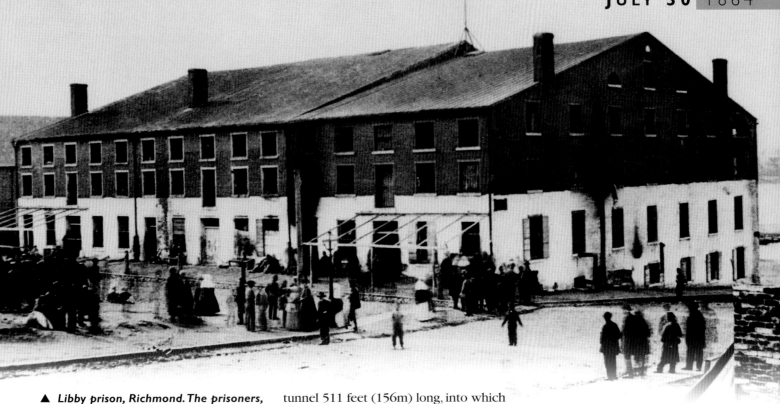

▲ *Libby prison, Richmond. The prisoners, mostly Union officers, were housed on the upper two floors. Cells in the basement held spies and dangerous prisoners.*

Petersburg and frustrated. The regiment was made up of former coal miners, and the soldiers came up with the idea of digging a tunnel under the enemy lines, planting gunpowder at the end of it, and blowing up one of the enemy forts.

Army engineers declared their plan impossible since they would have to dig a tunnel 500 feet (152m) long, and no mine had ever been dug so far. However, the commanding officer, Colonel Henry Pleasants, a mining engineer before the war, believed in the idea. He persuaded his corps commander, Ambrose E. Burnside, of its worth and soon had the regiment at work on the project. The 48th Pennsylvania took a month to dig a

tunnel 511 feet (156m) long, into which was put 4 tons (3.6 tonnes) of powder.

The charge is detonated today, the explosion blasting a crater in the Confederate lines beneath Pegram's Salient nearly 200 feet (61m) long, 30 feet (9.1m) deep, and 60 feet (18.2 m) wide. Then Union troops attack. Unit after unit charge into and around the crater, where thousands of soldiers mill around in confusion. The Confederates quickly recover and launch several counterattacks led by Major General William Mahone. The breach is sealed off, and the Federals lose 5,000 men for no result. Burnside is relieved of his command because of this disaster.

▼ *Chambersburg, Pennsylvania. On July 30, 1864, two cavalry brigades under Confederate General Jubal Early rode in and set fire to the town.*

▼ *A photograph showing damage done to a civilian house in Atlanta by the Union bombardment of the city, which began on July 20 and lasted for five weeks.*

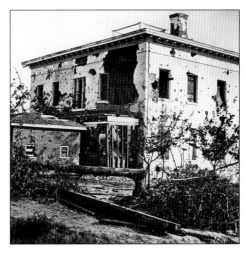

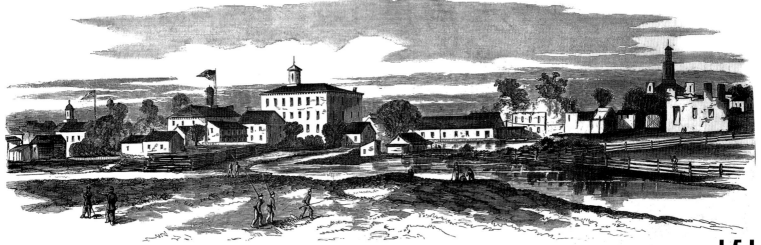

AUGUST 1

MARYLAND, *LAND WAR*
The Battle of Folck's Mill/Cumberland. A Union ambush at Folck's Mill prevents Confederate cavalry forces from disrupting the railroad near the town of Cumberland.

AUGUST 5

ALABAMA, *NAVAL WAR*
The Battle of Mobile Bay/Fort Morgan/Fort Gaines. The main entrance to Mobile Bay is defended

▶ *The shellfire-blasted lighthouse at Mobile Point photographed after the naval battle for Mobile Bay on August 5, 1864.*

▲ *Union officers of C and D Companies, 1st Massachusetts Cavalry, near Petersburg in August 1864. These companies served at the Army of the Potomac's headquarters.*

by Fort Morgan with 40 guns and Fort Gaines with 16 guns, and there are sea mines (known as torpedoes) placed along the channel. Confederate forces under Franklin Buchanan consist of the powerful ironclad CSS *Tennessee*, three wooden ships, 427 men, and 22 guns. David G. Farragut leads a Union fleet of 14 wooden ships,

▶ *Sailors and the starboard battery of 11-inch (25cm) Dahlgren guns on board the Union navy steamer USS Pawnee in Charleston Harbor, South Carolina, 1864.*

four ironclad monitors, 2,700 men, and 197 guns.

The Union ironclad USS *Tecumseh* fires the first shot as the Union fleet enters the channel today. Wooden ships are fastened together in pairs to face the heavy fire from Fort Morgan. The *Tecumseh* hits a mine and sinks. At its

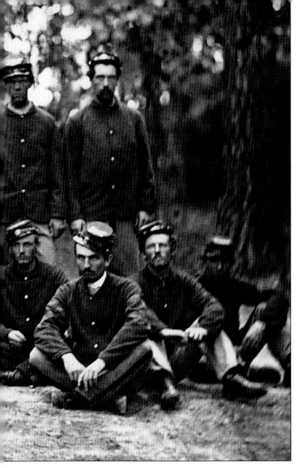

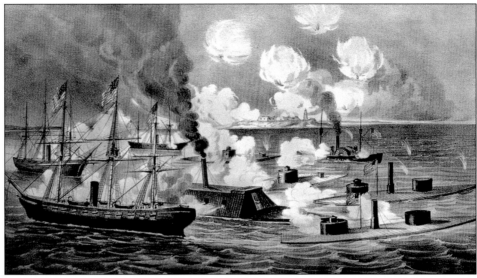

▲ At the Battle of Mobile Bay the Confederate ironclad CSS *Tennessee* (center), outnumbered 17 to 1, fought alone for nearly two hours before surrendering.

sinking the captain of the leading ship, the USS *Brooklyn*, halts in confusion and signals for advice from Farragut. From his flagship, the USS *Hartford*, Farragut issues his famous rallying order: "Damn the torpedoes! Go ahead!"

The *Hartford* then leads the rest of the Union fleet into the bay without

losing another vessel. They soon overwhelm the three wooden Confederate ships. For almost two hours the *Tennessee* continues the fight alone against the entire Union fleet. Its six-inch-thick iron armor is pounded with solid shot. At least three Union ships repeatedly ram the *Tennessee* at full speed. Surrounded by enemy ships, the badly damaged *Tennessee* surrenders. The three-hour battle ends in a Union

▼ The vast Union supply depot at City Point, Virginia, was the center of Union army operations in 1864–1865. Supplies arrived daily via the James River.

victory. Each side loses 300 men killed, wounded, or captured. The city of Mobile remains in Confederate hands for eight months, but the Union has achieved its goal of closing the port.

By the third week in August Union troops had succeeded in capturing Fort Powell, which guarded Grant's Pass into Mobile Bay, and Forts Morgan and Gaines at the bay's main entrance. The Union victory at Mobile Bay, along with

AUGUST 5-7

the capture of Atlanta, Georgia, on September 2, boosted Northern morale and Abraham Lincoln's chances of reelection as president in November.

AUGUST 5-7

GEORGIA, *LAND WAR*
The Battle of Utoy Creek. Another attempt by Sherman to break the railroad between East Point and Atlanta fails in the face of heavy Confederate resistance. The Union troops take up entrenched lines near the Confederate positions as a result.

AUGUST 7

WEST VIRGINIA, *LAND WAR*
The Battle of Moorefield/Oldfields. Confederate cavalry moving into the Shenandoah Valley are attacked and routed by Union cavalry at Moorefield.

AUGUST 13-20

VIRGINIA, *LAND WAR*
The Battle of Deep Bottom II/Fussell's Mill/Bailey's Creek. Union forces make another incursion across the James River against Richmond, but are once again pushed back by determined Confederate counterattacks.

AUGUST 14-15

GEORGIA, *LAND WAR*
The Battle of Dalton II. A Confederate cavalry force raiding into North Georgia is unable to dislodge Union

troops from defensive positions around Dalton, and is compelled to withdraw.

AUGUST 16

VIRGINIA, *LAND WAR*
The Battle of Guard Hill/Front Royal/ Cedarville. Some 300 Confederates, part of reinforcements for Early's troops in

the Shenandoah Valley, are captured in an ambush. The remaining Confederates drive two Union brigades to Cedarville.

AUGUST 18

VIRGINIA, *LAND WAR*
The Battle of Globe Tavern/Yellow Tavern/Blick's Station. Grant,

KEY PERSONALITY

DAVID FARRAGUT

David Glasgow Farragut (1801–1870) was born in 1801 near Knoxville, Tennessee. As a child he was unofficially adopted by Captain David Porter of the U.S. Navy. At age nine he enlisted on Porter's frigate USS *Essex* as a midshipman and saw action during the War of 1812. For the next 50 years Farragut served in the navy. Those times were mainly peaceful, and in 1861 he was due for retirement after a long but uneventful career.

Farragut's career, far from being over, was about to take off in a spectacular way. Although a Southerner by birth, he was a staunch Unionist. In January 1862 he was given command of the squadron tasked with capturing New Orleans, the largest city in the Confederacy. On April 24, 1862, under cover of darkness, Farragut's fleet blasted its way past the heavily defended forts Jackson and St. Philip, flanking the Mississippi below New Orleans. He lost only three vessels in

the action. The next day Farragut forced the surrender of New Orleans, which was soon occupied by Union troops. The capture of

New Orleans was a turning point in the war. Farragut was made a rear admiral of the U.S. Navy, the first man to hold that rank.

After the capture of New Orleans, Mobile, Alabama, was the only significant Confederate port left on the Gulf of Mexico. On August 5, 1864, Farragut led an attack on Mobile Bay, which was protected by sea mines (then called torpedoes) as well as Fort Morgan and a Confederate fleet. Blinded by the smoke of battle, Farragut climbed the rigging of his ship and had himself lashed to the mast so that he could see to direct operations. Shortly afterward one of his ships struck a torpedo (now known as a sea mine) and sank. This disaster brought the fleet to a potentially fatal standstill before the big guns of Fort Morgan. Farragut's cry— "Damn the torpedoes! Go ahead!"—rallied the Union fleet, which went on to win the battle.

This was Farragut's last battle. As a national hero he was awarded the rank of admiral in 1866. He died in 1870.

◀ *The camp of the Tennessee Colored Battery at Johnsonville, Tennessee, in 1864. About 20,000 of the 180,000 black Union soldiers came from Tennessee.*

Warren drive back Confederate pickets and reach the railroad at Globe Tavern. In the afternoon, Major General Henry Heth's Confederate division attacks and pushes back the Union troops toward the tavern. Both sides entrench during the night.

AUGUST 19

VIRGINIA, *LAND WAR*
The Battle of Globe Tavern/Yellow Tavern/Blick's Station. Confederate Major General William Mahone, whose division has been hastily returned from north of James River, attacks with five infantry brigades and mauls the right flank of Crawford's division. Heavily reinforced, Warren counterattacks and retakes most of the ground lost during this afternoon's fighting.

AUGUST 20

VIRGINIA, *LAND WAR*
The Battle of Globe Tavern/Yellow Tavern/Blick's Station.

▲ *Wounded soldiers recovering in a hospital. The cramped conditions and lack of basic hygiene meant that many hospitals were breeding grounds for diseases.*

The Federals establish a strong defensive line covering the Blick House and Globe Tavern and extending east to connect with the main Federal lines at Jerusalem Plank Road.
GEORGIA, *LAND WAR*
The Battle of Lovejoy's Station. A Union cavalry division under Brigadier General Judson Kilpatrick raids railroad lines in Georgia, finally being forced to retreat at Lovejoy's Station at the town of Lovejoy.

▼ *The Union gunboat USS Commodore Perry and its crew on the Pamunkey River in Virginia in 1864. The vessel was originally a ferryboat but was converted into a gunboat to boost the number of ships in the Union navy.*

determined to strike the Confederates so they will have to abandon their strong Petersburg defenses, has decided that the place to do this is the Confederate right. He therefore attacks near Globe Tavern in an attempt to take the Petersburg and Weldon Railroad. Units of the Union IX and II Corps, under Major General G.K.

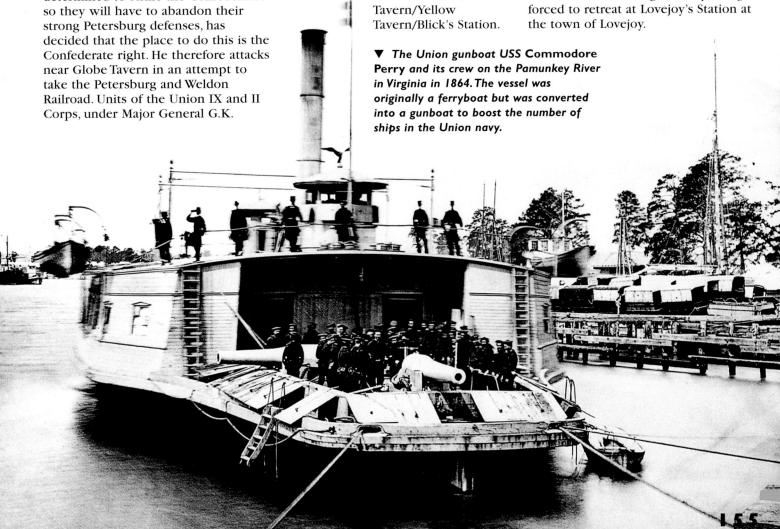

AUGUST 21

▶ *The Third Battle of Winchester. Heavily outnumbered, the Confederates fought fiercely throughout the day but were eventually forced to retreat.*

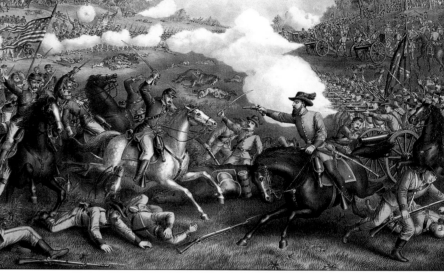

AUGUST 21

VIRGINIA, *LAND WAR*
The Battle of Globe Tavern/Yellow Tavern/Blick's Station. Hill tries but fails to breach the Union defenses. Grant has succeeded in extending his siege lines west and cutting Petersburg's main rail connection with Wilmington, North Carolina. The Confederates now have to unload rail cars at Stony Creek Station, prior to a 30-mile (48km) wagon haul up Boydton Plank Road to reach Petersburg.

WEST VIRGINIA, *LAND WAR*
The Battle of Summit Point/Flowing Springs/Cameron's Depot. In the Shenandoah Valley, two Confederate columns attack a Union concentration near Charles Town, forcing the Union troops to withdraw to Halltown.

▲ *A drawing by Alfred Waud of the quartermaster's stores of Sheridan's army at Harpers Ferry, West Virginia, in 1864.*

AUGUST 21

TENNESSEE, *LAND WAR*
The Battle of Memphis. Brigadier General Nathan Bedford Forrest raids Union-held Memphis, causing major damage and pulling Union troops down from northern Mississippi.

AUGUST 25

VIRGINIA, *LAND WAR*
The Battle of Ream's Station II. Spotting a weak point on the Union II Corps' front, the Confederates attack at Ream's Station, routing II Corps and taking 2,100 prisoners. Although a victory, the battle does not regain the railroad.

AUGUST 25–29

WEST VIRGINIA, *LAND WAR*
The Battle of Smithfield Crossing. Two Confederate infantry divisions push

▼ *A heavily reinforced dugout, called a bombproof, in the Union Fort Sedgwick during the siege of Petersburg, Virginia (June 1864–April 1865). It was protected by sandbags and gabions (wicker baskets packed with earth).*

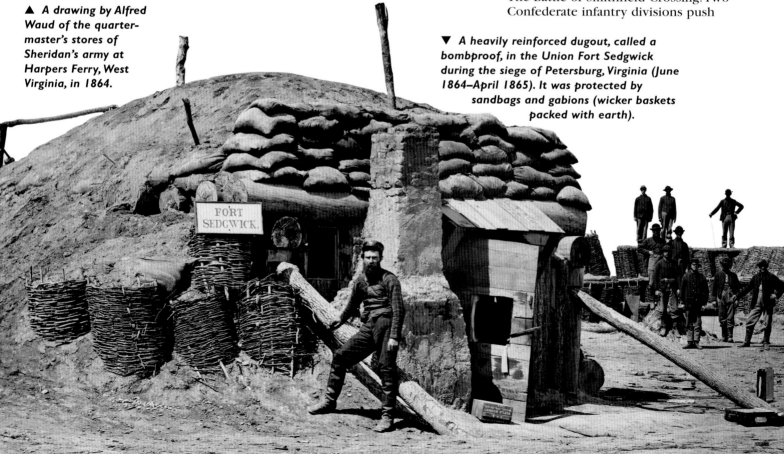

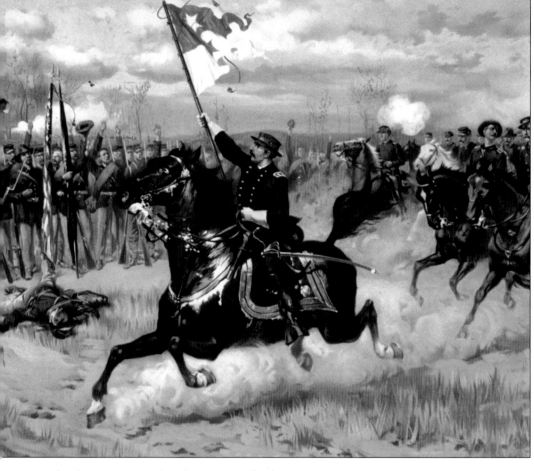

KEY WEAPON

TORPEDOES

Torpedoes were used in Confederate harbor defense. Unlike modern torpedoes, they did not move, and unlike modern sea mines, they did not usually explode on contact with a ship. (Reliable contact fuses had not yet been invented.) Instead, they were simply watertight cylinders packed with black powder and submerged. A cable or other device was used to keep the torpedo in place. Another cable ran to an observation post on shore. When an enemy ship came close to the mine, the shore observers would detonate it using an electric current. Although inefficient by later standards, the torpedo was the single most effective element in the Confederate naval arsenal. During the war Confederate torpedoes claimed 29 Union warships.

The spar torpedo was an explosive placed at the end of a spar and attached to the bow of a small boat. Manned by a crew of sailors, the spar torpedo boat would row under cover of night until it got the torpedo next to the hull of an enemy vessel. The torpedo was attached to the spar by an iron slide, which could be detached from the boat. The torpedo would then float up against the vessel's hull and be exploded by pulling a separate lanyard. With luck, the torpedo-boat crew would escape to safety, while the enemy vessel would be damaged or sunk.

An early attempt to use this technique was made by the CSS *Hunley*, a small submarine. In February 1864, the *Hunley* detonated its torpedo under the USS *Housatonic*. The attack succeeded, and the *Housatonic* became the first ship to be sunk by a submarine. But the *Hunley* also went down with the *Housatonic*.

back a Union cavalry division to Charles Town after a clash at Smithfield.

AUGUST 31

GEORGIA, *LAND WAR*

The Battle of Jonesborough. At the end of July, John Bell Hood's Confederates had retreated into Atlanta and were being bombarded by General William T. Sherman's forces.

▲ *Union General Philip H. Sheridan in the Shenandoah Valley. Chosen by Grant to command in the valley on July 7, 1864, he won a decisive campaign.*

Sherman realized that the city was too strongly defended to be taken by direct assault. On August 25 he withdrew most of his army, moving them to cut the railroads west and south of Atlanta. If he could cut the Confederates' supply line, they would be forced out of the city. Hood interpreted Sherman's movements as a retreat. When he received reports of Union troops near Jonesborough, just south of Atlanta on the Macon and Western Railroad, he figured them to be only a raiding party and sent troops under William J. Hardee to destroy them. Hood's miscalculation has dire consequences.

Hardee is surprised to encounter virtually the entire Union force near Jonesborough. Six Union army corps have moved in an arc around the Atlanta defenses. Hardee makes an ineffective attack, and the Confederates suffer high casualties. This failure forces the other Confederate corps, under Stephen D. Lee, back to a defensive position along the Macon and Western Railroad.

◄ *A grim-looking Sherman outside Atlanta. After taking the city, he ordered all civilians to leave their homes, declaring Atlanta to be a military encampment.*

SEPTEMBER 1

GEORGIA, *LAND WAR*

Sherman cuts the railroad north of Jonesborough, then attacks again in the afternoon, forcing Lee to retreat. Once the last supply line is cut, Hood's Confederates are forced to evacuate Atlanta. They leave tonight, and Union troops entered the city the next day.

The Battle of Jonesborough and the subsequent loss of Atlanta removed any doubt that the Confederacy would be defeated. Sherman's forces suffered 1,150 casualties at Jonesborough, and 35,000 for the entire Atlanta Campaign, but they had given Lincoln the victory that he badly needed. The mismanaged attacks at Jonesborough also showed the command failures that plagued the Confederate Army of Tennessee.

SEPTEMBER 3–4

VIRGINIA, *LAND WAR*

The Battle of Berryville. Major General Philip Sheridan launches a corps-strength attack against a Confederate camp at Berryville, without a decisive outcome to the battle.

SEPTEMBER 10–11

GEORGIA, *LAND WAR*

The Battle of Davis' Cross Roads/Dug Gap. Union forces perform a skilful strategic withdrawal to Steven's Gap following a heavy assault against their positions at Davis' Cross Roads.

SEPTEMBER 16

VIRGINIA, *LAND WAR*

Texas cattlemen supplied beef to Southerners east of the Mississippi River until the summer of 1862, when

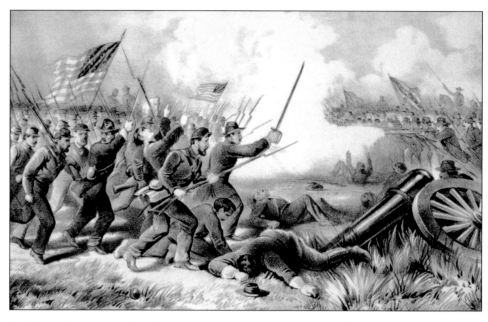

▲ *Union forces attacking the outnumbered Confederates led by William J. Hardee at the Battle of Jonesborough, just outside Atlanta.*

the Union navy took control of the river. Short of cattle, the Confederates have been reduced to cattle raids on Union troops ever since. Today, General Wade Hampton and his cavalrymen appear at Coggins Point in the rear of the Union army on the James River. They carry off the entire beef supply of 2,486 cattle. The "Great Beefsteak Raid," as it is called, brings joy and relief to the hungry Rebels.

SEPTEMBER 19

VIRGINIA, *LAND WAR*

The Third Battle of Winchester/ Opequon. The battle takes place east of the town. It is a key engagement of Union General Philip H. Sheridan's Shenandoah Valley Campaign against Confederate General Jubal A. Early. Outnumbered nearly three to one, the Confederates fight stubbornly all day, but their lines eventually break. After losing nearly a quarter of his men, Early retreats through the town.

SEPTEMBER 22

VIRGINIA, *LAND WAR*

The Battle of Fisher's Hill. Jubal A. Early's 9,500 Confederates took up a strong defensive position at Fisher's Hill, south of Strasburg, yesterday. General Philip Sheridan's Union army of 30,000 advanced and occupied important high ground. Today, Union

▼ *This photograph shows a railroad destroyed by Hood's Confederate troops during their retreat from Atlanta in September 1864.*

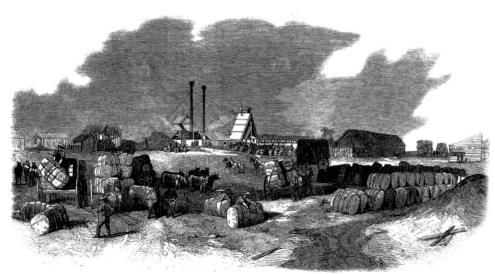

▲ *The cotton press at Piedras Negras on the Mexico side of the Rio Grande. It was built to handle the huge quantities of Confederate cotton coming across the Rio Grande.*

troops outflank Early and attack at 16:00 hours. The Confederate cavalry does nothing and the infantry is unable to withstand the assault. The Rebel defense collapses as Sheridan's other troop join in the assault. Union losses are 528, Confederate 1,235. Early retreats to Rockfish Gap near Waynesboro, opening the Valley to a Union "scorched earth" invasion.

SEPTEMBER 27

MISSOURI, *LAND WAR*
The Battle of Fort Davidson/Pilot Knob. A Confederate army aiming to capture St. Louis pushes Federal opposition into Fort Davidson. Although the fort is eventually evacuated, the Confederates lose too many men and too much time in its capture.

SEPTEMBER 29–30

VIRGINIA, *LAND WAR*
The Battle of Chaffin's Farm/New Market Heights. An assault by the Union's Army of the James against Richmond's defenses north of the

James River gains ground and forces Lee to pull in troops from Petersburg.

SEPTEMBER 30

VIRGINIA, *LAND WAR*
The Battle of Peebles' Farm/Poplar Springs Church. As part of Grant's attempt to cut Confederate lines of communication southwest of Petersburg, he despatches forces to hit Lee's right, extending the lines west and driving toward the South Side Railroad and the Appomattox River. The Union V Corps, followed by IX Corps, strikes southwest of Petersburg at Peebles' Farm, toward Poplar Springs Church. The Federals are initially successful, but General A.P. Hill counterattacks and opens a gap between the two corps.

Over the next two days the Federals dig in on Squirrel Level Road and near Peebles' Farm, repulsing Confederate attacks, in effect extending the Union siege lines and again stretching the resources of the Confederate defenders. Their lines are now dangerously thin.

▲ *A sketch by Alfred Waud of Wade Hampton's cattle raid. The Union troops who lost their cattle were quickly resupplied with a fresh herd.*

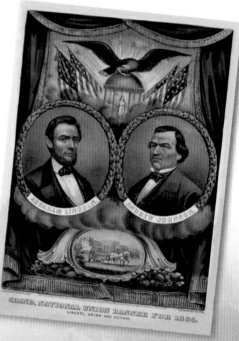

▲ *An 1864 Republican Currier & Ives print, showing War Democrat Andrew Johnson of Tennessee (pictured right) as Lincoln's (left) running mate.*

OCTOBER 2

VIRGINIA, *LAND WAR*

The Battle of Saltville. A failed Union attack against the saltworks at Saltville.

OCTOBER 5

GEORGIA, *LAND WAR*

The Battle of Allatoona. A failed Confederate strike toward the Western & Atlantic Railroad.

OCTOBER 7

VIRGINIA, *LAND WAR*

The Battle of Darbytown/New Market Roads/Fourmile Creek. General Robert

▲ The British-built CSS **Florida** *is rammed and captured by a Union steamer, USS* **Wachusett**, *in the Bay of San Salvador, Brazil, on October 7, 1864.*

E. Lee launches a bloody and futile attack against the Union far right flank around Richmond.

OCTOBER 9

VIRGINIA, *LAND WAR*

The Battle of Tom's Brook/Woodstock Races. The Union takes control of the Shenandoah Valley after routing Confederate forces at Tom's Brook

during intense raiding and scorched-earth missions.

OCTOBER 13

VIRGINIA, *LAND WAR*

The Battle of Darbytown Road/Alms House. A Union brigade is beaten back with heavy casualties while probing Richmond's defenses.

OCTOBER 15

MISSOURI, *LAND WAR*

The Battle of Glasgow. Sterling Price's Confederate expedition into Missouri takes Glasgow, Howard County, capturing many arms and stores.

OCTOBER 19

VIRGINIA, *LAND WAR*

The Battle of Cedar Creek. At dawn the Confederate Army of the Valley under General Jubal A. Early (21,000 men) surprises the Federal army at Cedar Creek and routs the VIII and XIX Army Corps. However, the Union commander, Major General Philip Sheridan, arrives from Winchester, rallies his troops, and launches a counterattack that defeats the Confederates. Confederate losses are 2,910, Union casualties are 5,665. This defeat is a disaster for the South because it breaks the back of the Confederate army in the Shenandoah Valley.

KEY PERSONALITY

PHILIP SHERIDAN

Philip Henry Sheridan (1831–1888) was born in Albany, New York, on March 6, 1831, to Irish immigrant parents. He grew up in Somerset, Ohio, and went to the U.S. Military Academy at West Point in 1848 after lying about his age to get in. An average student while at West Point, he was nicknamed "Little Phil" because of his short stature. The name stuck.

Sheridan graduated in 1853, after being held back a year for bad behavior. He then served in the 1st U.S. Infantry, fighting Native Americans along the Rio Grande in Texas. Sheridan hated the South with a passion and once said, "If I owned both Hell and Texas, I'd rent out Texas and live in Hell."

Sheridan began the Civil War as a quartermaster but lobbied for more responsibility. In May 1862 he was promoted to colonel of the 2nd Michigan Cavalry. Immediately, he proved himself worthy of his promotion. He went back to the infantry as a brigadier general in the Army of the Ohio in Kentucky, where he played a vital role in the victory at Perryville

on October 8, 1862. By the age of 32 he was major general of volunteers.

Sheridan impressed General Ulysses S. Grant with an attack at the Battle of Chickamauga in September 1863. Grant promoted

Sheridan to chief of cavalry in the Army of the Potomac.

In May 1864 Sheridan's troops attacked Richmond and, in the process, killed Confederate General "Jeb" Stuart. Sheridan then took command of the Army of the Shenandoah. With 40,000 men he destroyed much of the Shenandoah Valley, a fertile region known as the South's "breadbasket." In October 1864 he was surprised by a Confederate attack led by General Jubal A. Early. Sheridan rallied his troops, counterattacked, and secured a victory that left the Union in control of the valley. Sheridan received the thanks of Congress and was promoted to major general of regulars.

Sheridan's actions in early 1865, culminating in his capture of 6,000 men and six generals at Sayler's Creek on April 6, 1865, helped bring the Civil War to an end. After the war he was sent to Texas with 50,000 soldiers to threaten the French regime in Mexico. After a year's negotiations the French withdrew in 1867. Sheridan died on August 5, 1888, days after finishing his memoirs.

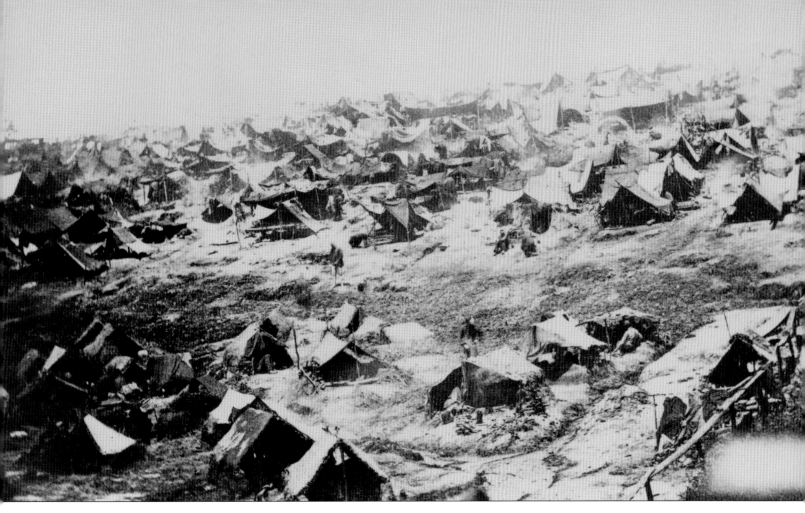

▲ *Andersonville prison camp. During heavy rains the camp's latrines flooded, sending the contents into the water supply, which spread typhoid and dysentery.*

VERMONT, *LAND WAR*

The St. Albans Raid. A group of about 20 disguised Confederate cavalrymen, led by Southern agent George Sanders and Lieutenant Bennett Young, leave Quebec, Canada, and ride into St. Albans, a town in Vermont 15 miles (22km) across the border. The horsemen gallop down Main Street and herd the terror-stricken townsfolk at gunpoint onto the town's green. There Young announces: "This city is now in the possession of the Confederate States of America."

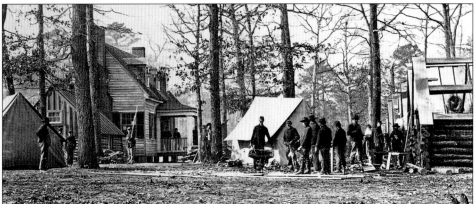

▲ *Both sides used Southern farms. This is Chapin's Farm, near Richmond, which served as Union General Benjamin Butler's headquarters in fall 1864.*

However, instead of consolidating their easy victory, the raiders proceed to rob the three local banks of a total of over $200,000. They then make a failed attempt to set fire to the town before fleeing back to Canada. One of the invaders is killed in the raid. The others are arrested in Montreal and later tried by the Canadian authorities; but

◀ *An army paymaster hands out pay to William T. Sherman's Union soldiers in Atlanta. Union soldiers received their pay regularly, in contrast to Confederate soldiers.*

the efforts of the Union government to have them extradited to the United States came to nothing, and the prisoners were all eventually released.

The raid on St. Albans causes great shock and excitement for a short time, but is soon largely forgotten. Nevertheless, it remains symbolically significant as the northernmost engagement of the Civil War.

MISSOURI, *LAND WAR*

The Battle of Lexington. Union forces meet Price's Missouri expedition at

OCTOBER 21

Lexington. They are unable to stop the Confederate advance, but do slow it.

OCTOBER 21

MISSOURI, *LAND WAR*
The Battle of Little Blue River/Westport. A confused Union attempt to stop Price's advance into Missouri is defeated on the Little Blue River.

OCTOBER 22

MISSOURI, *LAND WAR*
The Battle of Independence. Federal troops wrest control of Independence from Price's Confederates, although the Confederates put the Union troops back on the defensive.

OCTOBER 22–23

MISSOURI, *LAND WAR*
The Battle of Byram's Ford/Big Blue River. Having fought their way across the Big Blue River, Price's Confederate force is compelled to abandon its crossing at Byram's Ford. This exposes Price's rearguard and he is forced to retreat south.

OCTOBER 23

MISSOURI, *LAND WAR*
The Battle of Westport. Sterling Price has led the Confederacy's second big attempt to break the Union hold on Missouri. He marched from Princeton, Arkansas, with more than 8,000 troops bound for Missouri. At this juncture he and his troops have marched nearly

▼ *A pro-Democrat cartoon of presidential candidate George B. McClellan advocating a negotiated peace, while Presidents Lincoln and Davis rip the nation apart.*

▲ *Oilfields at Franklin, Pennsylvania, in 1864. Oil prices rose in the mid-19th century, stimulating other industries, such as railroads to transport crude oil.*

1,500 miles (2,400km) and fought no less than 43 engagements.

The final showdown takes place at Westport today. Price's men are defeated by Samuel Curtis' 20,000-strong Union Army of the Border. There are 1,500 casualties on each side. Westport, "the Gettysburg of the West," is the largest battle fought west of the Mississippi. The battle marks the end of organized Confederate resistance in Missouri, though guerrilla warfare continues.

OCTOBER 25

KANSAS, *LAND WAR*
The Battle of Mine Creek/Battle of the Osage. In another disaster for Price's Missouri expedition, 600 Confederates, including two generals, are captured while crossing Mine Creek, Linn County.

The Battle of Marais des Cygnes/Trading Post. Price's doomed

expedition suffers further heavy loses after a Union artillery and infantry attack at Marais des Cygnes.

MISSOURI, *LAND WAR*
The Battle of Marmiton River/Shiloh Creek/Charlot's Farm. Heavy skirmishing occurs as Price's

▶ *The 13-inch (33cm) Union mortar known as the "Dictator" mounted on a railroad car in October 1864 during the siege of Petersburg. Giant mortars were originally used in coastal forts. The Union used railroads to transform them into portable guns.*

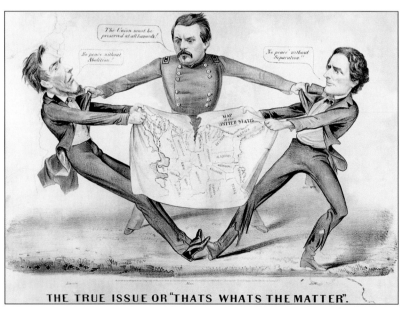

THE TRUE ISSUE OR "THATS WHATS THE MATTER".

Confederates cross the Marmiton River. Price's men are now being hounded.

OCTOBER 26–29

ALABAMA/TENNESSEE/GEORGIA, *LAND WAR*

The Franklin-Nashville Campaign. The Confederate Army of Tennessee under General John Bell Hood moves north from Atlanta, attempting to cut William T. Sherman's lines of communications and control central Tennessee.

ALABAMA, *LAND WAR*

The Battle of Decatur. Confederate forces beginning General John B. Hood's Franklin-Nashville Campaign are prevented from crossing the Tennessee River by a strong Union defense.

OCTOBER 27–28

VIRGINIA, *LAND WAR*

The Battle of Fair Oaks/Darbytown Road/Second Fair Oaks. Union attacks against Richmond's defenses at Fair Oaks and Darbytown Road fail, with 600 Federals being taken prisoner.

VIRGINIA, *LAND WAR*

The Battle of Boydton Plank Road/ Hatcher's Run/Burgess' Mill. A Union attack fails to capture the strategically important Boydton Plank Road in the Richmond-Petersburg theatre.

OCTOBER 28

MISSOURI, *LAND WAR*

The Battle of Newtonia. Price's columns are mauled near Newtonia.

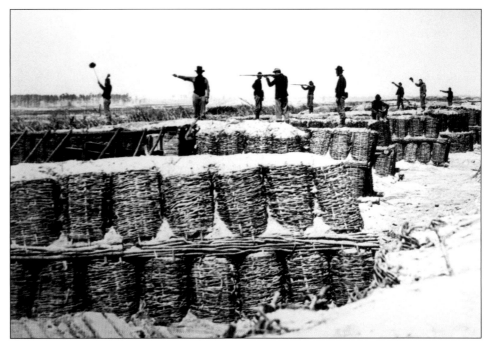

▲ *An elaborate system of trenches in the Union lines during the siege of Petersburg, Virginia (June 1864–April 1865). The trenches became more complex and better protected as the siege went on, tightening the Union investment.*

NOVEMBER 4–5

NOVEMBER 4–5

TENNESSEE, *LAND WAR*

The Battle of Johnsonville. Major General Nathan Bedford Forrest finishes his 23-day raid in Georgia and Tennessee with the near complete destruction of the Union supply base at Johnsonville.

NOVEMBER 8

WASHINGTON, D.C., *POLITICS*

Abraham Lincoln is reelected President of the United States, having beaten the Democrat McClellan by nearly 500,000 votes. Lincoln's success is due to Sherman's capture of Atlanta in September, a victory that lifted spirits throughout the North and revitalized the Lincoln campaign.

NOVEMBER 11–13

TENNESSEE, *LAND WAR*

The Battle of Bull's Gap. Major General John C. Breckinridge's expedition into

◀ *An engraving by William Waud of Union soldiers voting in camp in Pennsylvania. Lincoln took 80 percent of the soldiers' vote.*

East Tennessee sees the Confederates temporarily force Union troops from Bull's Gap on the East Tennessee & Virginia Railroad.

NOVEMBER 22

GEORGIA, *LAND WAR*

The Battle of Griswoldville. A Union brigade pushes toward Macon and

drives Confederate forces beyond Griswoldville. The Union troops then endure a three-brigade Confederate counterattack at Duncan's Farm. The Union troops hold their positions.

NOVEMBER 24–29

TENNESSEE, *LAND WAR*

The Battle of Columbia. John Bell Hood outmaneuvers the local Union forces to take Columbia during the Franklin-Nashville Campaign.

NOVEMBER 25

NEW YORK, *GUERRILLA WAR*

As General William T. Sherman's forces sweep through Georgia on their way to

▼ *Union troops resting after drill outside Petersburg, Virginia, in 1864. Some of the soldiers are reading newspapers or letters from home, while others play cards.*

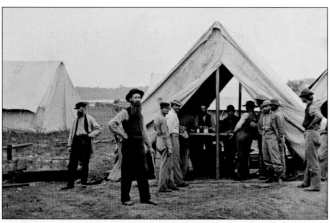

▲ *Soldiers wait in line to buy provisions at a sutler's tent during the siege of Petersburg, 1864.*

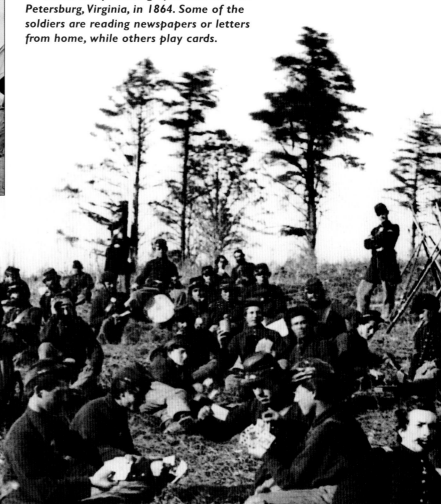

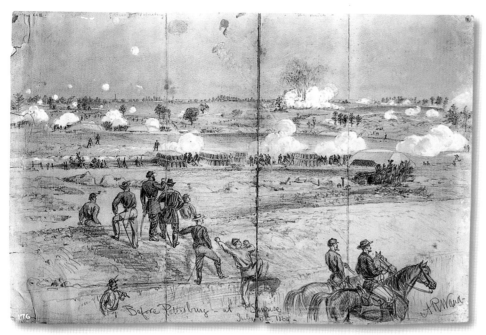

▲ *Federal artillery blasts Confederate defenses at the siege of Petersburg. The city was a vital rail center for the Confederacy, and it took Grant 10 months to take it.*

DECISIVE MOMENT

THE SIEGE OF PETERSBURG

On June 15, 1864, Grant sent 100,000 men of the Army of the Potomac south from Cold Harbor across the James River to swing west through Petersburg and attack Lee from the rear. However, the Union forces were stopped at Petersburg by General P.G.T. Beauregard. Two days later Lee ordered most of his army south to reinforce Petersburg, which was a vital rail center. Confederate forces set up lines of fortifications southeast of the city that could not be breached by frontal assault. Instead, Grant kept his army attacking to the west and south. His objectives were the two railroads that were supplying Lee's army and the Appomattox River, which marked Lee's line of retreat to the west.

In late August Union forces cut the railroad running south. Grant attacked again in late September and late October, extending the siege lines to 35 miles (56km) and threatening the last rail line open to Lee. Lee's position was now desperate.

This stalemate continued until February 1865, when Grant renewed his attacks. On March 29 Grant began his final push, sending 125,000 men to flank Lee's trench line. At the Battle of Five Forks on April 1 they overwhelmed a Confederate force of 10,000 and threatened to cut off Lee's line of retreat. Lee pulled out of Petersburg on April 2, retreating westward. It was the beginning of the end for his army.

the Atlantic Ocean, the Confederate government authorized a team of agents to travel to Canada in an attempt to influence the upcoming Union presidential election. These efforts failed, so the agents decided instead to attempt to burn New York City. The plan is carried out tonight. Fires are set in the St. James Hotel and other places, and by dawn 13 hotels and numerous other buildings have been torched. But the fires do not spread to become

general. City firefighters put out the blazes wherever they can, and in any case the conspirators are unable to create the right combustible mixtures for their fires. After a military investigation one man, Robert Cobb Kennedy, is captured, tried, and hanged for the attempt to burn New York City.

NOVEMBER 28

GEORGIA, *LAND WAR*
The Battle of Buck Head Creek. Confederate forces attack a Union camp near Buck Head Creek, Jenkins County, but a Union rearguard action inflicts around 600 casualties on the Confederate attackers.

NOVEMBER 29

TENNESSEE, *LAND WAR*
The Battle of Spring Hill. Union forces under Major General John M. Schofield repel piecemeal Confederate attacks as Union forces move through the area to Franklin. Confederate General John Bell Hood thus misses a good chance to contain and destroy the Union army.

NOVEMBER 29–30

COLORADO, *INDIAN WARS*
The Battle of Sand Creek/Chivington Massacre. Union Colonel John Chivington leads a massacre of 200 Cheyennes and a few Arapahos. Two-thirds of the victims are women and children.

◄ *A newspaper cartoon of late 1864 shows the supposed nightmare of the Confederate President Jefferson Davis when Abraham Lincoln is reelected president of the United States.*

NOVEMBER 30

TENNESSEE, *LAND WAR*

The Battle of Franklin between John Bell Hood's Confederate Army of Tennessee and Union troops led by John M. Schofield. It is part of the Nashville Campaign, the Confederate army's desperate attempt to retake Tennessee and

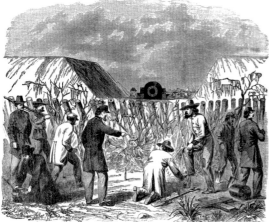

▲ *A Union officer supervises Confederate prisoners removing mines in front of Fort McAlister, Georgia, during Sherman's March to the Sea in 1864.*

▶ *A painting of the Battle of Franklin on November 30, 1864, showing a mounted Union officer directing his troops to repel the Confederate attack.*

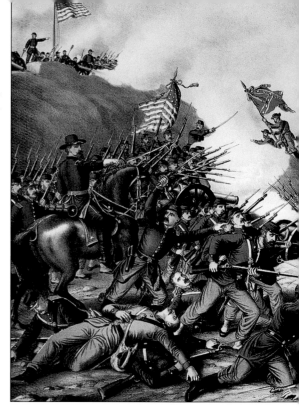

force Union troops to withdraw from the Deep South. Yesterday, John Bell Hood's 38,000-strong Confederate Army of Tennessee had narrowly missed trapping the smaller 27,900 Union force of John M. Schofield at Spring Hill. Furious that Schofield's retreating army had eluded him, Hood orders his men to make a frontal assault on the Union troops entrenched outside the town of Franklin today. With their backs to the Harpeth River, the Union force has to hold the position or be destroyed. The Confederates have a difficult task. Their assault against prepared defenses will have to be made over 2 miles (3.5km) of open ground.

In the faint light of an autumn sunset, with battle flags flying and bands playing "Dixie," Hood's soldiers make their charge. Well-directed Union rifle and artillery fire easily break up the Confederate attacks on the right and left flanks. In the center, however, the Confederates come dangerously close to breaking the Union ranks. Bloody hand-to-hand fighting ensues in

DECISIVE MOMENT

SHERMAN'S MARCH TO THE SEA

Following his capture of Atlanta, Union General William T. Sherman rested his army and planned his next move. His supply line, the railroad from Chattanooga, Tennessee, was under constant attack by the Confederate Army of Tennessee. After several weeks trying to protect the railroad, Sherman realized it was an impossible task. He decided instead to march to Savannah, a port on the Atlantic Coast 220 miles (352km) away. On the march his men would live off the land. The capture of Savannah would enable Union ships to supply the army and give Sherman a secure base from which to operate.

Sherman also hoped to strike a psychological blow to the Confederacy. Abandoning the supply line was risky, but Sherman was confident that Georgia farms produced more than enough to feed his troops. There was also a second risk. Sherman intended to turn away from the Confederate Army of Tennessee, leaving it free to try and invade Union-occupied Tennessee. To counter this threat, Sherman sent 35,000 troops back to defend Nashville. Then he burned everything of military value in Atlanta, and on November 15 set out with 60,000 men to Savannah.

As Sherman's men headed southeast, the Confederates turned back to Tennessee as predicted to embark on an ill-fated invasion. This left no forces to oppose Sherman except Confederate cavalry and Georgia militia. As a result, Sherman was able to spread his army along a path 60 miles (96km) wide. By moving in such a dispersed pattern, his army greatly eased the task of supplying itself from the countryside. Parties of foragers set forth each day to scour the land for pork, beef, corn, and other foods. As the troops advanced, they paused regularly to wreck railroads and burn factories, cotton gins, and anything else that might be valuable to the Confederate war effort. In many cases the authorized foraging was accompanied by theft and vandalism, officially deplored but unofficially tolerated. There were also thousands of lawless stragglers following the army, who were beyond military control.

Some of the most badly treated were the African American slaves liberated by the Union army. On one occasion a Union general burned a bridge over a creek to prevent any African Americans from following. Hundreds of slaves found their path to freedom blocked, and some drowned trying to swim the stream and escape.

Sherman captured Savannah on December 21, 1864. His next move was to join forces with Ulysses S. Grant in Virginia and defeat Robert E. Lee's army. Sherman considered moving his troops by sea from Savannah but then determined on a second march through the Carolinas. The march began on February 1, 1865.

This march was more challenging than the first. There were more Confederate troops obstructing Sherman's advance, as well as several swampy rivers. Winter rains had turned the roads to mud. Nevertheless, the Union troops surprised the Confederate command with the speed of their advance.

The destruction in South Carolina was much more widespread than in Georgia. The worst single event was the burning of Columbia, the state capital, on February 17–18, 1865. By early March Sherman's army had crossed into North Carolina. Joseph E. Johnston's Confederates tried to stop its progress at Bentonville on March 19–21, but failed. Sherman's marches through Georgia and the Carolinas had been decisive. They showed how weak the Confederacy had become, while their destructiveness totally demoralized the South's population and hastened its defeat.

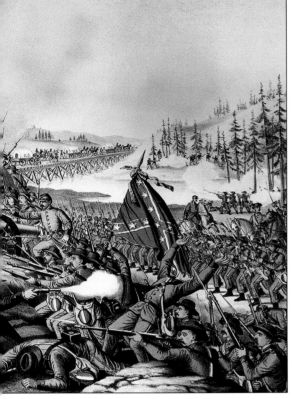

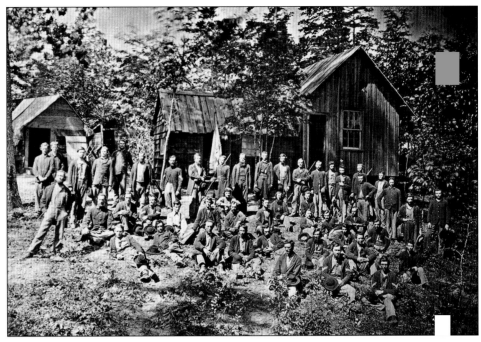

the trenches. At one point the Confederates charge through the trenches of an inexperienced Union regiment and drives it into headlong flight. Only a well-timed counterattack saves the Union line.

The fighting continues until about 21:00 hours, when Hood orders his men to withdraw. The ill-conceived attack has cost his army dearly. More than 6,200 Confederates lie killed, wounded, or captured. Among the dead are six

▶ The March to the Sea

Between November 15, 1864, and March 25, 1865, Union troops marched 600 miles (960km) through Georgia and the Carolinas. The marches showed how weak the Confederacy had become, and their destructiveness demoralized the Southern people.

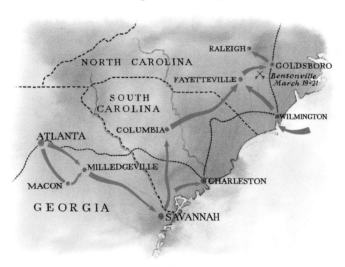

▲ *A company of Sherman's troops, the 21st Michigan Infantry, who in all fought 13 battles in the Civil War and were with Sherman on his March to the Sea in 1864.*

generals, including Patrick Cleburne, the "Stonewall of the West." Under the cover of night Schofield abandons the field and continued his retreat to Nashville. The Union troops are followed by Hood's much weakened Confederates, dispirited by their costly and futile attack.

SOUTH CAROLINA, *LAND WAR*
The Battle of Honey Hill. A Union raid to cut the Charleston & Savannah Railroad near Pocotaligo is decisively stopped and forced to retreat by a Confederate force on Honey Hill.

▼ *The depots and factories of Atlanta, Georgia, in flames. They were set on fire by William T. Sherman's Union troops before they departed on the March to the Sea.*

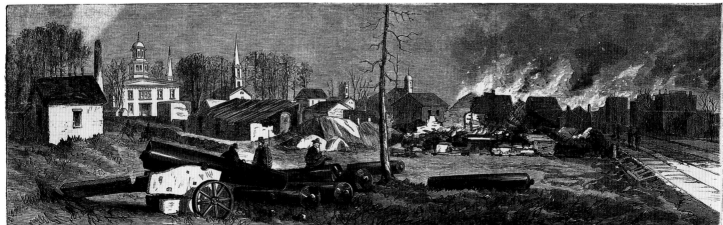

DECEMBER 4

DECEMBER 4

GEORGIA, *LAND WAR*
The Battle of Waynesborough. Union cavalry under Brigadier General Judson Kilpatrick defeat and eject Rebel troops from Waynesborough, Burke County.

DECEMBER 5–7

TENNESSEE, *LAND WAR*
The Battle of Murfreesboro/Wilkinson Pike/Cedars. Major General Forrest sets out on an expedition to attack the Nashville & Chattanooga Railroad and the Union army supply depot at Murfreesboro. Although the expedition causes some damage, Murfreesboro stays in Union hands.

DECEMBER 7–27

NORTH CAROLINA,
LAND/NAVAL WAR
The Battle of Fort Fisher. A Union expedition against Fort Fisher, covering the seaport of Wilmington on the Atlantic coast, fails as Confederate reinforcements move into the area.

◀ Scenes depicting events from Sherman's March to the Sea through Georgia, published in **Harper's Weekly** in 1864. The Union burned and looted its way across the heart of the Confederacy.

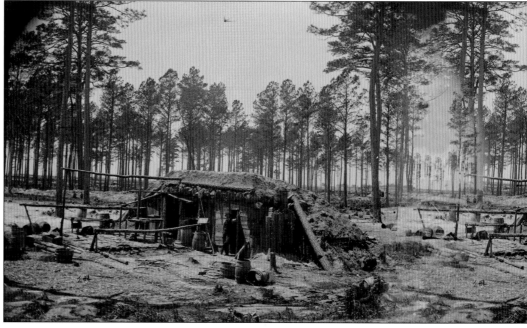

DECEMBER 13

GEORGIA, *LAND WAR*
The Battle of Fort McAllister II. In mid-November, leaving Atlanta in flames, Sherman embarked on his famous March to the Sea. Two huge columns of Union troops headed toward Savannah, cutting a huge swath of destruction as they marched through the fertile Georgia countryside. By early December Sherman was approaching Savannah.

The garrison at Fort McAllister provides the last real resistance to the Union troops. Sherman orders Major General O.O. Howard, commander of his right wing, to storm the fort. Howard delegates the mission to

▲ A Union shelter in the siege lines before Petersburg. Trench warfare involved daily hard labor digging, constant patrol duty, and the ever-present danger of death from snipers or artillery fire.

Brigadier General William B. Hazen, who attacks in the afternoon. His men enter the fort and capture it, the garrison of 120 men putting up only token resistance. Losses are: Union 134; Confederate 71.

Confederate General William J. Hardee and about 10,000 men abandon Savannah and flee north to South Carolina, now one of only two states firmly in Confederate hands. The war in Georgia is over.

GEORGIA, *LAND WAR*
The city of Savanah is well defended. It has strong fortifications on all sides, and the surrounding network of swamps and rivers forms a natural barrier to a

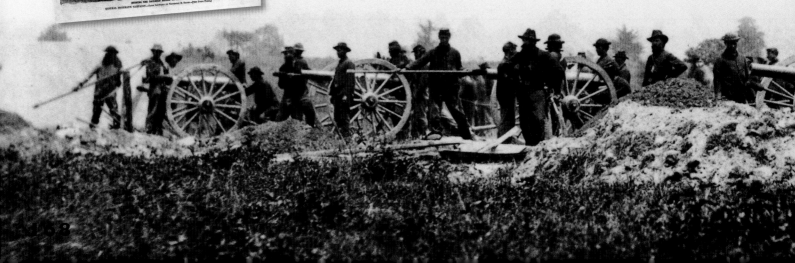

◄ *Returned Union prisoners of war obtaining new clothing on board the USS New York in December 1864. The soldiers are shown putting on the new clothing they have been issued and throwing their old clothes away.*

▼ *The entrance to a mine in the Confederate Fort Mahone during the siege of Petersburg (June 1864–April 1865). It was intended to undermine the nearby Union Fort Sedgwick.*

hostile army. Its strategic importance is immense. Capturing Savannah would give Union General William T. Sherman a secure base deep inside Confederate territory and a port where supplies can be brought in for his army.

The city is garrisoned by 10,000 regular Confederate soldiers and militia commanded by William J. Hardee. On December 9 and 10, Sherman's men took up positions on all sides of the city apart from the seaboard flank. Despite the numerical superiority of the Union troops—there are 62,000— Sherman decided to delay his attack until he received badly needed supplies from the Union fleet.

▼ *Union artillery and hastily tossed-up dirt at Petersburg, Virginia. The Rebels had the tactical advantage that they only had to fight defensively, though without relief they faced ultimate defeat.*

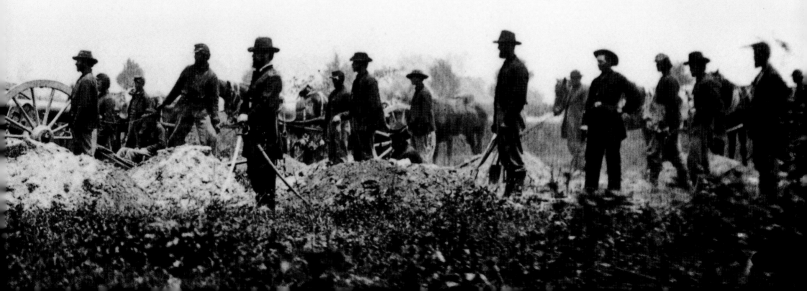

DECEMBER 15

While Sherman waits, one of his divisions assaults and captures the Confederate Fort McAllister on the Ogeechee River south of Savannah. Three days later, Union ships steam up the Ogeechee and delivered supplies to the waiting army.

DECEMBER 15

TENNESSEE, *LAND WAR*

The Battle of Nashville. In late November General John Bell Hood led 30,000 Confederates of the Army of Tennessee north out of Alabama. His objective was to recapture the state and put pressure on General William T. Sherman to call a halt to his campaign through Georgia. By the end of the month Hood had advanced his army north through Pulaski and Columbia, and had turned back a Union force of 27,000 outside Franklin. This battle cost Hood's army more than 6,200 casualties, including six generals, but Hood did not stop. On December 2 the Confederates were south of Nashville facing the strong Union fortifications that ringed the city. With winter coming on, Hood ordered his men to dig in for a siege.

▲ *Union General William T. Sherman's troops removing ammunition from Fort McAllister, near Savannah, Georgia. Union troops stormed the fort on December 13.*

Inside Nashville George H. Thomas, the commander of the Union Army of the Cumberland, was ordered on December 6 by Grant to attack Hood at once. Thomas, however, still planning his strategy, did not launch his attack until early this morning.

Before daylight Thomas' men strike Hood's right flank, pinning down three Confederate divisions. At noon 35,000 Union troops attack the Confederate left, forcing Hood to withdraw his line a mile to the south. Hood's new position is a strong one, protected by Peach Tree Hill on the right and Shy's Hill on the left.

DECEMBER 16

TENNESSEE, *LAND WAR*

The Battle of Nashville. Despite rain and sleet, Thomas attacks again. The Confederate right is hit

▲ *Union cannon firing on Confederate positions during the siege of Petersburg. Lee's army held off Union General Grant's forces for 10 months in 1864–1865.*

first but manages to hold. On the left Union forces take Shy's Hill, and Union cavalry gain the Confederate rear. Then an attack comes in on Hood's center, and his whole line gives way. The Army of Tennessee is routed. It now numbers barely 17,000 men and has lost most of its equipment. Hood retreats to Tupelo, Mississippi, and in January resigned his command. In contrast, Thomas is promoted to major general.

DECEMBER 17–18

VIRGINIA, *LAND WAR*

The Battle of Marion. Major General George Stoneman leads an expedition

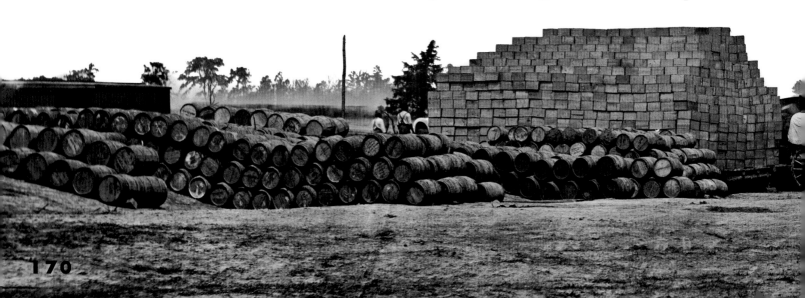

◀ *Union troops of the Army of Cumberland camped around Nashville in December 1864. Despite his devastating losses at the Battle of Franklin two weeks earlier, Hood still hoped to drive Union forces out of Tennessee.*

▲ *The railroad yard in Nashville, Tennessee. The photograph dates from December 1864, when Confederate forces attempted to retake the city.*

against lead mines and salt ponds around Marion and Saltville. At Marion Union troops destroy several key works.

DECEMBER 20

GEORGIA, *LAND WAR*

On December 17, Sherman issued an ultimatum to William J. Hardee: Surrender or face the destruction of Savannah. When Hardee refused to lay

▼ *A Union commissary depot at Cedar Level, Virginia, during the siege of Petersburg (June 1864–April 1865). Supply wagons can be seen next to the stores.*

down his arms, Sherman ordered his troops to prepare to storm the city. But he does not give the order to attack. Instead, he orders John G. Foster, commander of Union forces in South Carolina, to seal off the eastern approaches, the one remaining possible escape route from the city. Sherman hopes that once Hardee is completely surrounded, he will give up without a costly fight.

But before Foster can get into position, Hardee's men escape across a hastily constructed pontoon bridge over the Savannah River during the night and disappear into South Carolina. Union troops will enter Savannah unopposed tomorrow, the

21st, thus bringing the March to the Sea to a triumphant conclusion.

DECEMBER 20–21

VIRGINIA, *LAND WAR*

The Battle of Saltville. Stoneman's raiding party captures and destroys the salt works at Saltville.

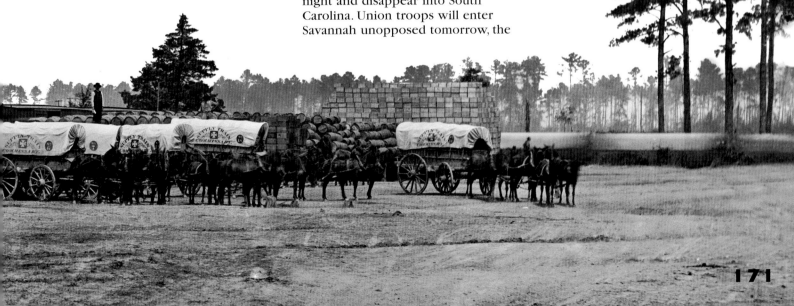

171

1865

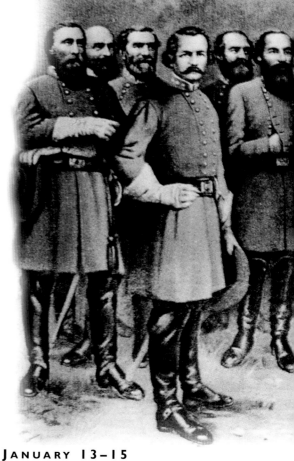

T he Confederacy was in its death throes as Lee and the remnants of the Army of Northern Virginia tried to link up with Joseph Johnston's army in South Carolina, in the process abandoning Richmond. But Grant and Sheridan cornered Lee at Appomattox, where he surrendered on April 9. Johnston yielded on April 26. Four years of war was over.

JANUARY 13–15

NORTH CAROLINA,
LAND/NAVAL WAR
The fall of Fort Fisher. Fort Fisher is finally taken by a large combined-forces Union operation. The Union can now attack Wilmington, the South's last open seaport on the Atlantic coast.

JANUARY 15

NORTH CAROLINA, *NAVAL WAR*
The only major Confederate port still open, Wilmington, is sealed off. The

▼ Confederate forces defend Fort Fisher, the last major Southern stronghold. It fell to the Union on January 15, 1865.

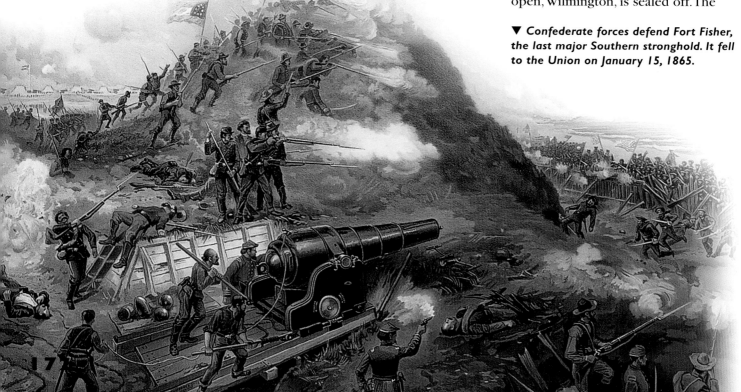

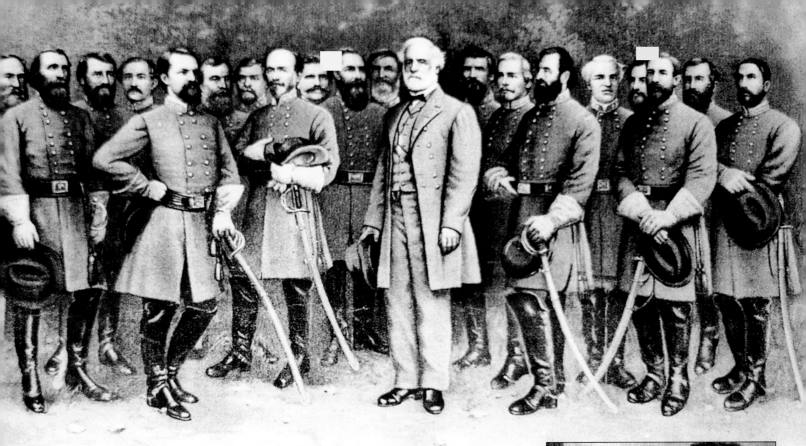

Confederacy has lost its last significant access to the outside world.

JANUARY 19

SOUTH CAROLINA, *LAND WAR*

Union General William T. Sherman, having completed his infamous March to the Sea, during which his army has stormed from Atlanta to Savannah in just five weeks, destroying everything in its path, vows to push on through the Carolinas into Virginia. Today, he orders a northward march into South Carolina. The state is considered to be the "cradle of secession," and many Union troops want to make it pay for being the cause of so much suffering. The 60,000 Union troops are opposed

▲ *A montage of the generals of the Confederate armies. The most famous, Robert E. Lee, is at the front sporting a white beard. Lee suffered a heart attack in 1863, and the stress of the war had aged him considerably by 1865.*

by the Confederate Army of Tennessee, led by Joseph E. Johnston from February and numbering fewer than 10,000.

FEBRUARY 3

SOUTH CAROLINA, *LAND WAR*

The Battle of Rivers' Bridge/Owens' Crossroads. Confederate-held crossings of the Salkehatchie River are outflanked by two Union brigades. The Rebels retreat toward Branchville.

▲ *Mosby's Rangers in the Blue Ridge Pass, Shenandoah Valley. Many of Mosby's raids were carried out in such rugged terrain.*

VIRGINIA, *POLITICS*

A peace conference aboard the *River Queen* in Hampton Roads, with President Lincoln attending, fails to reach a diplomatic ending to the war. Representing the Confederacy are Robert M.T. Hunter, John A. Campbell, and Vice President Stephens.

FEBRUARY 5–7

VIRGINIA, *LAND WAR*

The Battle of Hatcher's Run/Dabney's Mill/Rowanty Creek. A series of actions are fought stemming from a Union attempt to interdict Confederate supply lines in the Richmond-Petersburg campaign. These clashes are indecisive.

FEBRUARY 7

SOUTH CAROLINA, *LAND WAR*

Union troops under William T. Sherman marching through South Carolina on

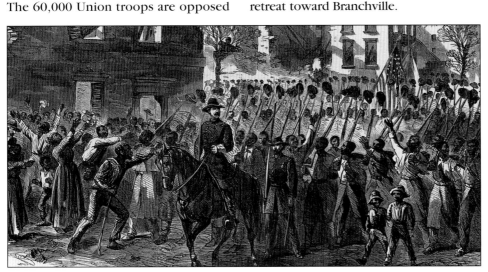

▲ *The Union 55th Massachusetts Infantry Regiment marching through Charleston in February 1865. Note the destroyed buildings in the background.*

FEBRUARY 17

▶ *Union General William T. Sherman's troops burn McPhersonville on their march through South Carolina in February 1865. Sherman's march demoralized the population of the South.*

their way north from Savannah, have been ripping up railroads and destroying crops and livestock. Sherman has divided his forces in two, making it difficult for the Confederates to effectively oppose the two-pronged Union advance. They are further weakened by their failure to anticipate Sherman's next move. Today, Union troops cut the Augusta–Charleston Railroad near Blackville. The Confederates are forced to retreat across the Edisto River. They then concentrate at Chester and Cheraw, abandoning the central part of South Carolina. Union generals Henry W. Slocum and Oliver O. Howard continue their advance, Slocum toward Lexington, and Howard to Columbia.

FEBRUARY 17

SOUTH CAROLINA, *LAND WAR*
A division of the Union XV Corps reached Columbia yesterday and shelled the State House. The city surrendered almost at once. Today, as Union troops enter Columbia, someone sets fire to bales of cotton that have been piled in the streets. High winds help spread the blaze, and over half the

◀ *A view from the Circular Church in Charleston after the evacuation of Confederate troops in February 1865.*

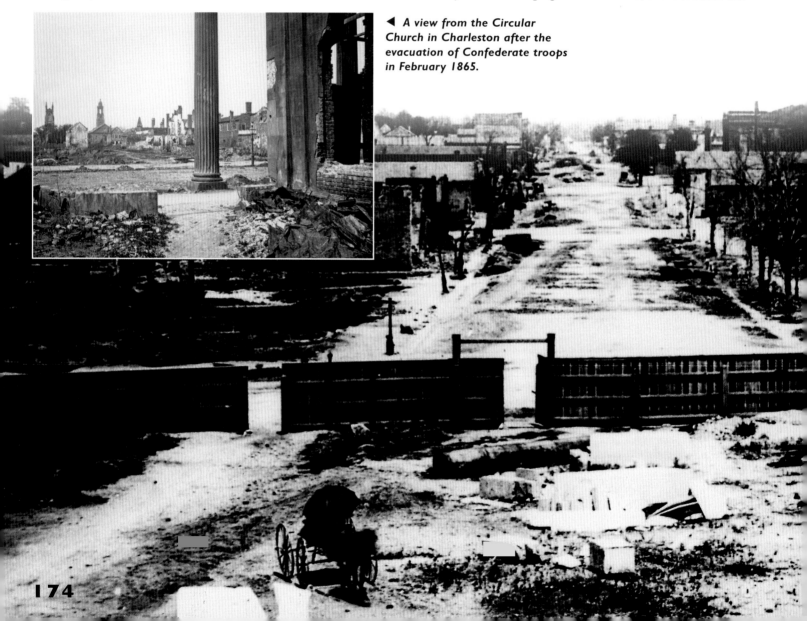

city is destroyed before the flames are brought under control.

The Union General Slocum witnesses the damage done to the city and later described the devastation: "Nearly all the public buildings, several churches, an orphan asylum, and many of the residences were destroyed. The city was filled with helpless women and children and invalids, many of whom were rendered houseless and homeless in a single night. No sadder scene was presented during the war."

Whether the fire was started by retreating Confederates or by arriving Union troops has remained a matter of controversy. The Union army stayed in Columbia until February 20, when it left to continue its march north.

FEBRUARY 22

NORTH CAROLINA, *LAND WAR*
The Battle of Wilmington/Fort Anderson/Town Creek/Forks

Road/Sugar Loaf Hill. With the fall of Fort Fisher to Union forces on January 15, the Confederate port of Wilmington was under great threat. About 6,600 Confederate troops under Major General Robert Hoke held Fort Anderson and a line of works that prevented the Federals from advancing up the Cape Fear River. In early February, the Union XXIII Corps arrived at Fort Fisher, at the mouth of the Cape Fear River, and Major General John Schofield took command of the Union forces, totaling 12,000 men. Schofield then began to reduce the various Confederate outposts. The Confederates were forced to abandon Fort Anderson on February 19, withdrawing to Town Creek to form a new defense line. But this line collapsed the next day. Tonight General Braxton Bragg orders the evacuation of Wilmington, and the burning of cotton, tobacco, and government stores.

KEY WEAPON

THE GATLING GUN

The Gatling was a six-barreled gun that used a rotating mechanism to load, fire, and eject its ammunition at a (then) phenomenal rate of 200 rounds per minute. The gun had several serious drawbacks. It was too big and heavy to be maneuverable in rough country and used black powder, which produced dense clouds of smoke that obscured the target. These problems were eventually solved by inventors around the world over the next 30 years. During the Civil war only 12 Gatling guns were used by the Union army. They were bought privately by General Benjamin Butler in 1864. Gatling himself sincerely believed his invention would bring an end to war because the carnage his new weapon could inflict would make any future war unthinkable.

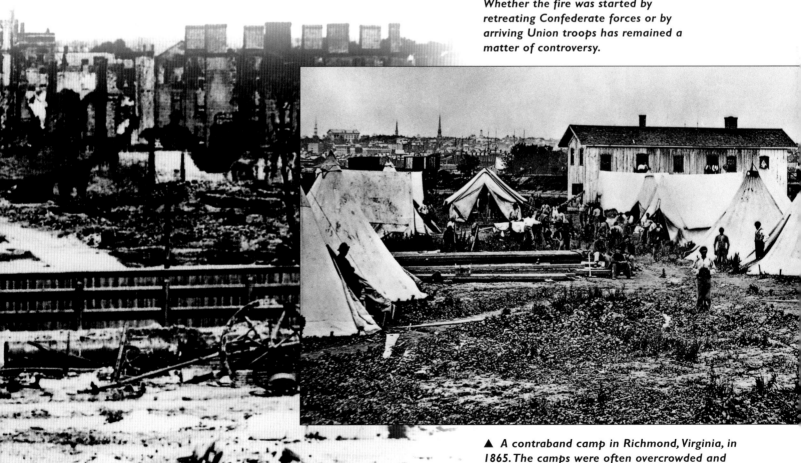

◄ A view of Columbia, South Carolina, after the fire that destroyed large parts of the city on February 17, 1865. Whether the fire was started by retreating Confederate forces or by arriving Union troops has remained a matter of controversy.

▲ A contraband camp in Richmond, Virginia, in 1865. The camps were often overcrowded and unhealthy. The attitude of many Union officers and men toward former slaves was often hostile.

MARCH 2

VIRGINIA, *LAND WAR*

The Battle of Waynesboro. Over 1,500 Confederates, the last of Early's force in the Shenandoah Valley, are captured by two Federal cavalry divisions at Waynesboro. Early escapes with 100 men.

MARCH 3

WASHINGTON, D.C., *POLITICS*

The U.S. Congress establishes the Freedmen's Bureau to deal with the problems resulting in the sudden freeing of thousands of slaves.

MARCH 4

WASHINGTON, D.C., *POLITICS*

President Abraham Lincoln makes his famous Second Inaugural Address, ending with the words "With malice toward none."

▼ *An African American military brass band, photographed in Washington in 1865. Brass instruments were the preferred instruments of most military bands.*

MARCH 6

FLORIDA, *LAND WAR*

The Battle of Natural Bridge. Union commander John Newton, leading a joint expedition to attack Confederate forces in the St. Mark's area, in the northwest of the state, is preparing to march on the state capital, Tallahassee. But, as he attempts to cross St. Mark's River at Natural Bridge, the Union troops run into strong resistance from Confederate artillery and are forced to retreat to the coast. This victory means that Tallahassee will remain out of Union hands for the remainder of the war, unlike any of the other Southern capitals east of the Mississippi River.

MARCH 7–10

NORTH CAROLINA, *LAND WAR*

The Battle of Wyse Fork/Wilcox's Bridge/Second Southwest Creek. Advancing Union forces in the Carolinas are initially stopped by General Bragg at Southwest Creek. However, Union attacks steadily push Bragg into retreat.

MARCH 10

NORTH CAROLINA, *LAND WAR*

The Battle of Monroe's Cross Roads/Fayetteville Road/Blue's Farm. A Union cavalry division screening Sherman's drive into North Carolina battles a Confederate attack near the Charles Monroe House in Cumberland. Neither side achieves outright victory.

MARCH 13

THE CONFEDERACY, *ARMED FORCES*

In the Confederate states it has been almost a point of faith that blacks could never be made into soldiers. Some Confederate officers, more concerned with winning the war, disagreed. In

▶ *Robert E. Lee (center, standing) talks strategy with the Confederate cabinet. President Davis sits next to Lee on the left. Lee's relationship with Davis was most cordial during the war, even when the Army of Northern Virginia was thrown onto the defensive after the Battle of Gettysburg.*

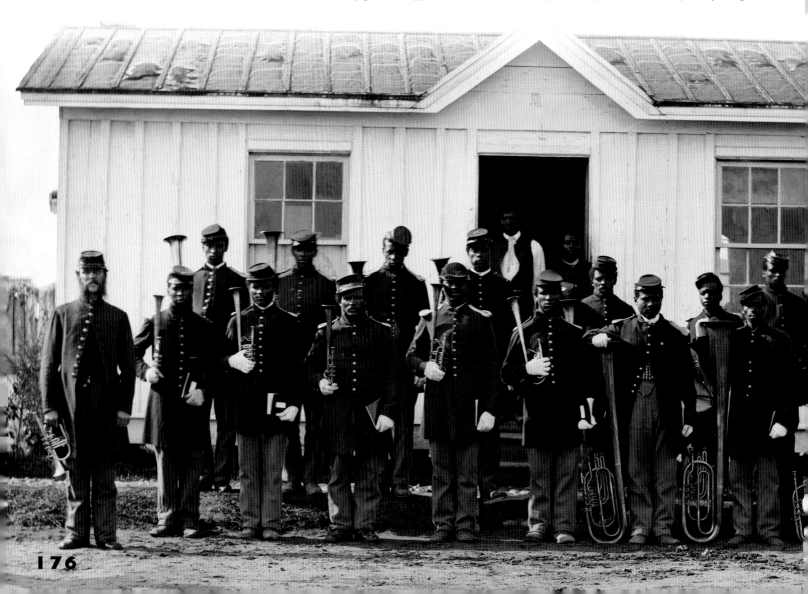

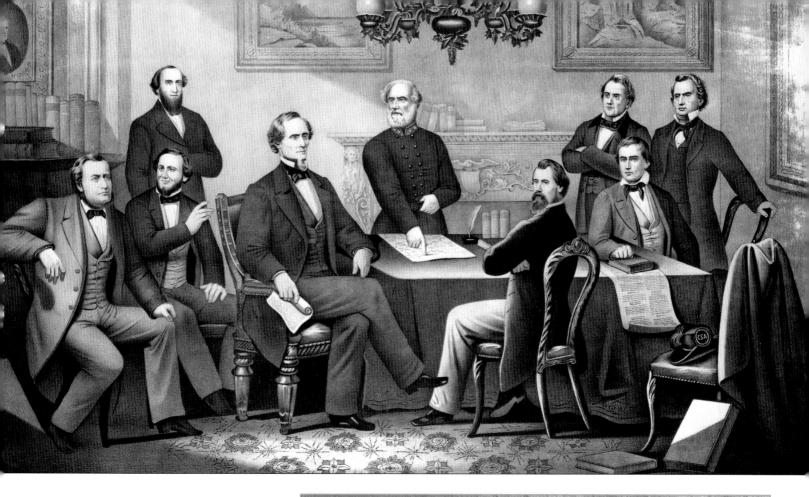

KEY PERSONALITY

JOSEPH JOHNSTON

Born on February 3, 1807, in Farmville, Virginia, Joseph Eggleston Johnston (1807–1891) was the highest-ranking officer to resign his commission in the U.S. Army on the outbreak of war. He entered Confederate service as a brigadier general—then the highest rank in the Confederate army. He was placed in command of all forces in Virginia following success at the First Battle of Bull Run (Manassas) in July 1861. In May 1862 he was wounded at the Battle of Fair Oaks and replaced by Robert E. Lee.

In November 1862, President Jefferson Davis placed the recuperating Johnston in command of the Department of the West. Johnston oversaw two Confederate armies, one based at Chattanooga, Tennessee, and the other at Vicksburg, Mississippi. Johnston and Davis disagreed over how best to defend Vicksburg. The town surrendered on July 4, 1863, and Johnston was unfairly blamed by Davis for the loss. The relationship between the two deteriorated even further as the war went on.

Johnston next commanded the Army of Tennessee in its effort to turn back General William T. Sherman's forces advancing south toward Atlanta, Georgia, in May 1864. Davis grew impatient with Johnston's defensive strategy and relieved him of command in July

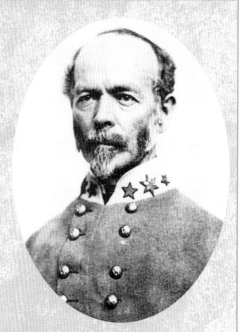

in favor of John Bell Hood. Atlanta fell to the Union in any case, and Johnston returned to duty in February 1865 at the request of Robert E. Lee. On April 17 Johnston met with Sherman to negotiate surrender terms.

After the war Johnston served as a congressman and then as commissioner of railroads. He died of pneumonia on March 21, 1891.

January 1864, Patrick Cleburne and 12 other senior officers of the Army of Tennessee signed a petition to Jefferson Davis urging him to recruit slaves. They recognized the Confederacy's need for more men to fight, even if it meant freeing the slaves. "As between the loss of independence and the loss of slavery," they wrote, "we assume that every patriot will freely give the latter—give up the negro slaves rather than become a slave himself."

Today, the Confederate Congress passes a law authorizing the use of black troops. On April 1, 1865, Colonel Otey of the 11th Virginia Infantry was ordered to recruit and train black units for the Confederate army, but it was too little, too late. The end of the war and the end of the Confederacy came within a month.

NORTH CAROLINA, *LAND WAR*
The Battle of Averasborough/Smiths Ferry/Black River. Union cavalry fight a day-long engagement with Lieutenant General William Hardee's Confederate corps, deployed across the Raleigh Road near Smithville. The Confederates eventually retreat after inflicting heavy casualties. Hardee is the author of the military manual *Rifle and Infantry Tactics*, first published in 1855.

◄ *A railroad battery used during the Civil War. A heavy gun mounted on an armored rail truck could be pushed by a locomotive into position to bombard the enemy.*

MARCH 19

NORTH CAROLINA,
LAND WAR
The Battle of Bentonville/ Bentonsville. By early March Sherman's army had crossed into North Carolina. Joseph E. Johnston tries to stop its progress at Bentonville. Johnston attacks in the afternoon, crushing the line of the Union XIV Corps. Only strong Union counterattacks south of the Goldsborough Road blunt the Confederate offensive. Elements of the Union XX Corps join the battle as they arrive on the field. Five Confederate attacks fail to dislodge the Union defenders as darkness ends the fighting.

MARCH 20–21

NORTH CAROLINA, *LAND WAR*
The Battle of Bentonville/Bentonsville. During the night, Johnston redeploys

▼ *A lineup of paddle steamers that had been pressed into service as troop ships to transport Union soldiers down the Ohio River. River transportation was invaluable for moving large numbers of Union troops and their supplies long distances to war theaters in the South.*

his forces into a "V" shape, with Mill Creek to his rear. Johnston remains in position today while he evacuates his wounded. In the afternoon on the 21st, Major General Joseph Mower leads his Union division across Mill Creek into Johnston's rear. Confederate counter-attacks halt Mower, thus preserving the army's only line of communication and retreat. Mower withdraws, ending fighting for the day. Johnston retreats during the night. Union forces pursue at first light, driving back the Confederate rearguard. The Federal pursuit is eventually halted at Hannah's Creek after heavy fighting. This Union victory has cost Johnston's army 3,092 casualties. Union losses are 1,646.

MARCH 27–APRIL 8

ALABAMA, *LAND WAR*

The siege of Spanish Fort. Spanish Fort, a Confederate-held position on the shore of Mobile Bay, is taken by the Major General E.R.S. Canby's XIII and XVI Corps after a long siege.

MARCH 29

VIRGINIA, *LAND WAR*

The Battle Lewis' Farm/Quaker Road/Military Road. As part of Grant's offensive moves against Petersburg, the Union V Corps under Major General G.K. Warren drives Confederate troops back from defenses on the Boydton Plank Road intersection.

▲ *Officers of the 4th U.S. Colored Infantry at Fort Slocum in 1865. Although black regiments were raised to fight for the Union, their officers were always white.*

MARCH 31

VIRGINIA, *LAND WAR*

The Battle of White Oak Road/Hatcher's Run/Gravelly Run. A Union advance toward White Oak Road is temporarily stopped by a major Confederate counterattack, but the day ends with the Union gaining significant ground.

The Battle of Dinwiddie Court House. A flanking march by the Union II and V Corps against the Petersburg defenses is temporarily stopped by the Confederates north and northwest of Dinwiddie Court House. However, the Rebels eventually have to retreat to Five Forks.

▲ *Washington, D.C. At the beginning of the war the city was only half built—the streets were unpaved, and there were open sewers. The dome of the Capitol was completed in March 1865.*

The Appomattox Campaign ▶

After evacuating Petersburg and Richmond on April 2 and 3, Lee's exhausted Confederates struggled west, planning to meet with Johnston's army. On April 6, Sheridan's cavalry overwhelmed the Confederate rearguard at Sayler's Creek, accounting for 7,500 troops of the Army of Northern Virginia and destroying a large part of Lee's wagon train. By April 7 Lee was down to 8,000 organized infantry. Union forces overtook them, and Lee finally surrendered to Grant at Appomattox Court House on April 9.

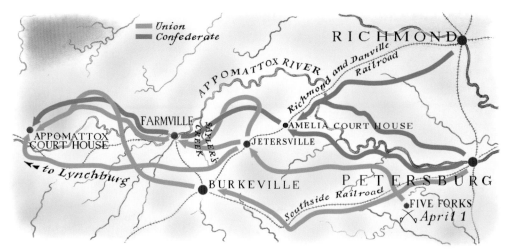

APRIL 1

VIRGINIA, *LAND WAR*

The Battle of Five Forks. As the Virginia weather began to improve in late March 1865, and muddy roads began to harden, Union General Ulysses S. Grant, who was besieging Petersburg, feared that his adversary, General Robert E. Lee, would attempt to evacuate the city's defenses and escape westward to join a Confederate army in North Carolina. To prevent Lee's escape, Grant planned an offensive to cut off his remaining escape routes to the west.

On March 31, elements of the Union Army of the Potomac under Philip H. Sheridan fought a sharp engagement with George Pickett's Confederates at Dinwiddie, west of Petersburg. After the fighting Pickett withdrew to a hamlet known as Five Forks, from which five different roads radiate like spokes on a wheel. One road leads directly north to Lee's last remaining supply line, the Southside Railroad. Lee ordered Pickett to hold Five Forks "at all hazards," and Pickett set about building fortifications to shelter his small force of infantry and cavalry.

Union forces renew the assault today. After moving stealthily into position, at 16:00 hours Sheridan's forces crash out of the pine thickets and break through the undermanned Confederate line in several places, killing and capturing thousands. During the battle Pickett is away at a picnic with some of his fellow generals, so he does not know of the defeat until the survivors began streaming past. By then it is too late for him to restore the situation, and he joins in the retreat.

On receiving word of the defeat at Five Forks, Lee is forced to make preparations to evacuate Petersburg, and Grant plans a climactic assault. While the Battle of Five Forks alone does not end the Petersburg campaign, the disastrous defeat helps seal the fate of Lee's Army of Northern Virginia.

APRIL 2

VIRGINIA, *LAND WAR*

Following Grant's defeat of Lee's Army of Northern Virginia outside Petersburg at Five Forks yesterday, he attacks the Petersburg defenses. The Confederates begin to retreat from Petersburg and their capital of Richmond today and tomorrow. The Confederate situation is now desperate.

Lee's weakened army races west in an attempt to outpace the Union troops and meet with Johnston at Danville, planning to make a combined stand. Lee loses a day waiting for

▼ *The ruins of the Richmond arsenal in April 1865. Buildings set on fire by the departing Confederates created a firestorm that reduced a large area of the city to rubble.*

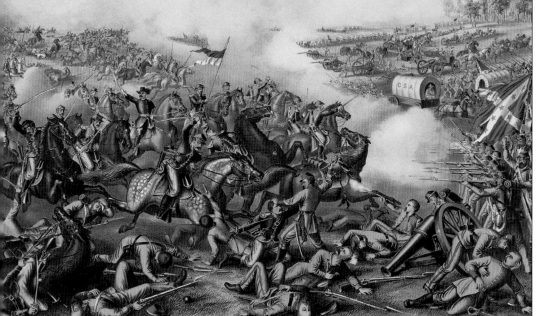

◀ At Five Forks the Confederates were routed by Union troops led by General Philip H. Sheridan. The Confederates suffered 5,000 men taken prisoner, and the rest fled from the battlefield.

▼ An engraving showing Lincoln's second inauguration on March 4, 1865. Chief Justice Salmon P. Chase administers the oath of office.

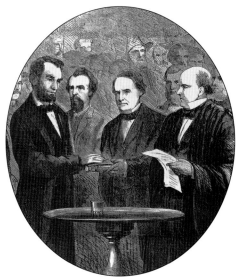

supplies for his hungry and tired men at Amelia Court House on the Richmond and Danville Railroad. The desperately needed supplies never arrive, and the hungry soldiers search in vain for food in the ravaged countryside nearby.

ALABAMA, *LAND WAR*
The Battle of Selma/Ebenezer Church/ Alabama. Three divisions of Union cavalry commanded by Major General James H. Wilson defeat Nathan B. Forrest's defense of the town of Selma. The defeat of Forrest is a major blow to Southern morale.

VIRGINIA, *LAND WAR*
The Battle of Sutherland's Station. Union columns striking toward Petersburg complete their takeover of the South Side Railroad, General Robert E. Lee's last supply line into Petersburg.

The Battle of Petersburg/The Breakthrough. A massive four-corps assault against the Petersburg lines is heroically resisted by the Confederate defenders. During the night, however, General Robert E. Lee orders the final evacuation of the cities of Richmond and Petersburg.

APRIL 2–9

ALABAMA, *LAND WAR*
The siege of Fort Blakely. Fort Blakely on Mobile Bay falls after a siege then a final assault by 16,000 Union troops on April 9. African American troops play a major part in the final operation.

APRIL 3

VIRGINIA, *LAND WAR*
The Battle of Namozine Church. A brigade of Union cavalry under Colonel William Wells attacks Fitzhugh Lee's cavalry near Namozine Church, without a clear result for either side.

APRIL 5

VIRGINIA, *LAND WAR*
Skirmishes break out as Union cavalry and infantry harass the Confederates in the area around Amelia Court House and Tabernacle Creek. Meanwhile, Union cavalry under Sheridan has outpaced Lee and blocks his route south at Jetersville on the Richmond and Danville Railroad. Lee is forced to set out west for Farmville, ordering supplies to be sent from Lynchburg.

Union forces catch up with the army's rear. Lee leads his men on a rapid night march west to Rice's Station on the Southside Railroad. Many sick and starving soldiers drop out through sheer exhaustion.

The Battle of Amelia Springs. Confederate cavalry engages in a running battle, starting at Amelia Springs, with Union troops returning from wagon-burning raids at Painesville.

APRIL 6

VIRGINIA, *LAND WAR*
The Battle of Sayler's Creek/Hillsman Farm. The straggling rear of the Confederate army is battered by a sustained assault from Union troops near Sayler's Creek. The fighting has a devastating effect. Between 7,000 and 8,000 of Lee's army—about one-third of those who have marched from Amelia Court House—are killed,

▲ The flight of President Jefferson Davis and his cabinet following the Union capture of Richmond on April 2, 1865. They attempted to run a government until May 2.

APRIL 6-7

wounded, or captured. Among those taken prisoner are six generals: Richard S. Ewell, George W.C. Lee, Joseph B. Kershaw, Montgomery Corse, Dudley M. DuBose, and Eppa Hunton.

The Battle of Rice's Station. General James Longstreet's movement south is blocked by the Union's XXIV Corps at Rice's Station, Prince Edward County, and is forced to withdraw over High Bridge toward Farmville.

APRIL 6-7

VIRGINIA, *LAND WAR*

The Battle of High Bridge. Longstreet's men attempt to fire High Bridge and Wagon Bridge over the Appomattox River after crossing it, but Union troops save the Wagon Bridge and so pursue the Confederates to Farmville.

APRIL 7

VIRGINIA, *LAND WAR*

The Battle of Cumberland Church/ Farmville. With desperate strength, Confederate forces under General Robert E. Lee near Cumberland Church/Farmville fight off the Union army's II Corps.

Grant sends a message through the lines to Lee asking for his army's surrender. Lee replies that he does not think the cause is yet hopeless, but asks for terms. In the meantime, Confederate troops, constantly under pressure from their pursuers, turn back an attack at Farmville where rations have finally been delivered. This, and fighting north of the Appomattox, delays Lee's retreat, while Sheridan with a combined force of cavalry and infantry is able to move ahead west and north to positions at Appomattox Station and Court House, blocking Lee's line of retreat to Lynchburg and effectively trapping the army.

APRIL 9

VIRGINIA, *LAND WAR*

At dawn, Gordon's Confederate infantry and Fitzhugh Lee's cavalry attack, with Longstreet following in support. Gordon's men hit the breastworks the Federals have hurriedly prepared and overrun them with two pieces of artillery. Then, as Gordon describes, "The Confederate battle-lines were still advancing when I discovered a heavy column of Union infantry coming from the right and upon my rear." Gordon fights hard to hold them back as yet another force of Union cavalry arrives, heading for a gap between him and

Longstreet. He sends word back to Lee that he has been fought "to a frazzle" and needs support immediately. When he receives word of this, Lee, knowing that Longstreet's men are too few to do the job, says, "There is nothing left for me but to go and see General Grant, and I had rather die a thousand deaths." Lee then orders white flags of truce raised all along the line as he sends word to Grant: "I ask a suspension of hostilities pending the adjustment of the terms of the surrender of this army."

With the Army of Northern Virginia in tatters, some of his subordinates appeal to Lee to scatter his army and continue the fight using guerrilla warfare. Lee, however, realizes that even if two-thirds of his 15,000 troops escape—probably an overoptimistic estimate—they will be an ineffective force scattered across the South.

At 13:00 hours today—Palm Sunday— Lee rides to the small settlement of Appomattox Court House. There he surrenders the first great army of the Confederacy to Ulysses S. Grant.

APRIL 10

VIRGINIA, *LAND WAR*

General Lee issues his final order to the men of the Army of Northern Virginia:

"After four years of arduous service, marked by unsurpassed courage and fortitude, the Army of Northern Virginia has been compelled to yield to overwhelming numbers and resources. I need not tell the brave

▼ **Robert E. Lee signs the document of surrender in the presence of Ulysses S. Grant in the parlor of Wilbur McLean's house at Appomattox Court House.**

survivors of so many hard fought battles, who have remained steadfast to the last, that I have consented to the result from no distrust of them.

"But feeling that valor and devotion could accomplish nothing that would compensate for the loss that must have attended the continuance of the contest, I determined to avoid

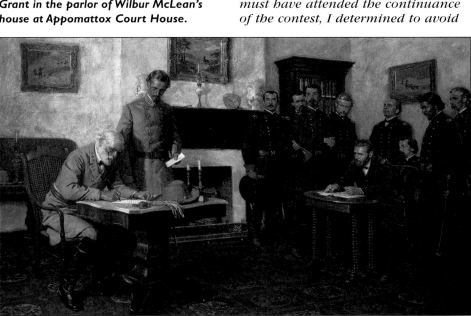

▲ Celebrations at Fort Sumter in Charleston Harbor, South Carolina, on April 14, 1865. The Union flag was raised over the fort four years to the day after it fell.

the useless sacrifice of those whose past services have endeared them to their countrymen. By the terms of the agreement officers and men can return to their homes and remain until exchanged. You will take with you the satisfaction that proceeds from the consciousness of duty faithfully performed, and I earnestly pray that a Merciful God will extend to you His blessing and protection.

"With an increasing admiration of your constancy and devotion to your country, and with a grateful remembrance of your kind and generous considerations for myself, I bid you all an affectionate farewell."

APRIL 14

WASHINGTON, D.C., ATROCITY

President Lincoln and his wife, Mary Todd Lincoln, spending a pleasant time at Ford's Theatre in Washington, D.C., are watching a performance of a very popular British comedy, *Our American Cousin*, in the company of Lincoln's military aide, Major Henry Rathbone, and Rathbone's fiancée, Clara Harris.

◀ The box at Ford's Theatre where President Lincoln was shot on April 14, 1865, by John Wilkes Booth. Wilkes broke his leg making his escape.

Shortly after 22:00 hours the actor John Wilkes Booth enters the theater, where he is well known, and makes his way unopposed to the presidential box. Timing his entry to coincide with a line from the play that Booth knows will draw a big laugh, he opens the door to the box, steps in, and shoots the president in the back of the head (the president's bodyguard had slipped out for a drink).

Major Rathbone tries to grapple with Booth, forcing him to the railing of the box. Booth then leaps over, catches the

KEY PERSONALITY

JOHN WILKES BOOTH

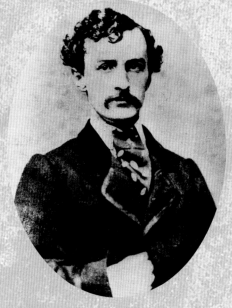

John Wilkes Booth (1838–1865) was born into a leading theatrical family on May 10, 1838, near Bel Air in the slave state of Maryland. The Booth home was 25 miles (40km) south of the border with the free North. Booth was proslavery from an early age and thus became fervently anti-Lincoln.

After some early failures J. Wilkes Booth (as he was known on stage) made his name with the Richmond Theatre Company in Virginia in 1859. While in Virginia he became even more attached to the Southern way of life and joined the Richmond militia for a short time. As a militia volunteer he stood guard at the gallows during the hanging of the antislavery figure John Brown.

Booth was in great demand as an actor in Washington, D.C., during the war years. On November 9, 1863, President Lincoln saw Booth star in *The Marble Heart* by Charles Selby at Ford's Theatre.

As the war went on, Booth became increasingly upset by Confederate defeats and began to gain a reputation for bouts of wild behavior. In May 1864 Booth gave up acting. He dabbled in the oil business and may have become a Southern spy, smuggling quinine and other medicines to the Confederate army. In

November Booth moved to Washington, where he and others devised various plots to kidnap the president. They intended to ransom Lincoln for the return of Confederate prisoners of war. But their attempts all failed.

On April 9, 1865, Robert E. Lee surrendered to the Union. In a desperate, last-ditch show of support for the Confederacy Booth decided to kill Lincoln.

On the night of Good Friday (April 14) 1865 Lincoln attended a performance of *Our American Cousin* at Ford's Theatre. During the third act of Tom Taylor's play Booth entered the unguarded presidential box and shot Lincoln through the back of the head with a pistol.

Despite having broken his left leg as he landed on the stage, Booth escaped on horseback. Twelve days later Union troops caught up with him on the farm of Richard Garrett near Bowling Green, Virginia. The soldiers set fire to the tobacco barn in which the assassin was hiding. Booth died in the ensuing battle, either shot through the neck by Sergeant Boston Corbett or by his own hand.

spur of his boot on the flag draped over the railing, and crashes to the stage below. He suffers a broken leg in the fall but immediately clambers to his feet. Shouting "Sic semper tyrannis! [So it always is with tyrants] The South is avenged!" he flees the theater and makes his getaway on a waiting horse.

A doctor in the audience rushes to the box to find the president slumped forward unconscious, the bullet having lodged just behind his right eye. Although Lincoln is still breathing, it is clear that he has suffered a mortal wound. He is carried to a boarding house across the road where, despite the best efforts of doctors, he dies just before 07:30 hours the following day.

▶ A Northern cartoon of 1865 showing two Southern women looking down on a Union soldier in a Richmond street, despite the fact that the Confederacy has been defeated and their city lies in ruins. It illustrates the refusal of many Southerners to face postwar reality.

APRIL 26

NORTH CAROLINA, *LAND WAR*

At the Bennett House near Durham, General William T Sherman again meets with Confederate General Joseph E Johnston, commander of Southern forces in the West (this is their third meeting since April 17). Final terms of capitulation for troops of Johnston's command are signed following the formula set by Grant at Appomattox. The same day the terms are approved by Grant:

"*All arms and public property were to be deposited by Confederates at Greensborough. Troops were to give their parole and pledge not to take up arms until released from this*

◀ **Joseph E. Johnston (right) surrenders to William T. Sherman (left) on April 26. Johnston's surrender was followed by that of Richard Taylor in Alabama a week later and that of Kirby Smith's Confederate army at New Orleans a month later.**

obligation. Side arms of officers and their private horses and baggage could be retained. All officers and men were permitted to return to their homes. Field transportation was to be loaned to the troops for getting home and later use. A small quantity of arms would be retained and then deposited in state capitals. Horses and other private property were to be retained. Troops from Te[x]as and Arkansas were to be furnished water transportation. Surrender of naval forces within the limits of Johnston command."

Thus the second major army of the Confederate States of America, 30,000 men, surrender. The Confederate Cabinet meets with President Davis at Charlotte and agrees to leave today with the aim of getting west of the Mississippi River.

APRIL 27

TENNESSEE, *NAVAL WAR*

One of the greatest disasters in U.S. maritime history takes place in the first weeks of demobilization following the end of the war. The riverboat *Sultana*, traveling on the Mississippi River north of Memphis with 2,000 troops on board, mostly veterans returning home from battle, catches fire and sinks, killing more than 1,400 men. The *Sultana* was a side-wheeler built at Cincinnati in 1863 for the lower Mississippi cotton trade. It was commandeered by the Union army during

RICHMOND LADIES GOING TO RECEIVE GOVERNMENT RATIONS.—[SKETCHED BY A. R. WAUD.—[SEE FIRST PAGE.]

▲ A postwar photograph of Robert E. Lee. After the war he became president of Washington College, in Lexington, Virginia. He set a great example by working hard for the country's reconciliation.

the war to carry soldiers and material for the war effort.

MAY 10

GEORGIA, *POLITICS*
Confederate President Jefferson Davis is captured after Federal troops launch

ARMED FORCES

PRISONER-OF-WAR CAMPS

For much of the war the policy of both sides was not to keep prisoners but to release them on parole—meaning they had to promise not to take up arms again until exchanged for an enemy soldier. The first prisoner exchange took place in February 1862, and in July both sides agreed to parole prisoners within 10 days and to exchange them at an agreed rate. One general, for example, could be exchanged for 60 enlisted men. However, by the summer of 1863 the exchange system had broken down due to a lack of trust on both sides. By late 1864 the number of prisoners being held in camps had soared into the hundreds of thousands. And conditions in many prison camps became murderous.

As prisoner numbers rose, both the Union and Confederacy had to resort to using vast open-air enclosures to hold them. The Union War Department opened the notorious Elmira Prison in New York State in May 1864. By August it was filled with 10,000 Confederates, half of them living in tents on a badly drained, polluted swamp. By November more than 700 men had died from typhoid, dysentery, pneumonia, or smallpox, and 1,000 men a day were falling sick. Some died from scurvy due to a lack of fresh vegetables in their rations.

In February 1864 the Confederates opened Camp Sumter near Andersonville in Georgia. The camp was meant to relieve the pressure on prisons around Richmond, but men were sent there without any regard to conditions inside or how the authorities might feed them. By July more than 32,000 men were crowded into the camp without any shelter from the sun and on starvation rations. The terrible conditions suffered by Union prisoners at Andersonville were first publicized in the North in late 1864, when a pamphlet published in Boston recorded the experiences of prisoners who had survived. Many Union soldiers gave graphic descriptions of life in the camp.

Daily rations at Andersonville were two ounces of pork, usually half rotting, plus a little rice and corn bread. Prisoners lacked wood for a cooking fire or a pan to cook in. Starvation, sickness, and depression were rife, and many prisoners either lay motionless or stalked vacantly up and down.

By August 1864 there were 35,000 men in Andersonville, and the death toll from starvation and disease had climbed to 100 a day. By April 1865 the total number of deaths in the camp had reached 13,000, although this may be an underestimate. There were calls in the North for retribution against the officers responsible. Immediately after the war ended, the camp commandant, Henry Wirz, was tried by a U.S. military tribunal, charged with cruelty and conspiracy to kill Union prisoners of war. He was found guilty and hanged in late 1865.

Today, it is commonly held that both sides were guilty of mistreating prisoners during the war. In most cases the sufferings of the prisoners had more to do with official incompetence and a lack of food and resources than with a deliberate policy of letting enemy prisoners die.

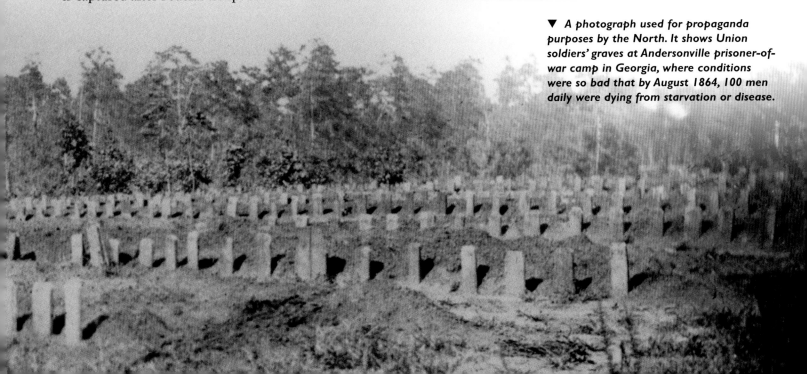

▼ A photograph used for propaganda purposes by the North. It shows Union soldiers' graves at Andersonville prisoner-of-war camp in Georgia, where conditions were so bad that by August 1864, 100 men daily were dying from starvation or disease.

▲ *A wounded soldier is welcomed home after the Civil War. Family life was profoundly affected by the war, mainly because of its long duration.*

a surprise raid on his encampment near Irwinville, Georgia. In the excitement he grabs a woman's shawl by mistake, beginning the rumor that he tried to flee dressed as a woman. He would be taken into custody and not released until May 13, 1867.

MAY 13

TEXAS, *LAND WAR*
The Battle of Palmito Ranch/Palmito Hill. Some of the last fighting of the war takes place near Brownsville, a month after Confederate General Robert E. Lee had surrendered in Virginia. In the Battle of Palmito Ranch, Confederates commanded by John S. "Rip" Ford defeat a Union force under Theodore H. Barrett, resulting in 30 Union casualties. Within days, word

arrives of the surrender of Edmund Kirby Smith, Confederate commander of forces west of the Mississippi River. On June 19, Union troops landed at Galveston and read out the Emancipation Proclamation, signaling the end of the Civil War in Texas.

MAY 23

THE UNION, *ARMED FORCES*
In front of cheering crowds and the new U.S. president, Andrew Johnson, the Army of the Potomac marches in grand review down Pennsylvania Avenue in Washington, D.C. Sherman's Army of the Tennessee, fresh from its victory over Joseph E. Johnston's army in North Carolina, parades down the avenue the following day. Of the great victory review Grant would recall in his memoirs, *"The sight was varied and grand: nearly all day for two successive days, from the Capitol to the Treasury Building, could be seen a mass of orderly soldiers marching in column of companies. The National flag was flying from almost every house and store; the windows were filled with spectators…."*

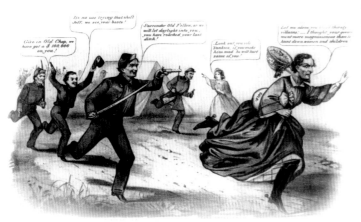

▼ *President Davis was captured on the night of May 10, 1865, near Irwinville in Georgia. He was not, as was later claimed by many people, dressed as a woman.*

▲ *Mounted Union officers followed by infantry parade down Pennsylvania Avenue, Washington, D.C., in May 1865, during the Grand Review of the victorious army.*

MAY 29

WASHINGTON, D.C., *POLITICS*
President Andrew Johnson grants an amnesty and pardon to Confederate soldiers and all those involved in the "rebellion." An oath of allegiance to the Constitution has to be taken by Rebels, and there are many categories of person excluded from the pardon.

KEY PERSONALITY

ANDREW JOHNSON

The timing of Lincoln's assassination, which happened only a few days after the end of the war, gave Andrew Johnson (1808–1875) the heavy responsibility of trying to reunite the North and South after four years of war. The task destroyed his administration within three years and saw Johnson himself impeached and on trial before the U.S. Senate, charged with gross misconduct.

Born in Raleigh, North Carolina, Andrew Johnson came from a poor family and had very little schooling. He began his working life apprenticed to a tailor at the age of 13. Moving to Greeneville, Tennessee, in 1826, he began a tailoring business of his own. He married Eliza McCardle in 1827, and with her help he learned to read and write and then went on to educate himself further and to take part in local debates. His business prospered, and he used his ambition, drive, and gift for public speaking to enter Greeneville politics, becoming a town alderman in 1828 and then mayor in 1830.

Success in Greeneville led Johnson into national politics. In 1843 he entered Congress as the Democratic Party's representative for Tennessee. He remained in Congress until 1853 and then returned to Tennessee as governor. He held the post until 1857, when he was elected to the Senate.

In his prewar political career Johnson stood up for the rights of the poor and for small farmers and businessmen, and spoke out against the plantation owners who dominated politics in Tennessee and the rest of the South. He championed the Homestead Bill to grant free land to settlers on the Western frontier (the bill was eventually passed into law in 1862).

In the great debate of the 1850s over whether or not slavery should be extended into the new territories, Johnson supported the Southern belief that it should. Although Johnson upheld the institution of slavery, he remained pro-Union and refused to support Southern secession even after Tennessee seceded in May 1861. Johnson was the only senator from a seceded state to remain at his post in Washington, D.C.

During the war the Republican President Lincoln recognized Johnson's political usefulness as a pro-Union Southern Democrat. In March 1862, after Union forces had occupied central Tennessee, Lincoln appointed Johnson military governor of the state. Johnson's staunch work for the Union, in the face of persistent local hostility, led to his selection as Lincoln's running mate in 1864. Lincoln

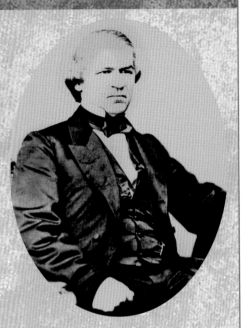

was reelected, and Johnson became vice president. He held the office for six weeks before Lincoln's assassination on April 14, 1865, made Johnson the new president.

Johnson tried to continue Lincoln's policy of clemency toward the defeated Confederacy. In this he was opposed by Congress, which was dominated by Radical Republicans who wanted harsher treatment of the former enemy and political rights for the freed slaves.

On May 29, 1865, Johnson announced a pardon for many former Confederates before Congress was in session. Johnson, who firmly believed he had the support of the people, went on to use his presidential veto to thwart several bills passed by Congress. On March 2, 1867, Congress ran out of patience with the president and passed, despite Johnson's veto, a Reconstruction Bill based on military administration of the Southern states and black suffrage. Congress also passed the Tenure of Office Bill, which limited the president's freedom to remove officials. In defiance of this Johnson dismissed Secretary of War Edwin M. Stanton, a Radical Republican, in August 1867. On February 28, 1868, Congress voted to impeach Andrew Johnson on 11 charges of misconduct centering on the firing of Stanton.

Johnson's Senate trial took place between March 5 and April 11, 1868. The president was acquitted and he continued in office until the end of his term in 1869, but he was almost powerless. Johnson later made two attempts to return to public office before winning a Senate seat in March 1875. He died suddenly on July 31.

▲ A cartoon showing the South chained to occupying Federal troops and being crushed by the policies of the Republican President Ulysses S. Grant.

JULY 7

JULY 7

WASHINGTON, D.C., *LEGAL*
Mary Surratt, Lewis Payne, David Herold, and George Atzerodt, all found guilty of conspiracy in Lincoln's assassination, are hanged at Washington Penitentiary.

SEPTEMBER 12

ALABAMA, *POLITICS*
A convention in Montgomery resolves to restore relations with the Federal administration. On the last day of the month the convention abolishes slavery. Alabama contributed between 75,000 and 125,000 men to the Confederate army. At least 25,000 Confederate Alabamians have been killed, and about 2,500 white and 10,000 black Alabamians enlisted in the Union army.

Union raids late in the war destroyed enormous amounts of property and have left Alabama so impoverished that it will take several generations to rebuild its economy.

▼ *A painting by R. Brooke entitled Furling the Flag, showing Confederate troops rolling up their flag. Soon the Confederacy would enter folklore as the "lost cause."*

NOVEMBER 10

WASHINGTON, D.C., *LEGAL*
Captain Henry Wirz, the superintendent of the infamous Confederate prison at Andersonville where thousands of Union troops died during the war, is executed for war crimes in Washington Penitentiary.

DECEMBER 18

WASHINGTON, D.C., *POLITICS*
The Thirteenth Amendment to the Constitution is ratified, abolishing slavery as a legal institution in the United States.

◄ *Members of the House of Representatives cheer the passage of the Thirteenth Amendment, which finally abolished slavery throughout the United States in December 1865, after the Civil War had ended.*

▼ *Former Confederate officers in Mexico, October 1865. They were among the estimated 10,000 Confederates who went into exile after the Civil War.*

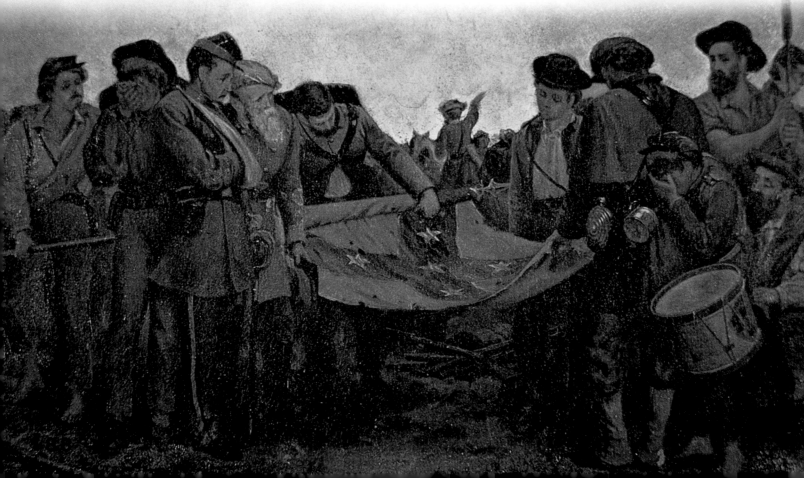

CONCLUSION

The Civil War had preserved the Union. At the beginning of the war President Abraham Lincoln repeatedly said that saving the Union was his only reason for fighting and that the war was not being fought to free the slaves. That changed over the course of the war, but saving the Union remained foremost among Union war aims, and it was achieved when the Confederate army surrendered in 1865.

The Civil War ended a debate that had plagued the nation since its creation in 1776 over whether states could voluntarily secede from the Union, just as the original 13 states had voluntarily joined it when they ratified the Constitution. After the Civil War the doctrine of secession was discredited; it has not since received serious consideration as an acceptable response to real or alleged wrongs done to a state. The Union is now accepted by Americans as permanent. Prior to the Civil War Americans commonly spoke of their nation in the plural: "these United States." After the war the nation became "the United States," suggesting that a loose collection of semi-autonomous states had been replaced by a system in which the states were more like subdivisions of one united country.

The end of slavery

Although the destruction of the institution of slavery was not the original aim of the Lincoln administration, the emancipation of nearly four million African American slaves became the major legacy of the war. The importance of that legacy lay not only in the fact of emancipation but also in the way it came about. More than 180,000 black men served in the Union military and thus played an important role in emancipation.

Wartime military service for African Americans enhanced their status in the postwar nation. The war also helped train a generation of postwar black leaders. The migration of African Americans to the North in the 20th century transformed Northern cities. Freedom did not bring an end to poverty and inequality for African Americans. However, emancipation unleashed the potential of millions of former slaves and their descendants.

The political landscape

The war also affected American politics. The period shaped the modern American two-party system and brought the Republican Party to long-term power. For decades following the war political loyalties reflected the party alignments that had emerged in the late 1850s. The Democratic Party was the dominant party of the South, while the Republican Party remained an almost exclusively Northern party. By the 1930s, however, the Democratic Party was the party of the underprivileged. The Civil Rights movement of the mid-20th century continued the political battles begun during the turmoil of the Reconstruction years (1865–1877).

The war left important legal and constitutional legacies. Chief among them are the three amendments added to the U. S. Constitution as a result of emancipation and Reconstruction. The Thirteenth Amendment (1865) permanently abolished slavery everywhere in the nation. The Fourteenth Amendment (1868) provided that the rights of citizenship could not be denied without due process of law, and the Fifteenth Amendment (1870) specifically extended the right to vote to African American men. For a century or more following the passage of these amendments, Southern states found

ways to prevent their enforcement. Civil Rights activists of the 1950s and 1960s used these amendments to fight for equality. The Fourteenth Amendment in particular provided the legal basis for many civil rights court decisions. For example, the "equal protection" clause was the basis for the 1954 Brown v. Board of Education decision outlawing school segregation.

A new kind of war

Often referred to as the first modern war, the Civil War was one of the first large-scale conflicts in which the Industrial Revolution played a direct role in how the war was fought, as well as in its outcome. The war saw the first use of ironclad warships, submarines, and machine guns. The trench warfare that characterized the sieges of Petersburg and Richmond near the end of the war anticipated the tactics of World War I (1914–1918). For the first time railroads were used to move entire armies quickly to far-off battlefields. The telegraph kept distant commanders in communication with troops in the field. Mass production of factory-made weapons, ammunition, uniforms, and supplies played a crucial role in the Union's ultimate success.

Military strategy and tactics were forced to change to meet these new conditions. Union General William T. Sherman's march through Georgia and the Carolinas, which destroyed homes and farms and struck terror into civilians, previewed shock tactics that would be used in future wars. The size of Civil War armies and the casualties also foreshadowed a frightening future for warfare. Of the 2.5 million men who fought for the Union and 1 million who fought for the Confederacy, 620,000 died in the war.

INDEX

INDEX

PICTURE CREDITS

Art Explosion: 10tl

Corbis: 8, 16 bl, 20-21b, 26-27, 44tr, 58tr, 79tr, 84bm, 92bl, 100b, 101, 114-115t, 150b, 161bl, 165bm, 166tl, 178-179, 184-185, 187, 188tm

Getty Images: 47bl, 54ml, 82ml, 86tr, 157tl, 162tr, 138-139

Library of Congress: 2-3, 7, 9t, 9mr, 9br, 10bl, 11, 12, 13, 14, 15tr, 15ml, 16br, 20ml, 22, 24tr, 24b, 25bl, 27tr, 27bl, 29br, 30-31, 31tm, 32-33, 32br, 33tr, 34, 35t, 35bl, 42t, 42br, 43bl, 45mr, 45bl, 46b, 48-49, 49bl, 50bl, 51, 53tl, 53mr, 53b, 54-55b, 56-57, 56bl, 57tr, 58b, 59tm, 59b, 60-61, 60tl, 61tr, 62-63, 62tr, 62bl, 63t, 64-65b, 64tl, 66-67, 66tr, 66ml, 67t, 67m, 68-69, 68bl, 69bl, 70-71b, 71mr, 71br, 72-73, 72tl, 73tr, 74tl, 75m, 77, 78-79, 78b, 79b, 81tl, 82-83, 82tr, 84-85, 85tr, 85bl, 86b, 87bl, 89tr, 90tm, 91, 92-93, 92t, 93br, 94tr, 94ml, 98-99b, 98tl, 100tr, 102-103, 103tr, 104m, 104br, 105mr, 106-107t, 107br, 108-109, 108b, 110ml, 111bl, 112tr, 112bl, 113, 114-115b, 115br, 116-117b, 117br, 118-119, 118tl, 119bl, 120-121, 120tr, 122tr, 123t, 123br, 125br, 125mr, 128-129, 130t, 131t, 131bm, 133t, 133br, 135bl, 140tl, 142tl, 151mr, 151b, 152-153, 152mr, 152b, 153tr, 154-155, 156tr, 156ml, 156b, 158tr, 158bl, 159t, 159mr, 160tl, 161t, 162bl, 164tm, 164ml, 165tl, 166-167, 167b, 168ml, 169tl, 169mr, 170-171t, 170-171b, 170tm, 170ml, 171tr, 172b, 173mr, 173bl, 174tr, 176-177, 177t, 179t, 181tl, 181tr, 181br, 183tr, 183bm, 184ml, 184t, 186-187, 186tl, 186bl, 188mr

Mary Evans Picture Library: 126t, 130ml

National Archives: 10mr, 15b, 18, 19, 21br, 23b, 25tr, 25mr, 26bm, 28-29, 28tr, 32tl, 33br, 36-37, 36bl, 37tl, 38tl, 39ml, 39b, 40tr, 40bl, 43tr, 44-45, 46-47, 47tr, 48br, 50tr, 52, 54-55b, 55tr, 61bm, 70ml, 73br, 75t, 75bl, 80, 81bl, 83tr, 83mr, 87br, 88, 89b, 90b, 95t, 96tr, 97bm, 98-99t, 102bl, 104-105, 107m, 108tl, 109tr, 110tr, 111t, 114tl, 116-117t, 116tm, 121ml, 122-123, 124-125t, 124-125b, 126b, 127t, 127br, 128bl, 129t, 132-133, 132tr, 134-135, 134b, 135tr, 137tr, 139tr, 140-141, 140bm, 141tr, 142-143b, 144-145, 144b, 145tr, 145br, 146tr, 146b, 147t, 147br, 149tl, 149mr, 149b, 150tr, 151t, 153b, 154bm, 155tr, 155b, 157bl, 158-159, 162-163, 163tr, 164-165, 167tr, 168-169, 168tr, 174-175, 174ml, 177br, 178tm, 179br, 180, 182-183, 185tl, 187tr

Peter Newark's Historical Pictures: 23tr, 30bl, 64-65t, 182br, 188b

Robert Hunt Library: 17, 20-21t, 38-39, 40br, 41, 70-71t, 74, bm, 76tr, 85br, 94-95, 96b, 97tr, 99br, 100ml, 106-107b, 107tr, 121tr, 136-137, 137ml, 137b, 138tr, 142-143t, 143m, 160bm, 161mr, 172-173, 175br